ROSA BONHEUR

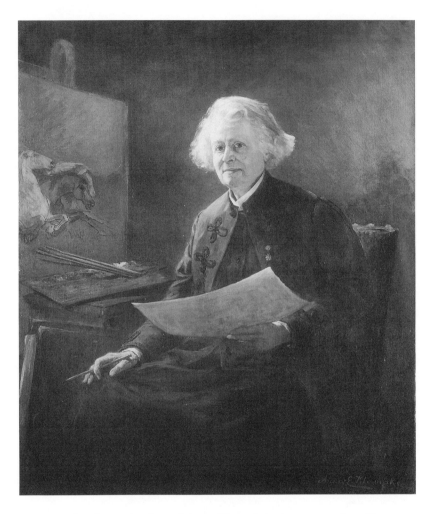

Rosa Bonheur, *the first of Anna Klumpke's three portraits of her,
dated 1898. (Courtesy of The Metropolitan Museum of Art. Gift of the
artist in memory of Rosa Bonheur, 1922.)*

ROSA BONHEUR
The Artist's (Auto)biography

❖

Anna Klumpke

Translated by Gretchen van Slyke

Ann Arbor

The University of Michigan Press

In memory of Thelma and Beamie

❖

for Fran and Babeth

Copyright © by the University of Michigan 1997
All rights reserved
Published in the United States of America by
The University of Michigan Press
Manufactured in the United States of America
♾ Printed on acid-free paper
2000 1999 1998 4 3 2

A CIP catalog record for this book is available
from the British Library.

Library of Congress Cataloging-in-Publication Data

Klumpke, Anna, 1856–1942.
 [Rosa Bonheur. English]
 Rosa Bonheur : the artist's (auto)biography / Anna Klumpke ;
translated by Gretchen van Slyke.
 p. cm.
 Includes bibliographical references and index.
 ISBN 0-472-10825-5 (hardcover)
 1. Bonheur, Rosa, 1822–1899. 2. Animal painters—France—
Biography. I. Title.
ND553.B6K613 1997
759.4
[B]—DC21 97-20701
 CIP

ACKNOWLEDGMENTS

It is a pleasure to thank the many people who, in various and sundry ways, have contributed to the making of this book.

Thanks to two fine people at Bailey-Howe Library at the University of Vermont: Nancy Crane of the Reference Department, who was instrumental in getting me a good photocopy of the original French text (thanks likewise to the library of Middlebury College, from which that rare text was borrowed); and Pat Mardeusz of the Interlibrary Loan Department, who never failed to locate the obscure and yet more obscure materials that helped me track down tantalizing references and pursue new paths in my research on Rosa Bonheur. Without a good library, without a good library staff, there can be no scholars.

Thanks to the University of Vermont for granting me a sabbatical leave, which got this project going back in 1990–91. That year was a precious time of discovery and delight.

Thanks to my colleagues in the Department of Romance Languages, notably Susan Whitebook, Janet Whatley, Grant Crichfield, Donna Kuizenga, and Philippe Carrard. Susan read the entire first draft of the translation. Her sagacious comments helped point the way toward a more familiar tone, a translation that tried to capture the very different but altogether congenial spirits of Rosa Bonheur and Anna Klumpke. Janet, especially, provided encouragement when my reserves felt dangerously low. Many thanks also to Jane Ambrose of the Department of Music for her comments, questions, answers, and unfailing enthusiasm for this project.

Thanks to colleagues at other universities. Lucienne Frappier-Mazur, already many years ago, pushed me on to think about mothers and daughters and provided great critical impetus. Frank Paul Bowman gave me my first inkling of the importance of the various and ever more amazing strands of socialist thought in nineteenth-century France. I hope that both may find the fruit of their teaching here. Robert B. Carlisle, who wrote a wonderful book on the Saint-Simonians and answered so many of my questions about the involvement of Rosa Bonheur's parents in that movement, read over the entire first draft of the manuscript, helping me avoid many historical blunders. I take full responsibility for any new ones that may have slipped into subsequent drafts. Therese Dolan and Madelyn Gutwirth shared my passion for Rosa Bonheur and helped this scholar of literature make a foray into the domain of art. Britta Dwyer provided invaluable aid when she generously offered to share with me her painstaking detective work following the trail of Anna Klumpke and her works. I

Acknowledgments

also want to thank Léo and Babeth Jahiel. Though they are not officially recognized teachers, I have learned so much from them both. For one thing, they put me on the right track regarding the history of cross-dressing permits. For another, Babeth drove me down to Thomery for my first visit to the Rosa Bonheur Museum there.

Individuals at several museums have patiently listened to my questions and done their very best to answer them. These include Robin Dettre of the Inventories of American Painting and Sculpture, Research and Scholars Center, National Museum of American Art of the Smithsonian Institution; Marietta Boyer and Cheryl Leibold of the Pennsylvania Academy of the Fine Arts; Julia Eldridge, the American Painting and Sculpture Department of the Metropolitan Museum of Art; and Krystyna Wasserman, the Library and Research Center of the National Museum of Women in the Arts. I am also grateful that the Metropolitan Museum allowed me to include in this volume a photograph of Anna Klumpke's first portrait (1898) of Rosa Bonheur.

Thanks to Hacker Art Books for letting me reproduce a copy of one of Rosa Bonheur's cross-dressing permits.

Thanks to Bill DiLillo of University Photography at the University of Vermont, who did such a fine job reproducing almost all the photographs that illustrate this volume.

Thanks to my animals, who gave me the comfort of their company and considerable amusement during my long sessions of work. Chickpea, the cairn terrier, spent many hours snoozing under my desk or chomping a bone while the computer whirred and hummed above. Mad Max and Ivan the Terrible, the pound cats, usually lolled about the study or even the desktop, inspiring me with dreams of lazy pleasure. On at least one occasion Max chewed up disks out of mean-minded jealousy, which taught me vigilance as well as the much needed lesson of always backing up work. These small creatures stood in for Rosa Bonheur's great and greatly loved menagerie. I only wish that, like hers, my household embraced otters, horses, and lions.

Last (but the last shall be first!), many heartfelt thanks to my husband, Z. Philip Ambrose. He fanned the flame when this project was but a glimmer in my eye, spurred me on through the many drafts of this translation, saw me through bouts of discouragement, cheerfully tolerated my single-minded devotion to my task as well as work habits that he found perplexing, gave me astute advice about language (as well as pestering me with questions!), and had the wonderful grace to share my tears of joyful recognition when we set foot in Rosa Bonheur's old studio in Thomery, France.

—*Gretchen van Slyke*

CONTENTS

Contents

PART 3
Anna Klumpke's Story

Contents

APPENDIXES

INTRODUCTION TO THE ENGLISH EDITION

Gretchen van Slyke

Biography and Beyond

In these pages two remarkable women of the last century tell their own life stories as well as the stories of the women they loved. When I first stumbled across Anna Klumpke's book in the fall of 1990, these stories so captivated me that the decision to translate the volume was immediate and irresistible. I had read nothing like it and yearned to enter more deeply into this world. The following pages are truly a labor of love.

The most famous, even notorious of the pair is Rosa Bonheur (1822–99), the great French animal-painter hailed as the most popular artist, male or female, of the nineteenth century and the first female artist to earn admittance to that once exclusively male club founded by Napoleon, the French Legion of Honor. During her lifetime Rosa Bonheur was often compared to George Sand. Obviously they shared a certain succès de scandale with their predilection for trousers, tobacco, and unconventional lifestyles. More importantly, they were both proud, independent women who, despite many obstacles, gave professional definition to their lives, one by the pen, the other by the brush. Among Rosa Bonheur's most famous works are the luminously serene *Ploughing in the Nivernais* (1849) and *The Horse Fair* (1853), a simply monumental canvas inspired by the Parthenon friezes and Théodore Géricault's Romantic stallions. The first is prominently displayed in the new Musée d'Orsay in Paris, while the second hangs in New York's Metropolitan Museum, a generous gift of Cornelius Vanderbilt in the heyday of the French artist's popularity.

Anna Klumpke (1856–1942) is the French painter's more discreet counterpart. An American artist, her best-known works are her portrait of Rosa Bonheur (1898), which she gave to the Metropolitan Museum on the one-hundredth anniversary of the French artist's birth, and her portrait of Elizabeth Cady Stanton (1886), which hangs in the National Portrait Gallery in Washington, D.C. Anna Klumpke made a distinguished career for herself on both sides of the Atlantic and eventually followed Rosa Bonheur into the ranks of the Legion of Honor. When she met Rosa Bonheur in 1889 at her chateau near Fontainebleau, which is now the site of the Rosa Bonheur Museum, Anna Klumpke was living in Paris, along with her mother and sisters. Although the family hailed from San Fran-

cisco, Mrs. Klumpke, who by all accounts must have been quite a formidable matriarch, had ambitions for her daughters that she felt would be better fulfilled in Europe. After having obtained a legal separation from her husband and custody of the children, she took them away for lengthy stays in Germany and Switzerland. Finally she settled her family in Paris, a destination elected because of the exceptional educational opportunities that city offered to women. Steadily encouraged to study diligently and to work toward professional careers and financial independence, Anna and her four sisters quickly made their mark. Augusta Klumpke, after becoming the first female intern in the Parisian hospital system, became a prominent neurologist. Dorothea earned a prestigious doctorate in mathematical science at the Sorbonne and went on to a noteworthy career in astronomy. Mathilde and Julia made their way in music, while Anna won prize after prize for her paintings.[1]

For Anna Klumpke, meeting Rosa Bonheur was a childhood dream come true. The great French artist, who was thirty-four years older than the American painter, had long been a role model for this younger "sister of the brush," as Rosa Bonheur liked to refer to her female colleagues of the arts.[2] Indeed, while Anna Klumpke was growing up in San Francisco, Rosa Bonheur knew such success that she was a household name in France, across the English Channel, and even across the Atlantic Ocean. In 1856, she had taken, at Queen Victoria's request, *The Horse Fair* to Buckingham Palace for a private showing. By the end of the century engravings of the painting were hanging on schoolroom walls throughout Great Britain and the United States. In the 1860s, many American newspapers, even in pioneer locations like Saint Paul, Minnesota, were offering free engravings of *The Horse Fair* to attract new subscribers. Little American girls could hold, in an admiring clutch, Rosa Bonheur dolls, which were quite as popular as Shirley Temple dolls a few generations later. As a child in San Francisco, Anna Klumpke had cherished her Rosa Bonheur doll. Drawing encouragement for her artistic vocation from that illustrious example, Anna Klumpke certainly never dreamed that she would grow up, cross the ocean, and become Rosa Bonheur's chosen portraitist, biographer, and beloved companion.

Meeting Rosa Bonheur not only fulfilled one of Anna Klumpke's childhood dreams. It utterly changed the course of her life. Some eight years after their first meeting, Anna Klumpke drummed up her courage to ask the gruff, reclusive Bonheur for permission to paint her portrait. Rosa Bonheur not only granted that request, but invited her younger colleague to come spend the summer of 1898 at her chateau in order to paint the

portrait. At first immensely pleased by this magnanimous display of generosity, Anna Klumpke was soon driven to despair by her illustrious model's whims and demands. Clearly the dream was becoming a nightmare. The mystery cleared a few weeks later when Rosa Bonheur declared her passionate love for Anna Klumpke, confessed that she had been doing everything possible to prevent her chosen portraitist from finishing her work and leaving, then asked her to consider joining their lives forever more. After great meditation on this unexpected proposal, Anna Klumpke joyously assented, at which point the two women sealed an alliance that they compared in an exuberant moment to the pact binding Faust to Mephistopheles, a union that they later solemnly declared "the divine marriage of two souls" (112, Fr. ed.).

This book is divided into three parts. In part 1 Anna Klumpke recounts, often in the form of a daily diary, meeting Rosa Bonheur, falling in love with her, working on her portraits, and finally setting up household with her. In part 3 Anna Klumpke uses the same technique: After presenting a summary of Rosa Bonheur's opinions on animals, feminism, crossdressing, religion, and art, Anna Klumpke falls back into a first-person narrative of the brief months they shared in Rosa Bonheur's chateau, followed by a moving account of the artist's death, burial, and the troubles that attended the probating of her will, which, to the considerable dismay of the French artist's family, left everything to her beloved American companion. If autobiography means telling one's own story, and biography telling the story of another person, these two sections can be described as a classic mix of the two narrative modes, each one remaining perfectly distinct.

Part 2, on the other hand, eludes easy description in such terms. This section of Anna Klumpke's book gives the impression that Rosa Bonheur is telling her life story in her own words. Yet it was entirely written by Anna Klumpke. In order to create this effect, she suppressed all references to herself, collapsed the psychological space between the biographer and her model, then invented from bits of conversation that she had recorded in her diary or perhaps even taken in dictation a voice perceptibly different from her own, a voice that recounts in an almost unbroken first-person narrative presumably everything from Rosa Bonheur's earliest childhood memories up until the summer of 1898, at which time this narration could have been put down on paper by the French artist. Although it is quite impossible not to fall prey to the illusion that these words are falling directly from Rosa Bonheur's lips, this voice is the result

of Anna Klumpke's clever ventriloquism. Yet there is no attempt to deceive here. Anna Klumpke is merely attempting to live up to the mission that her beloved companion explicitly entrusted to her: to speak for and as Rosa Bonheur, even to become her voice from beyond the grave, and still beyond that, to give voice to the women, now long dead, that Rosa Bonheur had loved in years past, her mother as well as the childhood friend with whom she had lived in conjugal union for over forty years.

Because this book makes a very deliberate attempt to blur the distinction between autobiography and biography, to merge the identities of several women in a loving communion that would outlive death itself, I have changed the title in translation. Were I simply to translate the title that Anna Klumpke gave her book in Paris at the beginning of the century, it would read *Rosa Bonheur; her life, her work.* That would suggest that this work conformed to classic conventions of biography. The parentheses that jump out from the new title, *Rosa Bonheur: The Artist's (Auto)biography,* are not meant to mystify, but rather to draw attention to the novel form of this work, born of one woman's cherished desire and brought to fulfillment as a result of a loving cooperation between two women. Indeed, Rosa Bonheur considered the marriage compact between Anna Klumpke and herself as inseparable from the (auto)biographical pact upon which this book is founded. This was made perfectly clear to Anna Klumpke near the end of their courtship, as she so well understood. The proof of this lies in the final chapters of part 1, suggestively entitled "Rosa Bonheur Makes Me Promise to Live with Her Forever After" and "Rosa Bonheur Entrusts Me with the Mission of Writing Her Life Story."

This book is not, therefore, the autobiography of Rosa Bonheur. Nor is it merely the biography of Rosa Bonheur. It is something beyond. All the while it is important to note that Rosa Bonheur, certainly no stranger to the pen, as her correspondence attests, could have tried her hand at autobiography. For reasons that she carefully explains at the end of part 1, she preferred not to do so. Instead, she determined to tell her story to Anna Klumpke, then entrusted that confidante with the mission of writing her story and presenting it to the public. Yet this contract set up between Rosa Bonheur and Anna Klumpke bears no resemblance to the lazy, commercially motivated ghostwriting operations that tend to characterize the industry that celebrity "autobiography" has become in contemporary Hollywood and New York. In an altogether different spirit, Rosa Bonheur was following a carefully conceived, long-nurtured plan. She aimed to accomplish at least two things: to put the question of gender at the heart of this confessional genre and to reveal in a sympathetic light the ways

that women could and did love, live, work, and thrive among themselves in chosen retreat from a patriarchal century. Quite aware that society, even her family and friends, took a dim view of women who wanted to make their lives together, Rosa Bonheur wanted Anna Klumpke to turn this book into many things: a public statement of the French painter's artistic credo, a manifesto of her particular brand of feminism, and, judged by her century's standards (and perhaps even our own), a bold story of lesbian love.

Portrait of the Artist as a Young Woman

The first born of Raimond Bonheur and Sophie Marquis's four children, the future artist came into the world in Bordeaux in 1822 and was baptized Rosalie-Marie Bonheur. Raimond Bonheur was a painter and art teacher of humble station and means. The origins of Sophie Marquis, on the other hand, never lost their high mystery. No doubt the illegitimate fruit of a liaison conducted among expatriate aristocrats during the turbulent years of the French Revolution, Sophie Marquis was born near Hamburg, Germany, and reared in Bordeaux by Dublan de Lahet, an affluent blue-blooded merchant. Although Sophie never learned her own mother's identity, Dublan de Lahet confessed on his deathbed—but without formally recognizing the claim—that his ward was in fact his daughter. Dwelling in two distinct social spheres, Raimond and Sophie were brought together by the art lessons that the handsome young teacher, known throughout Bordeaux as "Angel Gabriel," was hired to give the young lady. They fell in love and married, despite Dublan de Lahet's opposition to what he considered a painfully obvious mésalliance. This is a familiar pattern in the history of women in art, the pupil who becomes the master's wife,[3] and the results in this case were predictably devastating. As Raimond's spouse, Sophie began a hard, intinerant life, first in Bordeaux, then in various neighborhoods of Paris, for which she was ill prepared by her aristocratic upbringing.

Undoubtedly Raimond, a kind-hearted man whose soul brimmed with the love of all humanity, had good intentions toward his wife and children. Rosa Bonheur herself declared that family affection was part of his impulsive good nature. Yet, once the Bonheurs arrived in Paris, ardent desires for social reform began competing in Raimond's heart and soul with ever heavier family responsibilities and eventually won. In the early 1830s, when times were especially hard in Paris because of yet another revolu-

tion, Raimond and Sophie became members of the Saint-Simonian movement. Yet it is clear that Raimond's fervor for the new cult far surpassed that of his wife, already burdened with domestic cares. One of the many audacious social-reform movements that sprang up in the long period of promise and instability following the Revolution of 1789, the Saint-Simonians tried to bring far-reaching schemes in engineering, industry, and banking together with radical reconceptions of work, property, marriage, paternity, and the role of women in society. Out of this they wanted to weave a new humanitarian religion that would end war and exploitation and make the world one.[4]

Given the feminist tendencies of the Saint-Simonians and their expectant exaltation of the Mother, the female Messiah they so eagerly sought, it might be thought that the participation of the Bonheur couple in the movement would have lightened Sophie's load, but experience proved quite the opposite. Although Sophie had been promised an active role as "an adjunct in the headquarters of the sacerdotal army" (146), she found herself in the position of other Saint-Simonian women as soon as serious theoretical and financial difficulties arose.[5] As Rosa Bonheur relates: "As for my mother, there was no longer question of any role for her, aside from taking care of her children" (146).

Raimond believed so fervently in the movement that in 1832 he left his family to go join a select group of Saint-Simonian men who had taken vows of celibacy and banded together in retreat at their commune in Ménilmontant, then a remote part of northeastern Paris. During this period, which the leaders warned might be permanent, Sophie not only had to look after four small children, who ranged in age from ten down to four, but also to find ways to earn enough money to keep them all fed and clothed. Rosa Bonheur, the eldest child, recalled the grievous discrepancy between her mother's lonely hardships and her father's sublime enthusiasms: "My mother, the most noble and proud of creatures, succumbing to exhaustion and wretched poverty, while my father was dreaming about saving the human race" (154).

Spiritual absence followed upon physical distance. After the government indicted the leaders of the Saint-Simonian movement and then broke up the communal house in late 1832, Raimond returned home, but not without expressing his bitter resentment that family responsibilities prevented him from going off to the Orient on proselytizing missions with other Saint-Simonians. Whenever Raimond lamented that he had understood too late why celibacy was so necessary to his social calling, Sophie would dissolve into tears and convulsively press Rosa to her bosom. In her

mature years Rosa Bonheur readily admitted that as a little girl she had been too young to understand the meaning of her father's recriminations. Still, his words remained forever engraved in her mind. Finally, in 1833, Sophie Marquis Bonheur died at the age of thirty-six—after four pregnancies and twelve years of poverty, exhaustion, and increasingly desperate attempts to provide part, if not all, of the growing family's meager budget by giving piano lessons and making cheap garters. For the rest of her life Rosa Bonheur was consumed with regret that her mother, "after growing up like a princess" (154), died a pauper's death and rotted away in a potter's field. The fact that Sophie did not even get a marked grave cruelly exacerbated the bereaved daughter's sense of loss.

Although these traumatic experiences did not turn Rosa Bonheur away from Saint-Simonian sympathies in years to come, she never forgot her pained awareness of the sacrificial role that her mother had played in the family while her father dreamed of uplifting humanity. After reading up on the Saint-Simonian movement several decades later, she tellingly remarked: "What looked murky to me in 1832 suddenly cleared up. I understood what was noble about my father, but also my poor mother's anguish and pain, and I relived a moving drama whose ups and downs have had an incredible influence on my life" (145).

From these early experiences Rosa Bonheur drew a series of lessons that guided her throughout her adult years. Indeed, because of her concerns with children's welfare, she maintained that matrimony was a sacrament essential to society. Yet Rosa Bonheur remembered too well the heavy price her mother had paid ever to consider marriage for herself: "Our timid beauties of old Europe are too easily led to the altar, like ewes going to sacrifice in pagan temples. A long time ago I understood that when a girl dons a crown of orange blossoms, she becomes subordinate, nothing but a pale reflection of what she was before. She's forever the leader's companion, not his equal, but his helpmate. No matter how worthy she is, she'll remain in obscurity" (312). Another factor contributing to Rosa Bonheur's aversion to marriage certainly had to do with the status of married women as defined by the Civil Code, drawn up by Napoleon between 1800 and 1804. After excluding women from the rights and privileges of citizenship, the Civil Code further decreed a husband's duty to protect his wife and a wife's duty to obey her husband. By consenting to marriage, a woman lost most of her legal rights and essentially became her husband's ward, virtually his child. A wife could not, for example, participate in the management of jointly held property or even manage her own property without her husband's permission. She also needed his authoriz-

ation to operate a business or to exercize a profession.[6] Although nineteenth-century society afforded women few choices or opportunities outside of marriage, Rosa Bonheur was determined to do without such costly "protection" and to take art as her only husband. Not long before her death she summed up that lifelong resolution: "Art is a tyrant. It demands heart, brain, soul, body. The entireness of the votary . . . I wed art. It is my husband, my world, my life's dream, the air I breathe."[7]

It is easy to see how memories of her mother's struggles encouraged Rosa Bonheur's determination to live independently of men. Yet, despite the fact that her father and, beyond that, the Saint-Simonians as a whole failed to live up to the feminist ideals they espoused, it would be doing Raimond a clear disservice to overlook the important lessons that he taught her as a girl. Underscoring her father's positive influence on her development, she exclaimed in her last years: "Why shouldn't I be proud to be a woman? My father, that enthusiastic apostle of humanity, told me again and again that it was woman's mission to improve the human race, that she was the future Messiah. To his doctrines I owe my great and glorious ambition for the sex to which I proudly belong, whose independence I'll defend till my dying day" (311). However strange these remarks may strike our ears—and how much stranger the ears of Rosa Bonheur's contemporaries, when so many believed, as the famous nineteenth-century socialist Proudhon vociferously professed, that women were either housewives or harlots—this exaltation of womanhood was a central tenet of the Saint-Simonian religion. From their belief in an androgynous God, the Saint-Simonians deduced the need for male and female leadership of the church. The Supreme Father, already revealed to the faithful in the person of Prosper Enfantin, eagerly awaited the coming of the female Messiah who would usher in the New Age. In the interim, the Supreme Father called all women to a new destiny of emancipation, physical and spiritual, and invited their full participation in society. Breaking with the traditional Christian views of Eve's shame and Mary's solitary glory, they looked forward to the time when women would bring forth a new Adam ready and able to gather all the fruit of the Tree of Knowledge. Although the sect eventually splintered and broke up over these questions, the Saint-Simonians clearly saw how much nineteenth-century conceptions of sexuality, marriage, family, and property depended upon the condition of women in patriarchal society. Moreover, their challenge to that repressive order would become part of the movement's enduring legacy to feminism. Rosa Bonheur eloquently testified to this fact with these memories of her father.

Naturally Rosa Bonheur, as a young girl, had not yet clearly formulated these lessons drawn from her extraordinary childhood. Yet her adolescent struggles for independence acted out what she would only later learn to say. From earliest childhood she had shown sure signs of artistic vocation. In eager imitation of her father, she used to daub paint over every available surface and draw portraits of her dolls. Sketching animals in the dirt became such an absorbing pastime that reading held little interest for her. Throughout Rosa's short time at school, lessons always had to fight for a place among the animal sketches and cartoons in her notebooks. Forms, not words, were her chosen medium.

Although Raimond recognized early on his daughter's precocious talent, he did not want her to become an artist. From his own painful experience he knew what a difficult career it was for a man, and he feared even greater problems for a woman. Therefore, Rosa Bonheur had to defeat her father's plans for her future in order to lay claim to an artistic career. Shortly after Sophie Bonheur's death, he apprenticed his twelve-year-old daughter to a seamstress, an ordinary and desperate fate for working-class girls of the nineteenth century. Only after she proved herself unwilling and totally inept at that trade and then, to her considerable delight, got ignominiously expelled from a girls' boarding school where her father was teaching art did Raimond resign himself to the fate that Rosa Bonheur had already chosen for herself.

Even after Rosa had won that battle, the road to becoming an artist in her own right was still strewn with obstacles. At that time there was practically no professional training available to aspiring female artists except for that which might be provided in the home. Only in 1897, for example, were women finally admitted to the prestigious Ecole des Beaux-Arts—over such violent protest by male students that the police had to be called in and the school temporarily closed. Raimond, therefore, had to step into the role of teacher, her only teacher. Under her father's tutelage, Rosa soon became the pride and joy of his studio. Although she was thrilled when he compared her to the illustrious Elisabeth Vigée-Lebrun, subtle dangers lurked beneath his seemingly generous encouragement of her talent. Predicting that he would at last realize his ambitions for himself through his daughter, the once reluctant teacher set about yoking Rosa to his own aggrandizement. When her paintings began to sell, he told her to sign them with his name. Rebuffed on that score, the utopist began showing the colors of a frustrated patriarch and trying to undermine his daughter's independent resolve, what he disapprovingly called her boyish ways: " 'Ah!,' he'd say, 'you don't mince words, and you don't have a clue how

to be diplomatic. You think being a silly little sheep is stupid, so you refuse to live that way. But you've still got to learn that being a skittish horse is no better. He steams at the nostrils and foams at the mouth because he won't take the bit, but before long he's nothing but a worthless nag'" (176).

Perhaps the greatest danger of all for Rosa Bonheur's development as an artist lay in the organization of her father's studio. A visit to that studio had reportedly moved one of Raimond's painter friends to tears: "There was nothing more simple and touching than this household with its patri-archal ways. One day Delaroche stopped by for a visit. He found every member of this little world at work in the studio and the babies already busy with their pencils" (196). Obviously there is quite a different light that can be shed on the scene that Delaroche found so touching. All four Bonheur children eventually came to work there, and Raimond happily set up his eldest daughter as "the captain of the tiny troop" (173). In addition to supervising the younger children's work, Rosa also kept the family's meager pot boiling with the sales of her paintings, since Raimond was a notoriously poor manager of his career and of the family finances as well. His idea of saving money for a rainy day was to toss a bunch of coins into the far corners of the cluttered studio and to dig them up when there arose a need for cash. Unwilling to deprive himself of such an invaluable helpmate, Raimond did his best to make sure that Rosa wouldn't break free. Finally, two of Raimond's closest friends intervened on Rosa's behalf. Judging that they had seen quite enough of this paternal exploitation, they protested that Rosa deserved a brighter future than that of teaching her younger siblings how to draw. They also took it upon themselves to find her an inexpensive studio to rent. Only then did she gain the workspace and professional autonomy that she so sorely needed. Yet, even after her exit from the family studio, she continued to funnel most of her earnings back home in order to support Raimond and his children.

Toward the Domain of Perfect Affection

Rosa Bonheur readily admitted that her father provided her with the instrument of her art and the technical skill with which to use it: "my father and nature, in her beauty and grandeur, were my only teachers" (380). Even as an infant, she rehearsed his painterly gestures and made her dolls pose. Yet when the whole story is told, there can be no doubt that the deeper source of her inspiration sprang out of her relationship to her mother and the lifelong nostalgia that was the fruit of that early loss. At

the very beginning of her story she recounts that Sophie reluctantly gave her daughter over to a wet nurse after the child had severely bitten her breasts. From this bit of family history, Rosa Bonheur, who was to become best known for her animal paintings, moves on to her earliest memory, her love of stables and farm animals and her great delight when a cow being milked turned back to lick her face. Immediately thereafter she makes the loving association between her mother and animals explicit: "My aunt Elizabeth, my father's sister, claimed that I loved animals so much because my mother's bedroom was papered with bucolic scenes" (134). Animals also became a privileged means of communication between mother and daughter and guided Rosa's entry into the realm of letters. Rosa had no interest in learning to read and write, much preferring to spend her time drawing animals in the sand for her playmates. Despairing of ways to drum the ABCs into her daughter's hard little head, Sophie devised an ingenious scheme. She asked Rosa to draw next to each character of the alphabet an animal whose name began with that letter, and the painful lesson became a pleasure: "This intelligent object-lesson was a revelation for my infant brain, but it didn't make me love drawing any less" (135). Again and again Rosa Bonheur stressed that her adult inspiration and imagination sprang forth from her early relationship to her mother.

Unfortunately, this enriching play between mother and daughter came to an abrupt and untimely halt. Rosa Bonheur was just eleven at her mother's death. Already drained from her years of lonely struggle to look after her family while Raimond devoted himself to Saint-Simonian causes, Sophie died nursing Rosa, who was bedridden with scarlet fever: "Our doom weighed even heavier when I got sick. I can still see my mother bending down to make me drink my medicine. She'd put her hand on my burning brow, and I'd wrap my arms around her neck and plant long kisses on her beautiful eyes, brimming with tears. Alas! She got so worn out taking care of me that her constitution, already terribly beset by the strain of bearing up so proudly in such wretched circumstances, completely broke down . . . She died. After growing up like a princess, she didn't even get a proper grave" (154). Nourished by the memory of her mother's love, Rosa Bonheur's deep grief over this loss sublimated over time into the conviction, forcefully expressed in the first lines of her story and the last lines of her will, that her mother's soul protected, guided, and inspired her throughout her entire life.

After Sophie died, Rosa Bonheur's nostalgia for her mother grew insatiably. Certainly, the obscure circumstances of her mother's birth and ignominious burial in a common grave doubled her sense of bereavement.

At the same time, however, the desire to pierce these mysteries and to compensate for the loss fueled her imagination and artistic resolve in notable ways. During her mother's life and even more so after her death, Rosa Bonheur was curious to learn the identity of her maternal grandmother. During a trip to Bordeaux in 1845 she burned to question her putative grandfather Dublan's valet and her mother's old nurse. These inquiries came to naught. The valet whom she believed privy to the secret had been, she reports, "mysteriously assassinated" (172); and the old nurse tantalized Rosa Bonheur with these words: "What earthly good will it do you to learn your grandmother's real name? The only thing I can tell you is this: she was a great lady. . . . Anyway, . . . what difference can it make to you? You already know, don't you, that even if you're a descendant of kings and queen on your mother's side, your father comes from a family of cooks" (172). Beyond that, the old nurse not only kept stony silence on the matter but made Rosa Bonheur promise not to pursue her investigations. The Gothic nature of this mystery unleashed in her mind countless family romances about the maternal line. To the end of her life she was inclined to interpret the affection shown to her by aristocratic benefactors as signs that they knew Sophie's true identity and acknowledged her daughter accordingly.

There was even bitterer mystery at the end of her mother's life, for Rosa Bonheur could not locate her mother's remains, the bones next to which this inconsolable daughter longed to be buried. In this matter, she was not content to lament the family's precarious finances: pointing a finger at her father's indifference, she noted that at any time during the five years following Sophie's death he could have taken steps to give his wife a marked grave. Although Raimond took no such measures, Rosa Bonheur was herself busy symbolically burying and reburying her mother in order to commemorate that presence and her own loss. Whenever, for example, Raimond took his daughter off on the evening courting expeditions that resulted in his remarriage in 1842, she would wile away the time by picking up singed moth bodies under the street lamps and reburying them at home. These actions are obviously metaphorical reburials of the mother who had met in marriage the proverbial fate of the moth: "Out of boredom I was reduced to watching moths, drawn by the light, hurl themselves into the flame of a streetlamp. Some of these poor little bugs dropped dead right at my feet. I didn't want them squashed under the feet of passersby, so I'd fill my pockets with them. Back home I'd put the little bodies into a cardboard box meant to be their tomb" (170–71).

Given Rosa Bonheur's deep-seated but subtly expressed ambivalence

toward Raimond, it is no surprise that the daughter's ideas of a suitable memorial for the mother involved some desire for the professional "burial" of the father. She recalls a walk she took with her father in the Mont-Valérien cemetery a few years after Sophie's demise. Musing on her mother's death and watching her father standing among these ancient tombs, she found her thoughts drifting toward her father's future passing. When Raimond finally led the way back out of the cemetery, she started out trotting after him "like a dog with its master" (164). Yet this submissive stance soon gave way to something much more affirmative when she got the idea of walking in his footsteps. Moreover, the following remark clearly suggests that she did not mean this just literally: "This was an amazing idea for a little girl. Where did it come from? Maybe from my mother" (164). If the child was prompted to do this out of love for her father, she was probably expressing only the truest form of flattery and admiration. On the other hand, when she subsequently points to the dead mother as the deeper source of this transgressive gesture, its motivation becomes more problematic. Rosa Bonheur does not dwell on this point and rapidly changes the subject. Yet the question remained, only to receive a discreet reply some years later. After Rosa Bonheur received a gold medal at the Salon of 1848, the French government awarded the artist her first state commission, which was to be *Ploughing in the Nivernais*. When Raimond died the following year, she quite literally buried him with proceeds from this transaction. While noting this, she cryptically added: "Poor Father . . . he had no idea that the money I got for this painting was meant to pay for his funeral expenses" (194).

It is, in any case, perfectly clear that when the artist chose her professional signature, she was celebrating the source of her inspiration as well as defining her artistic mission. After her paintings began to sell in the mid-1840s, her father told her to sign them simply *Raimond*, dropping the last name, which struck him as sore irony in the family's wretched circumstances (Bonheur = happiness). Up until this time she had signed her work with the name *Rosalie Bonheur*. Although it was common practice for women artists in the nineteenth century to adopt male pseudonyms or to cling to names of ambiguous gender,[8] she adamantly refused even to consider taking her father's suggestion. Instead, she insisted on taking the diminuitive her mother had given her, making altogether explicit her commemorative intention: "I mean to glorify the name she took so that she'll be part of whatever fame may be mine. In her tender moments she used to call me Rosa, so Rosa Bonheur will be my signature" (175).

Throughout her life Rosa Bonheur endeavored to recreate something

similar to the bond that she had known with her mother. Out of this passionate allegiance she ultimately found ways to organize her life, both personally and professionally, accomplishing thereby a radical redefinition of matrimony as a mode of existence quite outside the regime of patriarchy.

Acquiring her own studio was the first step in this direction, a move facilitated by family friends by the name of Micas. As previously noted, it was M. Micas who insisted that Rosa Bonheur be allowed to work independently of her father, and Mme Micas who sallied forth to find the budding artist's first studio in Paris. Yet even more important for Rosa Bonheur's development and well-being were her affectionate relations with Mme Micas and, most of all, her daughter Nathalie.

Three years after the death of Sophie Bonheur, Raimond was asked to paint the twelve-year-old Nathalie Micas, who was thought to have a terminal case of tuberculosis. The sittings for this portrait brought the two families together. For Rosa Bonheur, who was fourteen at the time, these occasions were "the start of a new life" (167), heralded by a formidable explosion of prophetic dreams. Shortly before meeting Nathalie, Rosa Bonheur dreamed of a pale, brown-haired girl descending an old staircase toward her; and, as she later recounted to Nathalie's mother, she recognized both the girl and the staircase when she entered the Micas house for the first time. Encouraged by Mme Micas to talk about her devotion to her mother's memory, the still grieving girl soon confessed another dream about which she had not dared breathe a word to her father—a joyful dream of reparation that reunited mother and daughter:

> One night I thought I saw my mother standing by my bed. She was wearing a white dress, and her curls floated down over her shoulders. However great my shock, it couldn't match my joy. I shot up and tried to throw myself into her arms. A strange lethargy paralyzed my limbs. Yet I managed to cry out: "Dear Mama, you're not dead?"
>
> My mother smiled and shook her head. Then she put the first finger of her left hand up to her lips. Without ever taking her loving eyes off me, she vanished as quickly as she had come. The memory of this dream, this vision, has been my lasting consolation. Since then I've never stopped believing that my mother appeared in order to make me understand that she was still alive and close by. How often, in difficult moments, I've felt her protection! Oh! yes, she's been my guardian angel, the saint to whom I've raised my prayers and invocations. (168)

A free and loving play of analogy around the place of the absent mother continued the work of restoration inaugurated by this dreamwork. Treat-

ing the bereaved adolescent as her adoptive daughter, Mme Micas came to
stand in the spot vacated by Rosa Bonheur's mother. Even more impor-
tant, she served as the "sacred link" (234) in the lifelong union, both
maternal and sororal, that Rosa Bonheur and Nathalie established be-
tween themselves. Initially an exchange of services—Rosa gave Nathalie
art lessons while Nathalie looked after her clothes and her person—their
association was soon recognized as a virtual marriage within the Micas
household. Just before M. Micas died in 1848, he implored Raimond to
let their two daughters continue their lives together and blessed their
union in the most solemn of ways:

"Raimond," he told his friend, "I'm very sick, and I won't be leaving
my bed. You're not going to live much longer, either. Let our two
children stay together always. You see how much they love each other.
Rosa needs Nathalie to love and protect her. Come, children, I want to
give you my blessing."

We were both deeply moved and knelt down by his bed. Good Father
Micas placed his hands on our heads and said: "Never leave each
other's side, my dear children, and may God keep you!" Then he kissed
us. A few days later he was dead. Nathalie and I were always together
after that. We've been separated by death, but I hope that our souls will
be reunited. She and my mother are watching over me. (190)

After Raimond's death in 1849, Rosa Bonheur went to live with
Nathalie and her mother, and the three women remained inseparable until
death parted them one by one. In order to safeguard these living arrange-
ments, she had to turn a deaf ear to the jealous opposition of the remain-
ing members of the Bonheur family, apparently less concerned about the
potential for scandal in such unconventional groupings than about the
artist's financial support of their household. First in Paris, then at the
chateau of By near Fontainebleau, which they renamed the Domain of
Perfect Affection, these "backwoods women" (285), as Rosa Bonheur
referred to them, lived out their lives in chosen retreat. The walls of the
Fontainebleau chateau were like a material reminder of the firm resistance
that Rosa Bonheur had to maintain vis-à-vis society with all its conven-
tions, especially against the demands of her outraged family. Yet, within
that protected space, she could live without fear of the dangers that have
made women's expression of the need for intimacy a professional liability.
There she could find, in addition to support for her artistic ambitions, love
and emotional fulfillment.

The relations among the three women provided not only a propitious
atmosphere for the creative life but the very organizational principles of a

life devoted to artistic production. As soon as they moved into the chateau of By, one of the artist's chief preoccupations was to provide for Nathalie and her mother a life that was worthy of her love. At the same time, as Rosa Bonheur gratefully acknowledged, they chose to take over the kitchen and the farmyard so that she wouldn't have a single household worry. In a culture where, as Germaine Greer has so pointedly remarked, "the artistic ego is to most women repulsive for themselves, and compelling in men," Nathalie and her mother nurtured Rosa Bonheur's development as an artist and created an environment "almost unique in the annals of gifted unmarried women."9 From their first years together, Rosa Bonheur and her beloved companion worked in the artist's studio, "just the two of us, never opening the door to any flirting man" (178). Nathalie collaborated with her friend by preparing her canvases, sometimes giving them a finishing touch, copying them when need be. She also acted as Rosa Bonheur's hard-nosed liaison with art dealers, negotiating prices and driving bargains that the more accommodating artist would never, she claimed, have dared propose. In many ways Nathalie gave proof of a strong and independent spirit; she took serious interest in veterinary medicine, invented a railway brake-system that, in the estimation of many, would have obtained considerable success had it not been for antifeminist prejudice, and often insisted on masquerading as a Spanish flamenco dancer. Yet, foreshadowing Alice B. Toklas with Gertrude Stein, her role vis-à-vis Rosa Bonheur, one that she apparently chose during their first years together, was clearly auxiliary: "Becoming my equal wasn't her ambition. She just wanted to make herself useful and spare me the preliminaries. That was enough for this devoted heart" (178). Yet this obvious parallel remains an isolated point, particularly with regard to Gertrude Stein, for Bonheur's feminism makes her significantly different from the more conservative American expatriate writer, who could not relinquish her view that the world of culture was a place for men and one exceptional woman.

Mme Micas died in 1875. Nathalie Micas followed her in 1889, leaving Rosa Bonheur utterly bereft. That was the very year that the French artist first met Anna Klumpke, and nine years later the American artist began work on the first portrait of her beloved model. Out of this work relationship developed a deep love that drew the two artists together into a matrimonial pact. When they announced their intended union with great solemnity, they were not surprised to encounter the opposition of both families, whose loud objections about the couple's material arrangements masked their deeper qualms. Neither woman was particularly daunted,

least of all Rosa Bonheur, who had already been through all this once before. Reliving her memories of Nathalie for her new American companion, Rosa Bonheur recalled their staunch resolve to preserve their love, despite the hostility of surrounding society: "What would my life have been without her love and devotion! . . . Yet people tried to give our love a bad name. They were flabbergasted that we pooled our money and left all our earthly goods to each other. Had I been a man, I would have married her, and nobody could have dreamed up all those silly stories. I would have had a family, with my children as heirs, and nobody would have had any right to complain" (358–59). Wise to the ways of the world, Rosa Bonheur was determined to give her autonomy in matters of love and money a strong legal foundation. That she established in her last will and testament, appended to this (auto)biography. Flying in the face of her family's demands, she made Anna Klumpke her sole legatee, as she had previously done with Nathalie Micas, and insistently underscored her inalienable right to decide what to do with herself and her fortune. She also swore to make sure that the Bonheur family would get nothing if they separated the French artist from her new American friend and to demolish the chateau along with everything in it if either family succeeded in destroying their relationship.

In several significant ways Rosa Bonheur's relationship with Anna Klumpke repeats her history with Nathalie Micas and confirms the mother's lasting impact on the adult daughter's love choices. In her love for Nathalie Micas and Anna Klumpke, Rosa Bonheur was not seeking to replace her mother with other women. Yet, by a subtle play of analogy, Rosa Bonheur always wanted to see some resemblance between the women she loved and her long-dead mother. In her physical appearance Anna Klumpke reminded Rosa Bonheur of her mother, and her music making aroused memories, so vivid as to be almost hallucinatory, of Sophie at the piano. Having entered Rosa Bonheur's gallery of mothering figures, Anna Klumpke, to her beloved companion's great delight, signaled her warm recognition of this event by painting a sketch of herself that imitated a portrait of Sophie Bonheur. In a free exchange of mother/daughter roles, Rosa Bonheur also stressed the maternal aspects of her love for Anna Klumpke. This loving play of analogy embraced later loves, too. Just as Nathalie first stood in the place left vacant by Rosa Bonheur's mother, Anna Klumpke in her turn came to commemorate Nathalie's loss. Having perceived an eerie resemblance between Nathalie Micas and Anna Klumpke, Rosa Bonheur insisted that the younger woman take the watch and rings that had belonged to the Micas women. She wanted to pass

along these relics so that her new friend, who had never met these old friends, would have reason to remember them too. Rosa Bonheur also pressed Anna Klumpke to take Nathalie Micas's secret bedroom at By, luxuriously yellow in contrast to the rest of the house and accessed only by a hidden door in the corridor leading to Rosa Bonheur's room. Thus, she was able to reenact with Anna Klumpke the "perfect affection" that she had lived with Nathalie Micas. In order to complete that model, Rosa Bonheur even asked Mrs. Klumpke to come live with them at By "to take the place that good mother Micas had once filled so well." As Anna Klumpke writes, "It was her heartfelt dream and aspiration to recreate the family she'd been deprived of for nine long years" (390).

Subtle, resilient, and reversible, this loving chain of mothers, daughters, sisters, and lovers had no place for jealousy and proved its ultimate strength in death. Frustrated in her long desire to lie buried beside her mother, Rosa Bonheur arranged to be interred with Nathalie Micas and her mother in Père-Lachaise cemetery in Paris. There remained just one available place in the family vault, and Rosa Bonheur asked Anna Klumpke to take it: "Nathalie won't be jealous, I know. Her love for me is big enough to understand that when souls share everything, each one's happiness only increases the other's" (360). Rosa Bonheur was also firmly convinced that Nathalie Micas, like Sophie Bonheur, had in death become her guardian angel. In her last words to Anna Klumpke, Rosa Bonheur promised her the same care and protection. Rosa Bonheur expressly asked to die in Anna Klumpke's arms in the very same bed where Mme Micas had died in Nathalie's arms and Nathalie in the artist's embrace. Joining these beloved companions in the tomb, Rosa Bonheur intended to recreate the trio that had nourished her life: "So in death I'll be surrounded by the women I loved throughout my life, who gave me so much happiness" (360). When Anna Klumpke's ashes were added to the tomb in 1945, Rosa Bonheur's wishes were entirely fulfilled.

In addition to the maternal/sororal bond that Rosa Bonheur relived with Anna Klumpke, their relationship had a significant artistic dimension as well. Comparing her first and her second loves, Rosa Bonheur expressed this important difference: "Nathalie was my childhood companion. She witnessed my trials and tribulations, she shared my joys and sorrows. And you, my dear Anna, you've taken such hold of my heart that I'd declare you my very own daughter before an assembly of the Muses" (360). At a time when women had little possibility to obtain artistic training outside the home, when they encountered so many obstacles to their careers, their collaboration, based on the models of mother and child,

master and apprentice, would help remedy women's sorely limited access to the painting profession, promote the development of skills in a nurturing woman-to-woman context, and prepare the novice for competition in the broader hostile sphere. As a sign of this promise, Rosa Bonheur planned with Anna Klumpke to restore a little kiosk in the gardens of By and to change its name from the Temple of Love to the Temple of the Muses. Furthermore, the unbridled development of talent, rather than its subordination to another, was Rosa Bonheur's aim. In these words she explained her ambitious intentions toward her younger sister of the brush: "How happy we'll be together, don't you think, my Anna? Responsible only to ourselves, we'll each work hard, earn a living, and enjoy what we earn. . . . We're really doing to 'dig in.' God will help me guide your inspiration. At your age, I really used to 'dig in.' I want people to look upon you as my equal someday" (110). Thinking back to the source of her own professional ambitions, Anna Klumpke thanked her mother's support and the example of some artistic forebears on the maternal side, the Riepenhausens, who worked together, father and sons, in a family studio. It is in terms of that kind of collaboration, but recast in a feminist model, that Rosa Bonheur painted the picture of the productive life they would make together.

Rosa Bonheur's life with Nathalie Micas and Anna Klumpke was matrimonial in three subversively new senses of the term. In the first place, it twists the word *matrimony* in a pointed rejection of the patriarchal institution. Matrimony is now also marriage between women, a union initiated by a loving play of analogy around the place of the mother. Second, because the state would not give legal sanction to marriage between women, Rosa Bonheur exploited the next best thing—her last will and testament—in order to force some official recognition of their private vows. Despite her family's fierce opposition, she declared first Nathalie Micas, then Anna Klumpke, her sole legatee and staunchly affirmed her right, rather her solemn duty, to dispose of herself and her estate as she pleased. In this way she used the letter of the law against its spirit and established another transformed sense of matrimony: the transmission of property from woman to woman, bypassing the traditional father-son circuit and voiding the age-old prerogative of males in matters of property. In the third place, she bestowed an entirely new sense to the term: matrimony as inspiration, drawing upon the mother's spiritual legacy, bringing these hidden treasures to light, and making them accrue in order to constitute new legacies for other younger women. On both the affective and symbolic levels, these new senses of matrimony actively acknowledge

the reciprocal and nurturing bonds that Rosa Bonheur, like so many other women, needed in order to anchor herself to the traditions linking herself to *all* her mothers and sisters and, at the same time, to break open new ways of living, loving, and working for every one.

Such was the spiritual legacy that Rosa Bonheur wanted to leave behind at her death. She was also well aware that it would require considerable energy on the part of Anna Klumpke to secure that legacy and to execute all the clauses and codicils of her last will and testament. When Rosa Bonheur proclaimed Anna Klumpke as her sole legatee, she fully recognized that she was giving her American companion a prominent and nasty role in the almost inevitable postmortem drama, when the French artist's spokeswoman would become the target of public calumny.

As Rosa Bonheur anticipated, the conflict between her wishes and her family's claims came to a head shortly after her death in May 1899. Following the vaguest of instructions, which the artist had expressly chosen not to specify in her will, Anna Klumpke generously offered to give Rosa Bonheur's remaining brother Isidore one-half of the proceeds to be earned from an auction of the artist's studies and sketches. This offer, as she relates, "had been virtually accepted when all of a sudden I received a subpoena. The family accused me of having obtained Rosa Bonheur's succession by insidious means, by hypnotizing the great woman . . . There was to be a trial with all its attendant nightmares" (408). Certainly the easiest way to get out of these straits was to renounce her position as Rosa Bonheur's sole legatee. Yet Anna Klumpke recognized that she had no choice but to fight to preserve her beloved companion's will. After all, property distribution was but a small part of the much greater spiritual legacy that Rosa Bonheur's will meant to ensure. The legal battles, along with vitriolic attacks on the American heir in the Parisian press, lasted a year. Finally Isidore Bonheur abandoned his suit against Anna Klumpke when he understood that he would probably lose his case. Only then was Rosa Bonheur's matrimonial legacy fulfilled in letter and spirit and secured for the future.

Skirting the Dress Issue

A pioneering iconoclast in her time, Rosa Bonheur gained recognition on her own terms and was judged solely on the work that she produced. In the nineteenth century, women's painting tended to be considered a lady's pastime in the home rather than a full-time job on which her entire liveli-

hood might depend, as was the case with Rosa Bonheur. Avoiding the traditional subjects of women's painting—flowers, cats, sweet little dogs, children, all denizens of the domestic sphere—she generally devoted herself to draught animals at work or wild animals in the forest. Whereas a number of women artists, sensitive to demands for feminine decorum, went so far as to depict animals without genitals, Rosa Bonheur insisted on faithful representation of every detail of a bull or stallion's anatomy, thereby earning praise for her vigorous "masculine" style. At a time when a respectable lady would not even dare venture out unchaperoned into the streets of Paris, Rosa Bonheur spent day after day sketching in horse fairs and slaughterhouses, all crude, insalubrious places in which few women and certainly no ladies would ordinarily dream of setting their dainty feet. Rosa Bonheur did just that, and even alone. Although these experiences were obviously of great benefit to her art, the dangers for her person were truly daunting. How did she see to her safety? By assuming male disguise, and sometimes packing a pistol. When her work called her out into such places, she threw off the cumbersome adornments of her sex and went forth in trousers, workingman's smock, felt hat, and heavy boots. Many of her contemporaries even claimed that when Rosa Bonheur dressed up as a man, she acted out the role so well that no one would have been able to guess her sex.

This ingenious solution not only put her at odds with her day's prescriptions for feminine fashion and the biblical injunction against cross-dressing (Deut. 22:5). It also meant that she was making herself an outlaw, since it was illegal for women to wear trousers in nineteenth-century France. A woman who did so risked not only the embarrassment of arrest, but even fines and jail sentences. Yet in some very special cases a woman could—but only for reasons of health—petition the police for permission to wear trousers in public. If the authorities granted her request, she would be issued a very official *permission de travestissement* or cross-dressing permit, valid for periods of three to six months.[10]

According to information gathered from the archives of the Musée de la Police in Paris, only twelve women were able to obtain cross-dressing permits in the 1850s. Rosa Bonheur was one of these lucky few, even though she had no certifiable physical deformity of any kind and was healthy as a horse. Obviously the authorities must have exempted her from the rule of medical necessity in recognition of her celebrity status. A copy of one of her permits, on display at the Rosa Bonheur Museum in Thomery, France, is reproduced in figure 13.

Although Rosa Bonheur now had official permission to go about in

men's clothing, she vigorously maintained that it was only for reasons of work and personal safety that she wanted to wear trousers. Whenever she went out for social occasions, she insisted on putting on a dress and a curious little feathered bonnet. In so doing, she was probably trying to counter the notorious reputation generally attached to trousered women in the nineteenth century. If they were lucky enough to escape suspicion of wanting to foment some kind of heinous sex-role reversal that would turn women into men and men into so many bearded ladies, then they were judged guilty of indulging in shameless sexual practices. Rosa Bonheur desired fame, not infamy: a rare achievement for any woman of her time, and rarer still for a woman whose unconventional life-choices placed her in a particularly problematic position. While none of her contemporaries ever publicly accused her of straying from the straight and narrow path of feminine virtue, she was eager to dispel the notion that her trousers betrayed some rash scheme for sexual emancipation or merely a stagy bid for attention: "I strongly disapprove of women who refuse to wear normal clothes because they want to pass themselves off as men. If I thought trousers suited women, I would have given up skirts altogether, but that's not the case . . . If you see me dressed this way, it's not in the least to make myself stand out, as too many women have done, but only for my work. Don't forget I used to spend days and days in slaughterhouses. Oh! you've got to be devoted to art to live in pools of blood, surrounded by butchers" (308–9).

There were other reasons, too, for her prudence in matters of dress. Trumpeting a certain measure of conformity probably helped protect her "marriages" with Nathalie Micas and Anna Klumpke from the public eye. The demands of the market also counseled caution. Because her financial well-being was integral to her autonomy, she did not want to offend her buyers, for the most part aristocrats and wealthy British and American merchants. Reflecting on her mother's sad end, she remarked: "Had I ever married, domestic cares would have swallowed me up, as they did my mother. I was saved from that fate by Mercury, the god of commerce" (132). And as Rosa Bonheur undoubtedly knew, Mercury is also the patron of masquerade. In order to market her wares, she had to be a marketable quantity herself. If ever she forgot this, Nathalie Micas and one of her main art dealers, Gambart of London, were quick to remind her. When Gambart organized a trip to Great Britain for Rosa Bonheur and her inseparable companion in 1856, the artist was all set to leave with just one suitcase of art gear and painting clothes, that is, smocks and trousers. Having divined that Gambart planned a whole series of high-

society receptions, including a visit to Buckingham Palace, Nathalie inter-
vened and insisted on packing trunks and trunks of silk dresses, capes,
lace, and huge hats. When Empress Eugénie made her impromptu visits to
the artist's studio, Nathalie's great worry was that Rosa would not have
time to throw a skirt over her trousers. Gambart obviously shared
Nathalie's concerns. When Rosa Bonheur stayed at Gambart's palatial
villa in Nice, she would happily spend her mornings sketching in the
countryside in masculine disguise and suffer through afternoons of play-
ing the great lady. The daily switch from peasant trousers to proper femi-
nine dress was not of the artist's choosing, but the upshot of Gambart's
cultivation of her public image: "This tranformation, this return to my
sex, was imposed on me by fine M. Gambart" (286).

Yet prudence is not the whole story. Nor do Rosa Bonheur's skirts
signify regression to guilt, self-doubt, or sexual confusion, as some critics
have argued.[11] Instead, her skirts, like her professional signature, stand
for a steady, nourishing sense of feminine identity as well as a strong desire
to celebrate "matrimonial" possibilities among women who choose to
live, love, and work together. However great Rosa Bonheur's eagerness to
expand women's social and professional opportunities, however hard her
hands-on work to further these goals, she would never endorse attempts
to collapse all notions of some essential sexual difference. Here her Saint-
Simonian heritage, along with her belief in an androgynous Christ, helped
sustain her conviction that women, with the superior sensitivities she
believed them to enjoy, would play a messianic role in future society. And
like the Saint-Simonians, and so unlike her century, she did not believe
that sexual difference required men and women to occupy separate sexual
spheres and to carry out distinct and unequal roles.

Rosa Bonheur's moves back and forth between trousers and skirts can-
not be properly understood outside of the broad cultural context of her
times, especially in its hard-and-fast definitions of appropriate gender-
roles. When she protested that her gruff disposition, even a bit fierce by
moments, never stopped her heart from being "perfectly feminine" (311),
she was certainly not subscribing to conventional notions of womanhood.
Despite her success in dodging so many of the constraints that bore down
upon the skirted half of the population, she sometimes found herself on
the horns of a dilemma, professionally and socially. Proud to be a woman
and eager to foster the ambitions of her younger French sisters in the arts,
she was also well aware of the prejudice against female artists and their
work. Yet the critics who said that Rosa Bonheur painted like a man
meant to give her the highest praise. The flip side of that, as Germaine

Greer has remarked, is that painting like a woman was thought contemptible, so that a female artist was pressed to deny her sex or resign herself to the second rank.

Her trousers allowed her to indulge some of her favorite "manly" pastimes: sitting astride her horse, chasing game through Fontainebleau forest, and hunting chamois in the mountains. Her fondness for tobacco, likewise a "masculine" indulgence in the nineteenth century, once led to an amusing illustration of the conflict between skirts and trousers. One day in Paris when she was going out on calls in an open cab, she longed for a cigarette. The art dealer escorting her exclaimed that it just wouldn't do for her to be seen smoking in the streets. She staunchly ordered the driver to pull up the canopy, lifted up her skirts, showed him the trousers beneath, and lit up.[12] Yet the tragic aspects of that clash were never far from the surface. When enemy troops approached Fontainebleau during the Franco-Prussian War, she wanted to organize a citizen's militia and go meet the invader herself. After informing the local mayor of her plans, she received this humiliating reply: "However sad he was about the deplorable state of the nation, the mayor couldn't hold back a smile that froze me down to the very depths of my soul. He said a few words, ironical perhaps, but very wise, which made me understand that, despite the men's clothes on my back, I couldn't be a new Joan of Arc. Yet I could make myself useful, he added, by rolling bandages for the wounded and providing supplies for the men defending the fatherland. I went back to By all in tears, grieving over my impotence, yet resigned to let the storm pass over my head" (269–70).

Obviously such contradictions are not something that one individual could single-handedly hope to smooth over. Only the long-term evolution of fashion and, much more importantly, of deep-seated social attitudes would contribute to their future resolution. In the meantime Rosa Bonheur's intended theater of action, professional or social, usually dictated her choice of costume and comportment. Eluding that distinction, there were nonetheless certain circumstances that were neither professional nor social, but rather an amalgamation of the two. In these situations that most clearly reveal the web of complexities in which she maneuvered, she occasionally managed to play both ends against the middle.

Rosa Bonheur's hesitations about the final portrait that Anna Klumpke wanted to paint of her are telling in this regard. Although Empress Eugénie had declared that genius had no sex when she brought Rosa Bonheur the Cross of the Legion of Honor in 1865, a stubborn question remained.

How should *this* genius be clothed when presented to the public eye? To the portraitist's great satisfaction, Rosa Bonheur's family and friends declared that the artist had to sit for the portrait in a dress. On more than one occasion, Rosa Bonheur expressed her agreement with them: "I don't like the idea of appearing at the Salon in my smock. I want to leave posterity the image of me in women's clothes" (121). Yet, when Rosa Bonheur saw a sketch of herself in her work clothes, she seemed to regret her decision. Finally they agreed that Anna Klumpke would paint at least two portraits of Rosa Bonheur, the first in skirts and the second in smock and trousers.

Even before Anna Klumpke's (auto)biography of Rosa Bonheur projected the artist's private life into the public domain, it was a notorious fact that she almost always wore trousers at home. Although Nathalie Micas invariably insisted that her illustrious companion put on a skirt before receiving important visitors, Rosa Bonheur was happy to satisfy, perhaps even to provoke requests to show herself *en pantalon*. Dropping by one day to see the artist, Napoléon III's son chafed with impatience when he was asked to wait a moment. After being informed that the reason for the delay was to allow the artist time to put on a dress, he burst out that he particularly wanted to see her in trousers and smock. She never put on a dress for him again. It was also in trousers that Rosa Bonheur unabashedly entertained Queen Isabella of Spain. Queen Victoria's youngest daughter, too, was so tickled to find Rosa Bonheur in trousers with a skirt hastily thrown over them that she begged permission to take a picture of the artist in that bizarre attire.

In 1894 President Carnot of France promoted Rosa Bonheur to the rank of officer of the Legion of Honor in recognition of her individual merit and as a representative of those women whose work, talent, and virtue did honor to their sex and to the nation. A few years before bestowing that honor, he invited himself to her studio. Not just hoping to catch the artist in her work clothes, he specifically requested that she remain in trousers. Like Rosa Bonheur, Sadi Carnot was the child of a Saint-Simonian. In the course of their visit, the president and the artist shared memories about their Saint-Simonian childhoods and their hopes that the future might realize many of the promises of that doctrine. They were both convinced that women had a great role to play in creating a better world, if only society would abolish its prejudices and recognize the particular gifts of that sex. Shortly before her death in 1899, Rosa Bonheur reechoed these sentiments when she wrote that women artists "prove that

the Creator has made woman the noble companion of man, and that He has differentiated them only for the purpose of reproducing a noble race in this world."[13]

Finally, a note about the notes in this volume. Those preceded by the initials A.K. were originally placed by Anna Klumpke. The others have been added by the translator. In order to make my notes friendly to readers who may dip in and out of the volume, author and article or book are always summarily indicated. The full reference may be easily found in the bibliography.

Nearly all the photographs reproduced here are drawn from the original edition of this volume, *Rosa Bonheur; sa vie, son oeuvre* (Paris: Flammarion, 1908). Aside from some official portraits, I have particularly tried to choose photographs that give an intimate glimpse into the life that Rosa Bonheur and Anna Klumpke led during their brief time together in 1898–99.

NOTES

1. For more details on Anna Klumpke and her family, see her *Memoirs of an Artist,* ed. Lilian Whiting (Boston: Wright and Potter, 1940), pp. 22–24, as well as the following articles of Britta C. Dwyer, "Anna Elizabeth Klumpke," *Iris* 13, no. 1 (summer 1993): 33–35, and "Anna Elizabeth Klumpke: A *Salon* artist *par excellence,*" *Revue française d'études américaines* 59, vol. 17 (February 1994): 11–23. Dwyer is currently working on a book on Klumpke's life and art and her relationship with Rosa Bonheur.

2. See Tamar Garb, *Sisters of the Brush: Women's Artistic Culture in Nineteenth-Century Paris* (New Haven: Yale University Press, 1994), p. 3.

3. See, for example, Germaine Greer, *The Obstacle Race: The Fortunes of Women Painters and Their Work* (New York: Farrar, Straus and Giroux, 1979), especially pp. 39–54.

4. Robert B. Carlisle presents a fine, thoughtful reconsideration of the Saint-Simonian movement in his book *The Proffered Crown: Saint-Simonianism and the Doctrine of Hope* (Baltimore: Johns Hopkins University Press, 1987).

5. For an analysis of women's experience in the Saint-Simonian movement, see Claire Goldberg Moses, *French Feminism in the Nineteenth Century* (Albany: State University of New York Press, 1984), pp. 51–59. Another important source-book on the question is the book Moses coauthored with Leslie Wahl Rabine, *Feminism, Socialism, and French Romanticism* (Bloomington: Indiana University Press, 1993). In addition to a lengthy study of women in the movement, this book contains a great collection of writings by various Saint-Simonian women, many of which are translated for the first time into English.

6. For a good discussion of the repercussions of the Napoleonic Code on the lives of women in nineteenth-century France, see Moses, *French Feminism,* pp. 17–20.

7. Quoted in Dore Ashton and Denise Brown Hare, *Rosa Bonheur: A Life and a Legend* (New York: Viking Press, 1981), xii.

8. See Greer, *The Obstacle Race,* p. 320.

9. Greer, *The Obstacle Race,* pp. 35, 23.

10. Even before the Civil Code was established under Napoleon in 1804, the police regulation of November 7, 1800 (16 Brumaire, year IX of the Revolutionary Calendar) forbade women to venture out in public in trousers except during the traditional bedlam of Carnival. In order to obtain a cross-dressing permit from the prefect of police, the petitioner had to present medical evidence, certified by a health officer and attested to by a police commissioner, that some gross physical deformity made it impossible for her to appear in skirts in public. For example, a woman with such a dark, heavy beard that the wearing of women's clothes would make her seem like a flagrantly attired male transvestite might be allowed to wear men's clothing. Even with a cross-dressing permit, some restrictions still applied. As was clearly stated on the official form, a woman authorized to wear men's clothing could not attend balls, shows, or other kinds of public meetings. Women who broke this law risked not only the embarrassment of arrest, but jail sentences and fines in the case of repeat offenses.

Important sources for this legislation are John Grand-Carteret, *La Femme en culotte* (Paris: Flammarion, 1899); Laure-Paul Flobert, *La Femme et le costume masculin* (Lille: Imprimerie Lefebvre-Ducrocq, 1911); Eugen Weber, *France: Fin de Siècle* (Cambridge: Harvard University Press, 1986); and Valerie Steele, *Paris Fashion: A Cultural History* (New York: Oxford University Press, 1988). Also see my articles "Who Wears the Pants Here? The Policing of Women's Dress in Nineteenth-Century England, Germany, and France," *Nineteenth-Century Contexts* 17, no. 1 (winter 1993): 17–33, and "Rebuilding the Bastille: Women's Dress-Code Legislation in Nineteenth-Century France," in *Repression and Expression: Literary and Social Coding in Nineteenth-Century France,* ed. Carrol F. Coates (New York: Peter Lang, 1996): 209–19.

Initially, the rationale behind this law may have been to prevent women from slipping into men's clothes, entering the military, and taking up arms for France, as did the first female member of the Legion of Honor, Virginie Ghesquière, decorated in 1808. See Jean Alesson, *Les Femmes décorées de la Légion d'honneur et les femmes militaires* (Paris: G. Melet, 1886), pp. 6–9, as well as Raoul Brice, *La Femme et les armées de la Révolution et de l'Empire (1792–1815, d'après des mémoires, correspondances et documents inédits)* (Paris: L'Edition Moderne, 1913), p. 343. During the years of revolutionary tumult and patriotic fervor, many women did exactly that and even distinguished themselves on the field of battle. See my article, "Women at War: Skirting the Issue in the French Revolution," forthcoming in *L'Esprit Créateur.*

In 1792 prominent feminists like Etta Palm Aelder, Olympe de Gouges, and Théroigne de Méricourt had tried to persuade the Constituent Assembly of the revolutionary nation to organize an entirely female army regiment. These women were eager to enter battle not only in order to defend France but to make a case for their full participation in the affairs of the nation. They maintained that since women were ready and able to fulfill their duties as citizens, they could not be denied the rights of citizens. On this matter, the many fine books and articles by Darline Gay Levy and Harriet B. Applewhite, such as "Women and Militant Citizenship in Revolutionary Paris," in *Rebel Daughters: Women and the French Revolution,* ed. Sara E. Melzer and Leslie W. Rabine (New York: Oxford University Press, 1992), are most instructive. The arguments of these revolutionary militants failed to impress the legislators, imbued with Rousseau's notions that men and women should have distinct spheres of activity, the public forum for the former and the domestic foyer for the latter. In 1793 and several times thereafter the French authorities tried, with less than complete success, to purge the army of women soldiers in male disguise.

As the years went by, the law against women's cross-dressing worked as a corollary to the Civil Code, which prescribed separate and unequal status for men and women in the home, the workplace, and the nation. Keeping women out of men's breeches and in their skirts was a way of clearly indicating their difference from men and marking out the various places and roles they were *not* to occupy in society. Throughout the nineteenth century and even up until World War I, this law was frequently invoked and strenuously applied, especially in times of feminist upheaval such as the 1880s and 1890s. Despite attempts as recent as 1969 to seek its abrogation, the law is still on the books.

11. See, for example, Ashton and Hare, *Rosa Bonheur,* p. 53; Linda Nochlin, "Why Have There Been No Great Women Artists?" in *Women, Art, and Power and Other Essays* (New York: Harper and Row, 1988), pp. 173–75; and Albert Boime, "The Case of Rosa Bonheur: Why Should a Woman Want to Be More Like a Man?" *Art History* 4, no. 4 (December 1981): pp. 398–401.

12. This anecdote is related in Theodore Stanton's *Reminiscences of Rosa Bonheur* (New York: Appleton, 1910) p. 367.

13. Quoted by Stanton, *Reminiscences of Rosa Bonheur,* p. 63.

ROSA BONHEUR

❖

PART 1

Anna Klumpke's Story

Preface

I had long been one of Rosa Bonheur's fervent admirers when my life and no doubt some secret destiny made me her last companion and confidante. Thus I assumed the solemn duty to recount what the illustrious woman for whom I'm still grieving told me about her life. Her long, full career was lit with glory, and every worshiper of nature, art, and beauty in France and elsewhere rues the baleful day that marked its end. The memory of her, at least, is far from extinction: her beautiful work, admired all over the world, is a sure guarantee that she will live on for posterity.

Even while she lived, she had many biographers. Pens more expert than mine have written colorful, fascinating pages about her. However conscientious their talent, why did Rosa Bonheur not fully recognize herself in those portraits? Obviously, the authors did not know how to plumb the depths of her mind, and she could never entirely reveal herself to them, even though she did her utmost to satisfy their curiosity. This instinctive reserve vanished when she faced a woman whose love and devotion to her were sure, one with whom she felt in close communion.

After my long conversations with her, I was able to record at leisure, according to her express wishes, Rosa Bonheur's very precise recollections about her life and the works that made her famous, her thoughts and feelings about people and events, and, more generally, about the various social, religious, and moral problems that came up for consideration by this distinguished mind.

Yet my claim to Rosa Bonheur's trust and affection might be misunderstood if, before beginning the story of her life, I did not briefly explain how I came to know her. These circumstances gave birth to a loyal and sincere affection, which death alone could interrupt, between the great French female artist and a young American woman from San Francisco who had come to Paris to study painting. For the rest of my days, I shall keep in my heart the grateful and tender memory of our friendship.

Acknowledgments

I would be most ungrateful if, after recommending this book to the reader's indulgence, I did not thank all those who helped me carry out an endeavor whose difficulties often appeared nearly insurmountable to my inexperienced self: Her Majesty the Empress Eugénie of France, who deigned share with me her touching memories of the first female artist

who, with her help, entered into the glorious ranks of the Legion of Honor; to her name I would happily add that of Her Highness the duchess of Saxe-Cobourg-Gotha, if death had not taken her away soon after it struck down the woman whose cordial sincerity she had loved; Monsieur G. Macon, adjunct curator of the Condé Museum and Monsieur G. Cain, curator of the Carnavalet Museum, who gave me several precious bits of information; Mrs. W. Thaw, Miss Helen Gould, and Mr. Knoedler, who generously opened their collections for me; the administrators of the Metropolitan Museum of New York; the Hertford Museum of London; Messieurs Tedesco and the Braun firm in Paris, who allowed me to reproduce a great number of photographs of the paintings that passed through their hands, and especially Messieurs Lefèvre of London, who gave me permission to reproduce the admirable collection of engravings from the works of Rosa Bonheur published by their firm—together they allowed me, I believe, to offer the public a fine sample of the great artist's most remarkable works. But if this part of my endeavor has been successful, it is also thanks to the services of the Georges Petit firm and the long experience of Monsieur J. Augry, the head of the printing works. I am extremely pleased to express my gratitude to them here.

—A.K.

CHAPTER 1

Rosa Bonheur's Fame in America
❖
The Gift of a Wild Horse
Leads the Author of This Book to Meet Her

Rosa Bonheur's fame in America goes all the way back to 1858. Her painting *The Horse Fair,* shown in New York and many other cities of the union by M. Gambart, London's great dealer in French art, aroused keen curiosity, even true enthusiasm, in this country where animal painters have always found fervent admirers. The fact that a woman painted *The Horse Fair* made it all the more famous. After changing hands several times, it was donated in 1887 to New York's Metropolitan Museum by Mr. Cornelius Vanderbilt. His generosity consecrated, so to speak, Rosa Bonheur's renown in the United States. Certainly no one deserved this more than she. Yet it is amusing to note that the breed of horse that this canvas, reproduced in thousands of engravings, obviously meant to glorify contributed in fact to *The Horse Fair*'s popularity.

American breeders, who could now admire the size, energy, and noble forms of the Percheron horse thanks to Rosa Bonheur, became more and more eager to have these superb animals. Interestingly, the name of the great French artist, like that of a good fairy, soon began to turn up in their transactions. The first *Studbook,* which was published in 1885 by the Percheron Horse Society, founded only a few years before (1883) at Nogent-le-Rotrou to help preserve that horse and to compete with the breeders from Boulogne, best illustrates the artist's prestige. The title page sports a sketch that the Society commissioned from Rosa Bonheur. The Society also carefully included the facsimile of a letter in which the artist said how happy she was to help preserve the universally appreciated qualities of the Percheron breed. This attracted a lot of attention in America, as the Society let her know. Letters about Percherons soon began crossing the Atlantic. Rosa Bonheur lost no time in saying how novelists and travelers had fired up her curiosity, as an artist and friend to all sorts of beasts, about the wild horses of the American plains. How delighted she'd be to have some models! Between happy dreams and real longing there was but one short step.

Rosa Bonheur's wish was soon known across the Atlantic. Mr. John

Arbuckle, the president of Wyoming's Post Percheron Company, was most eager to satisfy. When a young wild stallion wandered into his corral, he ordered his men to capture it. The horse was so fiery and fast that it took no less than four days and nine cowboys to get him lassoed, subdued, and loaded on the train.

Mr. Arbuckle expected, of course, that Rosa Bonheur would thank him for this gift. Weeks and months went by without any word from her. He did not even know if the horse had arrived. A bit taken aback, he decided to take advantage of a trip to Europe to get news of the horse himself. I met him in Paris, where he told me of his plan. Not knowing any French was a problem for him, so he asked me to be his interpreter. Meeting Rosa Bonheur was one of my girlhood dreams come true. Naturally I jumped at the chance.

By is the name of a little hamlet right next to Fontainebleau. The chateau of By, where Rosa Bonheur lived for almost forty years, is actually what the French call a bourgeois home, and it would be futile to look for traces of turrets and drawbridges. With its garden and grounds, and the nearby forest of which this property is a kind of extension, the house is the most delightful country dwelling.

There is a high iron gate at the entrance. When Mr. Arbuckle rang the bell, a woman in white headdress appeared at the grille and said rather brusquely that mademoiselle was in Nice. We nonetheless explained the reason for our visit, which was to learn if Mlle Rosa Bonheur had received a wild horse from America. She became more cordial.

"Ah! those American horses!—we didn't get just one, but three at one fell swoop. If you want to see them, I'll show you."

Greatly puzzled, we followed her across the street and into an enclosure divided into a vegetable garden and a meadow.

"This is where mademoiselle keeps her horses," she said. "Here you'll probably find the one you're looking for."

In fact, three superb animals lifted their heads defiantly when we caught their eye.

"There he is!" Mr. Arbuckle shouted for joy. "I'm sure of it. See the brand *P. O.* on his rump! I'm so glad to see him in such fine fettle!"

"Did she use him as a model?" I asked.

"A model!" the good woman whooped. "The other two, yes, but never that one. It was impossible. Yet we're pretty good at taming the most rebellious characters. Come have a look over here."

She led us to a cage behind the bars of which we caught a glimpse of sparkling eyes.

"Here's mademoiselle's favorite."

A young lioness gave us a stony stare.

We were amazed to see our guide slip the bolt, open the cage, and begin to pet the wild beast. The lioness let herself be stroked like a nice big dog.

"You can see there's nothing to be afraid of with Fathma. Every morning we stroll in the yard, just like the good old friends that we are. If you want, we can all go for a little walk right now."

The lioness, who seemed to understand what her keeper was saying, got ready to jump down into the shed. I shot a look at Mr. Arbuckle. He seemed uneasy, and I confess that I was a bit nervous, too. We promptly replied that we did not want to cause the good woman any further inconvenience. We thanked her for her trouble and returned to our carriage. Our somewhat hasty retreat brought to the lips of the obliging servant a smile in which it was not hard to spot a glint of mischief.

We returned to Paris, frustrated. We had not seen Rosa Bonheur, and my compatriot, no doubt reassured about the fate of his wild horse, still did not know why he had never received the slightest thanks for his chivalrous act.

Two years later Mr. Arbuckle came back to France for the Universal Exhibition of 1889. Determined to solve the mystery this time, he arranged things well in advance. Before leaving New York, he wrote and asked me to request a meeting with Rosa Bonheur for the end of September. I demurred, knowing that the illustrious artist was deep in mourning for her beloved longtime companion. Only with the greatest reluctance did she allow anything to disturb her solitary meditation. On the advice of Mme Peyrol, her sister, to whom I explained the problem, I decided to tell Rosa Bonheur what Mr. Arbuckle wanted and why. She promptly replied by the following letter:

By, September 27, 1889

Dear Sir,

I would be delighted to receive your visit next Saturday, October 5, if you can.

I hope that you will not be cross that I have just given two of my mustangs to Colonel Cody. Yours was so wild! I had no use for him any more. Two cowboys are supposed to come lasso them on Monday.

I dare not invite you for lunch because I lead a very simple life; but if you

like fresh eggs, I would be very happy to entertain you as best I can. I must ask you to give me some forewarning if you accept.

Of course, my invitation includes your gracious translator.

I would be delighted if you could give me some horsy subjects for my compositions. That would me help out.

<div style="text-align: center;">R. Bonheur</div>

On the appointed day, Mr. Arbuckle and I arrived at By. Just as our driver was about to get down and ring the bell, the iron gates swung wide open. On the steps of the house, we saw a short little person dressed like a peasant in trousers and smock and holding a black and white dog. After directing the carriage to pull up at the porch, he stretched out his hands in the friendliest welcome. It was Rosa Bonheur (fig. 1).

I'll never forget our first meeting. Aside from her work, I did not know anything about the great artist who would later show me such poignant affection.

Rosa Bonheur was very well proportioned. So, although she was really very short, she seemed of average height. Over a high, broad forehead with a contemplative furrow between the eyebrows, her black eyes still had the extraordinary sparkle of youth. She had a small nose with finely chiseled nostrils. Her thin upper lip had a pretty curve; the fleshier lower one was amazingly mobile and betrayed her many moods and feelings. Her face was framed by a mane of magnificent silvery gray hair whose silky, abundant curls fell to the nape of her neck and circled that venerable head like a halo.

Her bizarre getup only half surprised me. For a long time I had known that she was in the habit of wearing men's clothes. I was pleased to note that, beneath such trappings, feminine vanity had lost none of its rights, the best token being the two magnificent amethyst buttons at her collar. Even her smock sported delicate embroideries at the shoulders, and two little feet, elegantly shod, poked out from beneath her black velvet trousers. Her whole person was most distinguished. With her venerable demeanor, she made me think of Corot and Henry Ward Beecher.

We sat down to lunch. After the usual preliminaries, Rosa Bonheur finally explained about the wild horse. She told us that just when Mr. Arbuckle's mustang had arrived from America, an unnamed gentleman from Chicago had sent her two others. Back then she had sincerely believed that all three were from the man in Chicago, and she thanked him alone. She begged forgiveness for this old misunderstanding as well as for giving Mr. Arbuckle's horse to Buffalo Bill.

"Please make your friend understand," she continued, "why I got rid of his kind gift. The animal was so skittish that I could never get near him. As soon as we opened the stable door in the morning, he'd gallop off into the meadow. Come evening, only hunger made him return to his trough and rack, which we kept full. Then the servants would run and shut him in. I used to be rather good at breaking horses; I thought I'd have the same luck with yours, but I had to give up. This wild horse stayed so thoroughly wild that, during the two years that this little game lasted, I was barely able to dash off a few sketches."

Mr. Arbuckle could not hold back a smile. "She wanted a wild horse, and this time she really got one," he said.

"It was, in fact, just what I wanted," Rosa Bonheur merrily added, "but I had to give up on him, and I thought I was doing the right thing by turning him over to Buffalo Bill, as I wrote you. His cowboys came for the horse just a few days ago. Those fellows really know how to handle ornery beasts without hurting them. It's a real pleasure to watch them work. After one of them lassoed your little horse, he calmed him down so well that he was able to go up and stroke his head. That's a task that I never could have given to a French groom."

Lunch was almost over. Instead of fresh eggs, we had been served a most delicate meal. The grapes for dessert were particularly superb and delicious.

"I've seldom seen such beauties!" Mr. Arbuckle could not help remarking.

"They're the local speciality. You had to notice on your way down that the walls here are covered with vines. The famous white grapes of Thomery are grown around By and then sent off to all four corners of the world. You've probably seen them in America, and apparently the empress of China won't eat any other kind. Our king Henry IV was very fond of them, and if you believe what they say," she added with a smile, "Thomery owes its name to this exemplary king, for he used to say: Ici, tout me rit!"[1]

Rocking with laughter, Rosa Bonheur stood up and invited us to go see her studio and most recent work. My eager thanks showed just how pleased I was by this honor.

1. "Everything smiles on me here." Bonheur is referring to a common technique of folk etymology, which attempts to derive a place name from a pun on the words of a famous visitor.

"I value your opinion," she said, "because I know you'll judge my work with an artist's eye."

This surprised and flattered me.

"Yes, indeed," she kindly continued. "I know quite well that you're a talented woman, and I noticed your beautiful portrait at the last Salon.[2] I also know that you've got two very intelligent sisters. You're all three proof that women aren't any less talented than men, that they can be just as good and sometimes even better."[3]

"Oh! mademoiselle," I exclaimed, "how can you be compared to other women? Your name will go down in the history of art! I'm so glad to have a chance to tell you here and now what so many women think of you!"

Turning a deaf ear to these words, she went on: "And I admire American ideas about educating women. Over there you don't have the silly notion that marriage is the one and only fate for girls. I am absolutely scandalized by the way women are hobbled in Europe. It's only because of my God-given talent that I could break free."

We arrived at a locked door. Rosa Bonheur opened it up with a little key from her pocket.

"Come in," she said in a grand tone, "come into my sanctuary."

We entered, duly awed by the word.

A huge canvas with wonderfully lifelike horses dashing around took up the whole back of the room.

"There I'm showing how they still thresh wheat in certain parts of southern France. Treading back and forth, these nine horses crush the husks with their hooves and squeeze out the kernels that are gathered up later on. I've been working on it for years now. I'd like this painting to be my masterpiece, but there's still so much to do that I wonder if I'll ever get it done. Since my dear friend died, I often lose heart."[4]

While Rosa Bonheur talked, my eye ran over her studio. All over the tables and chairs there were papers and various books, novels by Dumas, Bourget, and Zola, all in a jumble with wildlife studies; animal heads and racks of antlers were hanging on the walls. There were none of the paintings and studies I had expected to see. Rosa Bonheur noticed how amazed

2. A.K. A portrait of my mother.

3. Anna was the eldest of the six Klumpke children. It is especially remarkable that the five Klumpke girls went on to promising careers in art, medicine, music, and astronomy. For further details about the Klumpke family, see Klumpke, *Memoirs of an Artist*.

4. Entitled *Treading Wheat,* this painting remained unfinished at Rosa Bonheur's death.

I was: "You are surprised," she said, "that my sanctuary is barer than the studios of many novice painters. Yet for me it's chock full of memories and more inspiring than anywhere else because I can relive a past that is very dear to me. Besides, it's your compatriots' fault if there aren't any paintings on the walls. They lay siege to my dealers, who carry off my paintings when they're scarcely finished. That doesn't stop me from sometimes making them wait for years. You Americans always go full blast, which has its drawbacks for art. Granted, you can get some interesting photographs that way, but are they any better than a good memory flash? I don't think so. I confess, for example," she said, turning to Mr. Arbuckle, "that I was never able to catch the way your horse moved with a camera. But I got it perfectly well in my mind's eye and then put it down on canvas."

"And yet we've managed," he replied, "to cut exposure time down to 1/700th of a second. At that speed, not even a quiver can escape the lens. If you allow me, mademoiselle, as soon I get home, I'll send you a unique collection of cowboy photographs."

"Gladly, sir, but only if you'll take a study I drew of your horse. I feel a bit ashamed that I can't show you the real thing."

Of course, Rosa Bonheur's offer was gratefully accepted. Likewise, the photograph of herself that she gave us at the door (fig. 2).

"As for you, mademoiselle, I'll always be happy to see you again," she added, giving me her hand.

I grasped that fine, sensitive hand and passionately kissed it, remembering all the beautiful things it had created.

On the way back to Paris, Mr. Arbuckle shook his head and said: "Don't take her tokens of affection too seriously. She certainly gave us a warm welcome, but I think that's mainly because she found herself in a bit of fix where I was concerned."

"Right," I replied. "It's rather unpleasant to learn your benefactor's name and meet him face to face the day after you get rid of his generous gift."

"In any case," Mr. Arbuckle went on, "I'll certainly never dare give anyone a letter of introduction to her; and if you take my advice, you'll do just the same."

Despite these fine words, there was no way our relations could end so abruptly. Mr. Arbuckle had to get his photographs to the chateau of By, and Rosa Bonheur had promised him a study of his horse. So there were letters back and forth, with me as the go-between, the indispensable translator. Almost unconsciously, my relations with Rosa Bonheur became more and more cordial, despite the limitations of this epistolary exchange.

Buffalo Grass

After the Salon of 1891, in which I participated, a few friends in Boston urged me to come paint some portraits over there. I was easily persuaded by their entreaties. One might have expected my trip to interrupt the good relations that I had begun to enjoy with Rosa Bonheur, but it did just the opposite. It was only polite to inform the illustrious artist of my plans before leaving France. Her kind reply said that she was sorry to hear that I was going away and that she did not want me to leave without paying her one last visit. It would be fine if my mother wanted to come along, too.

On Saturday, August 1, my mother and I took the train down to By. Rosa Bonheur's carriage met us at the Moret station, and she gave us the most charming welcome at her chateau. Yet my mother missed the pleasure of seeing her in men's clothes; the gracious artist was wearing an elegant black velvet dress. She greeted us with outstretched hands and led us straight to the dining room where lunch awaited.

"But where's Gamine?" she blurted out, turning around. "Gamine! where are you? Come here, come, my little Gamine."

A small dog that I recognized as the one sitting in Rosa Bonheur's arms at our first meeting merrily ran up. Her mistress sat her on a chair near the table.

"Gamine never leaves my side," she added, "and she always gets the best morsels."

We sat down. Rosa Bonheur cut a slice from the rarest part of the filet, then minced it up on a small silver plate that she presented to Gamine. While the dainty little beast was savoring the tiny mouthfuls like a woman of fine taste, a door opened and out came four enormous Saint Bernards. After marching in ritual procession around the table, they came up one after the other to be petted by their mistress.

"These dogs are my oldest friends," said Rosa Bonheur, stroking them. "With these faithful guardians around, I've got nothing to fear."

When this odd parade was over, I heard their bowls being readied in the other room. The dogs dashed out with considerably less solemnity.

"Just listen to them jostle around to get at their rations," Rosa Bonheur chuckled. "Yet they don't bicker with Gamine for the honor of sitting at our table."

After lunch, she offered to show us some of her paintings and took us to her studio. While she was opening the door, I noticed hanging on a chair the work clothes that I had seen on my first visit. With a glance I drew my mother's attention to them. Rosa Bonheur picked up on my signal.

"Ah hah!" said she good humoredly, "you're looking at my men's clothes. I bet you make the same mistake most people do. They're wrong to think I despise women's clothes. Oh! of course, for work, I prefer men's. But today, in your mother's honor, I put on skirts, as you can see."

The studio door was wide open. Rosa Bonheur motioned toward it and said as solemnly as before: "Please come into my sanctuary, mesdames."

The sanctuary did not look any different. *Treading Wheat* sat in the same place, and it was no closer to being done than it had been two years before.

Rosa Bonheur took my hand and pulled me over to two very conspicuous easels: one with a superb study of a lion, and the other with a magnificent engraving of *The Lion at Home*.

"These are yours," she said. "I've signed them for you so that you won't forget me across the ocean."

Kissing me on both cheeks, she added: "I wish you every possible success over there."

She showed us a few plans for compositions and paintings. When she saw that I was particularly interested in a *Saint George,* she exclaimed: "Do you want it?"

"Oh, mademoiselle, you've already been too kind."

"Not at all! take it, I'll sign it right now."

Without waiting for my reply, she grabbed a pencil and dashed off a dedication.

After the sketches and the drawings came the engravings. One of her portfolios contained *The Horse Fair, The King of the Forest,* some heads of lions and dogs, and *Stampede of Scottish Oxen.* These fine works were all English and French engravings of her most famous paintings, many of which I had first seen a long time ago; for as a child in far-off California, I owed them my first swells of admiration for the noble artist who was now treating me like an old friend.

"These engravings have really helped spread my reputation in England and America," she said, snatching a roll of paper off an easel and unfurling it, to our eyes' delight. It was a wonderful charcoal drawing. A huge herd of Western buffalo, a breed that will probably soon disappear, was racing away from a prairie fire. They were terrified by the advancing sea of flame, and the artist made their panic marvelously real and powerful. The

turmoil of all those straining muscles, heaving chests, steaming nostrils and terrible horns created the most impressive mass. You could almost hear the beasts' bellowing horror, their rasping breath, crashing limbs, and the din of that tremendous stampede. A living tornado ready to smash and pound anything in its path!

"Here's the sketch of a painting I'd like to do," said Rosa Bonheur, "but there are a few things I need to make it completely real. The problem is the grass in the foreground. Being faithful to nature means getting every little detail just right. I'd be really glad if you could get me some of that vegetation. Ah! if I were twenty years younger, I'd love to go with you; we'd venture out together into your vast Far West and visit Indian reservations. How I'd love to see their wigwams with my own eyes and study their ways! What perfectly marvelous subjects for artists!

"Soon after the war,[1] I almost took such a beautiful trip. An admirer of my paintings, Mr. Belmont,[2] wanted to organize a buffalo hunt for me. What fantastic things we would have seen, my dear friend and I! We had to give up this pleasure to stay home with our beloved mother Micas, who had nearly gone blind."

No one said anything for a while. Rosa Bonheur broke the silence by inviting us to tour her estate. So once again I saw the great meadow, now empty, where I had ventured with Mr. Arbuckle three years before.

"Here's where my wild horses used to frisk about," she said. "How embarrassing when I found myself face to face with your compatriot! Just imagine that Mr. Arbuckle turned up the day after I'd just given away his present to Colonel Cody! I suppose that Buffalo Bill had better luck; he must have managed to polish my little stallion's manners."

"And what about the lioness who was here?" I asked, interrupting her.

"My poor Fathma! so nice and so very tame. That's right, you even saw her. She died, which made me really sad."

It was soon time to leave. We chatted all the way back to the chateau.

There was a magnificent yucca nearby in the garden. Pointing it out, Rosa Bonheur made us admire it and asked my mother if she liked flowers. Then she called her gardener and told him to take out the yucca without hurting the roots and to bring it to the studio along with a beautiful spray of roses.

"If you please, mesdames," she continued, "let's go back to the house and I'll help you pack up your souvenirs. It's almost time for your train."

1. Bonheur is probably referring to the Franco-Prussian War of 1870–71.
2. A.K. In 1856 Mr. Belmont was an American diplomat at The Hague.

A moment later, the gardener arrived with a huge armful of flowers. Among the bright roses the delicate tones of the yucca blooms stood out, but its roots were all gone. The poor devil had painstakingly shaved them off.

Rosa Bonheur's eyes flashed with anger, yet she contained herself. Only after the gardener had left did she burst out: "So what do you think of that, mesdames? Isn't that a fine example of masculine intelligence?"

As we were leaving, she noticed that I was having a hard time hiding something.

"So," she laughed, "you've got your autograph album, and you probably want me to sign it beside your illustrious professors and other noteworthy acquaintances."

"I confess," I said a bit embarrassed, "that was my plan on the way down, but I no longer dared to ask, since you . . ."

"Let me have it," she graciously insisted, taking the album. "My friends the Tedescos will get it back to you in a few days."

Before I could thank her again, she said: "You'll find a basket of Thomery grapes in your coupé. Your sisters have to get a taste of the local produce, too."

She kissed me and said: "I gave you a picture of me a while back. It would be nice to have yours in exchange. Send me one before you go."

Surprised and charmed by such hospitality, we returned to Paris with our arms full of gifts from the fine woman, whose professional scruple obviously matched her generosity. We knew that much of her kindness was occasioned by her fervent desire to get something she considered absolutely necessary for one of her paintings. As for the unfortunate yucca that had made her rail against men, we planted it the moment we got home. We hoped against hope that Rosa Bonheur's sweet gesture would make it miraculously sprout new roots. The harm was beyond repair. A few days later the lovely plant lowered its head and withered. Its little bellflowers had not yet wilted when M. Tedesco returned my autograph album. How eagerly I opened it up, and what pleasure when I found another token of the great artist's affection: a sketch of the *Scottish Shepherd*.

After sending Rosa Bonheur a thank-you note plus my photograph and receiving more good wishes from her for my success, I was off. By early October 1891 I was back in Boston and happy to see several of the people who had urged me to come over. Their kind recommendations gave a whole circle of fine connections. I sold a few paintings and rather quickly received enough portrait commissions to keep me busy for years to come.

Rosa Bonheur's sketch of her Scottish Shepherd, *added to Anna Klumpke's*
keepsake album in August 1891.
(Original French edition, p. 23.)

Though I was swamped with work, I did not forget my mission for Rosa
Bonheur. Yet whenever I dared ask how to get my hands on some of that
prairie vegetation, there was always the same ironic reply: "You'll just
have to go get it on foot. You certainly don't think that trains stop in the
God-forsaken places where that accursed stuff grows. What earthly use
would there be for a train station in a place without any houses, crops, or
people?"

I wrote Rosa Bonheur about these difficulties as well as my wish—
rather than my hope—to overcome them some day. Fortunately, she was
not the least impatient.

Just when I was beginning to abandon all hope, I happened to meet a
young woman whose help promised me speedy success in my quest. Miss
Collins was the head of a school that she herself had founded for an Indian
tribe in the Far West. She had some interesting photographs and gave me

one of prairie vegetation for Rosa Bonheur. I was very glad, but it wasn't quite my dream come true. Would that ever happen? Then one fine morning I was surprised to receive a very nicely wrapped parcel of dried grasses. A note from my sister[3] in Cincinnati told me that this was the buffalo grass that I had been clamoring for. After members of the Colorado Botanical Society had happened to learn that Rosa Bonheur wanted some, they had pillaged their collections for her. There was also a letter from the botanical society pointing out that buffalo grass[4] changed color a bit when it dried; they would try to get some fresh tufts, but unfortunately this vegetation shuns civilization and disappears almost immediately from settled regions. It usually grows, the letter continued, with grama grass and some wildflowers, with several specimens enclosed. Each clump makes a ball about a foot wide, and they are generally found twelve to eighteen inches apart. Buffalo grass grows in pale grayish brown soil that turns dust-color when dry.

I immediately sent Rosa Bonheur these specimens and Miss Collins's photograph. She promptly thanked me, adding that she was surprised by the plant's shape. I also saw that she mistakenly assumed that I was the young woman in the picture, which was Miss Collins.

While in America, I received many letters from Rosa Bonheur. She took every opportunity to prove to me and my family how much we meant to her. In December 1893, my sister Dorothea[5] received her doctorate in mathematical science from the University of Paris and sent Rosa Bonheur a copy of her thesis on the rings of Saturn. The gracious artist wrote her these thanks:

Mademoiselle,

Ever since you so kindly sent me your thesis, I have not had a single calm moment to thank you.

Today at last I can finally tell you my heartfelt gratitude and admiration, which you deserve to receive from everybody.

I could understand the first few pages, which I read last night. As for the math, I'm in the dark, along with three-quarters and a half of the general public. Just like sticking your nose into a book of Hebrew.

I'm absolutely awestruck by all these formidable equations and symbols. That should come as no surprise to you.

3. A.K. Mrs. Dalton, whose maiden name was Mathilde Klumpke.
4. In English in the original text.
5. A.K. Now Mrs. Isaac Roberts.

Allow me, dear mademoiselle, to say that I am proud to count myself among your friends and to thank you once again for having honored me with a copy of your doctoral thesis in mathematical science. I am deeply touched.

<div align="right">R. Bonheur</div>

Rosa Bonheur insisted on congratulating me, too, on that joyous event for the whole family.

<div align="right">*By, January 15, 1894*</div>

Dear Mademoiselle Klumpke,

I am delighted by your expressions of affection, which I return, with my whole heart and deep respect for you as a fellow artist. I hope to see you again in Paris, before the advent of a better world where the Creator may perhaps reunite us with the dear departed ones who watch over us.

You must be very happy, dear mademoiselle, about your sister's success. I feel deeply honored that she was so kind as to send me a copy of the thesis that earned her a doctorate in mathematical science from the University of Paris, a very high distinction.

I have already told you that your family is blessed by the Great Creative Spirit of all infinity, and it's true. The material world alone is a brief trifle in the minds of those who know how to decipher the Creative Spirit at work in our earthly lives.

Please give your mother my fond regards and let me kiss you both.

<div align="right">R. Bonheur</div>

New Visits to Rosa Bonheur
❖
Buffalo Bill's Indians

In June 1895 I returned to Paris, driven by the desire to plunge back into the artistic life of the great city, the atmosphere of its museums, the daily competition that fostered so much study and progress. I also meant to seek the advice of my former teachers and that of M. Thévenot, whom I had not yet met. As a portrait painter, I had become very interested in his work, which I truly admired. I wanted to improve my hand in the delightful art of pastels. Through considerable trial and error I had learned just how difficult they were. Unfortunately, in my youthful presumption, I had overlooked just one thing that was of major importance: M. Thévenot did not take students. I felt crushed hearing this.

For want of anything better, I returned to the Julian Academy[1] and rented a studio to spend the winter working on a painting for the Salon of 1896. I had not forgotten the illustrious woman who had often sent me fond regards across the Atlantic. Several things, including the death of her friend, Mme Carvalho,[2] which affected her deeply, prevented me from going back to By until midautumn. Once again my mother accompanied me, as she had four years before.

We had just stepped out of the train at Moret when a little old gent came right up and kissed me. I shrank back until I recognized Rosa Bonheur. My flabbergasted mother was ready to make loud objection to this attack.

1. The Julian Academy was a famous private Parisian art school of the period. Unlike the nationally funded School of Fine Arts, which did not admit female students until it was forced to by an act of Parliament in 1897, the more progressive Julian Academy had a regular practice of admitting women. For more details, see Klumpke, *Memoirs of An Artist,* pp. 14–20; and Germaine Greer, "'A tout prix devenir quelqu'un': The Women of the Académie Julian," in *Artistic Relations: Literature and the Visual Arts in Nineteenth-Century France,* ed. Peter Collier and Robert Lethbridge (New Haven: Yale University Press, 1994), pp. 40–58.

2. A famous opera singer of the period. In his *Reminiscences of Rosa Bonheur* Theodore Stanton documents Rosa Bonheur's close friendship with the prima donna.

Soon we were all having a good laugh. A bit later in the carriage, Rosa Bonheur was still chuckling: "What a terrible face you pulled, my dear Miss Anna, when I clasped you to my ancient heart right in front of all those people!"

I replied that in America we were not used to public displays of affection.

"That's hardly news, and it's for that very reason that I wanted to pull that old art-school prank on you. Besides, it only goes to show how very happy I am to see you again. And you, dear madame, did you recognize me?"

"No, I must confess that I did not," said my mother, "and I very nearly lost my temper. Fortunately, your tiny feet with their elegant shoes caught my eye. They had to be a woman's feet."

"True, I've always been vain about them. They often give me away when I'm working in the forest. Still this outfit has really given me a lot of protection since I've been alone."

The welcome at the station and lunch assured my mother and me that, despite four years' absence, Rosa Bonheur was as fond of us now as on the day she had sent us away with armfuls of studies and flowers. In the afternoon we made the obligatory visit to the "sanctuary." A huge half-finished canvas was standing on an easel.

"I'm painting a famous battle in the annals of the British studbook. The white horse is the renowned Godolphin Arabian, the father of a whole line of great English stallions. Maybe you've heard of him? Eugène Sue has written about him, and several others since. You don't know the story? It's mighty interesting. The bey of Tunis gave this horse to Louis XV, but the king only liked the short, stocky horses that were the fashion back then. Nobody was interested in this Barbary horse. The royal stables quickly sold him off, and he wound up pulling heavy carts through the streets of Paris. One day in the rue Dauphine, he just collapsed. This drew the attention of a passing Englishman, named Cook, who was a good judge of horses. He realized that the horse deserved something better than being slave to such a lowly task. Cook bought the horse and took him back to England. There he gave the horse to Lord Godolphin, who sent him to his stud farm.

"The white mare in the background is Roxana. She was meant for Hobgoblin, the black stallion who is fighting with the Arabian. A fierce duel between the two rivals decided the fate of that lovely Helen of Troy. Godolphin Arabian won.

"By some happy fluke, an old Stubbs engraving, published in London in

1794, fell into my hands. It helped me draw a faithful portrait of this heroic horse. When you do history, everything's got to be just right, and I never shrink from sacrifice to get the documents I need."

Then she turned to me and said in a reproachful tone: "I had no such luck with the buffalo grass. What's going on, my dear Miss Anna? You get your picture taken in the middle of the prairie. All you'd have to do is lean down and pull up some fresh clumps, and then you send me a few faded sprigs from somebody's dried plant collection."

"Unfortunately I've never been out on the prairie," I replied. "There aren't any trains that stop there. The young missionary who gave me the picture I sent you may look like me. I am not saying you think I'm somebody else, but you certainly thought somebody else was me."

"But I was sure I recognized the tip of your big nose under that broad-brimmed hat," she said by way of apology.

Then she began to pummel me with questions about my recent stay in America, the connections I had made, and the work I had done. I showed her a few photographs of my Boston portraits. "This one lives and breathes! who is she?" she exclaimed about the portrait of Mrs. Nancy Foster. With a few brief words I gave her some idea of this remarkable woman and feminist to whom the University of Chicago owes the construction of a special pavilion for female students.

"In America you always find some generous souls eager to devote themselves to women's education and emancipation. Your country is becoming great because you all understand that girls, once they marry, have unparalleled influence over their children's education."

Before I bade Rosa Bonheur good-bye, I asked her to recommend me to M. Thévenot.

"Gladly," said she, "but I've never met him. I understand why you're so enthusiastic about him. I like his work even more since I've taken up pastels. They're fun, despite the mess."

A few weeks later I went back to By to introduce Miss Sophie Walker from Boston. I had painted her portrait back there, and she wanted to buy a painting for an art museum that she had just endowed at Bowdoin University in Brunswick (United States).[3]

A study of a white horse caught Miss Walker's eye.

"My studies aren't for sale," said Rosa Bonheur, "but if you wish, I can do you a painting from this one."

"How much would that be, mademoiselle?"

3. Bowdoin College in Brunswick, Maine.

"Five thousand."

"You mean five thousand dollars, don't you? What joy to get one of your paintings at that price!" the visitor burst out.

"You don't understand," interrupted Rosa Bonheur. "Since you're Miss Klumpke's friend, I'm asking five thousand francs, not dollars."

Miss Walker's thanks were profuse. As for me, I was deeply touched by a gesture as flattering to me as it was advantageous to my compatriot.

Come winter I was asked to make another introduction. One day I received a visit from Mrs. Thaw of Pittsburgh, whose patronage had been invaluable to me during my last stay in America. In New York she had recently bought a Bouguereau and a Rosa Bonheur, which made her very eager to meet the two artists.

Mrs. Thaw had already paid a visit to M. Bouguereau, who had given her the most gracious welcome, but she knew how difficult it was to get into Rosa Bonheur's studio. That's why she appealed to me as a go-between, confident that I would do my best to help her out. Aware of the affectionate letters that I had received from Rosa Bonheur in Boston, she considered these a guarantee of success and counted on a visit that would give her and her daughters something fine to remember.

Rosa Bonheur's reply to my request was as prompt and positive as Mrs. Thaw could ever have hoped. Three days later, Mrs. Thaw, her sister, her two daughters, and I traveled to By. Rosa Bonheur gave these ladies the pleasure of seeing her in men's clothes. They soon got used to this strange outfit because of the artist's warm welcome and lively conversation.

On the other hand, two Yorkshire terriers gave us quite another treatment. One began barking in an extraordinarily noisy and ferocious manner for his tiny size. Fortunately, his fangs were not much to be afraid of. The other Yorkshire was quiet, but the little traitor kept trying to nibble my ankle boots. Miss Alice Thaw picked up the furious little beastie and held him in her arms. Instead of taking offense, he calmed right down and welcomed every pat.

"I can see you're an animal lover, too," Rosa Bonheur told her. "This little rascal is my favorite, and he knows it. Look at his silky coat. If I'd sent him to the dog show, he'd have won a great prize, but I couldn't bear to part with him. Charley is so cuddly and affectionate; he's got such beautiful eyes; the only thing he can't do is talk. Animals do have souls, don't you think?"

"Oh! mademoiselle, how glad I am to hear you say that," exclaimed Miss Alice. "Just this morning I was defending that very opinion against my mother."

Then the conversation rolled round to the painting that Mrs. Thaw had bought in New York. In the foreground there were sheep lying on the grass and a group of oxen in the background. Mrs. Thaw was obviously smug about owning such a fine piece.

"Why, you're talking about *Oxen in the Highlands!*" Rosa Bonheur burst out. "Try and find out how much she paid for it," she whispered to me a moment later.

I soon learned that the painting had sold for forty thousand francs, which she considered a fair price. Rosa Bonheur was clearly pleased to hear it, and I recalled the bargain she had offered Miss Walker.

She sat down at her worktable and took out a sheet of foolscap. Right before our wondering eyes, she did an elaborate pen-and-ink drawing. After adding a dedication, she handed it to Mrs. Thaw and asked her to accept the sketch as a memento of her visit to By.

"My goodness, you've drawn my painting!"

"That's right. I thought you'd be happy to see that I haven't forgotten your dear canvas."

Then she turned to me and said: "You've got to realize, Miss Anna, that a true artist must keep her subjects engraved in her mind, which is her personal museum. You should come live at By," she added with a smile. "I'd find you proper lodgings in the neighborhood. You'd work with me in the park and the forest, and I'd teach you how to paint landscapes. Portrait painters always need some landscape to liven up their paintings."

I thanked her, only half able to believe my ears.

We returned to Paris. This fine debut delighted Mrs. Thaw and her daughters and spurred them on to more visits to artists' studios. I had already mentioned M. Thévenot to her. She wanted us to go see him together, which of course overjoyed me. Mrs. Thaw bought a charming pastel from him. As for me, while we were looking at his work, I made a point of telling him that after coming all the way from Boston just to study with him, I had been crushed to learn that he did not give private lessons.

M. Thévenot said nothing to raise my hopes. But a few days later, he let me know that he was free for the duration of the Salon and would give me three months of lessons, starting in May.

Nothing could have made me happier. Taking lessons with M. Thévenot and working with Rosa Bonheur, wouldn't this be the best possible way to wind up my art studies in Paris? I owed it all to the wonderful Mrs. Thaw, who was definitely my good fairy. It was just too good to be true. I had scarcely made my arrangements with M. Thévenot when a letter arrived from By. Rosa Bonheur announced that she had found me perfect lodgings

almost on her doorstep and that she would expect me in early May. What hard luck to have to choose between two such delightful projects! Though I was sorry to disappoint Rosa Bonheur, I decided to stay in Paris, considering that Thévenot's lessons would be more immediately useful to me as a portrait painter than the advice of an animal painter, however precious it might be. Rosa Bonheur did not blame me for this decision; she still urged me to come consult her. Alas, that summer I hardly had a chance to take her up on her generous offer. Each time I saw her, the elderly artist was kind and affectionate as always, but I especially remember my farewell visit before my trip back to Boston.

Having brought up the topic of American Indians, Rosa Bonheur showed me a whole set of photographs, followed by a huge tome of engravings on the subject.

"This is Catlin's work," she said, "one of your compatriots who I think spent his life among Western tribes. He's the great artist of Indian life. Take a good look. He took such splendid advantage of things going on right in front of his eyes. I did the same when that fine Colonel Cody brought his Wild West show to Paris for the last Exhibition.[4] The Tedescos helped me gain entrance to the Indian camp, and Buffalo Bill was extremely good to me. He was nice as could be about letting me work among his redskins every day. That gave me time to study their tents; I watched everything they did, and talked as best I could with the warriors, squaws, and children. I drew studies of their buffaloes, horses, and weapons, all tremendously interesting. That's why I was so happy when Mr. Knoedler gave me the great chief's superb costume over there.[5] You know, I've got a real passion for this unfortunate race, and it's utterly deplorable that they're doomed to extinction by the white usurpers. But I guess you'll get to see a few Indians, since you're planning a show in San Francisco. Do me another favor when you cross the plains. This time try and get me some fresh buffalo grass for the foreground of my painting. Otherwise, I'll never dare start work on my huge *Buffaloes Fleeing a Fire* or *Wild Horses in the Far West*. That's another painting I promised myself

4. After having made a great hit with Queen Victoria, Buffalo Bill took his Wild West show to Paris for the 1889 Universal Exhibition.

5. A.K. Mr. Knoedler told me that one day Colonel Cody invited Rosa Bonheur and the two Indian chiefs Rocky-Beard and Red-Shirt to share his table. The elderly artist hardly touched her food, which was pointed out to her. "Why do you want me to eat?" she asked. "I do that every day, don't I? But it's not every day that I've got two such interesting beings right in front of my face."

to do, and I've just got to. It's unbelievable how I get the old fire back when my pencil brings to life those thrilling scenes from Fenimore Cooper.

"These projects are truly providential distractions. For a moment or two they help me forget how alone I've been since Nathalie Micas died, that devoted childhood friend who shared my joys and sorrows, who witnessed my trials and triumphs.

"I still have a lot of things to finish up before I meet again up there the souls I've loved here below.

"I'm all alone now. It's often hard to understand the Creator's designs."

As we said goodbye, she gave me a melancholy smile: "You're leaving, my dear Miss Anna, but I hope we'll see each other again in this world. This is not our last farewell."

I was deeply moved leaving her this time. Despite her assurances to the contrary, I felt sure that I had kissed Rosa Bonheur for the last time.

Gathering Sagebrush
❖
I Ask Rosa Bonheur's Permission
to Paint Her Portrait

I left for America with plans to show some new work in places where I had connections. First Boston, then Pittsburgh and Cincinnati, and I'd wind up in San Francisco, my birthplace. The long iron ribbon of rail between Cincinnati and San Francisco ran through Indian territory and the famous plains over whose vast range my old French friend would have so loved to gaze. But since the days of her favorite authors' dramatic tales, things weren't the same out there. Ploughs had split open the virgin prairie, which now sends up green shoots of wheat in the spring. More and more the land was tilled, except for that barren immensity in the West called the desert. I had a tedious memory of that dreary green expanse, but now I rejoiced at the thought of seeing it again. A lovely ray of light was cast over these forsaken parts by the grace of that blessed buffalo grass I had promised Rosa Bonheur. I had to admit that my pledge was foolhardy, for I had no idea if I'd ever be able to get her any. Were I to fail, the mere sight of that ludicrous object of desire would surely add to my remorse.

Near the end of spring I had a glimmer of hope in Cincinnati. The Christian Alliance was organizing a huge convention in San Francisco. So many people from all over the nation wanted to participate that some sixty trains, each draped with a huge banner reading Christian Endeavour Society,[1] were set to head out West. Everyone had to pledge to wear the badge, take part in all the services, and sing the prescribed hymns. The trip was supposed to take at least ten days, not counting Sundays. To break the monotony, the train would stop at each and every point of interest. Wouldn't this trip get me to my destination and also give me a unique opportunity to set foot on the prairie, however briefly? I promptly signed up.

For several days the sun made the air fiery hot. As we drew nearer to the desert, it got even hotter. The conductor warned us to ration our water. There was no way to get more in this thirsty country that we would cross

1. In English in the original French text.

as fast as we could, all the more since there was nothing to see. This did not suit my purposes.

"You won't refuse me," I said, "a brief stop to gather a few plant specimens."

"Stop the train for a bunch of nettles? You don't mean it, miss! The heat yesterday must have addled your brain," he added unceremoniously.

"Not at all," I retorted with a laugh. "My request will seem less bizarre when I tell you that Rosa Bonheur, the great French artist, asked me to get her some. She needs it for a new painting."

"Why didn't you say so in the first place? Rosa Bonheur, I've even seen some of her paintings. They're great. For her I'd stop the train anywhere. Too bad if anyone complains."

A few hours later, we were steaming through some dense vegetation. To the right and left, as far as the eye could see, the green waves of the plain rippled and rolled, its surface smooth except for big clumps of my own personal Golden Fleece. All of a sudden the train pulled up short. Had there been an accident? Instantly hundreds of curious heads peered out the windows. I leaped down from the train. Two nice acquaintances who had offered me their help also hopped down to take part in this strange harvest. I heard them yell as they tried to pull up a clump. Sagebrush has a stem armed with nasty spikes. Enough of that method. Then my friends dug around some clumps with their knives and uprooted them, dirt and all. This took a while. No doubt the passengers were getting impatient inside the train. Out they poured. The curious ones clustered round; the others chased prairie dogs and grouse. We had all the time in the world. While my friends were working, why not do some watercolor sketches of the virgin land? I opened my paint box. Disaster! My brushes were gone. I lopped off a hunk of hair and tied it to a pen. That made a rotten brush, just impossible. I ripped off the hair and replaced it with a wad of handkerchief. Much better. The colors spread rather well. While I searched my palette for the colors of earth, plants, and sky, I remembered Rosa Bonheur and wistfully imagined the sketches she would have done here.

Soon I had finished, the passengers got back in, and the train took off. After a few more sketches, I wrapped up my precious booty. At the next day's first stop I sent it straight off to Rosa Bonheur, along with a letter saying how glad I was to have finally kept my word.

The famous artist's reply did not reach me till the end of August. By then I had left San Francisco for an island in the Saint Lawrence, at Alexandria Bay, where I was painting portraits of the Douglas Miller family. A few days earlier I had received another letter from Rosa Bonheur that had

followed me all over America to say that she was showing her four big pastels. In her second letter Rosa Bonheur thanked me for thinking of her in the desert and for sending the specimens of sagebrush, which had not yet arrived.

The Millers thought it a great event that two letters from Rosa Bonheur had arrived one on top of the other on a little island in the Saint Lawrence.

"You must be so proud to be a friend of hers!" they said. "Ah! if Rosa Bonheur ventured as far as Deer Island, what a welcome she'd get! Let's invite her! She can paint the Saint Bernard, who just hates being a model." That superb dog figured in one of my portraits. "Then we'd have a painting by two artists."

"Just like Dubufe's portrait of Rosa Bonheur,"[2] I said, chuckling at Mr. Miller's idea.

"Yes, indeed," Mrs. Miller continued in a serious tone. "That painting owes much of its success, I'm sure, to the fact that Rosa Bonheur herself painted the bull she's leaning on. Do you know if there are any recent portraits of her?"

"Yes, but I don't think they really do justice to her bright, lively face."

"So why don't you ask if you can paint her portrait? If she agreed, that would be a great honor for you."

"I've mulled it over," I replied, "but I always shrink from asking. You've got to remember that Rosa Bonheur is surrounded by the best portraitists: Bonnat, Jules Lefebvre, Benjamin-Constant, Dagnan-Bouveret, Aman-Jean, and they're all her friends. How would I ever dare suggest it?"

"You're American, aren't you?" retorted Mrs. Miller. "You've got to be daring, believe me. The woman who writes you these sweet letters won't say no. She knows that a portrait can only boost your reputation. Besides, doesn't she want to see you again, even though she's seventy-five? She said so twice, didn't she, in the same letter?"

It was very tempting. I promised to write but faltered. While strolling along the river, I'd ponder a thousand letters, only to drop the idea. Then a secret voice would rise up and shout that I had to be daring. So, on September 14, a date engraved in my memory, I wrote the letter. Then, with my portraits done, I went to Boston to await her reply.

Weeks and months went by without a word from By. Had I hurt her feelings? Her inexplicable silence wounded me more than a frank refusal.

2. Edouard Dubufe's portrait of Rosa Bonheur was first shown at the Salon of 1857. For Rosa Bonheur's remarks on her teamwork with Dubufe, see chapter 8.

Fortunately January was fast approaching. The traditional New Year's greetings would give me a fine chance to remind her of my existence. I did just that, but without daring to say a single word about my main concern. I did not, however, neglect to ask about the white horse for Miss Walker and the plant specimens whose fate was still unknown to me. I also sent along an alphabet book illustrated by Nicholson. This time I finally had the pleasure of a prompt reply:

By, January 5, 1898

Dear Mlle Klumpke,

Thank you for your almanac,[3] which gives me a good idea of your fine, original talent. I was struck by the analogy between your imagination and Goya's. Do you know this famous Spaniard? Could it be that, unbeknownst to you, you've got a few drops of Spanish blood coursing through your veins? Maybe from your father, since your mother wasn't even born until after Goya died. No matter. Many, many thanks for your parcel and my fond wishes for 1898.

I'm really furious with myself. I still haven't found time to finish Miss Walker's white horse. I know I'm usually slow, but there's no end to interruptions. At my age, I can only work for short periods. And now, if I can manage, I'll be in a show with my female comrades in late March. Miss Walker's horse is next.

Please don't worry about getting me the buffalo grass. You've already sent me some. I'm just sorry I haven't got the sketches you dashed off for me in the desert. Also, your great American painter, Mr. Bierstadt from New York, was kind enough to lend me several studies.

I've got lots of ideas for paintings of the plains. Shall I finish them? God help me, I'd like to live long enough.

Good-bye, dear, sweet mademoiselle and worthy sister of the brush. Please accept, with my fond wishes, a fraternal kiss.

R. Bonheur

Before even opening it, I was overjoyed to recognize the handwriting and postmarks of that friendly letter. Yet I must admit that, after reading it over and over, I was sorely disappointed. Not a single word about her portrait: Rosa Bonheur must not have got my letter. As for that bothersome buffalo grass, it must have gone astray. Fate had even ordained a

3. It is curious that Rosa Bonheur uses the term *almanac* to refer to the alphabet book Klumpke sent her.

mistake about Nicholson's primer. Rosa Bonheur generously attributed the illustrations to me. That's why she thought I had some Spanish blood.

I immediately replied to tell her how sorry I was about the specimens, also correcting her flattering opinion about me and my ancestors. I saved the topic of the portrait for the end.

What a happy day—although I couldn't foresee how it would affect the whole rest of my life—when I received the following note:

By, March 31, 1898

Dear Miss Klumpke,

I've made a fine blunder about the album you sent me this winter. Silly as always, I noticed the work, not the name.

I thought you'd done the album. Knowing your fine talent, I just assumed that it was one of your artistic fancies. Yet I still think, and it's obvious that you do too, that Nicholson is part Spanish.

I am at your disposal, dear mademoiselle, for the portrait.

I don't much like posing, but I have such high regard for you that I'll do my best. Just one thing, I can't rejuvenate the model. She's quite quite the worse for wear. No matter. I'll give you my fraternal hospitality for as long as you need, whenever you wish.

I trust that your mother is still at your sister's and that everyone is fine. My sincere affection, dear Miss Klumpke, and come when you please.

Rosa Bonheur

Victory was mine! This letter, so original and frank in its expression, so beautifully affectionate in its simplicity, gratified my every wish. Friends, acquaintances, everyone who had ever taken an interest in my work rushed to congratulate me. Mrs. Thaw proved again how fond she was of me. She gave me some advice that probably made it possible for me to write these pages: "Since the famous woman has invited you to stay with her while you're working," she replied to my letter of farewell, "jot down your conversations every evening you're there. Your notes will be a fine souvenir of this important time." I vowed to follow her advice. From then on, I could think of only one thing: going back to France and seeing that great artist again.

We were in the midst of the war with Cuba. I had to leave Boston on an English steamer bound for Liverpool. From there I went to Paris. I thought that I'd be away for at most three months.

At By

❖

Sittings for the Portrait

❖

Rosa Bonheur's Conversation

When I arrived at By on June 11, it was a joy to find Rosa Bonheur still hale and hearty. After she inquired about my stay in America, my family, and work, we got right down to business.

"Shall we begin Monday?" she asked.

"But that's the thirteenth, mademoiselle!"

"So you're superstitious, are you?"

"A bit. Thirteen hasn't given me any reason to complain so far, but that's not when I'd like to start a piece that means so much to me."

"In that case, let's start Thursday, the sixteenth," concluded Rosa Bonheur with a smile. "Then you'll have time to see the Salon and the Louvre. I suggest you study Clouet's lovely portraits and let them inspire you."

On the appointed day I was right on time. Rosa Bonheur seemed a bit cross to see me already hard at work.

"It's a great honor that you're letting me do your portrait," I told her. "How can I ever thank you?"

"By doing a better job than the last ones. This time I'd like to be in women's clothes. But for today, my dear Miss Anna, let me keep my smock on. It won't hinder your search for the right pose and the best light."

I was delighted that Rosa Bonheur had offered of her own accord to pose in women's clothes. In truth, I would have felt uncomfortable asking her to do so, as my teacher, M. Tony Robert-Fleury, had recently advised.[1] Despite that relief, I was still uneasy about getting down to work, and Rosa Bonheur didn't make things any easier. She was so used to painting animals, who never change clothes, that she insisted on keeping her smock, as though it didn't matter.

I opened up my paints and picked up my palette.

1. He had been one of Klumpke's teachers at the Julian Academy.

"You don't have enough colors," said she. "Let's go get some in my little studio on the third floor." Up we went. "Here's what you need." She handed me some tubes of Naples yellow, gold ochre, and Veronese green. "Mixed just right, they'll give you some really delicate tones. But it all depends on how you do it."

This bit of technical advice, backed up by two or three masterly dabs on a palette, gave me time to regain my composure. A few minutes later, we were back in the "sanctuary." I sat down at my easel and asked Rosa Bonheur to take a pose. She obligingly picked up her brushes and palette.

I had begun sketching when one of her friends dropped by. Perfect timing! While they chatted, I was entirely free to draw my first strokes.

"That pose is pretty good," Rosa Bonheur said later. "You've got a fine sense of color and a subtle eye."

I don't know if she was happy about the sitting or if something else was going on, but over supper she was very merry, even a bit mischievous, as if she meant to make me pay for the pleasure she'd given me. Shooting me a playful look, she remarked: "You've got a nose like Cyrano de Bergerac's. Do you know what Rostand says about it?"

"No."

"Well, well, you've got to read that. Besides, it's famous. *Cyrano* ran all last winter at the Porte-Saint-Martin. Coquelin, who played the main role, always made everybody cry at the end.

"Here's the play," she said, back in the studio. "You'll see that Rostand's hero has a big schnozz, just like you. I should write on the cover: 'A portrait of Miss Anna Klumpke.' Don't pout, read it first, and you'll see what a great guy this Cyrano is." She roared with laughter. "This is the nose tirade."

Cyrano. Eh? What! You accuse me of being so ridiculous? My nose small? *The Bore.* Heavens!
Cyrano. My nose is enormous! Mean flat-nose, stupid snub-nose! Dullard, I would have you know that I pride myself on such an appendage, inasmuch as a big nose is, properly speaking, the sign of an affable, kind, courteous, witty, liberal, courageous man, such as I am, and such as you can never think of being, miserable rascal! for the inglorious face that my hand is going to seek above your collar is as bare . . .[2]

2. The nose tirade (act 1, scene 4) in Edmond Rostand's *Cyrano de Bergerac*, as translated by Helen B. Dole (New York: Three Sirens Press, 1931), p. 43. The version quoted by Bonheur/Klumpke is slightly different from the text of the standard editions of the play.

I listened hard, my eyes catching every expression on that wonderfully mercurial face. Cyrano's lines were saucy, smart, and well tempered; and her voice had just the right bounce and flash to bring out their best. I don't have words for the charm and verve she imparted to them.

After reciting four whole pages, all of a sudden she handed me the book and said: "What writerly wit!" I was about to say: "And even wittier reading!" when she went racing on: "I'm not worn out from our day today, Miss Anna, but I always go to bed with the sun and rise at five. Between seven and nine my servant and I take the two dogs for a drive. Then I work until lunch, read the paper and take a nap. After two, I'm all yours. So your mornings are free. I take breakfast in my room. You, too? Or would you rather come down and stroll in the park with the dogs?"

"If you don't mind, I'd like to come down."

"As you wish. Good night, Miss Anna," she said, shaking my hand. "Céline will see to all your needs. If you can't sleep, read *Cyrano*!"

I went to my room. Instead of taking her advice, I followed Mrs. Thaw's and wrote a summary of our conversation. The preceding lines are from the beginning of my journal at By. I finished the day's entry with these words: "It must be late, there's not a sound, save an occasional bark. God grant me his help and inspiration. I simply must do a good portrait."

So ended my first day under Rosa Bonheur's roof.

First thing next morning the elderly artist said: "My dear Miss Anna, I can't stand long sittings, and I won't pose every day. Take my 'sanctuary' and make yourself at home. I'll just work in the little studio you saw yesterday, which suits me just fine. On days when there are no sittings, you can do studies outside. I'm glad to be posing for you. My portrait will be something for posterity. Now, let's take a look at my outfits."

Rosa Bonheur opened a wardrobe full of dresses. "So you see that I've got the wherewithal for dressing up in women's clothes. Here's a silk dress, another one in brown merino with braid trim and two in black velvet. One of those is my official uniform, which would look pretty good, I think, for the portrait. The jet trim shimmers, and it's fun to paint glossy black against a matte black background. But if you prefer something simpler, I'll wear this navy blue one. It wouldn't be bad to have me with my back to the light. That always makes for a nice artistic effect."

"In such light your beautiful gray hair would make a halo. That was my first impression meeting you, and it's never left me."

"Too bad," said Rosa Bonheur, smiling, "you didn't ask me to sit for you back then."

"For a long time I've wanted to. Yet I'd never have dared ask such a

favor if my friends in Deer Island hadn't pushed me so hard. I finally gave in; but I must confess that your silence really made me suffer."

"What do you mean, my silence?" Rosa Bonheur broke in. "I wrote back right away, saying that I was glad to do it. Look, here's your letter from Deer Island. I've read it over so many times I know it by heart."

Seeing my letter right after hearing those words made me burst into tears.

"You mean you never got my reply?" she asked with surprise. "I don't know what to make of it. I wrote you in care of the Millers. Tell me how you got your mail on Deer Island."

I said that every morning we had to take a little boat across the Saint Lawrence to pick it up ourselves.

"So when the cold weather comes on, everyone goes back home to the city, right? That's why you never got my letter, Miss Anna. This ought to teach you that you're always better off on the mainland. Believe me, beware of islands! Don't cry any more about that lost letter. Yet I must say that I, too, was bewildered by your silence. But that's no matter, now that you're here. A good portrait is our sole concern. How about trying out a few poses? Do you have a camera? If not, take mine. While you're getting it ready, I'll go put on my blue dress."

As on the day before, the sitting was interrupted by a visit, this time from Countess Greffühle. Rosa Bonheur was a charming hostess, and it was fun to see her play the society lady, a role she pulled off very well. She looked most impressive in her Louis XV outfit.

The next day, right after lunch, she said: "I'm not taking off my smock today. Finish up the little sketch you started the day before yesterday. It's coming along nicely. Get to work, and I'll resume the pose" (fig. 3).

An hour later, she got up for a look: "The smock isn't that bad," she said, as if regretting having chosen a portrait in women's clothes. "The head's a pretty color, and the mouth is good. Just let them be. You can finish the hands another time. Guests are coming tomorrow for Sunday dinner. Let's see what they've got to say about it. You can't start the final portrait without trying out lots of poses."

"But, mademoiselle," I replied, "if I keep on like this, I'm afraid I'll cause you considerable inconvenience. I've just had a letter from M. Tony Robert-Fleury, and he assures me that it would be easy to rent a studio in Moret."

"No, no, I've got you here now, and that's right where you're going to stay."

On Sunday, June 19, after gathering some wild roses in the park, I

found Rosa Bonheur furiously dusting her studio: "Just so my cousin, Mme Lagrolet, won't find things too filthy. Every year she pays me a visit along with her husband, daughter, and sister. Give me the roses, I'll put them in the pretty Tiffany vase you gave me. There we are! All tidy. Now I'm going to watch for my guests."

She leaned out of one of the little windows overlooking the street and hooted: "They're here! Let's go down."

Of course, the only things they talked about were the American's arrival and her sketch. I was very glad that her friends and relatives unanimously agreed that she should wear women's clothes in the final portrait.

All day long Rosa Bonheur was in high spirits, such exuberance as I had never seen in her. At lunch and dinner, her witty remarks and funny stories came one right after the other. I had to stay up until two in the morning to get everything down in my journal.

Before doing any more studies for Rosa Bonheur's portrait, I wanted to consult my former teachers, M. Tony Robert-Fleury and M. Jules Lefebvre.[3] So one day I took my sketches and photographs up to Paris.

The sketch that Rosa Bonheur preferred also won M. Robert-Fleury's approval.

"The pose isn't bad," he told me, "and you've got a nice soft light around the head. There's always got to be a contrast between light and dark; the eyes are the main point. Modulate the background so that it's darker at the top and lighter at the bottom.

"The right hand looks good, make the shadows near the arm stand out. Stick with this pose. It's poetic. You should get right to work. But how are you going to do that? Did you find a studio in Moret?"

"No, I haven't had time," I replied. "Mlle Rosa Bonheur wants me to stay on. On days when she can't give me a sitting, she says I can work outside in the park."

"You may be making a mistake," he said, "to let her entice you to remain there. Moret would be such a pretty little town for your studies. Besides, you'd be so much freer. Try and change her mind. That may be hard, because she's so bossy and seductive all at the same time."

Once that subject had been broached, we had to keep on going.

"I remember," he went on, "a certain awards ceremony at Rosa Bonheur's art school. My father, who really admired her, introduced us before beginning the proceedings. This was back in 1856, when I was very young and just starting my career. I was simply fascinated by that little

3. Both had taught Klumpke at the Julian Academy.

woman with her pleated skirt, bizarre jacket, short brown hair, and spar-
kling eyes.

"The ceremony made such an impression on me that I can still remem-
ber the gist of what she said; she begged her students not to waste the
seeds of their God-given talent by trying to get fruit too fast. She also told
them to stay away from painting until they could really handle a pencil
and never to stop working on their drawing.

"Rosa Bonheur's always been faithful to the rule she gave her girls. Her
drawing is brilliant, the hallmark of her work. We haven't heard anything
about her for a long time. Her canvases go straight off to England and
America. Except for *Ploughing in the Nivernais* and *Haymaking,* her
work is scarcely known in France. True, these two paintings alone are
enough to make an artist famous."

As I was leaving, M. Robert-Fleury gave me his hand and said: "Take
heart! mademoiselle, you've got a good sketch, and I wish you well."

"So what did M. Robert-Fleury have to say?" asked M. Jules Lefebvre
when I told him the reason for my visit.

I repeated what his colleague had told me.

"Well, I think he's right. You've got a fine start. The head is simply
superb! How did you get into this? Did Rosa Bonheur just ask you to do
her portrait?"

"No, monsieur, I wrote her from Boston and requested the honor. I am
still moved when I think with what grace and simplicity she granted me
the favor—"

"That will make you the envy of many artists," interrupted M. Jules
Lefebvre. "You're lucky. Since Mlle Rosa is keeping you so close by, watch
your model carefully, imbue yourself with her traits, don't rush the final
canvas, do lots of preliminary studies. Take heart, I wish you much
success."

I went back to By, delighted to have my fine teachers' advice and ap-
proval. But for the first time I understood what a huge responsibility I'd
assumed, and I wondered if I hadn't been presumptuous.

Rosa Bonheur made me tell her everything they'd said.

"So M. Jules Lefebvre was surprised to hear that you're painting my
portrait?"

"That's right, mademoiselle, and I even thought I heard him sigh with
regret that it wasn't he."

"The great portrait painters have never asked me to pose for them,"
replied Rosa Bonheur, sounding like M. Jules Lefebvre.

"They probably didn't dare," I shot back. "But on the other hand, have I been overbold?"

"It may be that they didn't dare, but I wonder if I would have put up with the bother of sitting for a man. I'm doing it for you because you're American, and I love your country. After all, don't you Americans earn me my living?"

"Still I don't want to put you to any trouble. M. Robert-Fleury and even the Tedescos have urged me to take a studio in Moret. I'd come over only when you had time for me."

"Absolutely not, Miss Anna, you're in my house now, and that's where you're going to stay. Let's drop the subject. Ah! The Tedescos take good care of me; but they don't have to fear that I'll wear myself out. I want you to paint a good portrait. Don't worry, you've got what it takes. Trust your feelings, and let them be your guide. You're getting me to pose because I like you."

I spent the following days squaring out[4] the sketch approved by M. Tony Robert-Fleury, which I then transferred to the canvas, and began the underpainting.

"My word, you're moving fast!" exclaimed Rosa Bonheur when she saw how things were going. "So you're not taking M. Lefebvre's advice? No more preliminary studies?"

"No, mademoiselle. M. Tony Robert-Fleury told me to stick with this pose and get down to work."

"You're wrong. I think that you're in too much of a hurry."

Calling Céline, she continued: "It's already looking good, don't you think? There's nothing common about it. Very distinguished. I'm glad to know that, after I've returned to the astral realm, there'll be one good portrait of me here below. Here, I'll pose for half an hour. Work on the head, and watch your drawing."

This is how my first two weeks at By went, according to my illustrious model's program. My previous knowledge of her seemed very superficial now. Every day that I spent living in her house and sharing her life drew me deeper and deeper into that rich, diverse mind, a felicitous combination of rare intensity and great depth.

I particularly enjoyed our freewheeling conversations during the long sittings. We talked about everything under the sun. To my delight and

4. A technique that aims to keep the exact proportions when, for example, a sketch is enlarged and transferred from a sketchbook to a canvas.

surprise I heard her say things that I had already read in the works of English, American, or German poets. We naturally talked about art, our main concern, but we also chatted about the many things she'd seen and done, her friends and travels. She volunteered some spicy stories, recounted in the most amusing way, and also broached the most solemn of topics, morality and religion.

"I know you're a Protestant," she said, "but the differences between your religion and mine don't mean much to an enlightened mind. On the other hand, I object to some Catholic practices. I've never been able to tolerate the idea that sins can be forgiven by getting a priest's absolution, buying indulgences, or burning candles. I believe in divine justice, if not in this world, then the next. Do you know that once somebody tried to get me into a convent? I think that you can do humanity some good without spending all your time lying flat in front of an altar. Being moved by nature is true religious feeling."

However interesting her remarks, I was occasionally distracted by her facial expressions. They were such a fine, spiritual reflection of her feelings that it was a true pleasure to take M. Lefebvre's advice.

Subsequent Sittings

These pages are excerpts from the diary where I wrote down the day's events every evening before bed. At the very least, they provide an exact account of life at the chateau. Having done my best to render my famous model's words and deeds, I'd love to think that while my brush was retracing the lines of her face, my pen was drawing a good portrait of her character, especially her spirited, offhand conversation.

Thursday, June 30, 1898
This afternoon M. Ernest Lefèvre, a London publisher, brought Rosa Bonheur a huge pile of engravings. It took her the rest of the day to sign them all. While mademoiselle was busy, I painted a little sketch of her that the visitor begged to keep as a souvenir.

M. Lefèvre is a lively, cheerful man. He seemed quite pleased with my portrait and even said he'd buy it when I named my price. Surprised and flattered, I didn't really know what to say. At bottom I was terribly embarrassed by any talk of money in front of Rosa Bonheur. A moment later she drew me aside and urged me to accept his offer, but only if he agreed to have the portrait engraved. I can't decide anything until the painting is finished.

Once M. Lefèvre had gone, I asked whether she wasn't too tired out from what must have been, after all, a good day for her.

"What do you mean, a good day?" she asked in amazement. Then she laughed. "Ah! now I get it. But you're wrong, I haven't earned a single cent today. The English and the Americans simply won't buy my engravings unless they're signed. I know that Meissonier and others often take twenty francs per piece; but I'd rather let the publisher keep the profits."

Friday, July 1
After the sitting this afternoon, Rosa Bonheur stretched out on her lounge chair for a smoke while I kept on working (fig. 4). She scolded me for rushing: "Ah! that Miss Anna! she doesn't ever stop. True, I used to be like that. Now I tend to dawdle, doing less but thinking more. Also, I did more studies. I didn't just start a huge canvas without having gathered all the documents I needed."

She watched me wipe my palette and went on: "I don't work like that. I never wipe it off till I've scraped with a knife and poured on some turpentine. That way the wood stays clean. This palette, for example, looks practically new, yet God knows how long I've been using it for skies. Take it for your touchups. I'll even sign it for you."

She grabbed a brush and wrote:

A souvenir for Anna Klumpke. May my palette
bring you good luck.

Rosa Bonheur

By, July 1, 1898
After dinner, mademoiselle had me admire her beautiful trees and took me into the paddock where she used to keep her ewes and the stag that was her model for *The King of the Forest*. Then she said in a brusque tone: "I see you're not taking Jules Lefebvre's advice nor mine either. You prefer M. Tony's. Slow down, and don't take him too literally."

As I made no reply, she unhooked a heavy chain from a grate and shot me a mischievously threatening look: "This is still good for tying up a naughty beast."

"Like an Anna Klumpke?"

"That's right," she laughed, "an Anna Klumpke. I'd love to tie her up so that she'd have to start my portrait over and over again."

"You're too kind, but then how would I ever get it done?"

She, in turn, made no reply.

Sunday, July 3
This morning, Rosa Bonheur asked me to go to the forest. When it was time to get into the carriage, she shook her little Yorkies' bell collars. They came dashing up and popped into their baskets. The sun hadn't yet burned off the morning cool, and the woods were magnificent. Overjoyed by this early outing, Rosa Bonheur couldn't stop talking about the splendid forest and its natural poetry.

We stopped at the Fairy Pond. Daisy and Charley were let out to play and dive into the heather. Rosa Bonheur said: "I often come here to draw and paint. Several times I've run into my friend Allongé, whose fine work you know. A few days ago I heard he's quite ill."

Our path led down into a valley where Rosa Bonheur had done her studies for *The Wild Boars*.

"Some other time I'll show you the white birches that were the background for *The King of the Forest*."

Back home, she said it was too hot to pose, but let me shoot some pictures of her. Afterward she turned the camera on me.

Monday, July 4
"Today is young America's birthday," Rosa Bonheur announced this morning. "To celebrate, I'll give you a long sitting. Use it well!"

I'd got a good start on the head, and I prayed God to let me capture the penetrating gaze and the benevolent, poetic air that emanated from her whole person.

In the midst of posing, she blurted out: "You've got such goodness in your face that I can't help thinking of my mother. Your face is long and oval, mine is square. You say I'm cheerful? You're young at heart. Never would I have believed that we'd get along so perfectly. Your portrait has got fine tone and texture; it'll be good."

The arrival of M. Abraham Tedesco, the youngest of the three brothers who are mademoiselle's main art dealers, interrupted our sitting. I got up to leave, but Rosa Bonheur gave me a canvas and told me to paint a little sketch of M. Tedesco, whom she called Benjamin. On his way down to By he certainly hadn't expected to pose for me, but he was sweet and obliged like a gentleman. After an hour Rosa Bonheur peeked over my shoulder and said: "That's fine. Fix the hair a bit, and put down your brush. There's no need for any finishing touches. This will do as a souvenir for Mme Tedesco."

Tuesday, July 5
I worked on the head today. After the sitting Rosa Bonheur looked at the canvas and said: "Let the paint dry. When I've got an important piece at this stage, sometimes I just let it sit a whole year long."

"In that case, dear great artist, I've got time for a trip back to Boston."

"Ah! that's not what I meant," she said. "While the head is drying, you can paint the hands, the dress, and any background details you want."

Wednesday, July 6
When she got back from her drive, Rosa Bonheur was holding a letter bordered in black. Her voice was sad: "I've just lost my old friend Allongé, the one I mentioned a few days ago. He died last night in Marlotte. It would be so nice of you to go to his funeral for me tomorrow. Oh! what a fine man! and just sixty-five. That's not old! I really liked and respected him."

She gave me a poignant description of their good, forthright friendship and their days working together under the big oaks near the Fairy Pond.

After dinner we took a stroll in the garden. The air was sweet, but Rosa Bonheur seemed terribly sad. To cheer her up, I told her a few wild tales about art school. Naturally this led me to talk about M. Julian, how he wanted to see his female students vie with the men for first prize in various competitions, how he insisted that we learn to listen to our professors' critiques without bursting into tears, how we ought to try and follow in the footsteps of our glorious predecessors, women like Mme Lebrun, Angelica Kauffmann, Rosa Bonheur, these heroines of art and the pride of all women. As I talked, the elderly artist had a hard time hiding her pleasure: "M. Julian," she finally said, "knows that, with some pluck and determination, women can certainly compete with men."

Thursday, July 7

Yesterday at dinner we had a rare find, an almond with two whole nuts inside.

"A *philippine*,"[1] said Rosa Bonheur. "If you win, you get a long sitting. But what about me if I win?"

"I'm afraid I won't be able to come up with two polar bears, like that Russian great-duke a while back."

"They, unfortunately, were nothing but whopping lies some journalists dreamed up."

"What a pity. Well then, if you win, I'll try and get you a buffalo calf off the western plains."

"Great, but this time you won't forget those damned weeds."

"I truly don't understand why you never got them. The people in Yeno must have thought I was crazy and tossed that pack of nettles out the window."

"Unless," Rosa Bonheur objected, "they were stopped at customs. That's what happened with the oxen I tried to ship back from Scotland.[2] Men with power can have strange notions sometimes."

I fell asleep determined to win. Already I could see the portrait done, with MM. Tony Robert-Fleury and Jules Lefebvre singing its praises. Come morning, I was still thinking about the game; but while I was getting a lump of sugar for Grisette and Panther, mademoiselle's two

1. In France, a double almond is called a *philippine*. Tradition has it that when two people find one, they share the nuts and play the following game in which the first one who, after a set period of time, says to the other, "Bonjour, Philippine" wins.

2. A.K. For more details, see chapter 15.

favorite horses, it totally slipped my mind. At that very moment I ran into Rosa Bonheur who sang: "Bonjour, Philippine! bonjour, Philippine! Now *I* get my buffalo from the Wild West and *you* don't get a long sitting."

A bit disconcerted, I replied: "I realize, mademoiselle, that posing is a bore, but I'm doing the fewest possible studies in order to move faster."

"That's certainly clear. But there's something else we've got to discuss. Poor M. Allongé's funeral is today. Tell his widow that I'll come visit in a few days, and make her ride with you so that the poor thing doesn't get all worn out following her beloved husband's cortege."

When I got back, Rosa Bonheur praised his talent, comparing him to Lalande and Jules Dupré.

"I still remember the charming things he started drawing in 1857," she said. "Allongé's success came very late; he didn't have my luck."

This comparison, expressed in tones of fond admiration for the man whom I had just helped bury, prompted me to ask to see her many awards. As gracious as could be, she pulled a little coffer out of a drawer and showed me the Cross of the Legion of Honor topped with the imperial crown.

"This one means the most to me. Some day I'll tell you how a noble hand pinned it to my breast.

"These here are the Order of Emperor Maximilian and the Rosette of the Legion of Honor. Since they were bestowed by martyrs to the country, they mean a lot to me, too.

"This one, with its white and green ribbon, is a token of friendship from a great princess, Duchess Alexandrine de Saxe-Cobourg-Gotha."

Then she showed me a cross on a white and orange ribbon and said: "This is the Order of Isabella the Catholic. I like wearing it because I've always admired that great queen who sold the crown jewels to help discover a new continent. And strangely enough, England and America, who are always fighting over my paintings, haven't given me a single award."

Stung by that remark, I made up my mind to find some kind of rejoinder as soon as possible.

After dinner I gathered a few branches of laurel. While we were making our way toward a bench under a huge linden tree, I said: "It's not for me to defend England. But if America hasn't granted you a title, it's because she grants them to no one at all, as you well know. Washington refused to set up any such system. Now, I'm a red-blooded American, but I'll make so bold as to honor you with this crown of laurel made by my own hand."

"Kitchen laurel, right?" she scoffed.

"No. True laurel, the stuff of Apollo's crown, and each leaf comes with a good wish and a fond thought."

We sat down and Rosa Bonheur watched me weave her crown.

"Ah! Miss Anna, you're giving me back my youth," said she with a slight quaver. "I went quite wild after poor Nathalie died. I feel less estranged with you here. Let's go in. You can finish your crown tomorrow."

Friday, July 8

At two o'clock, Rosa Bonheur gave me a sitting. I worked on her hand. All of a sudden she bantered: "My famous crown has slipped your mind, hasn't it?"

"Not so, mademoiselle. Here it is. But first let me inscribe the ribbon with these dates: 1822–1922."

"You think I'll live to be a hundred, like Titian? That's a bit long!"

"How so?" Then I bowed and said: "I beg you, dear great artist, to allow a child of America to render you this glorious homage. Let the crown grace your brow, as once it did Virgil's and Dante's."

Two tears fell from her eyes.

"Ah! my dear Anna, how I love you!"

She drew me to her breast for a kiss. Then she removed the crown and hitched it up on the rack of a huge sculptured stag from which dangled a long necklace of the kind worn by women in the Pyrenees.

"Those beads belonged to my dear friend Nathalie Micas. I'm putting your souvenir right next to hers," she said, pressing an electric buzzer.

Céline came running.

"You see that crown? Make sure I'm buried with it."

Céline promised without really understanding. Rosa Bonheur turned back to me and added: "The same goes for you!"

I was stupefied by the turn of events my pursuit of patriotic vindication had brought about.

There were still a few sprigs of laurel on the table. Rosa Bonheur handed me the nicest ones.

"Keep them in remembrance of this day. This crown is my reward for a life of struggle, triumph, and glory."

Saturday, July 9

This morning Rosa Bonheur asked me to go for a drive in the forest. We were drawing deep breaths of the cool forest air beyond the Grand Mas-

ter's Cross[3] before the sun even began to burn off the light mist. Stretching their huge orange trunks up toward the heavens, the pines imbued the purple haze with the slightly acrid scent of resin. I was reminded of one of Henri Martin's sacred woods with his floating, diaphanous muses. I said as much to mademoiselle.

"I'm not very fond of these pines," she replied. "They always look like long pencils stuck in the ground, a bunch of masts, or even the spears of an army of Titans locked up below. Let's compare this spot with one of my favorites."

The little gig sped over several paths.

"We'll stop here," said Rosa Bonheur, tying the horse to a tree. "I trust Panther, and my knot even more. Now I'm sure she won't leave us in the lurch and go home alone.

"Animals are much smarter than most people think. The first few times I took Panther out, she trotted through the whole forest at the same rate. About two weeks later I noticed that she'd pull up without a word at the spots where I used to stop with her comrade Grisette. I'm sure the two friends traded secrets in the stable and that Grisette told Panther where she could take her sweet time. Ever since Princess Beatrice[4] took our picture, Panther's been proud and headstrong. The second her nose turns homeward, she wants to head straight back to the stable."

We were taking a delightful little path down into a vale: "These are the trees I'm crazy about," she gushed. "Don't you find these oaks and beeches, birches and junipers much more handsome than that tall, skinny picket back at the Grand Master's Cross?"

After yet more effusions about the trees, she said: "You make me feel young again. Now I want to go paint like mad. No, I simply can't pose for you today. I'd rather spend the afternoon on the white horse I promised Miss Walker so long ago."

After dinner Rosa Bonheur made me tell her how I started studying art and painting copies at the Luxembourg:[5] "So my *Ploughing in the Niver-*

3. This cross, and others referred to later on, mark intersections in the Fontainebleau forest.

4. A.K. Princess Beatrice of Great Britain, wife of Prince Henry of Battenberg.

5. For more details on Anna Klumpke, see her *Memoirs of an Artist*. The first three chapters concentrate on her family life with her mother and sisters and her entry into the art world.

nais really grabbed you? How come this painting made you decide to become an artist?"

I told her about my boundless admiration for that famous painting the first time I saw it. With my childish, all-American presumption I asked right away for permission to paint a copy. Then I camped in front of it, with my palette, paints, and a huge canvas. Needless to say, I was there a long time. As soon as I began to understand her gift for interpreting nature with such wonderful energy, I realized what a difficult task I'd set for myself. When the copy was finally done, I had the good luck to sell it to a fellow American for 1,000 francs, out of which 750 went for my first year's tuition at the Julian Academy. This small success having whetted my ambition, I began dreaming of my own paintings. Five years later I won an honorable mention at the Salon. "But I can't tell you, mademoiselle, how often I went back to the Luxembourg to study the masterpiece that did so much for my career. I really hoped that one day I might be so lucky as to kiss the hand of its creator. That's why October 2, 1889, an unforgettable date, stands out in my life. And now, here I am working in your house and your aura! You trust me enough to let me paint your portrait! How deliciously real! And what joy will be mine when I finish this great task! Is the portrait coming along fast enough? Are you satisfied with what I've done so far?"

Rosa Bonheur only replied: "How nice of you to tell me all these things. You started out a bit like me, only I no longer had a mother to rejoice with me in good times."

We sat down, and she began to tell me stories about her youth.

Sunday, July 10

A stormy morning. After her drive, Rosa Bonheur came into the studio where I was preparing for the sitting she'd promised me that afternoon.

"Well," she said, "I'm not posing today. It's Sunday. But we won't waste our time. I'm taking you out in the forest. But what shall we do until three?"

"Would you let me take a picture of you with your crown of laurel?"

She agreed and merrily exclaimed: "We'll call it *Old Europe Crowned by Young America*." I took several shots (fig. 5). Then Rosa Bonheur hung the crown back up in the rack of antlers and said: "This won't budge from here until it comes down to go into my coffin. You'll see to that, right? What are those tears for, Anna? I'm not sad. On the contrary, I'm glad to feel alive again. Let's have a smoke, then you can develop your pictures before we go."

Monday, July 11

This morning Rosa Bonheur announced: "You'll get a good sitting today. Only I want you to draw me in the same pose as for the portrait. Later you can trace the drawing and do a really finished study of the head. Once you've got these documents, you can use them for the portrait. It's already come such a long way."

Stunned by these demands and bothered by the idea of such laborious preliminaries, I asked if she were unhappy with the portrait.

"Of course not, but for your own good I want you to stick to my methods. You can't attack the final painting straight off. One sketch isn't enough. You need some serious studies. Don't be afraid of wasting time. These documents will last forever, and you'll use them time and time again."

"Dear mademoiselle," I replied, "I know posing bores you. I take up all your precious time. Shall we call off the sittings for a while?"

"Not unless you think staying with me is a bore. But I want you to listen to me, not M. Tony." Then, in a slightly irritated tone: "In any case, my 'sanctuary' needs cleaning. I'm ringing for Céline, and you're going to help."

I began dusting chairs while she busied herself with other things. Then she said: "You're flabbergasted, Anna, that 'the great Rosa Bonheur'"— she gave these words a pompous inflection—"cleans up by herself, even though she's got five servants."

"True, I'm somewhat surprised."

"It's an old childhood habit. Does seeing the painter of *Ploughing in the Nivernais* doing servant's work make you lose respect for her?"

"Oh! mademoiselle, how could you ever dream that an American would think such a thing? Isn't respect for work the very principle of our nation?"

"As a Frenchwoman, I agree. That's what makes me love the children of the New World; they don't admire loafers."

When everything was tidy, she said: "I'm hungry. Let's have some lunch. We've really earned it. But I'm not posing this afternoon; M. Tedesco is coming."

I told our visitor about my invitation to the Pittsburgh Exhibition, where I plan to send my portrait. Our conversation seemed to interest Rosa Bonheur. She'd like to be in the show, too, if she can get her *Oxen and Bulls of Auvergne* done in time.

Tuesday, July 12

This morning mademoiselle sent Céline and me to market at Moret. It

was nearly noon when we got back to By and brought the shopping baskets into the studio. Rosa Bonheur was busy writing, but she immediately paused for a general inspection of Céline's purchases. I was a bit surprised to see that she was such a good house manager.

Charley and Daisy, meanwhile, had moved in on a basket with two live ducks inside. The birds panicked and got loose. Screaming pandemonium ensued. Céline finally caught one of them. I was left holding it by the wings while Rosa Bonheur went after the other one, who was huddled against the far wall of the studio, near *Treading Wheat*.

"Come, come, my little beast," she coaxed and cajoled. "Don't be afraid, we're not going to eat you up just yet; you get to run around the farmyard a while longer. How silly of Miss Anna bring you in here. It's clear she's never handled a live duck before. What a pretty color!" she added, smoothing down its feathers, "doesn't that just make you want to get out your paints?"

"Indeed, but what about your portrait?"

"What will you do if I give you a sitting?"

It was obvious what was in her mind, and I said a bit reluctantly: "I'll take your advice and draw a study of your head as it'll be in the portrait. Now, will you pose for me?"

"Sure, around three."

We didn't talk much during the sitting. I worked hard on my drawing because Rosa Bonheur had several times criticized my neglect of details. In order to get a better look at my model, who was sitting against the light, I improvised a visor with a sheet of paper and some hairpins to shield my eyes from the glare. Rosa Bonheur watched me with a mischievous gleam in her eye. Apparently my nose overshot the paper, which amused her no end.

"How funny you look, Anna, I'm tempted to draw a caricature. Hand me your notebook, and we'll both get something done."

Still chortling, she began to draw. Though her pleasure came at my expense, I only wanted to congratulate myself. Didn't this give her face the bright, spirited, and mordant look I was so eager to capture? From time to time I even closed my eyes to engrave that gleeful flash in my mind's eye. Just when I was totally engrossed in my task, Rosa Bonheur got up and said: "That's it for today. I'm all done. Here's your portrait. Not bad, don't you think?"

She handed me the caricature. We both burst out laughing. Then she posted herself in front of my drawing and studied it for a long time. She

had stopped laughing. My heart pounded. What was she going to say? Finally she turned around and smiled: "It's got a charming, truly artistic feel. It's full of life, honestly. You must show your teachers. They'll be very pleased."

That evening, I was still aglow from her praise and found it easier to take her teasing about my morning blunder.

"I can see you've never raised ducks and chickens. Besides, that's hard to do in Paris."

"Not so, mademoiselle. In the rue d'Assas we had a garden with fourteen trees. It almost felt like living in the country. We had a tame hen who was very nice about letting us pet her. When the time finally came to cook her up, my sisters and I couldn't eat a single thing."

Rosa Bonheur liked the chicken story. She listened hard, and her face looked young again. I suspected that my anecdote had reawakened some old memories. She immediately launched into a story about a turkey and a monkey she'd once had.

"That monkey was a little devil, his fingers were into everything. He used to steal sugar out of my water glass, not to eat it but to stick it in the nightlight. Then I got the disastrous idea of trying to teach him some manners. The upshot of that was he went crazy about imitating me, especially with my palette and brushes. That meant I was scared silly every time he set foot in my 'sanctuary' that he'd smear paint all over my canvases. When Nathalie and I scolded him, he'd just snub his nose at us. I couldn't control his whims, so I finally gave him to the zoo, where I liked to watch him cut capers in his cage."

After dinner, Rosa Bonheur showed me some daguerrotypes taken when she was just a girl.

"I've changed a lot, haven't I? But I've always had short hair. I've got as much now as I ever did, but now it's white. It used to be dark brown with red highlights. I'll give you these pictures if you want."

"Really?"

"What else do you want me to do with them? They'll be in good hands with you. I'd like you to have them. Good night, tomorrow I'll give you a sitting."

Wednesday, July 13

This morning Rosa Bonheur took me out into the forest. While Panther ambled down a lovely lane, mademoiselle asked about my Boston connections and then said: "You've got just as many good friends here in France.

First of all me, for I'm very fond of you. Is that nice to hear? And you, Anna, do you love me a little bit?"

"Dear mademoiselle . . ."

"I can see that you do. For my part, I've always been fond of you."

Back home, Rosa Bonheur posed so that I could finish the drawing. After examining it, she said: "Leave it be now. It's just fine, and it'll be useful for the portrait."

"Just ten more minutes for the ear, if that's all right. M. Tony will like it better."

"Ah!" she mocked, "you still prefer his advice to mine. You're right," she continued a bit irritably, "only it seems to me that when the 'great Rosa Bonheur' tells you: 'Let the drawing be, it's just fine,' that ought to suffice. Anyway, the sitting is over. Do as you please. I'm going back up to work."

I've inadvertently wounded her pride and I'm deeply sorry; but what can I do?

That afternoon, while stroking a cat that Mlle Bellan had just brought over, Rosa Bonheur couldn't help saying: "Look what a wonderfully marbled coat he's got. If you knew how to paint animals, he'd be a nicer model than I am, wouldn't he?"

"Quite true," I thought to myself, without daring to say it.

Thursday, July 14

Rosa Bonheur seemed on edge this morning and said that I shouldn't count on her today. I didn't say a word. How I regret not having taken my dear teacher's advice! With a studio in Moret, I wouldn't be so cruelly hampered. What's the need of all these preliminary studies, especially since I've almost finished the head in the portrait? No doubt Rosa Bonheur has been lovely to me; yet, as I can well understand, posing bores her. I'll call off the sittings and go home to mother. I've hardly seen her since I got back to France.

Over dinner I told Rosa Bonheur what I'd decided to do. She made no objection at the time, but during the evening she gave me a bluet from a huge bunch that the gardener had just brought her and said in a tender voice: "My bad mood has flown away. I don't want you to leave. Tomorrow I'll pose for you."

Friday, July 15

With my drawing traced and transferred to the canvas, Rosa Bonheur gave me the sitting she'd promised.

I started to paint the study of the head. Mademoiselle seemed so pleased with it that at the end of the sitting she said: "You've got to let me have it. I'd be so happy to have a piece of your work."

"Nothing could make me happier, mademoiselle. It makes me very proud that you want it. I'm even afraid that I'll get ridiculously ambitious. Just imagine this drawing next to something of yours in a museum somewhere."

I expected her to smile. Instead, she replied with almost tender solemnity: "That would be wonderful. Then we'd always be side by side. And when you come join me up above"—she lifted her eyes to the heavens—"my mother and dear Nathalie will reach out their hands to you. How sad life is! Ah! I'll be so unhappy, so alone after you've gone! I won't have my Anna any more!"

"But, mademoiselle," I said, taking her hand, "I'll come back next May. In the meanwhile, you'll have time to work on some of the beautiful things you've got in mind."

Pressing my lips to the delicate hand clasped between mine, I said: "Let me have a cast of this hand that has worked so hard creating so much beauty. It'll be my talisman. You know, I'm convinced that the hand, just like the eyes, bears the indelible print of the soul. It's a manifesto of one's character and will. I hope that I'll manage to paint you a good hand in the portrait."

"Indeed, the hand is a living symbol of our inner being, a sign of the way we conduct our lives . . . I truly hope you'll be happy and successful. I love you like a daughter, my child!"

She kissed me and said: "Tell your mother tomorrow that having you here rejuvenates my heart. But don't stay in Paris, come back in the evening. I promise I'll pose for you Sunday."

Sunday, July 17

I returned yesterday evening, a bit sorry not to spend more time with my mother and sisters. Rosa Bonheur seemed happy to see me back. She had many fond questions about my family.

Early this morning, she took me to the forest and talked a great deal about her parents. Back home, she went into a dark corner of her studio and pulled out a young woman's portrait: "My father painted this of my mother." Her voice trembled with emotion. "You remind me so much of her. I almost see your oval face and eyes on this canvas. Stand next to it, let me compare."

She studied my face for a long time, then took a drawing out of a portfolio. "Here's my mother again in Gascon costume. You've almost got the same profile. Show me the picture I took of you the other day."

There was a moment of silence. Instead of putting the canvas back with its face to the wall at the far end of the studio, Rosa Bonheur set it on an easel and said: "This portrait means so much to me. What protection my mother has given me throughout the course of my life!" Her voice took an utterly dejected tone. "I can't pose for you today. Do as you like. I'll come see you around three."

Once again, despite her promises, I had to do without a model. I worked on the accessories. When Rosa Bonheur came back, she scarcely said a word about my work. Instead, she lit a cigarette, stretched out on the lounge chair and contemplated her *Treading Wheat*.

"Aren't you going to finish your painting for the 1900 Exhibition?" I asked.

"I'd love to, but I need a housepainter for the sky."

"A housepainter? Really, mademoiselle?"

"Why not? He'd scamper up the scaffold easier than I would, and while the sky was wet, I'd finish up the details. A housepainter would do just the trick, don't you think?"

"Mademoiselle," I replied, "shall I be your housepainter? Though I'm lame and use a cane,[6] I'm spry enough to climb up scaffolding. If you ever want to hire me, just send for me from America."

"All right, my dear Anna, I'll ask you back just for that. If my Nathalie were still alive, *Treading Wheat* would be done. She, too, wanted to do what you've proposed. What devotion to my fame! What ambition for my career!"

Continuing our conversation about this canvas, I asked Rosa Bonheur if she thought details needed careful elaboration: "Ah! yes, I love doing details, but the foreground has to dominate everything else. Though the middle ground can be full of details without detracting from the whole, it's got to stay back."

"Oh! mademoiselle," I interrupted, "give me a chance to capture the expression that just crossed your face."

"Something spontaneous," she smiled, "is often much better than something contrived. There's an old French proverb that says 'Style is the

6. As a child, Anna dislocated her right knee. Despite surgery, she remained lame for life. See her *Memoirs of an Artist,* p. 12.

man,' meaning that we translate what we are into what we write and paint."

"Let's see what you've done," she said, finally getting up. "We're through, right? It's too hot to pose any more."

She stood in front of my canvas.

"That's very good, Anna, that's what I really call drawing. And if God listens to my prayers, I, Rosa Bonheur, predict that you'll become a very great artist."

"How kind of you. That makes me really happy," I said, deeply touched.

She came up close: "If you only knew how young you make me feel, Anna. What happiness that you love me for myself, and not just for my art."

"Dear mademoiselle, there aren't words to say my admiration for you and everything you've done. It's like a religion for me, and I'll always be faithful."

"You move me almost to tears. Who knows, perhaps when Nathalie saw all the sadness in my heart, she said to herself: 'I must send my dear Rosa a true friend.' I'm very fond of you, Anna, and this old friend of yours will be mother and sister to you. And you'll become a great artist like me. Let's go down to the garden."

When we were at the door, there was a shrill cry: "Rosa! Rosa!"

"That's Coco begging for his daily lump of sugar." A superb red and blue parrot, Coco called out to Rosa Bonheur when she caught his eye. "I don't really dare get too close to his huge beak," she continued. "I haven't had much luck taming him. He's got a grudge against me since I punished him for snapping at my finger. Yet this little savage has lots of social graces. He can recite these commands perfectly: 'Bear arms! one, two, three!' and imitate a drum remarkably well. When it's going to rain, he never stops chattering and keeps on till it's over. He's as good a prophet as Matthew Landsberg."

There was a huge cage right next to the parrot. Rosa Bonheur opened the door a crack and stroked a white turtledove. She had nothing to fear from that beak.

"This old friend who is almost thirty knows me well. If only she could talk, what stories she'd tell! She's been friends with my dogs, my eagle, and every one of my cats."

Monday, July 18
The temperature hit ninety today!

"Once again I can't pose today," Rosa Bonheur informed me. "Paint me a little sketch of yourself. That would be really nice. I'll be upstairs touching up a drawing for M. Tedesco."

These perpetual delays vex me more than I can say. I couldn't hide a little pout when Rosa Bonheur sat down to write a letter after lunch. She noticed that I was put out, but her apology still brings tears to my eyes.

"I can't pose because I'm writing to your mother," she said, finishing her letter. "Sit down here beside me."

And the fine woman read me her letter:

By, July 18, 1898

Dear Mme Klumpke,

I take great pleasure in telling you how deeply attached I've grown, heart and soul, to your daughter, Mlle Anna. She is an angel of kindness. Despite my age, for I am older than you, I still have a loving heart, as did my adored mother whom I lost at age eleven.

I also lost a friend who was my guardian angel. After she died, I was torn between wishing to leave this earth and wanting to leave behind a few more testimonials to the talent God gave me. Now the noble souls whom I still love, even though they're no longer of this world, have sent me a new friend as well as your affection, I hope and trust. I'm proud and happy that this is drawing me closer to a family that I hold in such high regard and to a mother like you, who has instilled in her children such a strong sense of virtue and hard work. For this you have all my respect. You may also trust, dear madame, in the virtue and sanctity of my deep affection for your daughter.

Let me embrace you like one of Anna's sisters.

Your old daughter,

Rosa Bonheur

Tuesday, July 19

Despite the poignant sentiments she expressed in that letter to my mother, my desires are far from gratified: I cannot get on with my work because my model is so uncooperative. And now mademoiselle is going against my wishes and almost testing me. This morning she told me to finish up the little self-portrait she asked for yesterday. My self-portrait! Is that why I came all the way from Boston? Although I didn't much like it, I got down to work.

While I was studying my features in a mirror at my easel, her mother's portrait drew my eye. I tried to see why Rosa Bonheur thought we looked

alike. What if I took advantage of that likeness and redid the portrait, but with the light coming from behind? I fixed my hair accordingly and struck the same pose. Only the light was different.

Rosa Bonheur came into the studio around eleven. At first rather surprised by my transformation, she soon caught on.

"Ah! how sweet! You mean so well!" she exclaimed over my little study.

She began telling me about the beloved woman in the portrait.

"My mother was very pretty. Her brown hair glistened like copper in the sun. My father only knew how to make her sad. I really like your little sketch."

After lunch I finished it up, while waiting in vain for Rosa Bonheur to come pose. She had taken her portrait and turned its face to the wall.

"You've got to forget your work," she had told me, "then come back to it with a fresh eye. You won't start work again until I say so."

After that, how could I ask her to pose?

Around two o'clock, she asked me to go up to the third-floor studio to inspect her morning's work.

"Here's a charcoal that my friends the Tedescos picked up cheap in a sale, despite the fact I'd signed it. They brought it back for me to fix up. That's what I'm trying to do, not because it's fun or interesting, but just to keep up my reputation. I just hate patching up things I've botched. It's bad, isn't it? Speak your mind, I insist."

"I think," I stammered, "that your heather is a bit too red . . . But who am I to dare criticize you?"

Without giving me a direct answer, she said: "After I was named an officer in the Legion of Honor, I had to take up arms again. Talent, like rank, carries obligations. Pastels were coming back in, and I wanted to move in that same direction. I was reminded of some old masters from the Louvre that I'd admired in my youth. Convinced that the world of art is one despite its variety, I threw myself headlong into that speciality, even though I'd never had a single lesson. So I did four huge pastels that were shown last year at the Georges Petit Gallery. Much to my surprise, I can now say, like Corneille's hero: "My first stroke was a masterstroke."[7] Here are some photographs of *The Sheepfold, Buffaloes in Snow,* and *A Stag in Fog.* Do you like them?"

I didn't hide my admiration.

"So you see, your old friend doesn't lack poetry!"

7. Rodrigue in *Le Cid.*

Perceiving a hint of reproach in those words, I felt somewhat abashed. "Did I offend you just now? I should never have criticized you."

"On the contrary, you've just proven that you're a real friend. These three pictures are yours, once I write a dedication on them. Back to work now."

At six o'clock, Rosa Bonheur blew into the studio like a hurricane: "I'm so mad. What a total waste of a day! I've ruined that dreadful charcoal, and I want to blow my brains out."

"Not until after I've finished the portrait," I laughed.

"I'm dripping, I feel like drowning myself."

"Like Ophelia? I think the most dignified death for a great artist like Rosa Bonheur would be like Titian's, brush in hand."

"That's true," she said, proudly raising her head, "but come see why I'm so put out. I've ruined that horrid old thing, haven't I?"

Rosa Bonheur had quite simply turned that "horrid old thing" into a lovely pastel.

"Wouldn't you agree," I chuckled, "that great artists always do good work when they're dissatisfied with themselves?"

She shot me a smile and said: "You've got a good eye. I'm getting my energy back. Ah! I'd love to do so many more beautiful things."

"And why not?" I retorted.

She made no reply.

Wednesday, July 20

This morning, despite a downpour, Rosa Bonheur went out with Panther, her servant, and the two dogs. She returned at nine, drenched.

"Oh! it's nothing," she said, "I took a walk in the rain. This gray atmosphere is just captivating. Come upstairs, we'll light a fire and dry me off."

While the flames were crackling in the hearth, she picked up the piece she'd worked on yesterday.

"M. Tedesco's pastel is done. I'm not touching it ever again. Now I'll see to my red oxen."

"Do you like this?" she asked about the study of a horse close at hand. "Do me a copy. I want to see how well you manage. Then we'll trade. There'll be a dedication on mine so that you'll have something to remember me by."

"It's too much, really too much!"

"Are you trying to hurt my feelings? When you're back in Boston, my

dear Anna, you'll think of me from time to time, won't you? I hope you won't completely forget me."

"How could I ever forget you, mademoiselle? Whenever I'm working, I'll think about you and do my utmost to prove that I'm worthy of your interest."

Thursday, July 21

At long last I managed to get a short sitting after a drive in the forest.

M. Tedesco came by. Since the head in the portrait is almost finished, he was amazed to see me still doing studies. Ah! if he only knew how I recoil at the task.

He had us sign our biographical notices for the show in Pittsburgh. I'm worried about not finishing the portrait in time. The deadline for sending things off is just a few weeks away. The hands are barely roughed out, then the paint still has to dry.

After M. Tedesco left, Rosa Bonheur said: "I don't try very hard to be nice to men. You don't, either; but it's easy for you to be pleasant."

Moving on to the painted study of the head, she continued: "You'll give it to me, right? I like it better than the drawing, it's more personal. It may lack a bit of texture, but it's coming along very nicely. As for the portrait, you'll do just fine. Tomorrow, however, I plan to work on my red oxen."

Rosa Bonheur has been truly inspired of late. She's not making it easy for me to finish the portrait, probably because she doesn't want to lose any precious time for her own work. That's precisely why I've made up my mind to go away, saying I've got to show her portrait to M. Tony on Saturday, his day for consultations. That's the day after tomorrow. Rosa Bonheur agreed and promised to pose once more before I leave.

Friday, July 22

While we were driving in the forest, Rosa Bonheur asked: "Do you really have to go see M. Tony? Isn't my advice good enough for you?"

I made no reply. She added: "I thought you really admired me; but now I see you just pity your old friend."

"Pity!" I exclaimed. "I've always fervently admired you and your talent, mademoiselle. Envy, not pity, would be a better word for what I ought feel for you. Yet ever since I've been here painting your portrait, your tender kindness has made me tend to overlook the painter of genius and to love just the woman. You're to blame if I sometimes overstep the distance that stands between Anna Klumpke and the great artist to whom I ought to show more respect."

"Knock off the 'great artist' routine right now," she said irritably, "and love me for myself."

"That's what I'm doing, but you won't believe it."

"So many people have fawned all over me because of my art that it's hard to believe that I might be loved a little bit just for myself, but maybe you . . . maybe you're being sincere!"

"I am, believe me. Nothing can ever erase the memory of the happy days that I've had the privilege of spending with you, nothing, no matter how wide the ocean that may divide us."

A moment later, Rosa Bonheur stopped the carriage.

"Dear Anna," she said, "I'd love to make you love landscapes. The study of nature is so moving. When we're out driving around, I'm so glad to see that you can appreciate morning's subtle mystery. So few artists have been able to capture that effect! Why don't you create a new genre for yourself?"

Seeing that I made no reply, she promised to pose that afternoon.

After lunch she handed me a cigarette and told me to smoke it without making too many faces. Then she said: "Try and do it like me, then get your palette ready."

I ran to fetch the portrait and set it up in front of my illustrious model. I really wanted to finish the right arm. Even though her smock didn't make things any easier, I shrank from asking her to change clothes and worked on in silence. Meanwhile Rosa Bonheur poked fun at me for admiring M. Tony Robert-Fleury.

"Something wrong?" she asked without warning. There was no mistaking her ironical tone.

"Everything's fine, mademoiselle. Yet I'd be grateful if you could just slip on your jacket. Then I'd get the effect I'm trying for."

"Ah! Miss Anna, you amaze me! I've got to put on my jacket so that you can do my mouth, eyes, and hair. Does that mean my buttons inspire you?"

I didn't deserve that unkind remark, and it hurt. A few tears that I couldn't hold back dropped to my palette.

"Ah! you're crying, Miss Anna. Come cry on my shoulder, if that makes you feel any better," she laughed.

"Laugh if you please," I shot back. "I may not have much imagination, but I've always had to see the whole painting in order to do any decent work."

"That's what happens when you don't do enough studies. It stunts the imagination. Hand me my blue dress and grind away."

After dinner I started wrapping up my canvas. When Rosa Bonheur saw that, she ordered me to leave it here and to take nothing but my studies. Her voice was cross: "Have you no respect for my advice? Do you trust M. Tony more than Rosa Bonheur?"

"So you're jealous of him?" I answered, a bit nettled.

"Anna, you're being mean. Don't you understand how much I respect you?"

"I'm sorry, please forgive me."

"All right, let's drop the subject; but reread up in Paris the letter I wrote your mother last week. Good night!"

It was hard not to cry. What have I done to offend her so?

Saturday, July 23

As I was leaving this morning, Rosa Bonheur urged me to return by evening.

"Don't you want a little rest? I'll be back in four or five days."

"No, no," she said, "You've got to keep working on the portrait; I'll pose for you tomorrow. See you this evening, right?"

Once again my plans fell apart. Returning before dinner as requested, I found her waiting on the front steps.

"It feels like you've been away ten whole days," she said, kissing me. "I've really missed you. To cheer myself up, I've picked out a few studies for a new painting."

She added in a mischievous voice: "Well, Miss Anna, so what did wonderful Tony say?"

I felt a bit uncomfortable telling her how surprised he'd been to see nothing but studies. In his mind, the portrait was already done. As for the two studies, he liked the drawing more than the painting.

"I don't agree," Rosa Bonheur haughtily interrupted. "What didn't he like about the painted one?"

"The shadows beneath the hair, near the eye, nose, and chin weren't cool enough, yet he finds the overall tone lovely."

"It wasn't worth bothering him for that. I'd already told you the same thing. Is that all?"

"No, there's more. I'll tell you the rest while you smoke your cigarette."

Here was the rub. After the first shock she'd given me, I wondered how this headstrong, hotheaded character would take the rest of M. Tony's advice. He'd found all my new photographs of Rosa Bonheur interesting, but one in particular enchanted him: the illustrious artist standing in her smock, with her palette and crown of laurel.

"Here's the one you should do!" he had exclaimed. "If you've got pluck, start all over. Forget about the sitting pose, do this one instead. It's got infinitely more character. Besides, your studies of her head will help. They are in the same light, and you can use the sittings for the first portrait for this one. But just one thing: rent a studio, either in Moret or in Paris; you'll have so much more freedom and independence."

I told him my qualms about suggesting such a change to Rosa Bonheur. Then he picked up the photograph and wrote on the back:

Wonderful! . . . Here's the one for the portrait.

Tony Robert-Fleury

As we were going up to the studio, I timidly asked Rosa Bonheur to skim over the preceding lines.

"What's going on?" she stopped and exclaimed. "Now he wants me in my smock? Didn't you tell me that he really liked the first study where I'm wearing a dress?"

"That's true, but he was literally carried away by this photograph. That's why he's really pushing for the change."

"Oh! no, you've got to be kidding!" Rosa Bonheur said in a cross voice. "Finish the portrait you've started. It's coming along nicely."

"But, mademoiselle, I thought we were talking about one portrait, not two."

"What about the Pittsburgh Exhibition?"

"No matter. The important thing is for me to do a good portrait. Believe me, dear great artist, I won't abuse your kindness. I can rough out the painting in a rented studio here in Moret or Paris. When it's far enough along, I'll come back to By. I won't need any more sittings for the second portrait. It's got to be good, given all the affection you've shown me. My studies, all in the same light, will be a big help. M. Tony said I should do everything in the world to paint a good portrait, and that's why he wrote what he did. He thinks this pose is simply superb. 'You can't find a better one as to dress and light,' he said. May I, dear mademoiselle?"

Rosa Bonheur had let me speak my piece without saying a word.

"And what did M. Tony think of my crown of laurel?"

"I had to tell him about the little scene the other day. He smiled."

"Did you tell him where I put the crown and the wish I made?"

"No, mademoiselle."

Rosa Bonheur's voice went solemn: "Don't you ever forget! That little crown means more to me than you could ever believe."

Sunday, July 24

"Today my niece, her husband, and their son John are coming by," Rosa Bonheur announced, entering the studio this morning. "Yesterday I ordered a carriage from Lazare. Would you like to join us? We're going to Barbizon, the old familiar haunt you've so often talked about. You can show me Rousseau's and Millet's studios and the Gold Key Inn where you worked all those summers."

How could I refuse? Yet I was sorry about the sitting she'd promised me.

M. and Mme Launay soon arrived. Right after lunch, we climbed into the carriage.

Near the Apremont gorges Rosa Bonheur declared this the most impressive part of the forest.

"Diaz, Rousseau, and so many other artists worked for such a long time here; but there're still so many good paintings left to be done."

At Barbizon, in Théodore Rousseau's abandoned studio, I lamented the disrepair of the place where the famous artist had conceived so many masterpieces. Rosa Bonheur, on the other hand, was in high spirits. She went over to an enormous pile of beans in a corner, picked out two or three, and plucked a chunk of plaster from the decrepit wall. With great ceremony, even a curtsey, she handed me the stuff and said: "My dear Anna, keep this in remembrance of him, for this is the only remaining trace of the admirable artist who once made his sanctuary here."

I responded in kind to the solemn tone of her pleasantry, gathering the offering in my handkerchief. She was a bit taken aback. I still have the plaster and the beans.

Back at the house, after Rosa Bonheur's relatives had left, we sat under the big linden and watched a marvelous sunset. She was holding my hand when she said: "I'm so happy to have you here! You saw what a rascal I was today. My niece was probably flabbergasted, but I bet she doesn't understand why I'm so cheerful again.

"Write M. Tony and tell him I'll pose for the other portrait when the one for Pittsburgh is done. Instead of one portrait, we'll have two. Then he can come for lunch. But warn him that you won't need to go to Paris or Moret for the second portrait, that you'll be here with me." She pressed my hand again, and her face lit up with a wonderful smile. "Then I get to keep you a little longer," she concluded in a most tender voice.

Friday, July 29

Nothing much has happened this week. Rosa Bonheur has worked a lot on her oxen and given me, I regret to say, only a few short poses.

It's been hard to breathe on account of the weather. Even so, my portrait is coming along bit by bit. Yesterday a storm broke, which didn't stop Rosa Bonheur from taking me out into the forest once the rain had stopped.

"How I love this cool, gray weather," she said back home. "I can work on my oxen without wearing myself out. Come see what I did yesterday; you be the judge. How do you like the sky? Bring me that palette I gave you. You're not using it, and I need it for touching up the sky."

I ran to fetch it. She set out her colors, painted a few strokes, picked up a knife, and got ready to scrape.

"Oh!" I said, "let it be. I'd like to have it as it is. It'll be an inspiration for me back in Boston."

"So you really love me?"

"Yes, believe me."

She fixed her gaze on me as if she wanted to see down into my deepest thoughts.

"I can't believe you really love me. For a few days I've been thinking really hard. I look into the mirror and tell myself: 'You're nothing but a crazy old lady.'"

"Mademoiselle," I cried, "I'll never forget these days with you. When I'm gone and far away, I'll relive them with such emotion."

Since then I've done some studies outside. Rosa Bonheur has been working in her little studio. We've scarcely exchanged a word, but sometimes she stares at me with great intensity.

Rosa Bonheur Makes Me Promise
to Live with Her Forever After

July 30

Late this afternoon Rosa Bonheur came into the studio where I was working on the portrait's accessories. She looked it over absentmindedly and gave me a compliment or two. Then she turned around and placed her hands on my shoulders. While I gazed at her in surprise, she asked in tones of tender supplication: "Anna, will you stay here and share my life? I've grown attached to you. Life will seem so sad after you're gone. I'll be so alone again.

"You've rejuvenated my heart and restored my energy for work. After my dear Nathalie died, I lost the will to live. For nine years I've been all alone. And now you've started to take her place, the one I'll never be able to forget. Wouldn't you like to stay with your old friend? She'll make you her daughter and help you paint beautiful things."

My pounding heart was close to bursting, and I was so choked up that I couldn't utter a single word.

"You're hesitating, Anna. Why don't you say something? Ah! Maybe there's a sweetheart back in America? If that's the case . . ."

"No! no! it's not that!"

"So what is it? You can work much better here than in Boston, I'll guide your brush, you'll share my every inspiration. And you'll make me happy."

Tears streamed down my face. I finally replied: "I'm simply overwhelmed with joy! This is all so sudden, so unexpected! I need time to think! I really love you, I'd do anything to make you happy; but your family and friends, what'll they think? Won't they say: 'Oh, just look how that American girl has weaseled her way into Rosa Bonheur's life!' "

"Sit down here beside me and listen. You want to know what my family will think? Ah! my child, you forget I'm seventy-six and not getting any younger. You're young, you've still got a mother and sisters to love you. Since Mme Micas and her daughter died, I feel like my family is all gone. Those two were my true family. Sure, I've still got my brother Isidore, a few nephews and nieces."

"Wouldn't they like to live with you?"

"Oh! Anna, to live together, you've got to love each other and think alike. No one in my family has ever asked me what I thought of the company they keep. I'm free to do as I please. If my brother Isidore wanted to take in a friend, do you think he'd ask me if I liked the idea? You're really such a child. I've got only myself to reckon with. As for my friends, they'll just think it's good that you're here, seeing that you make my life a little sweeter."

"Dear mademoiselle, am I really the only one you've got?"

"True, a friend or two have let me know that they'd be glad to replace my dear Nathalie. But since there were no real affinities between us, I preferred to live all alone. You're still hesitating, Anna, why don't you say something?"

I wanted to throw myself into her arms, but didn't dare.

"Please, please, I need time to think," I stammered.

"Fine, my Anna, go think."

Shut in my room, I felt my heart prey to an emotion beyond words. I'd just heard this great woman bewail her sad and lonely life, even while so many artists envied her fame and happiness, and now here she is asking me to stay with her and share her life. Won't she soon regret such a weighty resolution? And what is my mother going to think? And what about Rosa Bonheur's friends and family? Truly in turmoil, I simply didn't know where to turn.

Dinner was silent. We hardly touched our food.

Back up in her studio, Rosa Bonheur made me sit down beside her and said: "When I saw you just before your last trip to Boston, I almost opened my heart to you, but I didn't dare interfere with your work. When you wrote and asked to paint my portrait, you made me happier than you could ever imagine. I'd been hurt by your silence. Fortunately, you wrote me a second letter. Once you were finally here and I felt sure you loved me, I did all I could to string out the sittings. I guess I tried to put you on a long leash, and I wore myself out looking for tricks to make sure you wouldn't finish up too fast.

"My dear Anna," she continued, pressing my hand, "it's because you sometimes remind me of my mother that I love you so much. You've got her oval face, her eyes, her profile, and even her hands. I've often wondered if my mother's soul didn't bring you here to console my last days and help me paint a few more beautiful things before I go join her up above. Sometime I'll tell you about her. Poor mother! Such a saintly woman. I adored her, and she died in wretched poverty. How awful not even to know where to go grieve over her! Yes, my child, I see my mother

all over again when I gaze at you [T].[1] Wouldn't you like to stay on and share your old friend's life? It's a lonely one but filled with happiness since you've been here."

Trembling with emotion, I knelt at Rosa Bonheur's feet. She took my head between her hands, looked into my eyes and said: "Oh! my child, if you [V] leave me, I'll just die! I thought I'd buried love with my poor Nathalie; but my old heart has come back alive to the love I see in your [T] eyes. I know you really love me and you'll stay. Right, Anna? Tell me I'm right."

"Yes, I love you [V] and I'll stay."

"So it's true!" she exclaimed, clasping me in her arms.

We let our tears mingle for a long while.

"Let [V] me get some rest," she said at last. "I'm tired, but so very happy! Goodnight, my Anna!"

It's nearly midnight. I haven't stopped quivering. How can I say everything in my heart? I really cannot believe this unexpected bliss: I am now Rosa Bonheur's friend and adoptive daughter.

Sunday, July 31

Rosa Bonheur was tired this morning.

"I didn't sleep much," she confided during our drive. "You mustn't think there was anything hasty about yesterday's proposal. I've been watching and questioning you, without your even knowing it. The more I got to know you, the more I loved you. How glad I was to see that you admired nature the way I do, that you shared my ideas about art and religion. I was trying to see if you were a free agent, if you liked my country, and if you loved old Rosa Bonheur . . . not only for her painting, but also for herself. How happy we'll be from now on! But why are you crying?"

"It all just feels like a dream."

"No, my Anna, it's wonderfully true. I'm going to tell my friends."

"Before you do that, please let me write my mother and see what she says."

"If you wish."

I went to my room to think about how to give my mother the news. I decided I'd better to tell her in person.

1. In these sentences and most of the following ones, Rosa Bonheur and Anna Klumpke use the formal *vous*. This sentence stands out with its sudden shift to the intimate *tu*. Subsequent shifts will be marked in this day's entry, V standing for formal address, T for intimate address.

That afternoon M. Tedesco came by with his daughter. Rosa Bonheur was radiant. Yet she kept her promise and didn't say a word. Mme Gauthier came for a visit, too. We talked about painting and lots of other things, but not a single word about the two of us.

M. Tedesco really liked the *Red Oxen*. After he left, I showed Rosa Bonheur my letter from M. Tony Robert-Fleury in reply to the news that I had permission for two portraits. He gave me his warmest congratulations and thanked mademoiselle for her invitation.

"True, I was a bit jealous of your teacher," Rosa Bonheur said, handing me back the letter. "I thought you preferred his advice to mine. I'm quite touched by his humble offers of advice for the future. His father left us some really moving history paintings. For several years that distinguished artist presided over honors day at that modest art-school for girls I used to run. I'd be delighted to have a chance to tell the son that I still remember how kind his father was to me as a young artist."

Tuesday, August 2

Yesterday morning, near Long Rock, we were ambling down a sandy lane alongside those strange mossy boulders amid the heather. Rosa Bonheur dropped the reins.

"Look, Anna, just look at those old junipers! and those birches lighting up this beautiful scene! Lots of old trees look dead, but it just takes a good warm sun to make the sap rise. Then, amid the dead branches, a new one shoots out and sprouts leaves. Haven't you noticed that lots of times with the chestnut trees in the Tuileries and up and down the Champs-Elysées? The tender green twig really stands out against the purplish tones of the dead tree. Just like my old heart, dear Anna, coming back to life because of you.

"I dream about great success for you. I want you to learn how to paint landscape the way I see it, in foggy mystery. Of course, you mustn't neglect your portraits, but create a new genre for yourself.

"You've got a fine eye. Don't fall under the sway of other artists. Trust your feelings, copy what you see. Don't spend more than two hours on studies and sketches for a painting. Some figure studies done in the open air, a few quick notes on the landscapes. I'll help and give you the benefit of my experience. I want you to command respect and be considered my peer some day."

"Oh! my dear friend, you've got too much confidence in my abilities, you expect too much."

"I have a mother's ambition for you, my child. I think you'll be the one to carry on for me. But let's step down. I'm going to tie up Grisette, and we'll go find someplace to sit."

In the quiet of that beautiful forest, Rosa Bonheur went on: "How often I used to come here with my dear Nathalie. Together we'd relive the events in our lives that she wanted to write about. She didn't have a painter's eye for nature's subtle hues, but she could really write. If Nathalie hadn't been ill so much, she would have written my life story. You're the one, Anna, I want to entrust with this task. In idle moments I'll ramble on and tell you lots of things, just following the drift of my thoughts . . . You can take notes. Later on, we'll put them in order and go over them together."

"What a mission you're giving me! but I'm no woman of letters."

"Didn't you tell me that every evening you write down your daily impressions and the advice I give you?"

"True enough, but just sketches. Isn't M. Gambart writing a book about you?"

"He's writing his memoirs. Of course, he's got to talk about me because he's sold so many of my paintings and engravings."

"But you've already had lots of biographers. Mirecourt, de Bois-Gallais, your nephew,[2] among others. Isn't M. Deslandes,[3] from Lisbon, pulling something together, too? Didn't you just send him some details about your life?"

"Mr. Deslandes is a fine scholar, writer, and critic. I have great respect for his judgment," Rosa Bonheur went on, "but, my dear Anna, he's a man. I could never tell anyone of the male sex how the pieces of my life fit together. You'll be not only my voice, but dear Nathalie's, too. You'll write about her the things she couldn't say about herself. You'll make us complete. Another thing, not a single biography about me even mentions how devoted I am to my poor dear mother's memory. In my eyes, that's the worst fault of all.

2. Eugène de Mirecourt, *Les Contemporains. Rosa Bonheur* (Paris: Havard, 1856); F. Lepelle de Bois-Gallais, *Biographie de Mademoiselle Rosa Bonheur* (Paris: Gambart, 1856); and probably the article that appears in Klumpke's bibliography as René Peyrol, "Rosa Bonheur, her life and work," trans. J. Finden Brown, *The Art Annual* (London), 1889.

3. Venancio Deslandes, formerly head of the National Printing Office of Lisbon. In 1897 he sent Bonheur a copy of Mirecourt's biographical sketch and asked her to comment on its trustworthiness. She gave him quite lengthy replies in the fall of 1897 and the summer of 1898. Many of her comments are reproduced in Theodore Stanton's *Reminiscences of Rosa Bonheur*, pp. 34–43, 101–2.

"Now that you know everything, we're going to tell Mme Klumpke."
That afternoon Rosa Bonheur wrote my mother this letter:

By, August 2, 1898

Dear Madame Klumpke,

I am writing, first of all, to thank you for your warm reply to my
letter. I'm sending this letter along with that of your dear daughter
Anna, my dear colleague in the arts, in order to tell you of my deep
affection for her. Over these past two months I've seen how loyal,
forthright, and honest she is. Because we think alike and despite the age
difference, I've asked her to live with me, to share this happy life of
work and tranquillity and to carry on as we've been doing. Mlle Anna
will tell you about our plans in her own letter.

For my part, dear Mme Klumpke, I was very lonely and despondent
after I lost the best and most cherished of friends, Mlle Nathalie Micas.
Nothing can ever make me forget her. Yet I feel that the fine affection
that your daughter and I share will, for the rest of my days, make me
once again happy to work and eager to produce a few more paintings
that noble hearts will appreciate.

I send you, dear madame, my fond regards and beg you to consider
me a bit like one of your daughters.

R. Bonheur

Wednesday, August 3

My mother must have received our letters this morning. How did she
react?

After dinner I helped my old friend enlarge a few forest scenes.

"Are you happy, Anna, about staying on with me?" she asked. "No
regrets? Certainly there's a sweetheart somewhere back in America."

"Yes," I laughed in reply. "I even had a marriage proposal in Boston,
and my suitor promised to wait for my answer until I got back. Don't
worry, mademoiselle, I've got lots of friends, but I'll never marry."

"You're still hesitating, right? You're wondering about my family and
friends?"

"True enough. They'll forever go on thinking that I'm here out of self-
interest, not for love."

"But Anna, you've got enough talent not to be a burden to me. Like
Nathalie, you'll pay your share of household expenses. You'll remain
independent, even under my roof. If it's hard getting portraits over here,
you'll just do open-air paintings of the village women and children. There

are so many touching subjects! You'll help me finish *Treading Wheat*, which may be my swan song.

"How happy we'll be together, don't you think, my Anna? Responsible only to ourselves, we'll each work hard, earn a living, and enjoy what we earn. Ever since I've known that you'll be staying on, I take interest in everything and want to do it all. I mean for you to get the respect and obedience I do. When our paintings for Pittsburgh are all done, we'll make a few changes in the house and settle down for winter. We're really going to dig in! God will help me guide your inspiration. At your age, I really used to dig in. I want people to look upon you as my equal someday."

"What? but you're at the summit of glory!"

"Nobody ever really gets there," she said, shaking her head. "No matter how well you do something, it can always be better. You'll see how good you'll get. Now the only thing I really want is to turn you into a second Rosa Bonheur."

"Dear great artist!" I exclaimed, "you can't mean that. I paint people, not animals."

"Aren't people animals?" she replied with a smile. "But let's look at this from a broader perspective. Whether you paint people, animals, or landscapes, the same principles apply. When I say I want to turn you into a second Rosa Bonheur, that doesn't mean that you'll do another *Horse Fair*. I know full well that you'll always be Anna Klumpke, with your own personality. But, with my methods, you'll go a step higher."

"Dear friend, there's no need to invoke the love of art to make me appreciate being able to enjoy your priceless lessons every day. If anyone accuses me of staying here out of self-interest, so be it. You love me, so I could care less what people may say. My conscience is my own business."

"Are you forgetting that I'm here to defend you, Anna? My family knows me. Isn't it quite natural for us to have grown attached? We agree on beauty in nature; we stand up for the same ideas; we like the same things. You're given me back the strength and energy I need for my work. People ought to understand all that.

"As for my relatives, my brother, my nieces and nephews, you'll be nice and sweet, won't you? But I'm warning you that there's no use trying for a real reconciliation. Sure, they've been nicer to me since Nathalie died, but that hasn't wiped away the past.

"But Anna, if you ever fall in love with a man and want to marry, you're always free to leave. I'd be very sad without you, but I only want you to be happy. You're as free as the air we breathe."

"I've already told you I'll never marry." I explained how my parents,

because of my infirmity, had brought me up in the idea that I'd be an old maid and favored me in their will. That took care of most of my worries about the future, and my paintings provided additional security. I had learned to paint because of my mother's salutary ambition for me. Having grown up in a family of artists, she took a cue from her mother's great-uncle Ernest Riepenhausen and his two sons,[4] who had always painted as a team, and decided that I would become an artist. That's why I had taken as many painting lessons as our travels back and forth across the Atlantic would allow.

The day I won a third-class medal at the Universal Exhibition of 1889, my mother was overjoyed and solemnly swore that this was my first step on the road to glory. One glimpse into that bright future, and my heart was totally conquered. That day I married Art. Rosa Bonheur had been listening hard.

"Anna," she solemnly asked, "will you work with me like the two Riepenhausen brothers, be my loyal companion to the end of my career and receive my last breath?"

"Oh! my dear friend, why are you talking about death? But you know how happy I'll be working and living with you."

"Your mind is so made up that you'll never leave me, you promise?"

"Yes indeed, and I'll keep my word religiously. Neither mother nor sisters nor anyone at all will ever be able to make me change my mind."

"We'll have a pact, a real pact," she laughed.

"Like when Mephistopheles asks Faust for his soul," I replied, echoing her laughter.

"That's just what I mean. So it's all settled? This will be the divine marriage of two souls, right?"

"Since you adopt me in your heart, I'll always be faithful."

4. A.K. Ernest Riepenhausen, born in Göttingen in 1765, was named Royal Engraver of Hanover in 1800. He was a man of talent, a great scholar of Antiquity, and an intimate friend to Goethe. Riepenhausen's burin made Hogarth's work so popular in Germany that many of his countrymen thought that the great English caricaturist was one of their own. Riepenhausen's two sons were sent to Rome by the king of Westphalia in order to copy works by the great Renaissance masters. Despite Raphael's influence upon them, they are known above all as history painters of the Romantic school, to which they remained faithful all their lives. The Michaut *Biography* says in reference to the paintings of Polygnote de Delphes: "This work will perpetuate the name of the Riepenhausen brothers, placed under the aegis of the great name of Goethe."

ffffortffortffort

"Thank you, Anna. Now I know you'll never leave me, no matter what. You've made me very happy. When you're a famous old thing like me, it's hard to believe that anyone loves you for yourself. I hope you'll never be sorry that you gave up marriage for your old Rosa Bonheur."

Friday, August 5
Tomorrow Rosa Bonheur is expecting M. Lefèvre from London, his wife and daughter. Tomorrow is also the day I'll hear from my mother. I'm impatient and uneasy.

Saturday, August 6
Our guests had already arrived when, just before lunch, Rosa Bonheur and I each received a letter. We had no time to confer. Over lunch mademoiselle drew on all her reserves of grace and charm and carried on the table conversation almost singlehandedly. Then we went to the studio, where Rosa Bonheur promised M. Lefèvre that she'd soon be done with *Wild Horses*.

"You could show it along with Miss Anna's portrait," she added.

M. Lefèvre took a long look at my work and agreed.

"My husband and I find Rosa Bonheur much cheerier now," Mme Lefèvre told me in a private moment. "I do hope, mademoiselle, that you can stay on a while longer. She's recovering her youth. She must be very fond of you."

"That is true, madame. Rosa Bonheur is very fond of me."

I didn't dare tell her that I'd decided to stay with the great artist for the rest of her life. My mother's letter had just made it clear that we still had some very real opposition to overcome.

Once the Lefèvres were gone, Rosa Bonheur showed me her letter from my mother.

"It may be very affectionate, but it's not at all what I expected. Is the one she sent you any more encouraging?"

"No, alas!" I replied. "I'll translate it for you."

"Your mother thinks my proposal is not to be taken seriously," Rosa Bonheur said afterward. "She doesn't like the idea of your giving up your career in Boston. Since she's told you to go see her next Wednesday at your doctor sister's house,[5] you'll bring her a new letter from me."

Friday, August 12
These past days have been full of strife and anxiety.

5. A.K. Mrs. Jules Déjerine, née Augusta Klumpke.

Wednesday, as I was leaving for Paris, Rosa Bonheur handed me an unsealed letter and said: "Read what I've written to your mother. This isn't a reply to her letter to me, but to the one she sent you. Study my arguments so that you can defend yourself and win her over. I can't live without you, and don't you forget it. Your family doesn't know me as you do."

"Don't torture yourself," I replied. "Rest assured that I'm not going to Paris to seek their consent. There's no need for that any longer; I've already given you my word that I'll never leave."

"Who knows?" Rosa Bonheur exclaimed. "Most people take a pretty dim view of women who live together, and that may influence your family. I've been battling that prejudice my whole life long. Happily, I've found in you the interpreter I need to get a fair trial in the future.

"If you start flagging, just leave; but don't you ever forget, my Anna, if you abandon old Rosa Bonheur, you're signing my death warrant."

A few hours later, I was with my family, and the letter that I was carrying was read aloud.

By, near Thomery, August 8, 1898

Dear Madame,

Here follows, as is my duty, a loyal and sincere reply to your letter of August 5.

My proposal to Mlle Anna, your beloved eldest daughter, was not made lightly. At my age—and I am much older than you, dear Mme Klumpke—one knows all about life. I must expect to die before Mlle Klumpke. Not for anything in the world would I want to leave her in the lurch.

If she decides to live with me, I intend, as a loyal and honest friend, to regularize before a notary a very clear position for her with regard to my house, where she will be considered as in her own home, and my estate. With my beloved companion Mlle Nathalie Micas and her mother, we took all necessary precautions because of our mutual families in order to avoid any and all unpleasantness about material interests, and [to ensure]⁶ order in our individual affairs.

For my part, I have real tenderness for your most distinguished daughter, and my love for her comes from my intuition into her beautiful soul and character and even her childlike naïveté.

Since we're both alone in life, wouldn't it be more pleasant for us to lead a happy life painting together, all the while remaining independent?

6. This emendation seems to shore up the troubled syntax of the French.

Thank God, I believe I've got too much pride and self-respect to impose in any way. Miss Anna is free as the air, as I am the first to agree, dear good mother that you are. I am urging your dear Anna to keep her Boston studio and her fine connections.

Your dear letter only adds to my respect for you, for there's some maternal feeling in my old heart for Anna. In no way do I resent that she's consulting you and her sisters. Quite the opposite. This is a very serious matter. Most of all, I love your dear Anna for what she is, I give you my word of honor.

She'll give you this letter herself the day after tomorrow, for she does not wish to decide anything before receiving your advice. I know what a fine family you are. Your daughters, who are all women of high intelligence and the best society, have brought you much honor. As for me, dear madame, I rarely go into society; but my talent and self-respect make me worthy of being a friend to you and yours.

This is all that I can say. I know that you are the best of mothers, and you have my affection and respect.

<div align="right">Rosa Bonheur</div>

Except for my sister Dorothea, who said that I was right, then flew out of the room, everyone turned against me. I had not expected to be so roundly condemned and felt considerably dismayed.

My brother-in-law[7] made arguments that I could hardly sneer at. Describing the brilliant career awaiting me back in Boston, he came back again and again to the great sacrifice I was making.

"What makes you think this is something more than an old woman's senile whim? What's to prevent her from just changing her mind someday? And if you stop getting along, how will you get out of this mess? Don't forget that she's over the hill."

"If we have the misfortune of a falling-out," I retorted, "I'll just go back to Boston. Thanks to my experience with an artist so popular in America, I won't have any trouble finding portraits to paint. I could also set up a school where I'd teach young women what I'd learned with the incomparable Rosa Bonheur."

"I agree that you could probably regain your professional status in America," my mother said, "but have you considered your position in Rosa Bonheur's household? You're too proud, I think, to be a lady-companion."

7. A.K. Dr. Jules Déjerine, now professor at the Faculty of Medicine.

"Naturally," I replied, "but I've got a better role to play. Not only will I be the great artist's friend and pupil, but also the spokeswoman for her ideas."

"That all sounds very nice, but her friends and relatives are bound to say that she's keeping you."

"They can say whatever they want. Besides, I'll have a studio in Paris for my portraits."

"Ah! my daughter, this won't be as easy or lucrative as you think. You're wrong if you think that commissions for portraits are going to flock after you down at By. Once you've decided to devote your life to Mlle Rosa Bonheur, you'll have to do your duty to the very end. Think hard, there's still time."

Seeing my unshakeable resolve, my mother added: "You may tell Rosa Bonheur what we've said. If she insists on keeping you, may God help you ensure her a happy old age."

Yesterday I returned to By where my old friend, anxious to hear my family's final word, was waiting for me.

"I can understand what your mother is worried about," she said when I had finished telling her everything, "and I've been thinking, too, since you left. You're young, I'm old, but I truly love you; this is not just some feminine whim. Yet I feel I've been selfish. I wouldn't want you to be unhappy. You're free to go, since your family doesn't want our happiness. But I've got to say, I'll die of grief."

"Didn't I promise to be your loyal companion till your last day on earth?" I exclaimed, pressing her in my arms.

"Ah! my Anna, you'll be the life or the death of me! If you want to marry later on, you'll still love your old friend, won't you? You won't forget her."

"I'll never forget you, have no fear," I replied. "I love you with all my heart. I didn't dare show you my feelings until today. Now I've got every right to say them. Ah! if you could only understand how I've always admired you! I'm talking about real devotion! And to think that now you've adopted me as your very own daughter! that you love me so much!"

"Yes, I do love you, my dear Anna, and so much that I pray God we'll never part, not even in the grave. Good night, my child, and sleep in peace."

This morning Rosa Bonheur wrote my mother the following letter:

Rosa Bonheur Makes Me Promise

By, August 12, 1898

Dear Madame Klumpke,

Since your dear daughter Mlle Anna returned yesterday, we've talked and talked. After long and hard thought we've decided to join our lives.

All alone until now, quite in a world apart, I was having a dreary old age.

Mlle Anna gave me a frank report about your motherly fears for her following my death. Therefore, I'll settle our affairs as soon as possible in order to guarantee decent independence for the new friend who has been sent me in this world. Then you'll realize my very noble affection for your daughter and the sincerity of my soul, which understands a mother's love so well. Seeing these fears, which would be entirely justified if I were not worthy of your Anna, of you and yours, makes me love you even more.

You may rest assured that I am quite worthy of your Anna's love, that she'll be respected and happy with me. Seeing how I treat her, you'll have no choice but to love me. Let me repeat that I am worthy of her friendship, your family's and your own.

Let me clasp you to my old heart,

Yours very affectionately,

Rosa Bonheur

Rosa Bonheur Entrusts Me with the Mission of Writing Her Life Story

Why have I thought it necessary to give a daily account, or nearly that, of our life at the chateau of By for those weeks in the summer of 1898? Not so much because of their huge place in my memory—the reader wouldn't be interested in that—but in order to show Rosa Bonheur speaking and acting in circumstances that made her independent spirit, strong will, and good heart plain to all, including me. Until then I hadn't known much about her except for her seductive charm and vigorous talent. These revelations changed the course of my life and added a debt of gratitude to my love for her. Too soon, alas, that love would become the most enduring sorrow.

It would not do to go on in such great detail about our life henceforth at the chateau. Our days were calm and necessarily a bit monotonous, despite all the novelty and poetry that artists discover in their daily work routine. Before I start on the specific object of this book, Rosa Bonheur's life story, I'll briefly note a few incidents that involved me and the conversations that led me to undertake this project. Those matters having a direct bearing on her story will find their natural place at the end of my book.

Though it wasn't easy, I managed to finish the fine woman's portrait (frontispiece). We sent our paintings off to Pittsburgh, and I planned to follow them across the Atlantic. Since I had promised to stay with Rosa Bonheur, my affairs in Boston, including my studio there, had to be settled once and for all. Rosa Bonheur very reluctantly agreed to let me go. I was already packing when that deplorable shipwreck occurred and the *Bourgogne* went down with five hundred passengers. So would I still go? Rosa Bonheur couldn't bear the idea.

"You're crazy to take such risks! What would happen to me, and who'd write my biography if my Anna disappeared into the watery depths? Send your power of attorney. You don't have to be there to wrap things up."

Yet I wanted to settle my Boston affairs in person. Otherwise, as I knew full well, there would be serious problems; and I wasn't wrong. Also, I really wanted to see my friends. I'd told them that I'd be away for just a few months, and now I didn't know when I'd ever see them again. But

Rosa Bonheur was so worried that I just couldn't do it to her. I canceled the trip.

M. Gambart, who had heard about my portrait from M. Lefèvre, asked to buy it. Because of all the memories attached to it, the work meant so much to me that I wouldn't have sold it at any price, had Rosa Bonheur herself not become her old friend's advocate.

"I'll pose for another portrait," she said by way of consolation. "If it's a better piece and strikes M. Gambart's fancy, you'll make a switch with him as long as he agrees to have the first one engraved."

Meanwhile I got down to work on the portrait of Rosa Bonheur in her smock, according to the pose that had so pleased M. Tony Robert-Fleury. When I asked Rosa Bonheur to sit for me, she replied: "I'll give you a few sessions, but you can always use your studies to finish it up. I don't like the idea of appearing at the Salon in my smock. I want to leave posterity the image of me in women's clothes. The portrait that I've got in mind won't be like the other two. I'll be holding little Charley on my lap. Will you be brave enough to paint it all by yourself?[1]

"You know the story about the bull with me in the portrait that Dubufe painted in 1856, don't you? He started off with me leaning on a table. I began grumbling the second time I posed. That's when he got the idea of having me paint a real live bull's head over the spot where that boring table had been.

"M. Gambart, who had commissioned the portrait, was just delighted by the change. Besides, the engraving sold much better with my signature.

"Maybe M. Gambart wants me to do for you what I did for Dubufe and also for Mme Consuélo Fould. As a matter of fact, if I listened to this old friend, I'd spend loads of time embellishing my portraits and even adding animals to other people's landscapes in order to boost their price. I don't know how many times he's tried to talk me into it. One day he even sent me two paintings with spots for the animals carefully marked out.

"Maybe, my dear Anna, you'll be accused of doing nothing but portraits of Rosa Bonheur. But didn't Van Dyck paint his patron to his heart's content? Nobody ever dared blame him for that. You can find portraits of Charles I at the Louvre, at Windsor Castle, in Dresden, Rome, Vienna, and Turin. An artist has certainly got the right to be grateful with his brush."

1. On her portrait by Consuélo Fould (1894), Rosa Bonheur painted the dog with which she appears. For more details about this portrait, see Theodore Stanton's *Reminiscences of Rosa Bonheur,* pp. 258 ff.

M. Gambart was not glad to hear that I was working on a second portrait of Rosa Bonheur for the Salon of 1899, and he tried to make me abandon the idea. Mademoiselle, thinking that I should not have to defend myself, wrote him in these terms:

When you buy a portrait, you've got no right, my dear M. Gambart, to demand that an artist not paint ten more of the same person, unless they're absolutely identical. In the present case, it would be simpler to keep the portrait you've already bought. It's very beautiful and artistic, with an original effect. Despite the model's advanced age, it's better than Dubufe's portrait.

One September evening, after a drive in the forest during which Rosa Bonheur had talked a lot about Mlle Micas, her late friend, she asked to see my diary.

"I'm curious," she said, "to see how you write about us and the things I tell you. You've probably already got some interesting bits, and I'll just have to flesh them out a bit in order to move right along to the important parts of my story. I'd also like to know what your own thoughts are."

From the very first day that she knew I was writing about her, I'd been anticipating this request and also the embarrassment it would surely cause me. My heart was really pounding when I gave her the diary from which I've taken most of the preceding pages. Without saying a word, Rosa Bonheur read through several pages most attentively. The more she read, the more nervous I got. I wondered if she found my naïveté ludicrous, perhaps offensive, or goodness knows what else. From time to time, she lifted her beautiful gray head and scrutinized me with her gaze.

When she got to the end, she closed the notebook, went over to her worktable and took out a blank sheet of paper. With considerable qualms I watched her slowly write out a few lines. For me, they were full of dire mystery. Finally a wonderful smile that lit up her face completely reassured me, and with tender joy in my heart I read what she had written: "Friendship, a divine affection nobler than transitory love, province of the Gods, is the place you come from. Your home is in the Heavens. Rosa Bonheur. By, September 4, 1898."[2]

"This divine affection never grows old," she said when I was done reading. "It lasts beyond our earthly existence. There is nothing greater or purer. The love of one soul for another is true kinship. It even surpasses

2. These lines are reproduced in Rosa Bonheur's quite illegible hand on page 123 of the original text. I've tried to do my best with them.

our God-given families; for, instead of receiving it from the Creator's hands, we choose it for ourselves.

"Spiritual communion is often missing in family affections. You've been sent to me by benevolent souls; I feel such extreme tenderness for you, and you can truly say that no one will ever love you as much as I do. Ah! why did we have to meet when I've got just a few years left here below?"

"Titian and Carlo Maratta didn't put down the palette until they reached the age of one hundred. It'll be the same for you. You'll still be painting in 1922."

"I don't think so, but let's both thank the Infinite Spirit for bringing us together."

She gave me back my manuscript and added: "When your heart is really in it, words come easily, no matter what language you're using. Now I know that you'll draw me with your pen just as well as with your paintbrush. And you'll combine your own impressions of me with my life-story. That'll be the best way to give the public a true account of how we met and fell in love."

Her biography was one of the great woman's main preoccupations. She wound back to it again and again in our long conversations. One evening in her studio as we were sitting by lamplight at her worktable and quietly chatting, Rosa Bonheur returned to her favorite subject.

"Many fine authors," she said, "have written loads of stories about me. Unfortunately they've always left in the shadows my feelings for my be-loved Nathalie and my devotion to my poor mother's memory. When they asked me questions, I was always totally sincere. Yet I could never forget that I was talking to men. It's because you're a woman, because I can open my heart to you with greater trust that I've chosen you to interpret my life for posterity. You'll understand that Nathalie and my mother were both my guiding stars. You'll know how to say what I mean with all the subtlety that is the privilege of our sex. You're also from America. For a long time now women over there have enjoyed the exceptionally favorable circum-stances that I've always dreamed of for my French sisters. My feminism and my clothes aren't meant to surprise you. It'll be easy for you to explain the reasons behind them. I'll tell you everything, without holding anything back, just like a devout Catholic talking to her confessor. As soon as you finish writing, you'll show me your work. Then I'll see what's been left out and needs to be added.

"Writing in French will give you extra work, but it's got the advantage of showing me as I am to my old friends in the art world. But I've got no desire to leave behind the kind of memoirs that some people love to indulge in. In a simple, candid way I'll tell you all about the things that have influenced me, for good or for bad."

However flattering my fine friend's confidence, my appointed task felt very heavy. Several times I had already caught myself smiling at the clumsy words I was writing in my diary. The only thing that had made me carry on was the thought that no one except for a few friends would ever read these lines. But now I'd have to publish these homely pages. Even worse, I'd have to take down everything about the various stages of her life that Rosa Bonheur would confide to me! I was terrified at the beginning. Yet it was a great pleasure to relive her career day by day through my writing. Her trials and triumphs became my own. Every step of the way I watched the stirrings of her lovely soul. I shared her devotion to her mother and her love for Nathalie. And all along I was thinking that my responsibility to my future readers would not be so great because Rosa Bonheur would edit my work. Alas! how could I have known that in such a short time I would be left alone with the task?

Did Rosa Bonheur sense that her end was near? I refuse to believe it. Yet, why else was she in such a hurry to tell me everything?

I've been despondent since she died. I've often thought that I accepted a responsibility beyond my strength. Yet amid these doubts something kept urging me on. While sorting through documents or gathering my thoughts, I could almost hear a tender voice saying in the dead of the night: "Pluck up, Anna, just keep at it."

I know how far I've fallen short in my difficult mission. If the reader fails to understand Rosa Bonheur's fine ambitions, if her gratitude toward the Micas family seems overblown, if the reader is not moved by the great artist's devotion to her mother's memory, Rosa Bonheur must not be blamed, rather her humble interpreter.

The second part of this book is made up of my conversations with Rosa Bonheur. Since I'm convinced that the reader will be more interested in hearing words almost straight from her lips, I've transcribed them without breaks except for a few stories, quotations, and notes for the sake of clarity.

Fig. 1. Rosa Bonheur and her black horse at the Chateau of By.
(Original French edition, p. 49.)

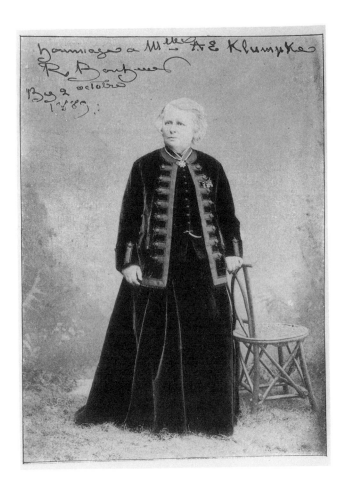

Fig. 2. Portrait of Rosa Bonheur at age sixty-three. Bonheur gave this photograph to Anna Klumpke as a souvenir of the American artist's first visit to the Chateau of By on October 5, 1889. (Original French edition, p. 9.)

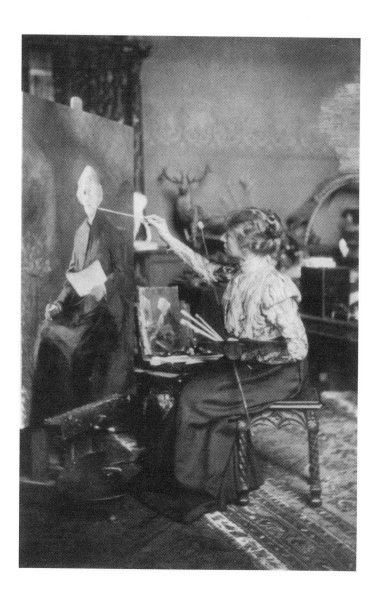

Fig. 3. Anna Klumpke at work at her easel at By in the summer of 1898. The photograph is by Rosa Bonheur. (Original French edition, p. 71.)

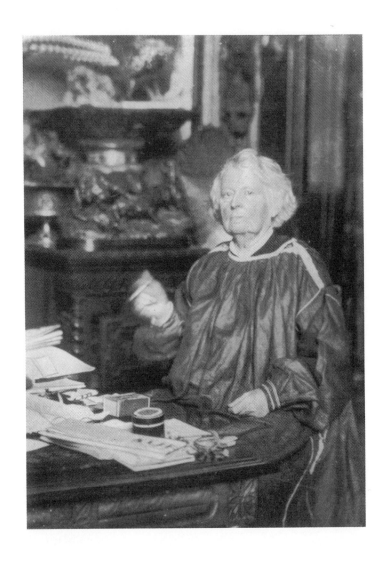

Fig. 4. Rosa Bonheur smoking a cigarette at home.
Photograph by Anna Klumpke.
(Original French edition, p. 93.)

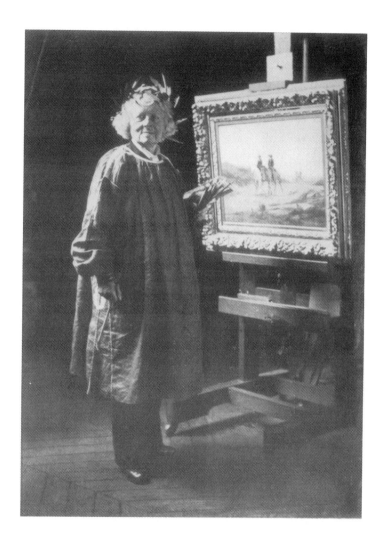

Fig. 5. "Old Europe Crowned By Young America." *Bonheur wearing the crown of laurel that Anna Klumpke wove for her, photographed by Klumpke on July 10, 1898. (Original French edition, p. 75.)*

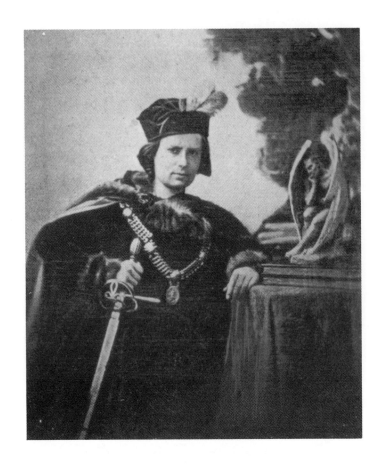

Fig. 6. Young Rosa in Templar regalia. Remembering the effect that her initiation into this secret society made upon the impressionable adolescent, Rosa Bonheur remarked: "Once a feeble little girl, now a valiant woman-warrior!" (Original French edition, p. 159.)

*Fig. 7. Rosa Bonheur's studio at the Chateau of By. As soon as
she bought her country estate in 1859, the artist
began building this studio.
(Original French edition, p. 245.)*

*Fig. 8. Rosa Bonheur and Nathalie Micas, the childhood friend
who was for many years the artist's companion.
(Original French edition, p. 293.)*

Rosa Bonheur's Story

Family

❖

Childhood in Bordeaux

❖

Arrival in Paris

Before I begin telling you my story, it's only right that I thank God for giving me a happy, exceptional life and letting my dear mother's soul protect me at every turn.

I've never stopped thinking about her. Everything good and beautiful that I've done during my seventy-six years on this earth has been her inspiration.

Her birth is still shrouded in mystery. Talent alone cannot really explain the respect that kings and queens have shown me over the years.

My mother was born at Altona[1] on March 2, 1797, if a baptismal certificate found in the family papers is to be believed.[2] Four days later she was baptized with the name Christine-Dorothée-Sophie Marchisio, known as Marquis. She was just two when M. Dublan de Lahet brought her and a German nurse to his house in Bordeaux.

M. Dublan, once one of Marie Antoinette's pages, was the son of a financier and royal treasurer for Louis XV.

After his return from the Emigration,[3] he found just a few scraps of his father's fortune, but with these he lived a comfortable life.[4]

M. Dublan called my mother his niece and ward and brought her up with his own children.

1. Near Hamburg, Germany.

2. A.K. Here, translated from Latin, is the certificate of baptism from the Catholic church of Altona, issued on November 6, 1824, by Fr. Jos. Versen, curate: "In the year 1797, there was born on March 2 and baptized on March 6 Christine-Dorothée-Sophie, the legitimate daughter of Laurent-Modeste-Antoine Marchisio known as Marquis and Marie-Anne Triling. The godfather was Antoine Paris and [sic] Christine-Dorothée-Sophie, his wife."

3. At the time of the French Revolution, many aristocratic families feared for their lives and emigrated to friendlier parts of the world until the danger subsided.

4. A.K. Monsieur Dublan de Lahet, a merchant by trade, lived in the rue de l'Intendance in Bordeaux. He also had property at Quinsac.

Around the age of ten she began her schooling, the very refined sort of education that great ladies received. She learned composition, French literature, Spanish, singing, dancing, and piano. Later on she had a drawing teacher, an artist who really knew how to stir up his pupils' enthusiasm.

This model teacher was a well-proportioned, handsome young man with blond curls. Everyone in Bordeaux called him "Angel Gabriel," but his real name was Raimond Bonheur.[5]

When my mother was thinking about marrying him, M. Dublan objected because the young man's station did not meet the expectations he had for his ward. They got married anyway (May 21, 1821).[6]

5. A.K. Raimond-Oscar-Marie Bonheur, the son of François Bonheur and Marie Pérar, was born in Bordeaux on March 20, 1796. He studied under Pierre Lacour, the director of the municipal art school. For a time he taught at a private school in Confolens, then at a boarding school in Bordeaux up until he left for Paris. The church of Saint-Seurin owns two of his paintings: *Saint Amand* and *Saint Seurin*.

6. A.K. Raimond Bonheur's marriage certificate reads:

"On May 21, 1821, after noon, before the Adjunct-Mayor of the City of Bordeaux, who has the power to act as Registrar, there appeared, in order to be united in marriage, M. Raimond Bonheur, answering to the name Oscar within his family, history painter and drawing teacher, age twenty-five, born in Bordeaux on March 20, 1796, living in this city at 54, rue d'Entre-deux-Places, the son of M. François Bonheur, without any profession, and Marie Pérar, both inhabitants of this city. And Mlle Sophie, age twenty-four, born at Altona, in Germany, in the year 1797, living in Bordeaux at 1, rue Poissac, the daughter of parents unknown, as attested by an affidavit received by the Justice of the Peace of the Third District of Bordeaux on April 28 of this year, confirmed on May 4 of this year by the Court of the First Instance of Bordeaux, of which the affidavit and duly certified copies have been remitted to us in place of the birth certificate of the future wife. The individuals appearing before us and wanting to be united in marriage are acting as legal adults; the first party by the consent of his father and mother here present and the second party free and autonomous in her rights and deeds, having no known parents. In consequence, they require us to proceed with the celebration of their marriage, of which the banns were published at the main door of City Hall on the sixth and the thirteenth of this month at noon. And whereas no opposition was signified to us.

"After the above-mentioned documents and chapter 5, section 6 of the Civil Code were read to these parties and their witnesses, both contracting members, one after the other, declared their desire to be husband and wife, and we publicly pronounced, in the name of the law, that M. Raimond Bonheur, answering to the

My father was twenty-five and my mother twenty-four. Their first child, whom they named Rosalie, is right in front of you.

When I was born on March 16, 1822,[7] in Bordeaux, rue Sainte-Catherine, no astrologer was standing by to draw up my horoscope. But after I moved to By, I got into watching the planets and wanted to learn what they were doing at the time of my birth.

Benevolent Aries was at the center of the heavens, with Mars majestically enthroned. This was apparently a good omen. Although I knew nothing about it back then, I started out by painting sheep.

Maybe it's because of Aries that I'm so independent. That's helped me overcome all the obstacles predicted by the stars. Sagittarius loomed in the east, looking all the more dreadful because in the west there was another fateful sign, Taurus, a symbol of blind fury.

The sun was in Taurus. The moon, quite low, and Venus were close by. This unlucky array would have clipped my wings because Venus, the planet of grace and love, was dominated by wicked, jealous Saturn.

Had I ever married, domestic cares would have swallowed me up, as

name Oscar in his family, and Mlle Sophie are united in marriage. The following constitutes legal publication and was drawn up at the office of the Registrar in the presence of Messrs. Jean Corbin, employee in the Office of Direct Taxation, 135, cours d'Albret; Pierre Huau, naval clerk, 34, allées des Noyers; Marie-François Choppy-Desagel, professor, 20, fossés du Chapeau-Rouge; and Edouard Subercazaux, domiciled at Tauriac (Gironde), doctor of medicine, principal witnesses. After this document was read aloud, the groom, the bride, the groom's mother, and the witnesses signed it with us; the father declared that he did not know how."
(Signatures follow.)

7. A.K. Rosa Bonheur's birth certificate reads:
"On March 18, 1822, at noon, there came before us M. Oscar-Raimond Bonheur, age twenty-six, drawing teacher, living at 29, rue Saint-Jean-Saint-Seurin, who presented to us a female child, born two days earlier at eight o'clock in the evening to the man declaring this birth and his wife Sophie, which child he named Rosalie. Drawn up in the presence of Messrs. François Bonheur, paternal grandfather of the child, cook, same address, and Guillaume Laville, clerk, 3, rue Castel-Moron, principal witnesses. This document was read aloud, the father and the last witness signed with us; the first witness declared that he did not know how.
Signed: O.-R. Bonheur, father.—Laville
Marianne Perard-Bonheur (grandmother)"
Therefore, at the time that his daughter was born, Raimond Bonheur was living at 29, rue Saint-Jean-Saint-Seurin, today rue Duranteau, and not in the rue Sainte-Catherine, as Rosa Bonheur believed.

they did my mother. I was saved from that fate by Mercury, the god of commerce, along with Pollux, one of the noblest stars in the firmament.

My mother began nursing me herself. But since I was a very strong baby and cut my teeth early, I wound up biting her breasts. So, with a heavy heart, she turned me over to a good peasant woman who fed me with a spoon.

My nurse adored me. She used to go out herself and milk the best cow for me.

Her zeal made my mother jealous. Just before my brother Auguste[8] was born, she wrote this letter to her friend Victoria Silvela:

Sunday, September 12

Dear Victoria,

My Rosalie is asleep on little Jules's bed, and I'm sitting at your desk. I've just had dinner with the *abuelita*[9] and did my best to jabber Spanish with her. You can just guess how well I do that.

I really miss you, dear Victoria. I've still got lots of things to get ready. Above all, I haven't hired a nurse yet. One from La Souille came by today. She'd be fine, and I'd like to hire her. She seems decent and looks fresh and healthy. Her baby, just nine months old, is as pretty as can be. She runs around everywhere just like Rosalie. She suits me perfectly, but we can't pay what she's asking.

But, dear Victoria, I'm boring you with all these household details. I always feel that you're as interested in my problems as I am in yours. On top of that, you'll have the same worries some day. But let's hope you won't have to give your child a stranger's milk. God willing, your baby won't be taken away from you and put into mercenary hands. People say you can never be too grateful for a good nurse, but I have to admit that I'll never like the ones I've had. I can't stand Rosalie's. I'd like to be very good to her, but I don't ever want her near this house. It just tears out my soul when I see her cuddling Rosalie like her own baby.

We usually lived with Grandfather and Grandmother Bonheur, *pépé* and *mémé* in local parlance. I remember our wonderful Sunday walks and picnics. In point of fact, I spent my early years half in Bordeaux and half at Quinsac, at M. Dublan's house, where we often stayed for long periods.

8. A.K. M. Auguste Bonheur, born September 21, 1824, died February 21, 1884, at the age of sixty.

9. Little grandmother, in Spanish.

As far back as I can remember, I can see myself tearing down to the meadow where the oxen grazed. They nearly gored me several times, never suspecting that the little girl they were chasing would spend her whole life making people admire their beautiful coats.

I had a more irresistible appetite for cow barns than any courtier for a king's or emperor's antechambers. You just cannot imagine how much I loved feeling some fine cow lick my head while she was being milked!

My aunt Elizabeth, my father's sister, claimed that I loved animals so much because my mother's bedroom was papered with bucolic scenes.

M. Dublan's sons used to go hunting. I loved to follow them and see the wild rabbits leaping in the fields. Once I even tried to imitate them by jumping over a ditch and fell in. They had a hard time rescuing me from the quagmire. One of my little shoes was swallowed up right in front of my eyes, which was nearly my fate, too.

Instead of learning to read and write, I preferred playing with the little peasant children. I would draw them pictures in the sand of all the denizens of our poultry yard.

French lessons always gave me a hard time. Beads of sweat would collect on my forehead while my mother wore herself out trying to drum the alphabet into my head. One day she had a brilliant idea. She told me to draw an ass next to the *A,* a bull next to the *B,* a cat next to the *C,* and so on right up to Z for zebra. I'd never seen one of those before, but it looked like a horse painted up by some shady trader in a moment of whimsy.

This intelligent object-lesson was a revelation for my infant brain, but it didn't make me love drawing any less. I tried to do pictures like my father, and I smeared paint over every empty spot my little hand could reach.

After my father explained that he had people pose for their portraits, of course I had to imitate him. I'd sit my little Punch doll down in a chair, then set to work drawing him.

Like most children, I really wanted to know how I'd got here. One day I asked M. Dublan about this engrossing matter. Without a moment's hesitation he said: "A steamboat brought you to Bordeaux." I was so struck by his reply that the very next day I ran down to the Garonne's sandy banks to see if a passing steamboat wouldn't bring me a little brother or sister. Of course, I had no such luck, but went back again and again, sure that my ship would come in the next time. One day I fell asleep on the shore. A wave would have swept me away if my nurse, who had been looking for me, had not snatched me up and brought me home, wide awake but dripping.

One evening when my mother and I were strolling along the Garonne, I

saw the moon and the stars shimmering on the water. I squeezed her delicate hand as hard as I could and shouted: "Mama, let's go to the end of the world, we'll see them so much better there."

Whenever my mother went shopping and got back some change, I thought she was buying money. She always tried to explain, but to no avail. Nothing ever made any sense to me.

I also remember that every Sunday my mother would dress me up in white. How proud I was of my dress, with my pantaloons sticking out beneath and my red shoes. My father painted a portrait of me like this, joyfully hugging my doll to my chest, with a pencil clenched in my fist.

My mother often sang and played the harpsichord. M. Dublan would accompany her on his flute. However long the concert, I sat on the floor, hard at work on my paper cutouts. First a shepherd with his dog, a cow, a sheep, and finally a tree.

One day the duo sounded sweeter than usual. I saw M. Dublan lean down over my mother's adorable head and heard him say: "Sophie, even softer." I stopped cutting. I don't know why, but I slipped up close to my mother and watched her with delight. She cast a tender glance my way from time to time. Suddenly touched by my ecstasy, she swept me up into her lap, put my little fingers on the keys of the spinet, and began to sing along to my improvised accompaniment. Then she studied all my cutouts. What tenderness penetrated my whole being when she smiled, pressed me to her heart, and covered me with kisses, calling me her "big Rosa." Ah! what a happy time for me.

My parents were friends with two Spanish families, the Silvelas and the Figueras. Victoria Silvela was the one to whom my mother confessed her jealousy about my nurse. In their homes one often ran into other Spaniards, such as the poet Moratin,[10] who called me his "pretty little duck" and loved to play with me.

The Silvelas left Bordeaux around 1828 and went to Paris. Soon they began urging my father to follow. Driven by the desire to earn more money, my father gladly lent them an ear. Now he had had a second son, Isidore,[11] and he didn't think he could fulfill his ambitions in Bordeaux.

10. A.K. Moratin (Leandro-Fernandez de), classical poet and playwright. He was born in Madrid in 1760 and died in Paris in 1828. With his comedies, *The Old Man and the Young Girl* and *The Café*, which date from 1792, and his work, *The Origins of Spanish Theater*, he made a name for himself in Spanish literature. During the French occupation, Moratin threw in his lot with King Joseph, which forced him into exile at the time of the restoration in 1814.

11. A.K. M. Isidore Bonheur, born on May 15, 1827, died November 19, 1901.

So he went up to Paris, leaving the three of us children and my mother in M. Dublan's care (1828).

Convinced that fame and fortune would soon be his, he arrived in Paris full of enthusiasm. Indeed, Plutus appeared to greet him with a smile. With an artist's impulsiveness he begged us to come up and join him, which seemed a bit hasty to the prudent M. Dublan.

Only because of my mother's entreaties did our wise and gracious guardian finally decide to pay our way to Paris. He put us in the stage-coach himself. With the thankless indifference of youth, we hardly noticed the tears and sighs of this fine old man and his kind housekeeper, Mme Aymée (1829).

Two days and three endless nights later we arrived in Paris and fell into the arms of our beloved father. It felt like we'd been separated for an eternity.

I was seven, and my brother Auguste was just five. Isidore, not yet two, was still in my mother's arms.

Right across the street from our lodgings in the rue Saint-Antoine[12] there was a pork butcher's shop. A little boar in painted wood stood prominently displayed, like a signboard, amid the bacon and the sausages. Though it was hardly a masterpiece, I thought he was alive. Before going out, I always commiserated with him, convinced as I was that he was waiting for slaughter.

Paris looked much bigger than Bordeaux, but much uglier. The bread tasted flat. Everything, even the sun, seemed rotten. And I missed my land, trees, and animals!

The Silvelas, who ran a boarding school for boys from Spain and South America, gave my father a real hand by finding him students at the beginning. This way my father set up a modest clientele that more or less, but rather less, provided us a living.

Meanwhile my brothers and I were growing up. Our mother was our only teacher until M. Antin, an old Jansenist who ran a school in our building, offered to take us on. My parents accepted his proposal on the spot. That's how little boys became my first chums.[13] Fortunately, I was

12. A.K. Numbers 50–52, formerly 153.

13. Bonheur stresses the lasting importance of this early coeducational experience: "The influence which it had on my lifework cannot be exaggerated. It emancipated me before I knew what emancipation meant and left me free to develop naturally and untrammelled. I well remember that I was not at all shy because my only companions were boys" (Stanton, *Reminiscences of Rosa Bonheur,* p. 7).

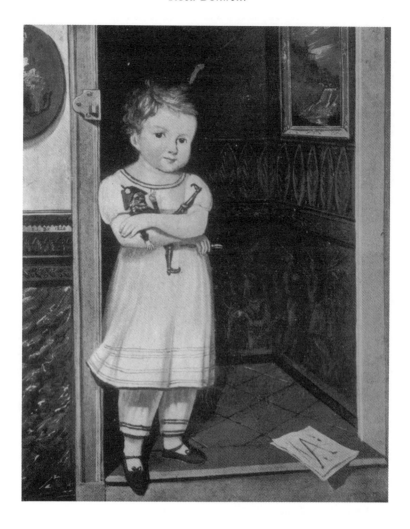

Portrait of Rosa Bonheur at age four, painted by Raimond Bonheur,
the artist's father. With one hand she is clutching her Punch doll and
with the other, a drawing pencil. (Original French edition, p. 139.)

hardly daunted by the prospect since I was used to holding my own with
my brothers. Whenever we went out to play on the place Royale, I was the
most boyish of the lot.

I've got a vivid memory of the July Revolution.[14] My little sister Juliette

14. The restored Bourbon monarchy fell after several days of street battle in the
last days of July 1830.

had just been born (July 19) when fighting broke out all over the neighborhood, and I clearly remember a cannon firing away toward the Bastille from right in front of our door. The first shot shook things up so much that it knocked my brother down from the porte cochere he had climbed up on. I also saw the royal guard attack and the insurgents throw them back with great shouts.

These were hardly happy years for us. Four children, and my father couldn't find any students. The cholera epidemic of 1832 made things even worse. I can still see the gloomy spectacle of those carts that used to rumble through the streets all day long with their load of dead bodies.

We had to leave the rue Saint-Antoine and went to the rue des Tournelles.[15] Our new home was an old Louis XIII–style building with a huge stone staircase. We lived above an undertaker, which made me afraid to be alone.

After the rue des Tournelles, we moved to the place de la Bastille,[16] then to the rue Taitbout.[17]

Near the end of 1830 my mother received an urgent call from Bordeaux. M. Dublan had fallen ill. Despite her headlong flight back home, she arrived just in the nick of time. When the old man, already at death's door, saw her, he strained to sit up and said: "Sophie, my daughter, my very own daughter, come embrace your dying father."

She ran sobbing to him and covered the contorted face of her newly found father with desperate kisses.

"My mother, who was my mother? tell me, father, I beg you."

"Child, I swore to keep that secret, but you'll find the answer in papers in my desk."

M. Dublan wanted to say something more, but he couldn't utter a single word. Crazed with grief, my mother devoted all her energy to his care, trying to prolong his life by a few more seconds. By some miracle of tenderness and daughterly love, she made him last a few more hours. During this time she paid scarce attention to what was going on around her (December 18, 1830).

When her father was dead, shriveled, and cold in his casket, she finally

15. A.K. Number 30. Raimond Bonheur seems to have left the rue Saint-Antoine in October 1830.

16. A.K. 1831.

17. A detail whose importance will become clear in the following chapter: in September 1830 the Saint-Simonians set up a public meeting hall in the rue Taitbout.

remembered the desk with its precious papers. When she went to have a look, she saw to her amazement that the lock had just been forced![18]

M. Dublan's death was the beginning of my mother's distress. At the very moment she found her father, she lost her protector. The looting of those papers meant no more help from Bordeaux. She had expected them to reveal the secret of her birth and no doubt entitle her to a part of her father's estate. When they disappeared, she was ruined.

From then on our lives were wretched.

18. A.K. M. Jean-Baptiste Dublan de Lahet died at the age of sixty-two. The widower of Jeanne-Kéty Guilhem, he lived at 15, fossés de l'Intendance.

Raimond Bonheur and the Saint-Simonians
❖
A Mother's Death (1833)

You know that a few months after the death of the famous philosopher Henri de Saint-Simon,[1] his disciples founded a religious association to popularize his doctrines.[2] In his youth this great man fought to help free America. After he returned to old Europe, he recognized only one kind of aristocracy: not the one to which this descendant of Charlemagne was entitled to lay claim, but rather the aristocracy of thinkers, engineers, poets, painters, of all those, therefore, who did useful work for humanity. After Saint-Simon's death in 1825, the faithful members of the new re-

1. A.K. At the beginning of the nineteenth century, Henri, comte de Saint-Simon (1760–1825), conceived a vast plan for social reorganization. Religion, family, property, work—nothing escaped his reformist vision. The most remarkable aspect of his project concerned the association of all working people and the overwhelming influence that he gave science and industry in the new society. Financial ruin and the unpopularity of his doctrines led him to attempt suicide in 1823. He continued his apostolate until 1825.

2. For an introduction to the Saint-Simonians as well as other forms of Romantic socialism, the basic works in English have been Frank Manuel's *The New World of Henri Saint-Simon* (Cambridge: Harvard University Press, 1956), and *The Prophets of Paris* (Cambridge: Harvard University Press, 1962); also Frank Manuel and Fritzie Manuel, *Utopian Thought in the Western World* (Cambridge: Harvard University Press, 1979).

In his recent book *The Proffered Crown*, Robert B. Carlisle provides a detailed history of the movement and its main proponents and convincingly argues for a revision of many ingrained ideas about the Saint-Simonians. My many references to this work will show, I hope, my grateful debt to Professor Carlisle.

Sébastien Charléty's *Histoire du Saint-Simonisme* (Paris: Paul Hartmann, 1931; first published in 1896) is still a useful reference work in French.

Moses, *French Feminism*, pp. 51–59, analyzes women's experiences in the Saint-Simonian movement. More recently, Claire Goldberg Moses and Leslie Wahl Rabine published, in English translation, a remarkable collection of hitherto inaccessible texts authored by Saint-Simonian women. Their book, *Feminism, Socialism, and French Romanticism*, also includes extensive historical and literary introductions to these documents.

ligion, whose most ardent proponents were Enfantin and Olinde Rodrigues, banded together and set up a sort of secular monastery in a huge house that still stands in Ménilmontant.[3]

In June 1830, the leaders of the reform movement published their membership list. It contained seventy-nine names, including my father's.[4]

My father was a born apostle. He liked to broadcast everything that he had learned and repeated, in short, whatever he found useful. He was a true servant of humanity.

He loved us impulsively, but his first priority was social reform. He never sacrified noble ideals to personal matters. When my father said that he was going to join the Saint-Simonians, my mother didn't object. Just the opposite. Thinking only of his happiness, she encouraged him to follow his heart. She even said that she'd join up, too.

At first, when they all hoped that the community would grow by leaps and bounds and spread all over the globe, the Council of the Apostles designed a huge proselytizing campaign for Paris.[5] Each district, twelve at that time, would have a permanent missionary station.

Back then I was too little to understand what was going on; but later on I tried to come to grips with the things that have made me what I am, so I bought lots of books and read all about the Saint-Simonians. What looked murky to me in 1832 suddenly cleared up. I understood what was noble about my father, but also my poor mother's anguish and pain, and I relived a moving drama whose ups and downs have had an incredible influence on my life.

The missionary stations were supposed to be staffed by three people: a doctor for the body; a doctor for the soul, who was to be a Saint-Simonian apostle; and an adjunct.

According to this lovely plan, my mother would have been an adjunct in the headquarters of the sacerdotal army. But there were enormous financial problems. The College of the Apostles managed to set up just four missionary stations. My father was named an adjunct in one of these. As

3. This house is still standing at 145, rue Ménilmontant in northeastern Paris. The little street that runs through what were once the gardens is called the Passage des Saint-Simoniens. See Carlisle, *The Proffered Crown*, p. 190.

4. Theodore Stanton adds that in the Saint-Simonian hierarchy Raimond was "among the faithful of the third degree" (*Reminiscences of Rosa Bonheur*, p. 59).

5. Here Rosa Bonheur must be referring to the attempts that the Saint-Simonians made in Paris in 1831 to attract converts from the working class. See Carlisle, *The Proffered Crown*, pp. 138–39.

for my mother, there was no longer question of any role for her, aside from taking care of her children.

Many men who have since become famous gathered round the Saint-Simonian leaders, Father Enfantin[6] and Father Bazard,[7] the "Supreme Fathers"; the Pereire brothers, the Talabot brothers, Hippolyte Carnot, Olinde Rodrigues, Edouard Charton, Jean Raynaud, Emile Barrault, and so many others.[8]

6. A.K. Enfantin (Barthélemy-Prosper) (1796–1864) became one of the most ardent exponents of the new social idea following Saint-Simon's death. After the July Revolution he joined forces with Bazard, formerly the chief instigator of the Carbonaro plots against the Restoration government. Olinde Rodrigues proclaimed the two of them Supreme Fathers of the movement. Bazard's political views soon made him move away from Enfantin, who dreamed of renewing society through love and affection. Acting both as priest and doctor, Enfantin also reformed marriage and claimed to guarantee spousal harmony through the intervention of those believers whom he invested as priests and confessors. At this point the Family became a veritable church, with Enfantin as its sole pontif, God's Elected One, the Living Law. In order to legislate harmony between the sexes, it became important that a woman be associated with the supreme pontificate. Then began the quest for the Female-Messiah, the Mother. Despite attacks from his former friends, Enfantin gained more followers with every passing day and sent his missionaries far afield. The trials of 1832 cut short all his hopes for the future. After he returned from Egypt, where most of his companions had converted to Islam, Enfantin was, in turn, a postmaster, member of the commission on Algeria, director of the Paris-Lyons Company and, from time to time, on the staff of the newspaper *Le Crédit*.

7. Saint-Amand Bazard. Before he became a Saint-Simonian in 1825, he had been a member of the French Carbonari, an underground political group of liberal persuasion that conspired against the Restoration monarchy. From July 1830 until November 1831 he and Enfantin acted as the Supreme Fathers to the Saint-Simonian faithful.

8. Emile and Isaac Pereire made some of the more material Saint-Simonian dreams come true. During the reign of Napoléon III they revolutionized banking and credit in France, helped set up the French railroad system and were active in politics. Although four Talabot brothers—Paulin, Edmond, Léon, and Jules— were affiliated with the Saint-Simonians in the early days, only Paulin and Edmond, both engineers recruited at the Ecole polytechnique, stayed with the movement. Edmond died of cholera at the communal house in Ménilmontant in July 1832, but Paulin went on to become active in politics, coal mines, and the French railroad system. Hippolyte Carnot led an active political career, except during the reign of Napoléon III, to whom he refused to pledge his loyalty. He was also the

All of the ideas that are still stirring up the working class came more or less directly from this amazing movement.

After the break between Bazard and Enfantin,[9] my father remained faithful to Enfantin and the Family.

The house in Ménilmontant was nothing like a workshop, rather a kind of seminary where the apostles were supposed to prepare for their glorious mission. Then, like Christ's apostles, they would take the good word and scatter to all four corners of the earth. The disciples of the new religion were almost all sturdy young men. They grew majestic beards, and everybody wore a really picturesque uniform: white trousers, a red vest, and a purplish blue tunic.[10] A curious detail shows just how far they pushed the outfit's symbolic value: the vest buttoned at the back, so that nobody could get dressed alone. This was their daily reminder of the need for fraternity.[11]

father of Sadi Carnot, president of the Third French Republic from 1887 to 1894. In 1894 Sadi Carnot promoted Rosa Bonheur to the rank of officer of the Legion of Honor. Olinde Rodrigues was the Pereire brothers' cousin. As an economist, he became very active in finance and industry and was instrumental in setting up savings banks, mutual-aid societies, and the French railroad system. A writer and pioneer in the magazine industry, Edouard Charton had an active political career in the 1870s. Jean Reynaud was an engineer, geologist, politician, and philosopher who wrote about Druids and Oriental religions. His scientific and theological treatise *Terre et ciel* (1854) made quite a sensation when it was condemned by the Roman Catholic Council of Périgueux. After his quest for the Female Messiah in the Orient with the *Compagnons de la femme*, Emile Barrault joined forces with Enfantin on the Suez Canal project and participated in the colonization of Algeria.

9. This schism, which took place in November 1831, was motivated by long quarrels over the place of women in the doctrine and their role in the organization as a whole. Enfantin proposed that two popes, a male and a female, should lead the movement in order to reflect the androgynous nature of God. He also advocated abolishing paternity and reformulating marriage in order to liberate the flesh and to bring about what he considered to be the complete emancipation of women. Bazard could not accept these positions. After suffering a stroke in August 1831, he died in August 1832. The break between the Supreme Fathers led to several defections from the movement. For an in-depth study of the personal and doctrinal issues involved in this matter, see Carlisle, *The Proffered Crown*, pp. 151–70.

10. A.K. Mr. Paul Bonnefon asserts that this costume was designed by Raimond Bonheur himself (*Raimond et Rosa Bonheur*, in *l'Art*, year 23, 3d series, vol. 3, p. 422).

11. Stanton also reports that Raimond Bonheur was responsible for this design (*Reminiscences of Rosa Bonheur*, p. 71).

In commemoration of the great Revolution, they all wore berets.

The Council of the Apostles decided that the commune would divide up into work details for the daily chores. Some of the men polished boots or swept up, others did laundry, cooked, or served food.

They also set up a gardening brigade. That's where my father worked.

These renovators of humanity needed money to keep on going. They lived on gifts from members and admirers.

Whenever possible, the College of the Apostles took out loans from capitalists who believed in the future of the budding institution. Yet they ran their finances most irregularly. I remember hearing someone tell my mother in early May 1832 that Father Bouffard, the general treasurer, needed more than two hundred thousand francs. At that time there were only seventy-five francs in the till.

Private visits took place on Wednesdays. The Saint-Simonian wives, including my mother, always went to see their husbands and brought along their children.[12] That's how I made friends with the children of the famous men I've mentioned.

For these weekly pilgrimages, my mother used to make me wear the Saint-Simonian bonnet. More than once packs of street urchins threw rocks at me and jeered at my hat with its huge tassel. I remember how happy it made my father to see us wearing the colors of the Ménilmontant Family, what a warm welcome he'd give his wife, how earnestly he'd tender, along with some fine words, the offering she had come for. Oh! there was never any lack of fine words! Whenever my father was in a fix, he would wax truly eloquent and rekindle my mother's faith by giving her a glimpse of the New Christianity's imminent triumph.[13]

Sundays were for the general public. I've even heard that the commune sometimes had as many as ten thousand visitors at a time. Just a few little

12. Although Enfantin continued to invoke the Female Messiah and to call for the total emancipation of women, women occupied a paradoxical position after the schism of 1831. They were removed from the degrees of the governing hierarchies. No women, not even wives who were actively involved in the movement, were allowed to participate in the commune. At Ménilmontant the monastic model was taken quite literally; the apostles' celibacy and the separation of husbands and wives were assumed to be permanent. This caused many of the women considerable pain, perplexity, and hardship. See Carlisle, *The Proffered Crown*, p. 189, and Moses, *French Feminism*, pp. 61–62.

13. Saint-Simon's last published work (1825) was entitled *The New Christianity*.

ropes cordoned them off from the rest of us, and they were enthralled watching the members of the new sect go about their business.

The first public ceremony took place on June 6, 1832. At that very moment, a cannon in the rue Saint-Martin was firing on a barricade heroically defended by a handful of republicans.[14]

The sunny sky suddenly clouded over. There were violent claps of thunder, and I saw one of the apostles look at Enfantin and shout: "Father, there are two storms at once."

We were there to witness the solemn taking of the habit. One by one, the apostles went up to Father Enfantin, who gazed at them like a high priest and asked: "Do you have the strength to take this vestment?"

My father stepped forward in turn. I didn't understand what he said, but later I read his speech in a brochure. You can find it at the Arsenal,[15] to which Father Enfantin bequeathed his books and papers.[16] My father didn't dare accept the apostolic vestment and said poignant things about his family's precarious situation. Yet, reassured by the fact that Talabot[17] joined the apostles, he was finally ordained.

On July 9, the foundations of the Temple were laid with great pomp and ceremony. The Family gathered on the lawn to await Father Enfantin, who came out of the house with a brilliant cortege. My father, who had been asked to serve as herald because of his beautiful voice and noble bearing, gave the solemn cry: "The Father!"

Félicien David's hymns were first performed at this ceremony. I was so impressed by their words and harmony that remembering these events makes me hear them all over again.

14. The July Monarchy (1830–48) was insecure in its early years. Many of those who had helped bring down the previous monarchy wanted a republic, and they felt betrayed by the new monarchy. During these unstable times France was frequently astir with conspiracy, riot, and insurrection, both real and imagined. The insurrection referred to here was of the real variety.

15. The Bibliothèque de l'Arsenal in Paris.

16. Carlisle in *The Proffered Crown* quotes, p. 185, a translation of one of Raimond Bonheur's professions of faith in Enfantin: "Father, I believe in you as I believe in the sun. You are in my eyes the sun of humanity; you warm it with your love, which is the living image of the Infinite love of God." In his bibliography Carlisle describes these and many other Saint-Simonian documents available at the Bibliothèque de l'Arsenal and the Bibliothèque Nationale.

17. Probably Edmond Talabot, who took part in the Ménilmontant experiment and died there of cholera on July 17, 1832.

By a strange coincidence, the public prosecutor chose this very day of celebration to subpoena the Saint-Simonians.[18]

Father Enfantin and the four head apostles were soon tried on charges of immorality and public disorder. They would also be prosecuted for fraud in a second trial later on.

The first case was heard on August 28. This persecution only increased my father's usual fervor. He went to court in his Saint-Simonian habit and marched in with the apostles who had been made scapegoats for the sins of the whole community.

My father was one of Enfantin's forty defense witnesses. Like all the others, he refused to testify. Father Enfantin had got indignant about the prosecutor's tactics and ordered them not to say a word, all the while boldly declaring that it was his aim to transform public morality. He presented two women as his legal counsel, which the court naturally rejected.

In two majestic processions from Ménilmontant down to the courthouse, my father and all the brothers marched as toward crucifixion behind Father Enfantin through turbulent crowds booing and cheering.

The accused were convicted on August 29. Heads high, they returned in silence to the persecuted Family's retreat.[19] On October 30, they went back to court. This time they were acquitted.[20]

18. The Saint-Simonians' legal problems began soon after the sensational schism between Bazard and Enfantin at the end of 1831. On January 22, 1832, a small army arrived at the Saint-Simonian house in the rue Monsigny, forbade Enfantin and Rodrigues to leave the house or to communicate with the outside world, and seized their papers. At the same time the authorities closed the Saint-Simonian lecture hall in the rue Taitbout. After months of investigation, the government indicted Enfantin and two others for "outrages against public morality committed in writings printed and distributed," for violation of the law on public assembly that forbade meetings of more than twenty people, and for embezzlement. The first two charges were the object of a trial in August 1832; the charge of embezzlement was considered in a separate trial in October 1832. For more details, see Carlisle, *The Proffered Crown,* pp. 185–86.

19. Carlisle gives a fine description and analysis of the first trial in *The Proffered Crown,* pp. 214–22. Enfantin and two others were found guilty as charged and sentenced to one year in prison and fines of one hundred francs each. Rodrigues and Barrault were each fined fifty francs.

20. For more details about the second trial, see Carlisle, *The Proffered Crown,* p. 222.

They celebrated the happy outcome with a banquet at the Suckling Calf, a restaurant in the boulevard du Temple that enjoyed a fine reputation among Parisian gourmets.

Despite the stalwart souls of the faithful, the conviction made the Family's situation really much worse. Very few newspapers—*The National*,[21] for example, even though it rejected Saint-Simonian doctrine—criticized the court action as an attack on free thought.

Their money was running out, and when Father Enfantin and his codefendants went to Sainte-Pélagie[22] in early December, the house at Ménilmontant was almost deserted. It was time to think about dispersing.

The apostles broke up into two groups. The first would keep on proselytizing in France; the second, which was much bigger, would go spread the persecuted doctrine in the Orient. Duveyrier and d'Eichtal led this group, some of whom headed for Egypt and the others toward Greece.[23]

My father couldn't join either one of these hives of missionary activity because of his family responsibilities,[24] which he sorely regretted. Several times I heard him say in exalted moments that the Catholic Church alone understood that men and women who wanted to devote themselves to a great cause had to choose celibacy from the very start.[25]

Whenever my father broached this topic, my mother would dissolve into tears, take me in her arms, and grip me in convulsive hugs. I was too

21. A staunchly republican newpaper that wanted nothing to do with any kind of socialism.

22. A Parisian prison that had occasion to welcome many of the most famous social reformers and dissidents in nineteenth-century France.

23. The Egyptian expedition, in which Enfantin participated after his amnesty and early release from prison on August 1, 1833, involved ambitious public-works projects such as plans for the Suez Canal and dams on the Nile. Another group, organized around Barrault's *Les Compagnons de la Femme,* went off to Greece and Turkey in order to spread the Saint-Simonian faith and continue the quest for the Female Messiah.

24. Contrary to this statement, Stanton claims in his *Reminiscences of Rosa Bonheur* that Raimond was in fact among the missionaries whom Enfantin sent out from Ménilmontant in late 1832, p. 75.

25. When Enfantin was challenged by a fellow member, a Swiss engineer named Capella, to defend the Ménilmontant experiment, he stressed the incompatibity of Saint-Simonian apostleship and marriage in his letter of reply: "I have constrained no husbands to quit their wives. But I feel the need to call woman to live, to a new union. It is better to be out of the old one, which doesn't mean to say one can't do good things married. Only one can't be an apostle—that is, a caller of woman to a new destiny." Quoted by Carlisle in *The Proffered Crown*, p. 188.

little to understand what these words meant, but they stayed indelibly engraved in my mind and played a big role in turning me away from marriage.

If you want an idea of my father's feelings of universal goodwill, go read his article in the National Library.[26] It appeared in a journal founded after the breakup of the Saint-Simonian family, in the first and only number of a paper called *The Theo-gyno-demophile's Notebook*. That long word means "the friend of God, woman and the workers."[27]

Ethics: One Truth among a Thousand

In religion, politics, and ethics, our many diverse opinions prove, after careful study, to be nothing more than the expression, the incomplete medium, of one will imperfectly conceived, imperfectly expressed, imperfectly judged, and which deserves our kind consideration and respect rather than our vain hatred, because this will that spurs on generous champions is good, as is its goal: the well-being and the salvation of all.

Indeed, these divisions that make the various parties hideous and shameful because of their excesses, which make them stupid and blind, this is all fermentation, a laboratory experiment that is preparing, filtering, testing, and purifying humanity's well-being and salvation. Out of the clash of various opinions is born the light that brings them closer to harmony every day.

But that proud penchant that makes us violently impose our own opinions, without taking into account the total picture, the particular time and place, is wrong. It is wrong to think that we alone stand for truth and justice and to see in all the others nothing but contrary vices.

It is wrong to overlook the goodwill, more or less luminous, more or less explicit, at work in men who are meant to grow strong together. I mean those who take up a banner in good faith, not the ones who do so to satisfy their greed. Unfortunately there are dangerous egotists in every party. Those who take pleasure in overshadowing a good intention and sowing division with arguments that they know to be false, who abuse the mind and make bad and subtle definitions are the cruel-

26. The Bibliothèque Nationale in Paris.

27. A.K. This item is cataloged under the name Raimond Bonheur with the call number Zp. 1390. It is a little brochure of sixteen pages in octavo, printed in 1833 by Cordier and signed by E. Javari, R. Bonheur, and G. Biard.

est and most criminal. Such traitors have often stood in the way of enlightenment, and more than once they have flooded the earth with human blood. But providence sweeps away these base deeds that are unworthy of humanity, and justice grows and requires better thoughts and deeds.

<div align="right">R. Bonheur</div>

Despite my father's reputation, he could find only a few pupils after the wreck of the Family. Yet he had four small children to feed! My mother gave private music lessons for twenty sous in her moments of respite from my little sister Juliette, barely two. These were her only out-ings, except for her early-morning trips to the central market for cheap vegetables, which were about all we ate. Our circumstances were simply dreadful.

I was so happy-go-lucky that I had no idea what dire straits we were in, and I often begged my mother to sing as she used to do in Bordeaux. She always agreed, and I was ecstatic whenever I heard her sing. One day her voice seemed sadder than usual, and I couldn't help saying: "Mama, stop, it sounds like you're singing for your supper."

"What a baby you are," she replied. "So grab a stick and dance."

And I danced, happy to see my mother smiling at me while she settled back down to work. She worked very hard, taking care of all our clothes and making cheap garters that paid even less than her music lessons. She sacrificed her health to this thankless task and barely scraped up twelve sous a day for our starvation budget.

Our doom weighed even heavier when I got sick.[28] I can still see my mother bending down to make me drink my medicine. She'd put her hand on my burning brow, and I'd wrap my arms around her neck and plant long kisses on her beautiful eyes, brimming with tears. Alas! She got so worn out taking care of me that her constitution, already terribly beset by the strain of bearing up so proudly in such wretched circumstances, com-pletely broke down . . . She died. After growing up like a princess, she didn't even get a proper grave. We were so poor that we had to let her be buried in a potter's field.[29]

Ah! what a sorry thing life is! My mother, the most noble and proud of

28. Bonheur apparently had a bout of scarlet fever. See Klumpke, *Memoirs of an Artist*, p. 50.

29. A.K. Madame Bonheur's funeral took place on May 1, 1833, and her remains were deposited in a common grave at the Montparnasse cemetery.

creatures, succumbing to exhaustion and wretched poverty, while my father was dreaming about saving the human race.[30] When I was flush with success and earning more than I could ever spend, what wouldn't I have given to know where to weep over my mother's remains, but it was too late!

30. In her correspondence with Venancio Deslandes, Bonheur maintained that Raimond was still living at Ménilmontant at the time of Sophie's death: "My poor mother's death occurred in 1833, at the age of thirty-five, or perhaps a little more. At this time my father was still with the Saint-Simonians at Ménilmontant, and came down only a few days before her death, she hiding from him her dire poverty" (Stanton, *Reminiscences of Rosa Bonheur*, p. 34).

Education
❖
Raimond Bonheur and the Knights Templar
❖
An Irresistible Penchant for Painting

After my mother died, Mme Aymée, who had been absolutely devoted to her, transferred to us her love for the woman for whom we were all grieving. Out of the goodness of her heart she wanted to take me back to Bordeaux. But I was already eleven, and my father preferred to give her my sister Juliette, who was just three. I went to live with him on the quai de l'Ecole.

After Juliette left, I was the only one still home. My father taught drawing in a boarding school, and he had managed to get my two brothers enrolled there. My aunt Elisabeth was left in charge of me. Her friend, Mme Pèlerin, who lived in the allée des Veuves off the Champs-Elysées, looked after me, and I went to a school run by the nuns of Chaillot.

This is what Eugène de Mirecourt wrote about my childhood:[1]

The Bois de Boulogne bore little resemblance to what the genius of luxury and improvement has made of it now.

There were just bunches of badly pruned saplings, a mediocre successor to the old oak, beech, and birch felled by the Cossacks in 1815.[2]

Broad, dusty avenues cut through those insipid little thickets at right angles. Practically nobody went there on weekdays, except to have a duel or to commit suicide.

A few bourgeois from around Neuilly would come looking for shade during dog days. Now and then you might run into four or five avid riders on old nags or poor little truants who sought relief from the teacher's cane or the dunce's cap by chasing butterflies or flushing blackbirds out of their nests.

Despite its sun-roasted shade and dreary solitude, the Bois de Boulogne had one fervent admirer back then: a little girl scarcely ten.

1. A.K. Eugène de Mirecourt, *Les Contemporains. Rosa Bonheur.*
2. Reference to the troops who occupied Paris after the fall of Napoleon.

She thought going to the park was the best thing of all. Every day that the good Lord sent neither fog nor rain, she was usually there.

With her alert face, offhand manner, cropped hair, and round face, you might have taken her for one of our heroes of hookydom. Yet a short dress over a pair of brown trousers showed that she was a girl.

She would pick huge bouquets of daisies and buttercups on the riverbank and the forest's edge, or else dive into a thicket and spend hours lying on the grass. There she would listen to the warblers, study the lovely effects of light filtering through the branches, or dreamily contemplate the huge white and pink clouds that the setting sun scattered through the sky.

Sometimes she would stop by the side of the road and draw pictures in the sand with a twig, pictures of everything that struck her eye, horses and riders, animals and people, men and women strolling. She framed her figures in fanciful landscapes full of windmills and thatched-roof cottages.

She would get so absorbed that she would not see the curious folks who gathered round.

Astonished, they would wax ecstatic over the accuracy of the figures that the little girl traced in the dirt.

Once someone said to her: "Do you know you're a very good artist, little girl?"

"Of course, sir," was the child's firm reply. "Papa is a good artist, too. He's my teacher!"

Needless to say, the young artist of the Bois de Boulogne was Mlle Rosa Bonheur.

Even as a child, she showed prodigious talent.

Her father, Raimond Bonheur, was a gifted artist.[3]

My father, who was a good teacher, was too smart not to recognize my talent, but the school of hard knocks had taught him that art was such a difficult career, even for a man, that he dreaded this risky profession for his daughter. Not unreasonably, he thought it best to apprentice me to a seamstress named Mme Ganiford. The trouble was, I couldn't stand working over a needle all day long with my head bowed, my tongue tied, and no fun except for sticking my fingers. How could a high-strung girl

3. This passage is drawn from pp. 6–10 of the edition of Eugène de Mirecourt's *Les Contemporains* already cited by Anna Klumpke. Rosa Bonheur found this particular passage and many others riddled with errors. See her corrections of the Mirecourt text in Stanton, *Reminiscences of Rosa Bonheur*, p. 34.

like me resign herself to that fate? As soon as Mme Ganiford was busy with a client, I'd tear out of her workshop into her husband's. He made percussion caps, and I helped him turn the wheel. This was a job fit for a giant squirrel, but I liked it much better than sewing hems. My father soon realized that it was impossible to overcome my loathing for needlework, and he had no choice but to take me back home.

For a while I tried my hand at the coloring trade with some friends of my father. The Brissons stenciled colors on fashion engravings, coats of arms, and kaleidoscopic views. Although the work was all right and I earned a bit of money, it wasn't a long-term thing. Mme Brisson was a fine woman, but a bit eccentric. Despite three sons, she was heartbroken because she didn't have a daughter. To indulge her fancy, she got the wacky idea of calling the boys by girls' names at home. Her youngest son, my best friend, answered to Eleanor.

Then M. Geoffroy Saint-Hilaire, the famous museum director,[4] asked my father to do a long series of natural history plates. From that point on, work and lessons took up all his time, and he had to give up teaching me himself. He didn't want me wallowing in ignorance, so he got the fine idea of putting me back in school, this time in an establishment run by the fine M. Gibert and his wife in the rue de Reuilly. As with my brothers, he worked something out so that the lessons he gave covered my fees.

I was a real devil there! If I'd had my way, all those little girls would have turned into tomboys. It comes as no surprise that Mme Gibert didn't much appreciate my free spirit. Instead of learning lessons, I spent my time sketching every beast in Noah's ark or drawing sublime caricatures of my teachers. I'd tie those lampoons to a bit of string with a wad of chewed-up paper at the other end and throw the whole thing up to the ceiling, hoping it would stick. Then there was the teacher hanging by the throat! My classmates used to split their sides laughing. I was, of course, severely punished, but to no avail because I noticed that my caricatures were never given back. I even thought that they were carefully stowed away. Maybe they caught too many likenesses?

Despite himself, my father really had to award me first prize in drawing,

4. French zoologist, professor at the National Museum of Natural History in Paris, and founder of the zoo at the Jardin des Plantes. He became a European celebrity after a widely publicized debate in 1830 in which he championed the notion of "unity of composition," i.e., that all forms of life have one basic structure that is modified by the environment in which they live.

but he knew from his colleagues that I was at the bottom of the class in every other subject.

Shortly after my mother's death he had become a Knight Templar. This was one of the many secret societies that had conspired against the Bourbon throne before 1830, attracting the very best of those French who loved progress and liberty. This association claimed direct descent from the warrior-monks it was named for.[5]

At the beginning of the fourteenth century[6] a ferocious French king[7] had more than a dozen Knights of the Temple burned alive on the terrace of the Pont-Neuf. On that very spot there now stands a statue of his most worthy successor, the good king Henry IV,[8] whom you certainly love as I do.

The Knights Templar set great store by their own gospel, which they claimed was the only true one. They had strange, mysterious rites. Back

5. The Order of the Knights Templar was founded in 1118 at the time of the Crusades. Its mission was to protect pilgrims on the routes of Palestine and to defend the Christian religion and its sacred sites from the Saracens, and its members took vows of poverty, chastity, and obedience. By the beginning of the fourteenth century, this high-minded mission seems to have been largely forgotten. The air was rife with accusations of greed, secular ambition, and corruption against the Knights Templar. Monarchs who were jealous of their great wealth and power finally decided that they had to be destroyed. After their grand master and other leaders were burned as heretics in 1314, the order came to an end.

Although some believed that the medieval Order of the Knights Templar had continued an underground life up through the centuries, the organization that Raimond Bonheur joined in the 1830s was set up in France at the end of the eighteenth century by Freemasons who wanted to draw upon the prestige of the medieval order and attract distinguished members of the aristocracy into their ranks. During the Restoration, the Knights Templar became a secret society that promoted liberal ideals and social reform. It is interesting to note that P. M. Laurent and Hippolyte Carnot, who would later become central figures in the Saint-Simonian movement, vacillated between the two organizations in the late 1820s. See Carlisle, *The Proffered Crown*, p. 62, and Stanton, *Reminiscences of Rosa Bonheur*, p. 10.

6. A.K. In 1314.

7. Philippe IV, known as Philippe le Bel, king of France from 1285 to 1314.

8. Henri IV reigned over France from 1589 until his assassination in 1610. During that period France was torn apart by wars between Catholics and Protestants. His conciliatory policies in matters of religion as well as his reputation for wit and gallantry made him legendary among French monarchs.

then their grand master was a famous doctor and one of my father's personal friends. They first met in a little café close to where we lived, the Café du Parnasse, once owned by Danton's father-in-law. My father's learned friend was named Fabré-Palaprat.[9] He devoted his life to the study of electricity. A founding member of the Galvanic Society of Paris, he tried to interest people in Volta's experiments, which were often dismissed as totally insignificant at the time.

Fabré-Palaprat had been awarded the Legion of Honor for his brave defense of Paris in 1814[10] and also the July medal for his actions during the Three Glorious Days of the Revolution of 1830.[11]

One day my father fetched me from school. That evening he took me to the Knights' Chapel in the Court of Miracles[12] to make me into a little Templar or, in the mystical terms of the order, to have me rebaptized. To complete the initiation ceremony, I had to trot on my little legs down through an archway of swords that the knights, lined up two by two, crossed overhead.

The celebrants, great numbers of them, so I thought, wore long white cloaks with a huge scarlet cross at the shoulder. Their heads were hidden by helmets that rose to a sharp point. A faint light flickered in the chapel where this extraordinary ceremony took place, and far-off strains of organ music seemed to rise up out of the depths of the earth. Of course, I didn't

9. Bernard Raymond Fabré-Palaprat, who was also the author of various pamphlets and books. A quick sample of their titles gives a good idea of the range and scope of his interests: *Galvanism applied to medicine* (1828); *Sketch of the heroic movement of the Parisian people, in the immortal days of July 26, 27, 28 and 29*—"profits from this sale going to the victims" (1830); *Levitikon, or a demonstration of the fundamental principles of the doctrine of the Primitive Christian-Catholics, followed by their Gospels, an Excerpt from the Golden Table and their Ceremonial Rite for the Religious Service* (1831); *Observations on a Mute Healed by Galvanism* (1835); *Historical Research on the Knights Templar and their Religious Beliefs* (1835).

10. In March 1814, just before Napoléon's fall, Paris tried without success to defend itself against the invading armies of Great Britain, Sweden, Prussia, and Austria.

11. The July Revolution took place July 27–29, 1830. These three days, often referred to as *Les Trois Glorieuses*, brought down the restored Bourbon monarchy and inaugurated the reign of Louis-Philippe.

12. An area in central Paris where various kinds of outcasts, beggars, and thieves allegedly congregated and formed their own underground societies. This area was mostly wiped out by urban-renewal projects in the second half of the nineteenth century.

understand what was going on, but I felt transfigured. Once a feeble little girl, now a valiant woman warrior! (fig. 6).

For nights afterward I had a terrible time trying to fall asleep in my little school-cot. One night when a beautiful full moon was shining through the windows, I just couldn't stand it any longer. I got up, hardly bothered with any clothes, but carefully buckled round my waist the little wooden sword they'd given me. I slipped down to the garden where I set off with a kingly strut like Don Quixote.

Masses of magnificent hollyhocks lined the garden paths. Behold! A hostile army of Saracens! I drew my awful weapon out of its cardboard sheath, then cut and thrust until the last one lay flat on the sand.

After having split all those enemies of God and country down the middle, which had not been not fast work, I was so exhausted that it was hard dragging myself back up to bed. I fell sound asleep, happy to have done my duty, and woke up at the usual hour. When I joined my class-mates for breakfast, all the little misses looked grim as could be! Having totally forgotten my nocturnal triumph, I innocently asked what was going on.

"What's going on!" raged Mme Gibert. "You know exactly what's going on! You're the dirty little brat who cut down my hollyhocks, aren't you! I'm going to tell your father, and you're out of here!"

That excess of knightly enthusiasm got me expelled, which settled my future life and work. When I got home, my father put a plaster cast and some pencils and paper down in front of me and said: "Daughter, since the only thing you can do is draw funny little men, these are your tools from now on. Try and learn how to use them so that you can earn your keep and lead a decent life."

Despite his severe tone, I was delighted. It was just what I wanted to hear. At long last I was going to be able to draw to my heart's content, without anyone scolding me for it!

Back in our little studio in the rue des Tournelles, I worked desperately hard, lovingly drawing copies of the plaster casts my father gave me, not even pausing when friends dropped in. As soon as he came home in the evening, he'd inspect my day's work. He corrected my mistakes more severely, I think, than those of his pupils, but if I managed to draw some-thing decent, he was glad to congratulate me.

One day my father left his paints home. I grabbed them, tore down to buy a few cherries, and then began painting my first still life on a little canvas I dug out of a corner of the studio. I can still see the surprise on his face. "That's very good," he said, hugging me. "Keep on like that, and

you'll turn into a real artist." He patted my hair and said in an emotional voice: "Maybe, daughter, I'll fulfill my own ambitions through you!"

Soon he agreed to set me up in the Louvre. Now I could work in this sanctuary to my heart's content! I was so happy that the whole first day my hand shook like a leaf and I couldn't draw a single stroke. When I got home that evening, my father saw how upset I was and asked: "What's wrong with you? Are you sick?" I threw myself sobbing into his arms and wailed: "I'm so overwhelmed with joy that I couldn't even draw today, but this is the last time that you'll have to complain about me being so lazy."

My father told me, of course, to be on my guard with my fellow art students in the beautiful

Sketch by Rosa Bonheur of an "old maid" ["vieille fille"] (Original French edition, p. 162.)

sculpture gallery. I minded what he said. Apparently I even strutted around like a soldier, with my heels making wonderful reverberations on the tile floor. That's why the Beaux-Arts[13] students called me "the little hussar." At least I managed to keep them at a distance.

A few of them scoffed at me, but I got revenge with my caricatures. These are a few samples of what I could do when I was just fourteen, an art student and an old maid. The old maid in the latter wasn't one of my persecutors, just the opposite; she was very nice and would have rushed to my defense, if that had been necessary.

I'd spend the whole day at the Louvre. Bread, fried pototoes, and a few sips of water from a fountain suited me just fine for lunch. My father didn't do much cooking in the evening. He used to send me to a little neighborhood joint to fetch some broth. That, along with some bread, was our entire dinner.

13. The National School of the Fine Arts.

Sketch by Rosa Bonheur of an art student she observed at the Louvre during her student days. (Original French edition, p. 163.)

Before bed I'd study French history in a book that my father had got for a song, a general outline of things from the Gauls up through year three of Louis-Philippe's reign.[14] Not only did my father teach me the high points of French history, but he made me write about the events that really struck my imagination.

I remember taking a stroll with him one afternoon. We walked from Paris out to Mount Valerian, where there was then an old cemetery around the ruins of a huge monastery.[15] My father lingered among the graves, probably thinking about my mother, whom he had lost a few years before.

Afterward he walked on in silence, totally absorbed in his thoughts. I trotted behind, like a dog with its master, all the while musing that someday I'd lose him, too. I was quite moved by this thought, and out of love for him I began to walk in his footsteps. This was an amazing idea for a little girl. Where did it come from? Maybe from my mother.

During evenings at home, in order to take my mind off our many worries and the haunting thoughts of my poor dead mother, I'd sometimes draw plaster casts of animals by lamplight. I soon realized that there was a real advantage to working like this. The shadows stood out so clearly that I could engrave in my mind the shapes of the oxen, sheep, and horses with

14. Louis-Philippe took the throne in July 1830.

15. Some eleven kilometers to the west of Paris. A fort was built on this site shortly after this visit.

surprising ease. A sculptor named Mène,[16] a very talented friend of my father's, had made many of these models. I found these wonderful casts so interesting that I began making my own. Having learned to handle the trowel as well as the paintbrush, I created a whole herd of miniature animals, ewes, wethers, rams, oxen, bulls, horses, and deer. I was the one who gave my brother Isidore his first lessons in modeling and sculpting.

"Seek your way, daughter," my father said again and again. "Seek your way, try to surpass Mme Vigée-Lebrun, whose name is on everyone's lips these days.[17] She's a painter's daughter, too, and she did so well that by the age of twenty-eight she got into the Royal Academy,[18] and now she's a member of the Academies of Rome, Saint Petersburg, and Berlin."

These words haunted me night and day, and I ran them over and over in my mind. Yet it seemed to me sheer madness to follow her path.

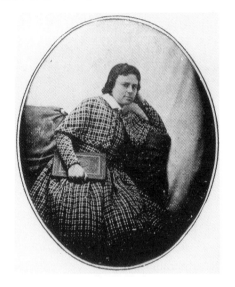

Rosa Bonheur at age sixteen.
(Original French edition, p. 166.)

"Couldn't I become famous," I once asked my father, "by just painting animals?"

16. A.K. Mène (Pierre-Jules), 1810–1880.

17. Elisabeth Vigée-Lebrun (1755–1842), French portrait painter known particularly for her portraits of Marie-Antoinette, Mme de Staël, and other high-placed women. Her *Mémoirs* first appeared in 1835 and have recently been republished in two English translations.

18. Before the French Revolution, no more than four women could be members of the Royal Academy at any one time. In her pioneering essay, "Why Are There No Great Women Artists?" (1971), Linda Nochlin discusses this and several other institutional obstacles that stood in the way of aspiring women painters (republished in *Women, Art, and Power and Other Essays*). Germaine Greer continues this discussion in her book *The Obstacle Race*. The pages that she devotes to the humiliations suffered by Vigée-Lebrun offer a darker complement to the rosy scenario put forth by Raimond Bonheur.

"Of course," he replied, "and I'll repeat what a French king once said: 'Si Dieu le veut, tu le peux.'[19] Let this be your motto."

From that day on I worked especially hard copying drawings by Salvator Rosa and Carl Dujardin.[20] I liked pictures with horses, dogs, or sheep, and my favorite painters were Paul Potter, Wouwermans, Van Berghem.[21] As I said in the *Ladies' Home Journal*,[22] I found the old masters simply fascinating. That's why I cannot say often enough to beginners: fill your head chock full of studies; they're the true grammar of art, and you can only gain from spending your time this way.

The art students who had made fun of me stopped jeering when they saw my copies.

I finally sold my first painting and made one hundred francs. What joy! I thought I'd really made it! Little by little I lined my father's pockets.

Here's a daguerrotype of me back then. The album I was holding never left my hands. In those pages I sketched everything I saw. My brown hair had copper highlights, just like my mother's. It was shorn off after she died; for who was going to take care of my curls then? The little checkered dress and cape were my uniform. As you can see, I wasn't running around Paris dressed like a boy, as some of my biographers have claimed. I didn't start wearing trousers until after my first Salon, when I began going to slaughterhouses and markets to study the oxen and horses.

Life with my father was a mix of tragedy and farce. His studio, which was rarely swept out, was chaos, confusion, a real bazaar. Every time he got his hands on some money, he'd toss the coins to all four corners of the studio, since he was afraid of spending it too fast. When he needed a bit of money, he'd say: "Come, daughter, dig around and find me a twenty-franc piece."

Nathalie Micas, who came to play such a big role in my life, found me in these sorry circumstances. I was fourteen; she was only twelve, but taller than I was. Although her family came from Portugal, they had been in

19. If it's God's will, you'll find a way.

20. Respectively, Italian artist of the Baroque period who is best known for war scenes, seascapes, and stormy landscapes; and seventeenth-century Dutch painter known particularly for portraits, biblical motifs, and peasant scenes.

21. Potter was a seventeenth-century Dutch painter particularly known for landscapes and animal paintings. Philips Wouwermans and his brothers Peter and John were seventeenth-century Dutch painters. They are particularly known for biblical motifs, military subjects, seascapes, and hunting scenes. Van Berghem was a seventeenth-century Dutch landscape painter.

22. A.K. December 1896.

Paris for a long time. One of her great-uncles was a Knight of the Order of Saint-Louis and a lieutenant general under Louis XV and Louis XVI.

M. Micas was a victim of the Revolution. After it swallowed up his father's entire estate, he had been forced to take up the printing trade. Later on, he started manufacturing various kinds of covers and casings, and his wife managed a little workshop at 43, rue de Montmorency with twenty-odd women employees.

One day M. Micas walked into my father's studio. He had come to ask him to paint Nathalie's portrait: "You've got to take me out of turn, sir," he said in a terribly sad voice, "because the poor little girl won't be with us much longer." Apparently his daughter was very frail, which gave them a lot of worry.

She began posing right away. It was the start of a new life.

As soon as I saw the sick girl's face, I was filled with wordless surprise. Just a few nights before I had seen the same pale, brown-haired girl in a dream. She was coming down an old staircase toward me.

There was another wonder in store for me a few days later. The first time I went to the Micas's apartment, I immediately recognized the staircase in their building as the one in my dream. I just had to tell Mme Micas about this strange coincidence. That, of course, led Nathalie and me to talk about our childhood. I was stunned to learn that we had already met a couple of times. During one of those Sunday visits that my mother and I used to make to Ménilmontant, I had fun with some other Saint-Simonian children throwing apples over a wall to a bunch of little boys and girls, among whom was Nathalie. We had a ball watching them fight over our gifts.

Nathalie was also the little girl who was taken out for a walk every day on the place Royale.[23] I thought she was funny because of the green visor that her parents made her wear to protect her weak eyes from the sun's glare! That visor made the little scamps of the Antin school[24] hoot with laughter, and I was one of the worst.

Mme Micas often came to Nathalie's sittings. More than once she was moved to tears by what I told her about my mother and how truly devoted I was to her memory. That fine woman grew fond of me, and she tried her best to make me forget my irreparable loss. With all her kindness, how

23. Now the place des Vosges.

24. In chapter 9 Rosa Bonheur told about the coed school run by M. Antin that she and her brothers attended during their first years in Paris.

could she have failed to win my love and trust? She was the first one I told about a dream that I dared not mention to my father.

One night I thought I saw my mother standing by my bed. She was wearing a white dress, and her curls floated down over her shoulders. However great my shock, it couldn't match my joy. I shot up and tried to throw myself into her arms. A strange lethargy paralyzed my limbs. Yet I managed to cry out: "Dear Mama, you're not dead?"

My mother smiled and shook her head. Then she put the first finger of her left hand up to her lips. Without ever taking her loving eyes off me, she vanished as quickly as she had come. The memory of this dream, this vision, has been my lasting consolation. Since then I've never stopped believing that my mother appeared in order to make me understand that she was still alive and close by. How often, in difficult moments, I've felt her protection! Oh! yes, she's been my guardian angel, the saint to whom I've raised my prayers and invocations.

My father always sold his paintings for ridiculous sums. For him, 150 or 200 francs for a portrait was a windfall. When Nathalie's was all done, M. Micas wanted portraits of himself and his wife. The main thing that these frequent meetings achieved was that the two men soon became the best of friends. Maybe they were just made for each other, but M. Micas was deeply moved by my father's tender care for little Nathalie, and that certainly made their friendship bloom.

Our house was often a mess, and my clothes were, too. Nathalie volunteered to take over a chore I always botched. So she always came early and left late. I paid her back with drawing lessons in which she reveled and showed real talent. I was very proud of my pupil.

M. Micas and my father took equal pleasure in our growing affection. My father's nickname for Nathalie was Nanette. M. Micas's for me was more poetic; I was "his little forest flower."

Around that time my father met some people whose patronage proved very useful to him: M. Feuillet de Conches, M. Germain-Leduc, and the Czartoryskys.[25] Princess Adam Czartoryska even came to our house. She

25. Baron Félix-Sébastien Feuillet de Conches was the son of a sculptor. In his day, he was a well-known writer on agricultural matters and one of Balzac's friends. Pierre-Etienne-Denis Leduc, known as Saint-Germain, was a French journalist and author of various novels and books on agriculture and geography. During the Second Empire he managed all the court ceremonies at the Tuilieries. The Czartoryskys were an ancient princely family of Poland. When Russia once

did beautiful embroidery that was sold for the benefit of the many Polish refugees in France just then. She found several pupils for my father, and I gave a few drawing lessons to her daughter, Princess Ida. Oh! that was time well spent! We used to slide all up and down the great gallery. I was already a young lady, but I still loved roughhousing. At twenty I still played horse now and again with my brother Isidore.

A funny little English lady also came to the studio. She was the wife of Admiral Cockburn, who took Napoleon, on his way to Saint-Helena,[26] on board the *Bellerophon* for the trip from Rochefort to England. One day she took me out to Versailles, an occasion to which I owe my first white dress.

Meanwhile, we had moved to the rue de la Bienfaisance (1837–38), then to 29, faubourg du Roule (1838), and finally to 13, rue Rumford (1841), but before that there was a big change at home. My father seemed tortured by something. From time to time he'd cast a curious glance my way. At dusk he'd often take me into town and patiently wait in front of a house for a young woman. As soon as she appeared, he'd take her arm, and the two of them would walk up and down for an hour or so.

I really wanted to know what they were talking about, but I dared not approach, keeping such a respectful distance that I couldn't hear a single word.

This wasn't much fun. Out of boredom I was reduced to watching moths, drawn by the light, hurl themselves into the flame of a streetlamp. Some of these poor little bugs dropped dead right at my feet. I didn't want them squashed under the feet of passersby, so I'd fill my pockets with them. Back home I'd put the little bodies into a cardboard box meant to be their tomb.

One evening my father took me upstairs with him into the apartment of the young woman. Although she was just nine years my elder, she had a son nearly as big as I was. After introducing us, my father told me that this lady would be my new mother and his new wife and that the house would be better taken care of. Meanwhile he wanted me to go get my sister in Bordeaux, since she was going to come back and live with us.[27]

again put an end to his country's national aspirations in 1831, Adam-George Czartoryski, his wife Anna, and many other Poles went into exile in France. Anna Czartoryska devoted most of her life to helping out Polish refugees in Paris.

26. The South Atlantic island to which Napoleon was exiled after his defeat at Waterloo in 1815. He died there in 1821.

27. A.K. The widow Peyrol, who became the second Mme Bonheur [in 1842],

You wouldn't believe me if I said this wasn't a rude blow, but it came as no real surprise. I was very glad to get away from a house where the newcomer would reign as mistress. Seizing upon the pretext of my sketching, I even dragged out my absence by making trips into the country and worked very hard on some studies of shepherds on stilts. My father wound up fearing that I'd never return and wrote me urgent entreaties from Paris.

The mystery hovering over my poor mother's birth was one of my main preoccupations in Bordeaux. I meant to take advantage of the situation by questioning old Mme Aymée. I thought, and not without reason, that if only I could get her to talk, I'd soon learn everything. Unfortunately, I ran into stony silence. Not wanting to admit defeat, I began poking around at city hall. Mme Aymé cast a sullen eye on my efforts.

"Stop trying to find things out," she said at last. "What earthly good will it do you to learn your grandmother's real name? The only thing I can tell you is this: she was a great lady, and you must respect her memory by staying out of her secret. Promise me that you'll stop meddling in this old business."

I gave her my word, albeit reluctantly.

"Anyway," she went on, "what difference can it make to you? You already know, don't you, that even if you're a descendant of kings and queens on your mother's side, your father comes from a line of cooks."

I later learned that Mme Aymée had always had great misgivings about M. Dublan's manservant, who was also in on the family mystery. Oddly enough, the man was said to have been mysteriously assassinated at the same time as one of Bordeaux's mayors.

Several times I could have continued this investigation with almost certain success. Yet my sacred promise to Mme Aymée always stood in my way.

Mme Aymée asked me lots of questions, of course, about my life in Paris and my father's household. So I had the worst time getting her to give up my sister. She'd brought Juliette up since the age of three, and my sister had just turned sixteen. Mme Aymée loved her like her own flesh and blood, and it really broke her heart to let her go. When Mme Aymée took us to the stagecoach, she was all in tears and devoured the girl with kisses.

Whatever apprehension I felt about going back to my father's place on rue Rumford, at least the house was in much better shape.

was born Marguerite Picard on May 5, 1813; she died in 1887 at the age of seventy-four.

My sister Juliette, just like me, had a real gift for drawing. My father put her to work in the studio along with me and my two brothers. Then he could keep his eye on a whole brood of artists who would make him famous one day.

I was the captain of the tiny troop, which relieved my father accordingly. M. Micas, on the other hand, totally disapproved of the arrangement. Remarkably astute, he didn't think I should be a drawing teacher for the rest of my life. The time that I was devoting to teaching my brothers and sister would be much better spent, he thought, if I used it to improve my own talents. So he told my father to rent me a studio where I could work on my own and give free rein to my every inspiration.

My father objected to the expense, always a major consideration for us. But this didn't stop good Mother Micas from taking the initiative. After much scouting around, she found me room in a huge battery of studios at 56, rue de l'Ouest. The place seemed made just for me. The rent was so low that my father had to pipe down. Besides, wasn't I the one who kept the pot boiling at home? I had to pay for nearly everything out of my sales. Oh! I wasn't fussy about the price my paintings fetched and gladly accepted any offer. I sold them for three hundred francs a piece, recouping any losses by the sheer number of them. I needed money to help out my dear father, for I knew that he had a bad heart and wouldn't be long for this world.

CHAPTER 12

First Tastes of Success
❖
Debut at the Salon (1841)
❖
Travels in Auvergne

When my paintings began to sell, my father told me to sign them *Raimond*. The name Bonheur[1] struck him as a nasty joke in our case. I asked, "Wouldn't that be an insult to my mother? Instead, I mean to glorify the name she took so that she'll be part of whatever fame may be mine. In her tender moments she used to call me Rosa, so Rosa Bonheur will be my signature." Today I have no regrets about having shown how much she means to me.[2]

My father often scolded me for being boyish, strong-minded, and outspoken.

"Ah!" he'd say, "you don't mince words, and you don't have a clue how to be diplomatic. You think being a silly little sheep is stupid, so you refuse to live that way. But you've still got to learn that being a skittish horse is no better. He steams at the nostrils and foams at the mouth because he won't take the bit, but before long he's nothing but a worthless nag. You need talent and modesty to win respect and distinguished friends. You know full well that I'm not saying this out of any admiration for high-society ways and so-called bon ton. Those polite formulas were once beautiful, but now they've turned into a bunch of grimaces. I've got nothing but scorn for all that because it masks so much hypocrisy. Yet society isn't really so bad. Rules of etiquette aren't total lies, just as people who pray aren't all arch-hypocrites. Just the opposite, most of them are good, decent folks. You've got to stay within the bounds of real decorum. These Bohemian anarchist ways[3] aren't the earmark of a fine mind. The same goes for

1. *Bonheur* means happiness in French.

2. A.K. The Salon catalogs show these names: in 1841, *Rosalie Bonheur;* in 1842, *Rosalie R. Bonheur;* in 1843, *Rosalie Bonheur;* starting in 1844, *Rosa Bonheur.*

3. *Bousingot* in the original. According to the *Grand Larousse du Dix-neuvième siècle,* the *bousingot* is, first of all, a little leather cap worn by sailors but,

that wanton, free-and-easy air that only makes one yearn for a woman's exquisite tact. I'm telling you all this because I don't want anything to tarnish the bright halo of talent that stirs up so much cruel envy. It's like politics. So many people want to tear everything down, but they've got no plan whatsoever for putting up something better the next day. This is our stumbling block these days. It's always taken longer to build something up than to tear it down. But you've got a good heart, daughter, and you'll change your views. Some things may look stupid and childish on the outside, but you've still got to respect them and dig deeper. No imitation or exaggeration, just truth, beauty, and dignity. That's the divine path that lifts us high above the brutes and even worse sorts. Now I'm done with my sermon, which was just a poor father's heart brimming over with the desire to see his most precious asset remain pure and unblemished."

These are more or less the terms of a letter he once wrote me. Poor father, I gave him a hard time with my free spirit! I only put up a fight now and then because I adored him and wanted to defend him against himself; he was so good and easy to exploit!

I was nineteen (1841) when he first urged me to send two pieces to the Salon: *Goats and Sheep* and *Two Rabbits*. I can still see them in my mind's eye. He thought they'd be accepted, and both were.[4] How proud and happy I was! Same thing the next year for three paintings and a little freshly shorn ewe in terra cotta.[5]

I showed more animals in 1843 and 1844.[6] In my dear little studio I

more importantly, the name given to some young and turbulent republicans in the early 1830s. In order to express their rage and disappointment with the new monarchy of Louis-Philippe, they started wearing vests like Marat's, fixing their hair like Robespierre's, and donning the *bousingot*. Like many Romantic artists, they had contempt for the bourgeoisie, the French Academy, the classics, bald men, and banality, and they exalted color, noise, things bizarre, and the Middle Ages; but they were also political animals of the most exasperated sort; they cultivated extreme positions and enjoyed notorious reputations for riot, anarchism, demagoguery.

4. At that time, works submitted to the annual Salons could not be shown without the consent of a special jury. A few artists, such as those who had won important prizes in previous Salons, could bypass this selection procedure.

5. A.K. Salon of 1842: *Animals Grazing, Evening Effect; Cow Lying Down in a Pasture; Horse for Sale;* a terra cotta entitled *Shorn Ewe.*

6. A.K. Salon of 1843: *Horses Leaving the Watering Place; Horses in a Meadow;* and a *Bull* in plaster. Salon of 1844: *Cows Grazing on the Banks of the Marne; Sheep in a Meadow; The Meeting, Landscape with Animals;* and a *Donkey.*

studied the myology, osteology, and physiology of all kinds of beasts.[7] That was good preparation for the dissections I'd do later on, when the love of art made me start hanging around slaughterhouses. I pored over anatomy books, taking tons of notes and even making outlines to help me remember things.

Nathalie would come to my little studio every morning. There we worked and lived, just the two of us, never opening the door to any flirting man.

How wonderfully well that fine friend used her wits to gain me time, tracing out my drawings and transferring them just so to the canvas. Becoming my equal wasn't her ambition. She just wanted to make herself useful and spare me the preliminaries. That was enough for this devoted heart.

We'd keep our noses to the grindstone until lunch. At the chime of twelve we'd take out Nathalie's cutlets and grill them on skewers at the open door of our little cast-iron stove. What a feast to see the juices run off into the saucer where we dipped our fried potatoes! I've never eaten anything quite as delicious and cheap.

This routine suited Nathalie just fine. My dear friend was obviously flourishing. Her cheeks got rosy, and her eyes began to sparkle. Her parents had deluded themselves thinking that she had tuberculosis. She only looked sickly for a long time because her wet nurse, a selfish woman, had deprived her as a baby.

Come evening, we'd each go home to our parents for dinner.

Working inside my studio's four walls just wasn't enough for me. In summer I'd ramble around the neighborhoods of Batignolles, Ternes, and the north flank of Montmartre. I went to Villiers, near the Neuilly park, where there were only farms, cow barns, and stables. Sometimes I even left Paris and found a room wherever I wound up. In Anet, for example, I

7. A.K. At that time Rosa Bonheur wrote down her daily agenda in tiny notebooks stuffed with drawings and sketches. For certain days one can read lines like these:

"Study of the sky, morning and evening, around Clamart. Children lighting a fire. Prepare colored paper for fast sketching. Draw cows and horses. Study of bulls. Bas-relief of horses to study movements. The same for oxen, stallions. Do Nathalie out-of-doors.

"Two drawings for charity, one for Mr. David (d'Angers), sketch from nature. Do oxen at market, horses. Read Richard (du Cantal) on equine conformation, go to the horse fair, slaughterhouses. Prepare horse anatomy drawing. Finish up my big horse studies."

often stayed with a justice of the peace and his wife who spoiled me with kindness. The crumbling walls of the famous castle that Henry II had built for Diane de Poitiers there tempted my pencil less than the grazing sheep, goats, and cows.

I was only happy in the company of these animals. I really got into studying their ways, especially the expression in their eyes. Isn't the eye the mirror of the soul for each and every living creature? Nature didn't give them any other way to express their thoughts, so that's where their feelings and desires get reflected.

I did my best to get every little thing just right. If an animal moved while I was drawing, I didn't just wait for it to return to the pose that I'd found interesting. I'd try to get the new one down on paper. But if it reverted to the original, I'd finish up the first sketch.

With my boundless energy and patience, I could go on for five or six hours in a row.

My eyes were so good back then that I could see the things I wanted to work on from afar. Not a single detail escaped me in a landscape, and my faithful rendering often baffled the public and even hurt my reputation.

If you want a good idea of nature's beauties, you've really got to study the background and the middle distance. Only then can you blur the details by putting them back in context. Wouwermans, Hobbema, Metzu, Van Ostade, Terburg, and Berghem followed this method,[8] which I've tried to make my own.

I sent six paintings to the Salon of 1845.[9] That made a grand total of eighteen since 1841, and every one had been accepted. This time I won a third-place medal.[10] I was overjoyed, but Nathalie even more so. I'll never forget how her face with its sickly pallor suddenly lit up when I read her the letter announcing my first success. I think that day was really the beginning of our affection. From then on our bond was complete, and we

8. For Wouwermans and Berghem, see note 21 in the previous chapter. Meindert Hobbema was a Dutch landscape painter of the seventeenth century. Gabriel Metzu or Metsu was a Dutch painter of the seventeenth century. The Van Ostade brothers were Dutch painters of the seventeenth century. Adriaen was particularly known for his genre paintings, and Isaac for his winter landscapes. Gerard Terburg was a Dutch painter of the seventeenth century, known particularly for his refined domestic scenes.

9. A.K. *The Three Musketeers; Ewe and Lamb Lost in the Storm; Ploughing*, where two horses pull a plough; *Bull and Cows; Ram, Ewe, and Lamb; Grazing Cows.*

10. Rosa Bonheur won this prize for *Ploughing*.

were nevermore apart. I wasn't happy unless she was close by. As for Nathalie, her greatest pleasure in life was coming to work in the studio with me.

That prize made it easier for me to sell my paintings. I still gave my father everything I earned, except for the money to buy Margot. I just had to have that fine mare. I suited her up with a man's saddle and, sitting on her back like Don Quixote on his Rosinante, I gradually broadened the circle of my travels. Though deep in my heart I was still a faithful Templar, not even once did I go tilting at windmills.

Often in my travels over the dusty roads of Ile-de-France I'd meet herds of livestock being driven to slaughter in Paris. I particularly remember a time during the summer that we rented a little cottage at Chevilly for my animal studies. At dusk I was riding Margot back toward Paris. The road was congested with herds of cattle and sheep, and Paris, that enormous city teeming with such misery and abounding with such splendor, Paris looked utterly lost beneath a cloud of filthy, dismal fog!

I mournfully contemplated all this living flesh, all the blood of these poor beasts, bellowing and bleating in a cloud of dust. Soon they'd all fall under the butcher's knife.

Poor innocent creatures, born only to die that miserable death! I wondered why there were so many victims. Had these mute beings already had a life? Had they been people like us and earned this horrible punishment because of their crimes and errors? What a wretched fate! And how awful to have to kill them. This scene inspired two paintings: *Miller on the Road,*[11] and *Off to Market.*[12]

After working without a break all through the summer of 1846,[13] I was exhausted. I really needed some rest or, at the very least, a change of scene. At the urging of my stepmother's relatives in Auvergne, I decided to pay them a visit but refused to think that staying in the provinces for a few months, even under duress, had to be without any benefit for my work.

Near the end of 1846 my stepmother and I took off in a stagecoach, one of those heavy five-horse contraptions that kept Paris in touch with every part of the kingdom, since there weren't any trains yet. We certainly didn't go as fast as the express trains these days. The horses trotted along on the

11. A.K. Salon of 1848.

12. A.K. This canvas is dated 1854. At the auction on November 15, 1906, at the Galerie Georges Petit, it sold to the highest bidder for thirty-two thousand francs.

13. A.K. At the Salon of 1846 Rosa Bonheur exhibited *Herd on the Road; Rest; Sheep and Goats; Pasture;* and a drawing, *Ewe and Lamb.*

flats but only walked up even the slightest hills. With all the mountains we had to go over, just guess how often they walked and gave the passengers a chance to stretch their legs. I usually sat on the top deck, but I didn't mind walking uphill in front of the horses. Auvergne is a wonderful part of the country, as I had ample time to notice during the eight full days it took to go from Paris to Clermont, then another day and a half to get to Mauriac, where my stepmother's family lived. Here is one of my treasures, a letter I wrote to Mme Micas from down there.

Mauriac, Friday morning, September 6, 1846

My dear friends, I've been here since Tuesday, 9 P.M. Excuse me for having dillydallied about writing the letter I promised you;[14] but if you only knew what it's like in this fine spot where everyone is so hospitable, where I've been so well entertained that I still haven't had a moment to myself! Here, as in the mountains everywhere, people think that the best way to honor guests is to wine and dine them as they did our ancestors at the dawn of time, who had sturdy constitutions and could rise to the occasion. As for me, if I don't run out of relatives and friends pretty soon, I may die of indigestion. But it would be mean not to respond to their warm welcome. Besides, I'm feeling fine, and my stepmother even finer. She has sprung back surprisingly well in the last two or three days. We had a great trip, especially me—it was such fun on the top deck.

We got to Clermont Monday at 6 A.M. How can I tell you what I felt seeing the Puy de Dôme, that enormous snow-capped peak! If Maurice hadn't held me down, I would have climbed each and every mountain, but we had to leave at 10 P.M. for Mauriac. We dropped our things at the hotel and drove to a forest halfway up the mountain, where I saw more beautiful things. At last evening fell and we left. Then the road got really bad! Over and around huge crags all the way to Mauriac, one moment down in the ravines, and the next hanging high above them. Judge for yourselves: it takes a full day and night to go thirty leagues.[15] But there's nothing to worry about just now. Winter is the dangerous time.

I'm in a hurry today, so I'll stop here. I'm eager to hear from you. Please write back. Mme Micas, I embrace you with all my heart, and you too, Mr. Line Fisherman (M. Micas). You ought to see this place. You'd catch trout while I caught the magnificent sights, the lovely waterfalls cascading

14. Bonheur addresses both M. and Mme Micas as *vous*.
15. A league is approximately four kilometers, or two and a half miles.

over the rocks. The water is like crystal. It's wild and beautiful, beautiful a thousand times over. Yesterday I went to the bridge over the Ause in a rustic oxcart. Tomorrow I'm going out hunting with Jacques. In short, I'm as happy as can be. I embrace you.

Your friend, your child if you will,

<div align="right">Rosa Bonheur</div>

The following lines were for Nathalie:

My dear friend, as you[16] can see, there is no lack of fun things to do. It's so beautiful around here that I can only wonder at nature and copy what I see. That's hard: imitation is such a cold way of rendering what is. I'll do my best. Ah! if you were here too, I'd be mad with joy. I can only half enjoy a pleasure without you. That's because you understand me, my dear Nathalie. I feel that I haven't seen you for a month. And things are so different here that I feel even farther away. I'm all mixed up in the morning. When I wake up, I am simply amazed not to be where my head was. I'm impatient for news of you. Don't write to me at general delivery until I tell you to. It's not as easy as you think to pick up letters. Here's my address: care of Fauché,[17] innkeeper at Mauriac.

I kiss you, my friend,

<div align="right">Rosa B.</div>

I kiss you as I love you.

I did a huge amount of work during that end-of-summer trip. When it was time to go after a few weeks down there, my albums and portfolios were stuffed with sketches and studies of the region's picturesque sites, people, and animals.

The four paintings I sent to the Salon of 1847[18] were based in part on these studies.

The stories and studies I brought back from Auvergne gave me lots of subjects for paintings. They also made Nathalie go into such raptures that she had just one wish: to go down there with me. I couldn't resist her pleas. As soon as the Salon of 1847 shut its doors, we took off together. Here is one of Nathalie's letters to her mother from Auvergne:

16. Rosa Bonheur addresses Nathalie as *tu* throughout this letter.

17. A.K. M. Fauché was related to the second Mme Bonheur. His daughter later married M. Auguste Bonheur.

18. A.K. Salon of 1847: *Ploughing, Landscape and Animals (Cantal)*; *Grazing Sheep (Cantal)*; *Studies of Pureblood Stallions*; *Still Life*.

Dear Mama,

Yesterday Tuesday I got your letter. Despite the short time that we've been apart, I was really impatient to get it, although I'm having a good time. This country is quite different from what I had imagined. It is charming. The land is rich, and one can always find a spot of shade. The thatched-roof cottages could not be more artistic. I'm painting one right now. I won't say which one: I want people to recognize it. You[19] tell me, good mother, not to do anything extravagant. I thank you, but if you were here, you wouldn't even recognize me. I am—rather we are—calm as can be. We are reined in by our desire to get something done, and it's only at sunset that we take our little walks together.

You get some rest, too, dear mother. You work so hard. You, beloved mother, are the subject of our loveliest conversations. You also tell me, dear mother, not to get in my dear Rosa's way too much. I may deserve some blame, but since she hasn't been able to do such beautiful studies for a long time, she gets carried away in spite of herself. Well, dear mother, we'll do the best we can, and we're working hard. Yesterday the locals were on our backs all day long, which was a horrible nuisance. Another bother, the weather has turned bad, and we have to work in a shed.

Selfish as I am, the thought that you've got some work to do, even though I can't give you a hand, certainly helps make time seem less long. In short, good mother, maybe time and the good Lord won't let so many years of hard work into the wee hours be in vain. I almost forgot to tell you that I'm feeling well as can be and I've already got some color on my left side. You see, Mother, I'm making progress.

I am going to leave a little room for Rosa. This letter is from the two of us, and we love you both the same.

Your loving daughter who sends you two thousand kisses.

Jeanne-Nathalie Micas

I added a postscript for Mme Micas:

Dear mother Micas, we got your letter yesterday. Nathalie had been impatient for it. I've been here for three days. If you[20] only knew how happy I am. Everything is just right, such kind hosts, such a rich landscape that it could keep you busy sketching from memory for three whole months, and then I'm with my Nathalie, too. Mother Micas, when you see

19. In this letter Nathalie addresses her mother as *tu*.

20. Throughout this letter, Rosa Bonheur addresses Nathalie's mother as *vous*.

my family, tell them that I'm doing pretty studies, that I'm calm and happy.

I kiss you with all my heart.

Your devoted Rosa,
Rosa Bonheur

A few months after we got back, a great misfortune struck. Poor M. Micas fell gravely ill. In no time his case looked hopeless. A few days before he died, he called my father and me to his bedside.

"Raimond," he told his friend, "I'm very sick, and I won't be leaving my bed. You're not going to live much longer, either. Let our two children stay together always. You see how much they love each other. Rosa needs Nathalie to love and protect her. Come, children, I want to give you my blessing!"

We were both deeply moved and knelt down by his bed. Good father Micas placed his hands on our heads and said: "Never leave each other's side, my dear children, and may God keep you!" Then he kissed us. A few days later he was dead.[21] Nathalie and I were always together after that. We've been separated by death, but I hope that our souls will be reunited. She and my mother are watching over me.

21. A.K. M. Frédéric-Louis Micas, born on December 9, 1802, died on March 19, 1848, at the age of forty-six.

Gold Medal at the Salon of 1848
❖
Ploughing in the Nivernais
❖
Raimond Bonheur's Death (1849)

Almost all my biographers claim that I owe my gold medal to *Ploughing in the Nivernais*. Just the opposite—my gold medal won me the commission for that painting.

On February 24, 1848, the very day that the Second Republic was proclaimed,[1] Ledru-Rollin,[2] the Minister of Internal Affairs, informed French artists that there would be elections for the preliminary jury. But five days later, on February 29, it was decreed that, just this once, each and every work submitted for the Salon of 1848 would be accepted.[3] You can just guess how much excitement this announcement stirred up in art studios. Consequently, the catalog for the Salon of 1848 had 5,180 items, more than twice the number for the Salon of 1849.

The Bonheur name was well represented. We alone took up almost a whole page in the catalog, and that's not even counting our sculptures.

My brother Auguste had a still life, a child's portrait, and one of me; Isidore, a painting and a plaster cast of the same subject, *Horseman Attacked by a Lioness*. My father had a landscape. I sent six paintings: *Oxen and Bulls of Cantal, Grazing Sheep, Running Dog, Ox, Miller on the Road*, and *Oxen Grazing in Solers*. I also sent a bull and a ewe to the sculpture section.

Because they didn't have to worry about the jury that year, lots of artists showed unexpected talent. Some even got a real spark and put out a rare number of remarkable pieces. On the other hand, several paintings were

1. This was the end of the July Monarchy and the reign of Louis-Philippe that had begun in 1830. As in 1830, the monarchy fell after a brief uprising in Paris.

2. Member of the Provisional Government of the Second Republic.

3. During the July Monarchy, works to be shown at the Salons first had to be approved by a jury drawn from the ranks of the fourth class of the Institute of France. Their verdict stood without appeal. This system was the cause of many protests, from mediocre artists to celebrities such as Ingres. A modified jury system returned in 1849.

hailed by bursts of Homeric laughter. That was very good for those feck-less souls who had flown in the face of ridicule by signing their works. Indeed, how many hard-luck artists had always blamed a biased jury for their failures? Now they were stripped of their fine illusions and had to give up trying to compete with Raphael and Rubens!

The panel of judges awarding the prizes included all the big celebrities. Horace Vernet[4] was the president; the others were Robert-Fleury, Sr., Léon Cogniet, Delacroix, Meissonier, Corot, Jules Dupré,[5] Flandrin,[6] Isabey.[7] These august magistrates surprised me with a gold medal for all my work at the Salon. A gold medal for me, a humble beginner, who had only won a bronze before that!

Anatole de la Forge, the brave defender of Saint-Quentin,[8] gave me a great compliment. If it had any merit, my head would swell with pride. He said that, though I was only twenty-six, I was already a dangerous rival for Brascassat, who was the Paul Potter, the king, of the modern French animal painters.[9] He even said that Brascassat subsequently tried so hard and well to outdo himself because he knew he was vying with me.

4. Director of the French Academy in Rome from 1828 to 1835, this history painter and portraitist was more or less the official painter of the July Monarchy. He was particularly drawn to Napoleonic and other military motifs.

5. Respectively, Romantic history-painter and father of Tony Robert-Fleury, one of Anna Klumpke's teachers at the Julian Academy; academic portraitist and history painter of the period; the famous painter of the Romantic school, much appreciated by Baudelaire, among others; widely acclaimed genre and military painter of the period; major Romantic landscape-painter of the period; and Romantic landscape-painter of the period.

6. At the time there were three Flandrin brothers active in the arts. It is not easy to ascertain to which one she is referring here.

7. Romantic seascape-painter of the period.

8. Anatole de la Forge was a journalist, diplomat, and politician of liberal persuasion. His defense of Saint-Quentin refers to an episode of the Franco-Prussian War. After the defeat of Napoleon III and the fall of the Second Empire in September 1870, de la Forge was named prefect of the department of l'Aisne, most of which was then occupied by the Prussian army. At Saint-Quentin he organized resistance against the invaders and even took up arms against them in October. The fact that an open city dared stand up to the enemy made quite an impression on many patriotic citizens, including Rosa Bonheur.

9. Like his contemporary Rosa Bonheur, Jacques-Raymond Brascassat was particularly known for his Dutch-inspired paintings of domestic animals. For Potter, see note 21 in chapter 11.

When I got my prize, the ministry chimed in, on a onetime basis, with a magnificent Sèvres vase, plus the commission for *Ploughing in the Nivernais.* That came to be the name of the painting, but the government only asked me for a ploughing motif similar to two of my paintings in the Salon. I was to be paid three thousand francs.

I'll never forget my father's joy at this double triumph. He felt that my success was truly his own. Hadn't he been my only teacher? Another thing added to his legitimate pride: he loved the government honoring his daughter,[10] and its advent had nourished his dreams.

I was certainly delighted, too. When I picked up the first installment of fifteen hundred francs at the Finance Ministry, I was walking on air.[11] Those three big banknotes made a triumphal entrance at home. We'd never seen so much money all at once.

I decided to paint a team of six oxen yoked up two by two. Getting down to work, I also had in mind to celebrate the ploughman's art of opening those furrows from whence comes the world's bread.

Needing to work from nature away from Paris, I accepted an invitation to spend the winter of 1848 with the family of one of my father's friends, M. Mathieu, a distinguished sculptor who was teaching at the Chateau de la Cave in the Nièvre. Nathalie went with me. Her presence, along with her encouraging words, were good for my work. Intent on finishing this piece for the Salon of 1849, I painted amazingly fast.

Alas! I cannot help feeling a twinge of pain whenever I think of my *Ploughing in the Nivernais.* Although it really made my reputation, what gloomy memories it calls back. A few days before my father died, he made another proud inspection of my work. He embraced me and said: "You're right on the heels of Vigée-Lebrun. So it's not in vain that I made her your role model." Poor Father, despite his long and ever worse suffering, he had no idea that the money I got for this painting was meant to pay for his funeral expenses.

My father lived almost to the day just a year more than his friend M. Micas, who was too good a prophet. He died on March 23, 1849.

The journal *Le Crédit,*[12] where Father Enfantin, back from Egypt, was working, gave this report of my father's funeral:

10. In its earliest weeks, the Second Republic showed socialist tendencies.

11. A.K. September 19, 1848.

12. Journal founded by Enfantin. It first appeared in November 1848 and lasted until August 1850.

Last Sunday, artists, writers, and men of the world marched in the funeral cortege of a humble, hardworking artist whose name will live on in the history of modern art. Raimond Bonheur was a landscape artist, and he leaves behind almost unknown canvases revealing the secret germ of a vigorous, imaginative talent. Sunday, one of our great artists, Léon Cogniet, admired some of Raimond Bonheur's work just before the funeral and told us: "I had no idea of this great talent!" For how many artists, alas!—as for the friend we are grieving—does the day of justice come only on the day they die!

Raimond Bonheur was passionately devoted to art. A poor man with many children, he made artists of them all. The eldest of that young family, Mlle Rosa Bonheur, has won an important place for herself among our first-rate talents. Two of his sons, Auguste and Isidore, have exhibited very promising paintings and sculptures. There was nothing more simple and touching than this household with its patriarchal ways. One day Delaroche[13] stopped by for a visit. He found every member of this little world at work in the studio and the babies already busy with their pencils. He came away with tears in his eyes.

Raimond Bonheur led a long and courageous battle against poverty with a serene, unwavering confidence in God. In his last few months he became head of an art school for girls established by the city of Paris. No one is better entitled to that position than Mlle Rosa Bonheur, and the goverment would do well to entrust it to her.

M. Gustave d'Eichtal[14] said some heartfelt words over Raimond Bonheur's grave. He spoke warmly about his devotion to his family, his self-sacrifice, talent, and courage; but what he failed to say was that, in addition to this deep devotion, this pious cult of family, Raimond Bonheur was just as dedicated to the generous ideals of peace, freedom, and progress. A child of the masses, he spent his whole life ardently aspiring to improve the lot of this class that he never stopped loving.

L. J.

13. A famous history painter who was a professor at the Ecole des Beaux-Arts and a member of the Institut. His name became closely identified with the style of the *juste-milieu.*

14. A founding member of the Saint-Simonian movement, a participant in the Ménilmontant experiment, and one of Enfantin's long-term associates after the movement broke up. After Raimond's death, he continued to have good relations with Rosa Bonheur.

I was twenty-seven when my father died. Two months later *Ploughing in the Nivernais* was shown at the Salon.[15] I had a hard time finding it in the catalog, since it was listed as *Boarding in the Nivernais, Sinking*.[16] This made me momentarily cross, all the more because this mix-up raised lots of questions that I couldn't answer. Fortunately people still liked it.[17]

[Here I want to reproduce a few of the opinions expressed about *Ploughing in the Nivernais*.[18]

In his little book on Rosa Bonheur,[19] Eugène de Mirecourt wrote in 1856:

> None of Rosa Bonheur's works shows any sign of what painters call the tricks of the trade. All of them are sincerely felt and scrupulously executed . . . Her simplicity succeeds better than the fine devices of other painters, and public opinion, that big spoiled child, was not displeased by the work of this naïve brush.
>
> When people looked at Mlle Bonheur's paintings, at these enormous white or red oxen with their clear eyes and foaming muzzles, they were surprised to feel something true and serious. They were moved by the peaceful, natural sight of these sheep grazing on tasty meadow or mountain grass. They felt ecstasy looking at these landscapes that have

15. A.K. The Salon of 1849 opened on June 15 at the Tuileries palace.

16. The French text reports the erroneous title as *L'Abordage nivernais, le sombrage*.

17. A.K. Some time after Rosa Bonheur's death, I received a letter from America asking if the great artist had not painted a second *Ploughing in the Nivernais* similar to the one in the Luxembourg Museum. I did some research and finally found this note in a ledger where Nathalie Micas recorded the subject and the price of Rosa Bonheur's paintings:

"Copy of *Ploughing* sold to M. Marc, four thousand francs, but two thousand were given to Auguste for his collaboration."

Oddly enough, Rosa Bonheur sold the copy for one thousand francs more than the original. An engraving was made of this copy, which is no doubt hanging on the walls of some house in America. The left background of this copy is different from that of the original painting.

[Translator's addition: According to Rosalie Shriver, this copy is now at the John and Mable Ringling Museum of Art in Sarasota, Florida. The original version is at the Musée d'Orsay in Paris.]

18. All material from this sentence through the end of the chapter was added by Anna Klumpke.

19. A.K. Eugène de Mirecourt, *Les Contemporains. Rosa Bonheur*, pp. 46–47.

such a melancholy, dreamy charm, such an abundance of sweet country smells.

A short time later Mazure wrote:

After the old Dutch painters and better than the French landscape-painters of centuries past, we now have some very good livestock painters: Messrs. Brascassat, Coignard, Palizzi, Troyon, and above all a woman, whose talent rises to the level of genius, Mlle Rosa Bonheur.

Several artists may be praised for artfully arranging animals in a landscape, but if we consider just the animals without worrying about the landscape, if we ask for a monograph on ploughing, Rosa Bonheur stands alone. Go take another look at *Ploughing in the Nivernais* at the Luxembourg Museum. What beautiful oxen, with their coats of many colors, well-defined muscles, and powerful dewlaps! There is so much spring in their step that, despite their heavy mass, they seem to weigh practically nothing. They pant and strain, but with what energy and resolution! The handsome man driving them represents mankind's power over the forces of nature at their most intense, the life and work of the loved one. There is such space around the man and the animals! We feel the greatness of nature at its most imposing. Yet we are sorry that the earth and sky do not seem to have much depth in this work, so alive in other respects.[20]

Finally, Emile Cantrel, in *L'Artiste*,[21] compared Rosa Bonheur to George Sand in these terms:

There is a most intimate relationship between the two talents. Mlle Rosa Bonheur often reads George Sand, her favorite author, and I would not be surprised if Mme Sand felt the same way about Rosa Bonheur's landscapes. George Sand has a special genius for landscapes; and in her paintings Rosa Bonheur gives song to the trees and eloquent speech to the animals, grass, and clouds. Both can understand the mute symphonies of creation and render them in the passionate, harmonious language of art: one, through descriptions drawn by a pen equal to Ruysdaël's brush and Lorrain's palette; the other, through stories told by a palette with all the genius, the masterful style, the vigorous color that have so rightly glorified the pen.

George Sand and Rosa Bonheur are two landscape artists in Jean-

20. A.K. *Paysage (Dieu, la Nature et l'Art)* (Paris: Tardieu, 1858), pp. 103–4.
21. A.K. *L'Artiste,* the issue of September 1, 1859.

Jacques's school,[22] two superior women who are the envy of Europe, two serious and confident painters who will give France the right to bask in glory—two brother geniuses.[23]

As Cantrel was right to say in *L'Artiste*, there was something similar about the talents of Rosa Bonheur and George Sand. Many people even believe that the pages in *The Devil's Pool*[24] (1846) that describe fieldwork with so much poetry, feeling, and color were Rosa Bonheur's inspiration for her *Ploughing*. That may be, although there is no real proof. Yet, may we not suppose that the love of nature, exalted in all the Romantic literature inspired by Rousseau, brought forth in different genres a similar interpretation of ploughing a field, an act that is both ordinary and sublime?

In a more recent work, *Masterworks of Art at the Luxembourg Museum*,[25] M. Adrien Dézamy devoted a sonnet to *Ploughing in the Nivernais*:

Labourage Nivernais
Six grands boeufs nivernais, six grands boeufs blancs et roux,
Labourant un coteau, par un matin d'automne,
Traînent une charrue inerte qui festonne
Et rampe, avec un bruit de ferraille et de clous.

Tandis que sur leur dos, son aiguillon de houx,
Voltige pour hâter leur marche monotone,
D'une voix de fausset, le conducteur entonne
Quelque vieille chanson au refrain lent et doux.

Le soc ouvre les flancs de la terre féconde . . .
Aux trilles des oiseaux s'envolant à la ronde
Par un long beuglement l'attelage répond.

22. The school of Rousseau, the philosopher of the late eighteenth century who exalted nature with quite Romantic feeling. Given his desire to confine women to the domestic sphere, Sand and Bonheur would probably have been anathema to him.

23. Literal translation of the French: "deux génies frères."

24. One of George Sand's pastoral novels.

25. A.K. *Les Chefs-d'oeuvre d'art au Luxembourg. Rosa Bonheur* (Paris: Baschet, 1880). In-folio.

Le soleil resplendit sur la campagne en fête:
Et devant ce tableau si vivant je m'arrête
Et fredonne un refrain du vieux Pierre Dupont.]26

26. Dupont was a socialist poet and songwriter of the period and much loved
by many revolutionaries of 1848; one of his famous songs is entitled "The Oxen."
A prose rendering of the sonnet could read like this:

Six huge Nivernais oxen, six huge white and red oxen, till a slope on an autumn
morning and drag a heavy plough that scallops and crawls with a clank of iron and
nails.

While his holly-wood goad flies over their backs to quicken their monotonous
pace, the driver intones in a falsetto voice some old song with a slow, sweet refrain.

The ploughshare opens up the flanks of the fertile earth . . . To the trills of the
birds fluttering around, the ox team replies with a long bellow.

The sun is shining on this festive countryside: and facing this painting that is so
alive, I stop and hum one of old Pierre Dupont's refrains.

Trip to the Pyrenees
❖
A Season at Ems (1850)

After my father died, there was nobody at home I could confide in. The emptiness scared me. I asked Mme Micas if she would take me in and consider me as Nathalie's sister, in keeping with M. Micas's last wish. Then my family became jealous. My stepmother, who made me miss my mother's charms every time I laid eyes on her, complained a great deal about what she called my desertion of the paternal home. Wasn't I entitled to follow my heart and go live with my friends? Had I married, would I have stayed with her? It was natural for me to appeal to Mme Micas the day after she, in a burst of wonderful generosity, had given me everything she had so that I could pay off my father's debts. Because of her devotion to me, I could give a quick boost to my resources, which was good for the whole family. Although I lived somewhere else, nothing had changed. I still helped them out and kept the pot boiling. I lent drawings to my two brothers, and how many times did I share the sale price of paintings they'd worked on? I signed over to my brother-in-law[1] my royalties on the animal sculptures he's still casting in bronze. I also drew him some good lithographs he later published.

So as not to hamper my brother Isidore's career in any way, I stopped showing sculptures when I realized how talented he was. And I was always good to my stepmother. A year before my father died, she gave us a little brother, Germain.[2] As soon as I was able, I paid for the child's education.

I received several marriage proposals, which I always turned down. My stepmother, moreover, had a mania for matchmaking in the family. A son from her first marriage married my sister;[3] one of her nieces became my brother Auguste's wife. I didn't want anyone to give me a husband like

1. A.K. M. Hippolyte Peyrol.

2. A.K. M. Germain Bonheur, born in 1848, spent his life painting and died in 1881.

3. A.K. Marie-Julie-Joséphine-Victoire known as Juliette Bonheur was born on July 19, 1830, married M. Peyrol in 1852, bore two sons, MM. Hippolyte and René Peyrol, and died on April 19, 1891.

that. Not that I was cold and indifferent, unable to appreciate the homages of a man who might have become my husband. But there we are, I wanted to keep my own name. Luckily I managed to make it a bit famous, probably thanks to my mother's protection. Why can't art, like religion, have its vestals?

The summer after my father died, Nathalie was always sick. Wanting to provide her a salutary change of scene, good mother Micas offered to pay us a trip to the Pyrenees out of her savings.

I jumped at the chance, expecting that these mountains, higher and more picturesque than the ones in Auvergne, would open up new horizons for my painting.

I wasn't wrong. These mountains—which Louis XIV had declared abolished—so enthralled me that I've often gone back.

Before setting out, Nathalie and I requested permission to wear men's clothing.[4] So we didn't ride sidesaddle, with the traditional hat and veil, through these craggy parts, but sat astride our steeds like real horsemen. True, we often got on the same horse to spare good mother Micas's savings.

When she sent us off, Mme Micas made us promise to send back an exact account of everything interesting that happened along the way. Since I never stopped drawing and painting, it was almost always Nathalie who wrote to her mother. I just barely took time to dash off a few lines. True, Nathalie wrote what I would have wanted to say. Besides, her heart and pen gave a charming turn to ordinary thoughts.

I've kept all these precious letters. While rereading them I've often felt that I was reliving some great old times.

[In my turn,[5] I read over the letters that kept the good lady back in Paris

4. After taking note that many women were going out in men's clothing, the police order of November 7, 1800, attempted to restrict this practice. Accordingly, any woman who wanted to wear men's clothing was required to request permission from the prefecture of police. In order to receive permission, she had to establish her identity, profession, and domicile and present a notarized doctor's certificate. Health matters were considered the only valid reason for making such request. Any woman found wearing men's clothing without permission risked arrest. Fines and even prison terms awaited repeat offenders. These *permissions de travestissement* were valid for periods of three to six months, subject to renewal. This law was enforced throughout the nineteenth century, especially in times of feminist activity; and it is still on the books.

5. A.K. I thought that I ought to insert into Rosa Bonheur's narration an account of her trip to the Pyrenees drawn from the letters that she entrusted to me.

up on every detail of "her two daughters'" daily activities. Despite the nasty weather, they bubble with good cheer and enthusiasm. Nathalie's letters sometimes have a nice literary flourish. The offhand comments that Rosa Bonheur scribbled now and again are lively, colorful, and charmingly picturesque.

The waters did not do much for Nathalie's delicate health, but the novelty of it all, the beautiful sites, and the imposing wildness of the mountains delighted them both. "No doubt at Eaux-Bonnes," Nathalie wrote,[6] "you meet only ghosts, living cadavers who cough and spit from morning till night, or else elegant pests," but what beautiful excursions in the surrounding area! One day, Rosa Bonheur, the animal lover, could not resist the charms of a young mountain dog that looked like a bear. Here is her postscript to Nathalie's letter:

Good mother Micas, Nathalie has told you that I let myself in for temptation. Good Lord, did I ever! What a dog! A mountain dog that'll get big as a donkey. Well, there you are! We always fall back into our same old sins. This one, however, will defend us. Dogs of this breed know only their master, so I'm going to teach him to guard my studio at night. With a strapping fellow like this around, I'll be able to leave the key in the door.[7]

The two friends soon left rain-soaked Eaux-Bonnes for a nicer spot, hoping that the waters of Saint-Sauveur would do Nathalie more good. En route they saw Lourdes and its castle, still unknown by the crowd, Bétharam with its sanctuary and many pilgrims, and Argelès with its black marble houses. At Saint-Sauveur they rushed to take the waters to get their strength up for more side trips. The reputation that the two young ladies had earned as "horsemen" at Eaux-Bonnes was, of course, confirmed, even though there were fewer people at Saint-Sauveur and it kept on raining. They worried about Mme Micas; business was bad for the season. Rosa Bonheur tried to cheer her up in this letter:

Sometimes things go well, sometimes they don't, and you always have to stick your glasses on your nose, something I'll avoid for as long as I can. But when that's impossible, you'll have to make lots of glasses cases because I'm sure to lose dozens.

Nathalie has probably told you that we're fine for money. My poor friend is rather sorry to be spending so much while her mother is

A literal transcription of her letters might have seemed a bit long to the reader.
6. A.K. June 17, 1850.
7. A.K. Eaux-Bonnes, July 26.

working. If she gets her health back, she promises to work like a horse! She takes after you. As you know, she's no lazybones. As for me, I'm feeling better and hope that these waters will give me back my strength. Then I'll paint beautiful pictures and earn tons of money and stop bothering you. But I know you're glad to do this because you love me like your own child. I love you back the same way. Your number two daughter.[8]

She painted and drew her way through these trips, with all the subjects they offered her. Every turn opened up a new vista, and the animal painter discovered furry and woolly beasts unlike the ones in Paris, Nièvre, and Auvergne. Her portfolios filled up with drawings. Meanwhile they went to Gavarnie, which delighted them, and to Barèges, which pained Nathalie.

"Here you find three or four hundred soldiers," she wrote,

mostly all mangy, leprous, full of scabs, lame, half blind, and scrofulous. In perfect harmony with the inhabitants, the streets are small, muddy, and tortuous. At this time of year, the burg, which people insist on calling a city, is almost always under a thick fog that prevents you from seeing anything five steps away.

We went to see the ruins of an old castle and brought back an armful of flowers that would be the envy of our best gardens. They look beautiful and smell wonderfully good.[9]

From the top of Mount Bergons, while Rosa Bonheur painted with her color box in her lap, Nathalie scribbled up a report for her mother, which they both signed.

Monday morning

My dear and good mother,

I'm so full of the little excursion we've just had that I cannot resist spilling over about it. We're at the top of Mount Bergons. From here we can see the whole range of the Pyrenees down into Spain. Just now four beautiful eagles are soaring over our heads, which really adds to the wildness of the country. We're catching another glimpse of superb Marboré, its beautiful waterfall, and the vast plateau called Roland's Gap.

The guides are cool as a cucumber telling you this tall tale: "Roland cut this gap with his saber." It's at least six hundred feet wide. It's the same thing when they show you his horse's hoofprint. You can gauge Roland's size by that of his sword and the horse's size by the man's.

8. A.K. July 27.
9. A.K. Saint-Sauveur, August 2.

Rosa is painting a little sketch while I'm being lazy and writing you this letter. It's five, and the sun is casting its last rays; the cows are moving from one meadow to another with leisurely moos. The tinkle of their bells is drawing near, and the poor beasts seem to be thanking God for the evening cool. When you see them running around the mountains, you'd think that they were deer. They're not only fleet of foot, but golden and rather small.

We're going to get going. We've come across some rather curious geological specimens, in addition to one that Rosa found, a mixture of copper, silver, and iron.

Wednesday we went to the Sias bridge. There was a village wedding going on, and as we were working, the wedding party came up and sat down, and we all talked. As they were leaving, they invited us to go dance with them.

You know how much we love you. Loving kisses from the two of us.

<div align="right">Jeanne-Nathalie Micas
Rosa Bonheur</div>

A few days later Rosa Bonheur bravely picked up her pen and dashed off a devil-may-care letter, but so witty and cheerful. Every line tells her deep affection for her sick friend and for the mother back in Paris who could follow her daughters only in spirit.

<div align="right">*Tuesday morning, August 12, [1850]*</div>

Dear good mother,

This morning I'll pick up where Nathalie's letter left off. We've been to Luz, which is quite close by. Since it was market day, we bought some Spanish grapes from a Spaniard in a superb costume. Right now I'm pilfering a few of them on an empty stomach. They're very good, and I'd love to be able to send you some. Nathalie is just getting up. We're going to the doctor today for her aches and pains. This, I think, is what taking the waters always gets you. Here's the sun poking up his nose. Not bad. Ah! I almost forgot to tell you that we bought a basket for Eulalie, a beautiful one made around here and trimmed with red and blue, by golly. Here's its portrait: it's big as a house and light as a paintbrush.

Nathalie is combing her pigtail and beautifying herself for the doctor. She's got a soft spot for this kind of mammal. We've done all kinds of things, dear fat mother; you don't have lazy children. On the banks of a poetic mountain torrent we washed our clothes. I'm good at soaping, which makes Nathalie happy. I received lots of compliments, well

deserved to boot, for your children's diapers were rather dirty. Since peo-
ple around here don't do laundry and there's no way to get the crud out
without lye, we're surely more clever than the local washerwomen.

Nathalie isn't doing too bad, aside from all her dreadful aches and
pains. They're no laughing matter. Well, we can always hope!

Today we're going to have a look around. Since the clouds are lifting,
we'll do a study. Have no fear, Nana will put a jacket on under her coat, or
I'll make her put it on. There are more rocks than dirt around here. Now,
now, I'm going to stop or I'll just go on being silly. I'm in high spirits this
morning, proof for me that the clouds will lift. Nathalie is going off to
drink her water. She just gave me a good little kiss. I don't want to be
selfish, so I'll give it back to you, her good mother who, without even
knowing it, made me a friend who will make my whole life happy, for I am
happy. No one has ever had a true friend like my Nathalie. I'm writing you
this because she won't be reading my letter. It's time for the mail to go off. I
hurry to kiss you as I love you—a whole lot. See that no one back there
forgets me.

Yours truly for life,

Rosa Bonheur

On August 30, 1850, the two friends finally returned to Paris and kissed
their good fat mother, as Rosa Bonheur called her, whom they had not
seen since June 8.][10]

The trip to the Pyrenees was a great artistic success. Yet it had done
nothing to improve my dear Nathalie's health, the main purpose of the
undertaking. The doctors even said she absolutely had to go to Ems for
another cure. So we'd scarcely got back from the south of France when we
had to set off for Prussia. The bad weather that had dogged us in the
Pyrenees only got worse in that northern spa. It was so rainy and cold that
we had to leave Ems after imbibing those clear waters for just two weeks.
Still we made a nice stop at Brussels and visited the Exhibition.

[Rosa and Nathalie's correspondence with Mme Micas, briefly inter-
rupted by their return to Paris, resumed as soon as they crossed the
border.[11] Although there were no boulders, mountains, or torrents, none

10. A reminder that this long bracketed passage is material selected, edited, and
summarized by Anna Klumpke. After this closing bracket Klumpke slips back into
her invention/recreation of Rosa Bonheur's first-person narration.

11. Another reminder that the bracketed material has been selected, edited,
and occasionally summarized by Anna Klumpke.

of the imposing scenery of the Pyrenees to describe, they watched another kind of spectacle, which called forth their lively wit.

Soon after they arrived in Ems, Nathalie wrote:

Ah! Germany is certainly not France. The farther away from France we get, the more we appreciate our native land. We've already thought of you, my good mother, many times; our mother who travels so easily around her room, who tells us again and again that we don't know how to manage, we'd just love to see her among these savages. Rosa wants to tell you the comic parts of our trip.

Here is Rosa Bonheur's lively account, embellished with some drawings.

Ems, 11 A.M. Monday morning

My dear mother Micas, we finally arrived, but not without mishap, since Prussia is a beastly country. First of all, it's dreary listening to people jabber all day long when you don't understand a word they're saying. Asking for the slightest thing means going through a veritable pantomime. With all your easy armchair travels, I'd love to see you, poor mother, in the Prussian kingdom. As for our trip, we left Paris at eleven and got to Brussels at 6 P.M. the next day. After spending the night there, we set off again at 7 A.M. and arrived at Cologne twelve hours later. But I forgot to tell you that at the Belgian border customs made us unpack all our trunks. And at the Prussian border, the same thing all over again. Yet in Belgium that was no trouble because everyone spoke French. But I really wish you could have seen us at Cologne. It was enough to make you lose your mind. One was speaking English, another Russian, yet another one Flemish and then Polish: *voif-flish-fouch-crak*. . . do your best to try and figure something out. Yet that was nothing. Worst of all, they don't understand a thing about French money, so we had to exchange our lovely French gold-pieces for some nasty bronze coins. At first you've got no idea what they're worth, especially since you can't understand a single thing. For four hundred francs we got a bag of scrap that looks like second-rate buttons. I guess the Prussian king coins money when his livery is worn out. Anyway, Nathalie and I spent a long time staring at the coins without making head or tail of them. The bag was so heavy that one of us couldn't carry it alone.

Continuing with our trip, we went to bed at Cologne after a dinner of buttered bread and potatoes. Bread here means potatoes. No bread, no wine either. I ask for some beer. That can be had only in low-class joints. A

bottle of wine costs three francs. I ask for porter, thinking I'll get by cheaper. I'm stunned to learn it costs three francs sixty-five, like wine. Well, that's the way it goes here.

After a night in Cologne, we take a 6 A.M. train to Bonn, a steamboat to Coblentz, and finally a carriage to Ems. After we arrived yesterday afternoon at four, we had an unpleasant, but very refreshing and purgative meal washed down with clear water, as is the local custom. I look around and ask for *bine,* as they say, not beer, some three-franc Rhine wine. This morning Nathalie drank milk and I had a soup that looked like watereddown mustard. For three meals a day, we'll pay, even if we scrimp, about five francs a head. Our room looks like the one we had at Saint-Sauveur, and the beds, hum! are hard as rocks.

This morning we went to see the doctor, who very carefully read the letter from M. Cazalis.[12] He seems conscientious enough. Tomorrow morning we'll start taking the waters. He promised us they'll do Nathalie a lot of good. He is almost certain of fine results. We have to walk, but not too much, get fresh air and rest. After the doctor's, we went to the water station, since you've got to buy your own glass here, a goblet in Bohemian glass that costs a mere five francs. A fine price, don't you think? But it's yours to take home. Besides, the waters are free, aside from a tip when you leave.

Things are much more luxurious here than in the Pyrenees because there are many more foreigners. Yesterday evening we took a little stroll on the promenade, a flower garden on the banks of a pretty little stream entirely surrounded by wooded mountains and meadows. I think there's music every evening. Yesterday they were playing something in a little kiosk outside. It's so poetic to listen to music in such a pretty setting. We sat down and snorted at all the caricatures in sight. There's a lot to laugh at, to be sure. They say that French women are coquettes, but you should see how pretentious these folks are. There are women way past their prime out for adventure. In short, very elegant and very ridiculous, and we'll get lots of funny shows without even batting an eyelash. Lord! society people are such nitwits and even worse! I'm beginning to think a simple heart is extremely rare and common sense even more so. There really hasn't been much progress on that score.

So we're settled. There's no way for Nathalie to wear herself out cooking. And if she asked for cauliflower, they'd give her a candle. It's simply

12. A.K. The Micas's family doctor.

impossible, and we'd spend even more that way. Postage seems rather expensive. So, since I want to write to my sister every once in a while, I'll enclose a little note for her, and you'll be kind enough to drop it in the mail in Paris. Don't worry about a thing, our good mother, I'll take good care of my friend and bring her back to you in fine shape. We're going to get a good rest and plan our daily activities. I kiss you and am yours truly for life.

Rosa Bonheur

P.S. Since Nathalie is all set to mail this, I can polish off this sheet by giving you some idea of what Prussian soldiers look like. I don't know why, but I'm very interested in this nice little king or emperor of Prussia.[13] Maybe because he keeps our dear Henry V[14] within one of his fortified cities, and well fortified at that for fear that someone might steal his prize. God willing, he'll always stay in a country where the laws are in such harmony with the monarchical spirit. That'll be much better for his health.

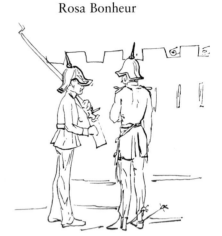

Sketch of Prussian soldiers observed at the Spa of Ems, Prussia in 1850. (Original French edition, p. 214.)

Raimond Bonheur's daughter did not repudiate her father's republican ideas. Yet the bad weather did not allow them to enjoy the spa's charms much. On day eight Nathalie wrote:

Since we've been here at Ems, today is the only time we've dared go climbing, and I'm writing you this letter, beloved mother, from up in the rocks. Rosa is doing a study. I would have liked to do some drawing, but no way; it's hard to find a good place to sit, and the only thing I can see from here is the stream. I can hear little birds higher up, and beyond, a braying goat, and if our little doe were here, she'd have a wonderful

13. Friedrich Wilhelm IV, who was elected emperor of the Germans the year before. He declined the honor.

14. The count of Chambord, who was the Bourbon pretender to the French throne.

time! We're at the spot where all the goats come to browse. At least it's a bit picturesque.

More and more patients are going away, and I do believe that we'll be the last to leave Ems.

They would hardly have been sorry to hasten their departure from a country where everything was so outrageously expensive that they couldn't even drink wine, but only mediocre beer that made them long for Mme Micas's savory bordeaux. On top of that, their shoes and clothes decided to wear out, which made Nathalie complain:

Ah! our dresses are falling apart, and our hat ribbons have faded from green to yellow. In short, Mother, we've gone to the dogs. I would be so happy if you could have my black dress fixed up.[15]

The trip was a total failure: little pleasure and no profit for Nathalie's health. After two weeks, driven off by rain, they gave up and planned to go home. Just then, the sun, as if to jeer, seemed eager to show its face. Too bad, they left anyway, and Nathalie gave this farewell salute to the city without any regrets:[16]

So I say to you, soon, soon, my beloved mother, I'm sending you a thousand big kisses from both of us. Kiss Grandmother for me and soon all of you, the happy bunch and our friends.

To hell with Ems and all these jabbering folks! What happiness to see human faces again! Friends and France forever! Just now I'm supremely happy, and if I weren't afraid of being thought crazy, I'd pick up my legs and dance a polka.

Soon, see you soon!

Your daughter who loves you with all her heart and soul for life,

Jeanne Micas

We return with light hearts and empty purses.][17]

At the Salon that year (1850), which opened in late December (the twenty-sixth), I sent two paintings: *Morning Effect* and *Sheep*.

In 1851, I also showed some works in Brussels, *Souvenir of the Pyrenees, Cows and Sheep,* and a drawing, *Ox in the Mountains, Scene from Auvergne.*

15. A.K. This letter is dated: "Tuesday, 10 A.M."

16. A.K. Letter dated: "Sunday or Monday morning, 1 o'clock."

17. Again a reminder that the bracketed material has been selected, edited, and occasionally summarized by Anna Klumpke. The closing bracket marks the point where Klumpke slips back into her invention/recreation of Rosa Bonheur's first-person narration.

M. de Morny

❖

The Horse Fair (1853)

❖

Haymaking (1855)

❖

Travels in England and Scotland (1856)

Less than a year before my father died, the government made him head of an art school for girls in the rue de Touraine-Saint-Germain, later renamed the rue Dupuytren. Now located at 10 bis, rue de Seine, this school was founded in 1803 by two ladies who maybe didn't know much, but at least they sensed what the future held in store for women artists.[1] During my father's brief tenure as head of that institution, his zeal and devotion to his duties were much appreciated. I was appointed to take his place, which I owed as much to his memory as to my recent triumphs at the Salon. For ten years I was head of that school, and I am rightfully proud to say that it prospered and that my work was not in vain.

My students adored me and faithfully followed my advice.[2] Some went even a step further. One morning I was surprised to see several of them show up with cropped hair. They had wanted to imitate me, and no doubt thought I'd be pleased. They soon realized that it was just the opposite: "I am sorely tempted just to walk out on all of you," I told them, "and not come back till your hair has grown out enough to hide the scissor marks."

After a few years I had to admit that I couldn't get enough of my own work done unless I gave up these far too absorbing tasks. In 1860 I

1. The founders were Mme Frère-Montizon and Mme Fanny Beauharnais. Charlotte Yeldham provides much useful information about the school and its role in women's art education in nineteenth-century France; see her book, *Women Artists in Nineteenth-Century France and England,* 2 vols. (New York: Garland Publishing, 1984), 1:40–48.

2. A.K. In order to help teach drawing, Rosa Bonheur did two series of animal studies (large and small) that were lithographed by Sirouy, Laurens, Soulange-Teissier.

decided to step down. But before that, I brought in my sister Juliette, whose fine native talent had been cultivated by my father for three years.[3]

When I say that these tasks got in my way, you mustn't think that I had stopped painting; for in those very years didn't I do the painting that really made my name?

The story of that work is rather bizarre. For a long time I'd been dreaming about painting a horse fair. Around 1844 M. Richard (du Cantal), head of the Horsebreeding School, sent me a copy of his book *Study of the Horse*, which I found very useful. Once the author became a good friend, his precious advice quickly rounded out my knowledge of anatomy. This learned man's motto sums up exactly what I think and wholeheartedly believe: "Science is the key to nature's treasures. It teaches us her infinite riches and unveils the marvels of the universe, which remain an enigma for the ignorant." I've got the highest respect for learned people: my father taught me to think that they were the apostles of nature. They've got only one failing in my eyes, but an immense one. They put their lights under a bushel basket, always couching their revelations in formulas that few people can understand.

Though I'm just an ignoramus, I'm quite sure that science would make prodigious gains with a change of method. If learned people listened to this naïve admirer of their genius, they'd share their discoveries with us without getting all bristly. That would be much more clever on their part.

3. A.K. In 1859 Arsène Houssaye, inspector general of fine arts, presided over the awards ceremony at the Imperial Drawing School for Girls. H. Flandrin, Martinet, and Signol made up the panel of judges. After Rosa Bonheur's introductory remarks, Arsene Houssaye spoke in the following terms:

"It is a great honor for you, mesdemoiselles, to have as your teacher a glorious artist who is the pride of France and the envy of all Europe. If nature is the teacher of teachers, it can be said that Mlle Rosa Bonheur has taken nature as her studio. We have to go all the way back to the golden age of Flemish painting in order to find an artist who understands landscape painting as well as she does: I mean Paul Potter. Since then, no one else has had a more intimate, profound, and poetic comprehension of God's first work, trees, meadows, and animals. If Mlle Rosa Bonheur were not here with us, I would be delighted to praise this beautiful talent that is the pride of all women.

"Mlle Rosa Bonheur is an inestimable teacher, since she is a glorious example for you in your youthful ambitions and initiates you into the realm of art with her profound knowledge. Nobility has its obligations, young ladies, do not forget for a single second that the lessons of such a teacher are your titles of nobility."

How many times did I hear Father say how much he admired Arago,[4] the illustrious man who found the secret of talking clearly about light itself? I truly hope that some day there will be the kind of book about him that his memory deserves.

I've read some astronomical treatises, which left me with the impression that science, like art, mustn't lose sight of practical applications. Otherwise, it's damned and its fruit is poison. Art and science, as I'll never stop saying, have magical powers, purifying and ennobling our thoughts.

As I was saying, after my father died, my only teachers were the artists in the Louvre and good nature herself, whose magnificent book lies ever open before our eyes. Memories of those artists combined for me with nature's teachings.

That's why I would happen to think about the Parthenon friezes while in a crowd of horse dealers trying out their beasts. "And why not do something like that?" I asked myself. My idea was not to imitate, as you can surely guess, but to interpret, which inspired me to do countless compositions and studies. I wanted to paint this work on a canvas at least eight feet by sixteen, much larger, therefore, than my *Ploughing in the Nivernais.*[5] One morning as I was getting down to work, I received a surprise invitation from M. de Morny, then the Minister of Internal Affairs, who also oversaw the Division of Fine Arts. He wanted me to go see him in his office.

This happened shortly after the December Days.[6] Several of my father's political friends had fallen victim to this coup d'état; some were exiled, others deported to Africa, where they died far away from their families. Now I was a staunch supporter of the Republic and felt deeply troubled by these events. When I entered the office of the man who had masterminded the overthrow,[7] I was trembling inside. Expecting a tiger, I was dumbfounded to find just the opposite: a true gentleman of imposing stature, full of grace and distinction. With a sparkle in his eye and a smile on his lips, he spoke with perfect elegance and courtesy.

4. François Dominique Arago, the nineteenth-century French physicist and astronomer.

5. *Ploughing in the Nivernais* measures 5′9″ by 8′8″.

6. On December 2, 1851, Louis-Napoleon Bonaparte, who was then the elected president of France, overthrew the Second Republic (1848–51). Eager to imitate his uncle Napoleon I, he replaced the Republic by the Second Empire and had himself crowned Napoleon III.

7. M. de Morny was the new emperor's illegitimate half brother and served as his right-hand man all through the Second Empire.

"Mademoiselle," he said emphatically, "I've taken the liberty of asking you here because His Majesty's government recognizes your rare merit and wishes to honor you by commissioning a work for the state museum. Do you have some sketches among which we could chose the subject that would allow you to develop your talent to your best advantage?"

His charming welcome and proposal promptly reassured me, and I replied with obvious satisfaction: "M. le Ministre, I'll be delighted to show you my sketches for *Haymaking* and *The Horse Fair.*"

"Very good, mademoiselle," he said, "please come back with your studies, and I'll look them over with you."

At our next audience, after examining my drawings, M. de Morny said: "Mademoiselle, both compositions are charming, but I prefer the rustic motif because it does more honor to your overall reputation. You're famous for your oxen and sheep, but you've painted too few horses for us to ask you to paint a scene as turbulent as a *Horse Fair.* We've not seen enough of your horses."

M. de Morny chose the sketch I liked least of all, told me the dimensions of the canvas, and said I'd be paid twenty thousand francs.

Even though I was very flattered by the honor, I insisted on showing that I could paint horses just as well as oxen. So I replied, with my artist's independence: "M. le Ministre, I'm preparing a composition that means a lot to me. I've always loved horses, and I've been studying how they move since tender childhood. I know in particular how remarkable the Percherons are, with their superb high necks and withers. I was meaning to paint a *Horse Fair.* With your permission, I won't begin *Haymaking* until this one's done."

M. de Morny made no objection.

"Take whatever time you need, mademoiselle," he replied. "*Haymaking* will be welcome at any time. We would be sorry to hamper you in any way."

So I kept going on my *Horse Fair.* It would even have seemed indecent to hurry, since my father was no longer there to share in my delight and benefit from my small fortune. Yet my canvas was ready for the Salon of 1853. It was wildly successful, and the jury unanimously declared that from then on anything that I sent to the Salon would be automatically accepted.

After the Salon, what was I going to do with *The Horse Fair?* I sent it to the Ghent exhibition (1854). The Royal Society for the Encouragement of the Fine Arts of Ghent showed me delicate homage by giving me a magnificent brooch with a cameo engraving of my painting. Since this token of

esteem came from the land of Rubens and Van Ostade, I was deeply moved. Yet my canvas, no doubt because of its huge size, still didn't have a buyer. That same year there was to be an exhibition in Bordeaux. I promptly sent down my painting, only too happy to associate my birthplace with my first great triumph. I would have been overjoyed to see my painting in the Bordeaux museum, and I made them an offer for fifteen thousand francs. The city commissioners, who thought I was being presumptuous, turned me down. I didn't take that too well.

While my canvas was trotting all over the globe, I moved my studio from the rue de l'Ouest to 32, rue d'Assas. There, with an entire house, a courtyard, and garden, I could work at ease and parade all the animals in Noah's ark through the premises (end of 1853).

Meanwhile, my painting's success at Ghent had made such a sensation in the French press that M. de Morny, to whom I had sold another painting from the Salon of 1853, *Cows and Sheep*,[8] showing them on a sunken road, finally understood how wrong he had been to appear hippophobic in the fore-mentioned interview. One day while I was working on *Haymaking*, the marquis de Chennevières, then the director of the Fine Arts Division, came into my studio and very nicely asked me to substitute *The Horse Fair*, which M. de Morny had turned down, for the painting I was working on. Much to my regret, I could not yield to his request. I had just sold *The Horse Fair* the day before.

As it happened, a London art dealer, namely M. Gambart, had come to inquire about the price. Nathalie, who took care of my financial affairs, promptly replied: "It won't leave France for less than forty thousand francs."

M. Gambart accepted on the spot, knowing full well that Bordeaux had refused to take it for fifteen thousand. Once everything was settled, he told

8. A.K. The good relations between the count de Morny and Rosa Bonheur were not limited to the commission for *Haymaking*. The notebook in which Nathalie recorded everything concerning her friend's work reports that they had agreed on a price of four thousand francs for *Cows and Sheep*. However, when the painting was delivered, M. de Morny insisted on paying only three thousand. Although Nathalie maintained that the work could easily have sold for six thousand francs, Rosa Bonheur was accommodating. She offered the minister a sketch of *The Horse Fair* and a portrait of Louis XVI, apparently happy to pay off by these means two pardons that had been recently requested and very graciously granted, the first for a political prisoner, the second for a military man under disciplinary action. At Rosa Bonheur's request, her very own brother Auguste had been the beneficiary of the count de Morny's high influence.

me he wanted to show *The Horse Fair* in London, at Pall Mall, then throughout the major cities of England. He also intended to call for subscriptions to get it engraved by Thomas Landseer, the brother of Sir Edwin Landseer, the painter. Though I was very pleased to have sold my painting, I couldn't help thinking that Nathalie had *throttled* him a bit. To appease my conscience, I offered to paint M. Gambart a quarter-sized reduction of it. If he liked, the engraver could use the small one while the other was traveling around. M. Gambart eagerly accepted, and Nathalie got right down to work on a copy I later finished up.

This copy, meant only to facilitate Thomas Landseer's work, had a curious fate. A wealthy art lover, Mr. Jacob Bell, bought it from M. Gambart and left it to the National Gallery in London. This I learned with mixed feelings. Delighted to have a piece in that great English museum, I was a bit put out that it was only a copy. Then it dawned on me that if I redid the painting with the help of my old studies, I could produce a second original that the museum administrators would certainly love to exchange for their copy. I settled right down to work. Once the painting was finished, I offered it to the National Gallery. Alas! all in vain. Bound by the terms of Jacob Bell's will, the museum administrators couldn't accept my proposal.[9] So, the only thing of mine in this famous museum is a painting that, despite its merits, cannot be as interesting as I would have liked.[10] As for the large canvas, my labor of love, it traveled all over England and off to America. These peregrinations did not hurt its value. When it left M. Gambart's hands, it went to Mr. Wright, and from there to Mr. Stuart, whose collection was sold in 1887. When it was put on the auction block, *The Horse Fair* sold for 268,000 francs ($55,500), the price that Mr. Cornelius Vanderbilt paid for the pleasure of giving it to the Metropolitan Museum in New York.

As for M. de Morny's *Haymaking*,[11] which I completed more than a year after *The Horse Fair,* it had a good showing at the Salon of 1855 and won a gold medal. Now it belongs to the Luxembourg Museum.

But back to M. Gambart, who was one astute art dealer. One can rightly say that before agreeing to sell my canvas to Mr. Wright, he tried to make as much as he possibly could off it, beginning with the return of the forty

9. A.K. This painting was later bought by an Englishman, Mr. Mac Connel, for twenty-five hundred francs.

10. A.K. This painting is now in the Tate Gallery.

11. A.K. M. Richard (du Cantal), the agronomist, is said to have posed for the peasant driving the oxen.

thousand francs it had cost him in the first place. To make things easier for him and show him how happy I was about the work's fine engraving, I turned over to him all future profits from its sales.

As for the exhibits he intended to set up in all the major cities of the United Kingdom, M. Gambart hatched the brilliant idea of getting me to contribute to their success without my even knowing it. He knew my passion for unspoiled nature and my weakness for Walter Scott. Wouldn't these exhibits give me a wonderful chance to satisfy these two desires by a trip to the Scottish Highlands? That's the idea he tried to plant in my mind. He also pointed out what an advantage it would be for me to supervise Thomas Landseer's work on the engraving.

Along with other fine pretexts, the idea of studying the English school, seeing the works of the famous animal painter Sir Edwin Landseer, and meeting him as well as several of his fellow artists—all these pleasant prospects quickly overcame the repugnance that I, like any French citizen, unfortunately felt at the thought of leaving my country.

One problem remained: language. I couldn't speak a single word of English, nor could Nathalie. But M. Gambart found the winning reply to this terrible objection, too. He promised to be our interpreter and quartermaster wherever we went. As it was impossible to hold out any longer, we starting packing.

Thinking of nothing but my palette, brushes, and paint box, I would have left Paris with just one little suitcase.

Nathalie, much shrewder than I, had gathered that M. Gambart was setting up a series of triumphal receptions for me. So she readied a formidable array of equipment: silk skirts, mantlets, lace, gigantic hats that nearly hid our faces. You can just imagine what an event our departure was, with good mother Micas telling us: "Children, you've got too much luggage, you won't know what to do with it all, you'll have to sow some bags along the way."

How right she was to have these maternal qualms! This we realized as soon as we got to customs and tried to explain.

Nathalie, appointed our historiographer by her mother, carefully recorded the tale of our trip. Every now and then I'd add a few lines to Nathalie's letters in order to show good mother Micas that I hadn't forgotten her, despite my preoccupations, but I was seeing so many interesting things that I hardly even had time to draw.

My sketches were useful for years to come. They helped me out with *The Stampede of Scottish Oxen, Oxen in the Highlands, Crossing Loch Loden, The Boat, The Razzia,* and several other major paintings.

[The itinerary set up by M. Gambart began with a stay at Wexham rectory,[12] a pleasant summerhouse the very aristocratic art dealer had rented near London. There he delighted in treating his two friends to the most pleasant, flattering hospitality.[13] In their honor he invited literary and artistic celebrities, Sir Charles Eastlake, the president of the Royal Academy, and Sir Edwin Landseer, the famous animal painter, and many others. They were all quite merry, if one takes good Nathalie's word for it.[14] She was hardly accustomed to this "life of gluttony," where people ate from morning till night.

From Wexham they went on to London in order to see the city, visit prominent people, and meet Thomas Landseer, who was to do the engraving of *The Horse Fair* for M. Gambart. They went to Windsor and the forest, where Rosa Bonheur was particularly delighted to see herds of two or three hundred deer in liberty. Despite dinners and gadding about, she still found time for a few studies.

At that time *The Horse Fair* was on exhibit in Birmingham along with other canvases, including three Rosa Bonheurs. That city being right on the way to Scotland, M. Gambart simply had to take the two travelers to Birmingham. Wouldn't that, all in one fell swoop, get them a triumphal reception and guarantee the show's success? Everything had been perfectly organized to that end. The first day there, Nathalie, still a bit dazed, wrote to Mme Micas:

Birmingham, August 13, [1856]

Dear good mother, we've just arrived in one of the great English cities. At noon we got to the hotel and scarcely had time to get dressed for a lunch at the house of a great art lover[15] who came to fetch us. The nicest reception awaited us at this gentleman's house. The most distinguished writers and artists of Birmingham had gathered to salute Rosa and offer her, on behalf of the city, their sincere compliments. Her picture is on exhibit here, and the show is very successful. There we are, dear good mother, for the chapter on pride. Now, as for comfort, we are traveling like true princes.

12. A.K. Just as before in the case of the trips to the Pyrenees and to Germany, I thought that here I ought to intercalate, from their correspondence, the story of the trip that Rosa Bonheur and Nathalie made to Scotland.

13. A.K. From August 7 through 13, 1856.

14. A.K. Letter of August 11, 1856.

15. A.K. Mr. Birch.

I almost forgot to tell you that after we left the art lover's house, we went on to another one[16] with yet another lunch in her honor. Over here people lunch all day long. But this one was truly a banquet worthy of Balthazar, with the rarest fruits and the most sophisticated delicacies. Driven in a stagecoach, with all these gentlemen trailing behind, we entered this truly palatial estate.

At the first house the ladies found the sweetest and most moving way to honor Rosa. Over the entrance they put up a flag with the colors of France and the initials R.B.

Good-bye, good mother. I embrace you with all my heart.

Today has been rough on my emotions; I was thinking about you and regretting that you weren't here. Rosa was superbly simple in the midst of this triumph.

Good night once again and a kiss from your loving daughter.

Jeanne Micas

Rosa Bonheur added a fond word and this impulsive little sketch so that, as she said, the good lady could see what kind of rig her daughters were being dragged around in.

Rosa Bonheur added this sketch to Nathalie Micas' letter to her mother to
illustrate their reception in Birmingham, England in 1856.
(Original French edition, p. 232.)

After Birmingham, Glasgow. Rosa Bonheur finally had the great joy of setting foot on the land of Ossian and her dear Walter Scott. She was also delighted to meet, at every step, art-lovers who gave her compliments and so many orders for paintings that it seemed she would never be able to do them all. A man named Wilson, a major Scottish coal-merchant, entertained her in his castle at Banknoch, but her stay was very brief. M. Gambart was impatient to take his two guests to the most picturesque

16. A.K. Mr. Bouloc.

parts of the Scottish coast and the Highlands. So by boat and by carriage they made their way via Greenock and Inverary up to Oban. There, on Loch Linnhe, a steamship picked them up and took them to Ballachulish, on the shores of Loch Leven.

At Ballachulish the tourists stayed in a hotel wedged between the sea and the mountains. They spent more than two weeks in this wonderful place, making daily excursions with M. Gambart into the Highlands, on the loch, or out to sea. Rosa Bonheur wanted to catch dogfish. Up there they met a fine man who would give Rosa Bonheur permission to paint one of his hounds only if the model got the picture.

Nathalie, who was less adventurous, often stayed back at the hotel. Her thoughts would fly back to her mother and inspire the most affectionate letters.

Sunday, August 24[17]

My dear Mama,

Rosa drove off this morning with M. Gambart. Wanting to have a long chat with you, I preferred to stay here. When everyone's around, you can't even think straight. I'm writing to you from one of the hotel drawing rooms, which would be the most poetic room imaginable if it weren't for the wind's melancholy wail. The little birds are so tame that they come tapping at the window. The tide is coming in. You just cannot imagine what the ocean is like. This morning before she left, Rosa said: "Next year I want your mother to go to Brittany with us."

Rosa has never clucked over me so much, saying she must repair through the daughter the hurt that she's given the mother. "Your mother is very good," she said this morning. "I love her dearly, and I really believe that even if she were my own mother, I wouldn't love her any more than I do. I'd like her to know that it's my head alone that is bad, not my heart. But since I call myself her child, she'll forget my faults and try to think that I'm a good girl, as all mothers do with their children, even the worst ones." This, Mother, is how we always talk when we're alone. We talk about you, the sacred link in our life together.

In her letters Nathalie also talked about Rosa's work. At the beginning of their travels, there was no doubt a moment when she feared that her friend, who had no time for doing studies, would have to resign herself to bringing back only a rich harvest of memories of "these new things that nobody has done yet, not even the English." Rosa said that they were

17. A.K. Letter from Ballachulish, August 24/25.

terribly ignorant of the veritable goldmine that their country was for artists. But she soon began to make up for lost time, as Nathalie wrote from Ballachulish:[18]

Rosa has finally got down to work, and she's moving along on three beautiful studies. As for me, I'm doing nothing. Rosa claims that I really need to watch her, which means that she is giving me good lessons from which I shall try to profit. It is very hard to find a boy to carry Rosa's box. Often this good M. Gambart loads himself up like a veritable beast of burden. Oh! what beautiful country this is!

Rosa Bonheur was carried away by the Scottish peasants' superb livestock. She came across oxen, bulls, and sheep of sorts practically never seen in France. She sketched them as much as she could, but thought that she would soon have to go back home without having filled up her sketchbooks. Then she got an idea—if she could not stay any longer with such models, why not take a herd back with her? About the only place where she could find just what she wanted was Falkirk fair, on September 9. Although she did not want to tarry in Scotland, she made up her mind to do so, certain that her time would not be wasted.

At the beginning of September they left Ballachulish for Falkirk and crossed through another picturesque, poetic region: wild Glencoe; Loch Katrine, which calls up memories of *The Lady of the Lake;* the Trossachs with their marvelous valley; and Glen Falloch, way up north of Loch Lomond, where one evening Rosa made the banks resound with her powerful voice.

The steamer down Loch Lomond delighted them. Then they arrived at Dumbarton, and a few hours later they were back at Banknoch with Mr. Wilson, who had kindly offered to take them to the fair.

Their remaining days were certainly put to good use. The area was well endowed with coal mines, smelters, and foundries. They made a point to visit the most interesting sites, and Nathalie wrote after one of these outings:

Dear good mother,

I'm writing this letter without any idea what day it is. Today we went to see the oldest iron foundry in the whole world, certainly the most beautiful thing that one can ever wish to see. Just imagine furnaces that have been burning, day and night, for two hundred years without ever going out, not even for a second. It has produced at least 25 million francs of iron. We were shown everything with the greatest care, and right in front

18. A.K. Letter of Thursday, August 28.

of our eyes a pot was cast for us. We saw them melt down the iron and pour it into the mold. What makes the event truly rare is that tonight it will be our soup pot. This has been a most interesting day for us.

We had only one regret—that you weren't here with us, my dear Mama. That would be too much happiness, and yet it will have to come, for I'm counting on it.[19]

The next day they went off to Edinburgh. This time it was Rosa Bonheur who sat down to write one Sunday:

Dear fat mother,

We are spending the loveliest Sunday bored to tears. It's pouring outside and in this country the Lord's day is so thoroughly sanctified that there's not a single soul in the streets and you can't even visit the castle. We're in a big drawing room at the hotel, staring at the ends of our noses or snoozing.

In the same letter Nathalie also told the previous day's disappointments: In my last letter, I mentioned a little trip that we were planning to the island of Bass-Rock.[20] So yesterday we set forth on this expedition, which . . . got all washed up, and here's how. We were quite a gang, because two artists, Mr. Goodall, whom you know, and Mr. Maclise, whom you've heard about, and one of their friends joined us. We chartered a steamer for the day so that we'd really be in charge. Things began pretty well, but after we'd been at sea for an hour, these gentlemen felt sick, and halfway there we had to give up the idea of hunting the sea goose. The weather was foul, and our little ship was dancing around like a nutshell. As for me, I kept quiet and was very happy about this obstacle. Although I've become used to the sea, I still can't harbor nice thoughts about her when she's in a bad mood.[21]

Finally it was the eve of the famous fair. Huge numbers of cattle turned their heads toward Falkirk. To get to the city, they swam across the mouth of the firth at low tide while drovers in boats alongside held them up by the horns. There were also boatfuls of sheep ferrying from one bank to the other. For an animal painter, could there be a more captivating sight than this? Rosa Bonheur did several studies.

19. A.K. Undated letter, probably written from Banknoch on Friday, September 5.

20. A.K. Bass-Rock is an enormous rock where seabirds congregrate at the mouth of the Forth.

21. A.K. Letter from Edinburgh, September 7.

On Tuesday, September 9, the day of the fair, Nathalie wrote to Mme Micas:

<div align="right">*Banknoch, Tuesday, September 9*</div>

Dear good mother,

Never have I seen a country so unfree as England. Wherever you go, someone is always watching. You can't take a single step without the entire English press knowing the next day what you did and said. "This is great freedom," says M. Gambart; Rosa and I call it a great inquisition. Everyone knows that Rosa is going to Falkirk fair. Therefore, she is followed or escorted by two hundred people. If fame has its good points, it is sometimes boring and tiresome. Yet I believe that these nuisances will bring forth a good harvest in the future. People are more and more enthusiastic about her work, and if the French start to give her trouble, she can easily do without them. She'll never paint enough pictures to meet the demand.

All right, I've got to go so that Mme Gambart and I can meet up with Rosa and the gentlemen at the fair.

Your loving daughter, and a kiss from Rosa.

<div align="right">Jeanne Micas</div>

These gentleman, two members of the Royal Academy, made quite a sensation driving up to the fair with the great French artist in Mr. Wilson's carriage, which everyone recognized.

Rosa Bonheur picked out seven oxen. The drover, eager to separate them from the rest of the herd, began hitting them. A great commotion ensued. The oxen threw themselves down on some nearby sheep and crushed the life out of a few. Things finally calmed down, the oxen were paid for, but no one would take any money for the dead sheep. The seven oxen, plus five sheep that Rosa had already bought, were sent to Wexham rectory. A few days later the travelers also arrived back, after having made a detour to the Isle of Arran and a nineteen-hour boat trip down to Liverpool.][22]

We had had some misgivings before starting out on this trip that nevertheless gave us such great satisfaction in matters of art and pride. As it happened, we had to go back to France earlier than we would have wished, given all the pictures and studies I had started and wanted to finish

22. Another reminder that all this bracketed material is Anna Klumpke's third-person narration of the Scottish trip. Now the narrative returns to Bonheur's first-person mode, an effect created by Klumpke's narrative ventriloquism.

up. Plus, I had a whole herd of animals in M. Gambart's cow barns. But it was almost time for the awards ceremony at my art school. I simply had to go back,[23] especially since M. Robert-Fleury, Senior, had done me the honor of agreeing to preside at the ceremony.

When it was over, I returned to England to resume my interrupted labors. Nathalie stayed in Paris and fixed things up in the rue d'Assas so that some of the Scottish oxen I was bringing back could stay there. But I had not counted on the imbroglio of customs law and the epidemic animal diseases that nations generously ascribe to all their neighbors so that they can close their borders to livestock imports. I had to give up and resell in England the beautiful beasts I was so proud of.

In Nathalie's papers I found a copy of the letter she wrote while I was away to Mlle Love de Lyne, a young lady of very distinguished family who had just entered the convent. While we were traveling though Scotland, she had written, urging us to follow in her footsteps.

I fully recognize the merit of these monastic heroines who give their lives entirely to God. Yet I'm convinced that the Creator would be much more moved if a girl with no taste for marriage devoted herself to humanity instead of lying flat at His altars.

Here is Nathalie's letter:

[Paris, October 1856?]

Dear Love and sister,

For a long time now I have wanted to answer your kind letter announcing that you have once and for all renounced the world. Please accept, my dear friend, from Rosa and me, our sincere congratulations.

We both thought that, given your faith, truly nothing but the convent would suit you, but let me say I doubt the same would apply to a woman artist who needs great freedom of thought and movement. I'll repeat, my dear Love, what I've often said in the past: salvation can be worked out anywhere, and a mountain top may be just as good an altar as the inside of a cloister. Believe me, don't try to convert us; love your old friends as they are. They are proud to think that they do not offend God by staying in the bosom of the world, where, after all, the good fortunately outweighs the bad. And very often when we find something bad, the thing itself is not bad, but we ourselves are. Therefore I shall say like one of our friends, everything is for the best in the best of all worlds.[24]

23. A.K. Rosa Bonheur returned to Paris at the very end of September 1856.
24. An obvious allusion to Pangloss in Voltaire's *Candide*. To an ardent

Let's not try to see evil, but good. So you believe, my dear Love, that our Rosa has no faith because she won't accept certain practices. But would she be what she is if she didn't believe in God? If she didn't have a living, holy faith, if her heart were not free of all doubt, would she be able to admire what is grand and marvelous in nature?

Would God have given her understanding of Him if she did not believe in Him? Would He have made her one of His elect? My dear Love, don't try to change this treasure of God's. Rosa is not the work of man, in neither mind nor body. She is the work of God alone. She wanted to answer your letter. She may do so when she gets back, for I must tell you that we didn't find your letter until after we got back from Scotland. Rosa stayed a few days for the awards ceremony at her school; then she went right back to England.

I would like to tell you about all her triumphs, but that is difficult in a letter. While you were with us, you knew what success she had. Well, that was nothing. The English and the Scots are much more enthusiastic about her than the French. For that reason we had to respect the strictest incognito in order to move around with some degree of freedom. Otherwise, there would have been nothing except parties, dinners, and outings. More than ever Rosa detests public appearances. She is pleased about her success, which proves that her work has found its reward, but she runs away from honors. Here again our friend shows what she is made of, amid the wonderful fame that would go to the head of more than one of these gentlemen if only they could get just a taste of it. She is just as modest and simple and indulgent toward the talents of others as she was when you met her. You can certainly see, my dear Love, that for her to remain what she is, amid all these heady vanities, she has to be one of God's elect.

You ask me, my dear Love, to send you a person who knows how to draw. If I knew of someone alone in the world, I would talk to her about your convent, where everybody sounds happy, from what you say. As for my little Angélique, she does not belong there yet. With what she earns, she feeds her father and mother, who are both elderly and unable to work. She carries this heavy load alone, and the day she stops providing for them, they will die of hunger or go begging in the streets. If the convent wanted to take them in charge, she might consider leaving the world. Just now she is with the Etchevery family in the Pyrenees, where, I can assure you, things are not merry.

Catholic like Love de Lyne, even the mention of Voltaire's name would certainly be anathema.

I am reluctant to say good-bye, my dear Love, but I must say good night to my poor Rosa, who had to go back to London all alone.

Therefore, good night, my dear Love. You can always count on our true friendship.

<div align="right">Jeanne Micas</div>

At the Chateau of By, Near Fontainebleau
❖
M. Tedesco
❖
M. Gambart

The Horse Fair's success in the United Kingdom had a surprising echo in France. All of a sudden my career was at its zenith. The English were snatching my engravings out of each other's hands, and the Americans vying for my paintings. Thanks to that exotic enthusiasm, I could spend as much money as I liked and not worry about it. Major commissions were pouring in from all over the world. I became a star of the art world, and my Friday receptions in the rue d'Assas were sought out by the most brilliant society. Even M. de Morny showed up on several occasions. But every day I was beset by throngs of people who flocked to my place as if I were some kind of strange beast. They thought they could just show up whenever they pleased and impose the burden of their presence. They tried to wheedle autographs, drawings, sketches, and all sorts of souvenirs out of me. If I'd liked being in the camera's eye, I could have had whole days of it.

To get away from that constant obsession and back to nature, I made up my mind to "go to the birds," to quote Aristophanes; in other words, to retreat into solitude and live far from the madding crowd.

One of my friends, Count d'Armaillé, agreed to look for a house for me. It had to be far away from any commotion and so isolated that I could let myself go and live the life of the forest and fields. Close to Fontainebleau he discovered this property where I've been living for nearly forty years. There are about seven and a half acres of land, planted with age-old trees that stand comparison with those of the neighboring forest, and a two-story house that people around here call the chateau. It was just what I wanted, and I bought it.

The word *chateau* sounds pretentious. It probably comes from the fact that around 1400 the house was home to an officer of the Crown, the king's beekeeper. His royal charges went around plundering honey from the neighboring broom plants, grasses, heather, flowerbeds, and vineyards.

The royal beekeeper had the funny name of Bigre,[1] which in time be-

1. In French slang, "gosh," "holy smoke."

came Bige and then By. I came across this curious etymology in the book that M. Huet, Thomery's schoolteacher, wrote. At the beginning of the fifteenth century a certain Henri de Bye, commander of Saint-Jean-de-Latran, lived in the chateau.

The lordly line of By went on unbroken for almost four centuries. During the Hundred Years' War some Scots were garrisoned here, and a few became known as the princes' favorites. In the old papers I found an act signed by Marie de Medicis, which I gave to Countess d'Armaillé.

The last known lord of By was a certain François de Quesnoy. In 1730, at the death of his wife Jacqueline de Saint-Rémy, the daughter of M. de Lamotte-Fouquet, he sold the chateau to Jean-Maximilien Leleu. The new owner was much more pious than his aristocratic predecessors. Anne Leleu, his wife, had a chapel built, which was consecrated on July 13, 1775. Mass was said every day, even on solemn feast-days, so long as another priest celebrated at Thomery at the same time.

The walls of the chapel are still standing, but the tiny nave, which was falling apart, was turned into a grape cellar a long time ago. M. Huet told me that while the masons were digging it out, they found Anne Leleu's coffin. I wanted to honor the lady of the manor, so fondly remembered in these parts because of the mutual-aid society she founded. So that she might repose in her former domain, I had a grave dug for her at the foot of the most beautiful beech tree on the grounds.

For a while the Leleu nephews lived in the chateau. They sold it to a Pierre Michelin, who left it to his son-in-law, Louis-Jacques Fabvre, a rake who spent the family fortune on the ladies. Thanks to his extravagance, I was able to buy the house and lot for a modest fifty thousand francs.

I paid the first installment on August 9, 1859, and began building a studio over the toolshed and laundry (fig. 7).

On June 12, 1860, the estate became mine. Right away I moved my furniture, studies, and animals down from Paris.

Oddly enough, I had scarcely moved in when an abundance of bees took advantage of the studio's overhanging roof and came to live with me. No doubt, when they saw that an animal painter had replaced the royal beekeeper, they figured they had nothing to fear. When the wasps followed suit, I wasn't so happy. They attached their nest to a rope some workmen had inadvertently left hanging in the dovecote.

Aside from these trivial matters, the move gave me more serious things to think about. The most important one was providing for Nathalie and her mother in a way that was worthy of my love. How happy it would have made me to give back to good mother Micas just a tiny fraction of

the kindness she had shown me in my direst straits! But her mind was made up. Mme Micas was absolutely determined to remain independent. She would live with me only if I rented her a part of the house. Since there was no way I wanted to leave my dear friends, I accepted these bizarre conditions but insisted on a thirty-year lease. There was also a special clause stating that in the event of my renter's death the same agreement would apply to her daughter, but to her alone.

You understand that the point of all this mumbo jumbo was to set up a union that nothing, short of death, could disrupt. Once all the legal affairs were settled, Mme Micas and Nathalie moved into the chateau. They promptly took over the kitchen, farmyard, and animals, so that I didn't have a single household worry. When I entertained my brothers, sister, and friends, good mother Micas saw to everything. She was a model of care and economy and ran the house with amazing skill, down to the minutest details. Even though her mother was so clever, Nathalie, in her devotion to me, found ways to equal, maybe even to surpass, her (fig. 8).

The affection of these two women really helped me develop my talent. My greatest ambition was now fulfilled, since in this wonderful place I could devote myself heart and soul to art. Although getting away from Paris delighted me, I didn't mean to sever all links with the great city, and I've always kept a little apartment there.[2]

I had to do many repairs and redo all kinds of things in the house as well as on the grounds, which became my real studio. It would be good to do a few more, if only to get the little summerhouse back in shape. In the old days it was called the Temple of Love, just like the one at the Trianon,[3] and I've been told the former owners threw the occasional party in it. Nathalie repainted it several times, but since my dear friend's death I've let everything go. Part of the roof caved in, and ironically a shrub decided to take root at the peak. Even so I still want to get the summerhouse repaired. Then we'll call it the Temple of the Muses.

I fenced in the lot next door and built some little sheds, sparing nothing for my animals' comfort. At times this place has been a veritable Noah's ark: mouflons, stags, does, izards, boars, sheep, horses, oxen, and even lions.

I was very fond of all my boarders, the sheep most of all. I've had up to

2. A.K. When Rosa Bonheur told me all this, she had had an apartment at 7, rue Gay-Lussac for several years.

3. Marie-Antoinette had a Temple of Love built on the grounds of the Little Trianon at Versailles.

forty at a time. Good mother Micas used to stuff mattresses with their wool. Out of concern for their welfare I ordered the servants not to shear their bellies so that they'd have some protection from biting flies during the summer. Ulysses and his men would have had an easy time hanging onto their fleece to escape the watchful Cyclops.

Nathalie's tests for one of her inventions were certainly the most unforgettable thing ever witnessed by my trees. In 1861, I believe, my friend hatched the idea, quite unexpected for a woman, to build a wedge brake that would stop express trains dead in their tracks. She had a little railroad built on the grounds to test it out. The head of the line was right in the middle of my old oak trees. At times the tests were dangerous. How often, for example, did I see the train bolt and throw off its sacks of ballast!

Once these projectiles landed so close to me that I nearly got brained. Don't smile, Nathalie took her invention very seriously. Yet I've got to admit I always thought my dear friend had a bit of screw loose on that score.

One fine day Nathalie, after much fiddling around, felt so sure of her contraption that she drummed up all our friends to witness a grand experiment, on July 13, 1862.

In point of fact, the test proved her right. The little locomotive stopped right where it was supposed to. I can still hear the salvos of applause that hailed her triumph.

Nathalie was so overjoyed that she lost all control and threw her arms around her assistant mechanic, forgetting that he was covered with soot. Every member of the household, four-footed and two-footed, was jubilant. Even the dogs kissed, and good mother Micas shed every tear she had.

The next day Nathalie was so worn out from all this excitement that she did a bit of painting with me to rest up and clear her mind.

She was so proud of these brilliant results that she took out a patent and asked to test her brake on a line just outside of Paris. It was a success, but since the project sprang forth from a woman's brain, the engineers wouldn't adopt it. Nathalie gave up working on her brake. A few years later, an Englishman made a trifling improvement, gave it his name, and managed to sell it for a hefty sum.[4]

4. In his *Reminiscences of Rosa Bonheur,* Theodore Stanton reproduces testimony from several railway engineers and shop foremen who were involved in testing the Micas brake. They nearly all confirmed that it was a good invention, and that antifeminist bias led to its marginalization (pp. 89–94).

When I was getting my first taste of success, I had the good luck to meet two important art dealers, who were also true connoisseurs.

The first was M. Tedesco, whose three sons are just as able as their father. They're fine proof of the old saying, "What's bred in the bone comes out in the flesh." They've always had a great nose for sniffing out my companions of the palette. For over forty years they've kept me and my paintings famous.

The second was M. Gambart, who printed engravings of my paintings. Quite some time ago, his nephew, M. Lefèvre, took over the business.

M. Gambart and the Tedescos were so eager for my work that they'd scarcely wait for me to finish something up before shipping it off to England or especially America.

I was terribly annoyed that they didn't even leave me time to get something done for the annual salons. The last thing I showed back then was *Haymaking* at the Universal Exhibition in 1855.

M. Tedesco and M. Gambart have never stopped bombarding me with really tempting proposals. I could have piled up a huge fortune, but why go to all the trouble? So that my heirs would get a bit more?! Nathalie and I had more than we needed. Like Agassiz—that glorious French zoologist, who became an American citizen and was such a hard worker—I've always thought that I had no time for earning money. Life is too short.

I've never compromised my freedom for any reason whatsoever. Once my independent streak even got me into a carnivalesque debate.

I had promised to paint somebody a team of horses or oxen or a ploughing scence, whatever inspired me, for eight to ten thousand francs. He was supposed to get it after a little while, yet I'd made a point of saying that I'd get around to it "when I felt like it." Though he asked where it was time and time again, several years went by. I just couldn't get myself to finish it up. He finally lost patience with me. Learning that I wouldn't have cared a whit if he had just canceled the order, he got even more put out.

When I wrote him saying: "My desires and aspirations make it a duty for me to devote my time to new compositions. I pick up my brush when I feel like it," he was simply outraged. After lots of squabbling and carrying on, the case went to court at Fontainebleau. I was found guilty and ordered to hand over the painting within six months with a fine of twenty francs for every day beyond that, or else pay court costs and damages. I chose the latter. That little adventure cost me sixty-three hundred francs.

The decrees of Themis,[5] you see, put artists and contractors in the same

5. Daughter of the Titans and mother of Prometheus, Themis was a Greek

category. People obviously assume that artists can produce a fine piece by the appointed day, like building a wall, digging a ditch, or tarring a road. Yet the Muses don't inspire their children unless they labor for love of art alone.

I had a nicer time with another prominent person, Duke d'Aumale.[6] Though he'd been in exile since 1848,[7] he kept up his interest in Parisian art. Countess de Ségur let me know that he wanted a piece of my work. So I painted him the *Shepherd in the Pyrenees,* now at the Chantilly Museum, and shipped it off to England. The prince sent me this flattering thank-you:

Twickenham, June 5, 1864

Mademoiselle,

I must tell you myself, on behalf of the duchess and me, how delighted we are by your charming painting. I daresay that it is one of your best (which says a good deal) and we are very pleased to have it. Please accept all our thanks, with my deepest respect.

H. D'Orleans

What the letter doesn't say is that my asking price was five thousand francs, and the prince paid me double. I think artists today aren't used to such princely gestures.

goddess of Justice.

6. Henri-Eugène-Philippe-Louis d'Orléans, Louis-Philippe's fourth son (1822–97).

7. This was the year of the fall of the July Monarchy. The former king, Louis-Philippe d'Orléans, and his family went into exile in England.

CHAPTER 17

The Empress at By (1864)
❖
Rosa Bonheur Receives the Legion of Honor (1865)
❖
The Exhibition of 1867

For a long time now my paintings have been well received by art lovers far and wide. That has earned me lots of money and let me live down here at By since 1860. I've also received several flattering tokens of esteem, some even quite recently, as you know. I'm not just talking about prizes from the Paris Salons and medals from shows here and abroad, but also sheepskins and honorary memberships from foreign academies and art societies.[1] There was another kind, too.

Little books and articles have been written about me. In one that I've already mentioned, Eugène de Mirecourt, way back in 1856, asked the Empire to award me the Cross of the Legion of Honor.[2] At that time you could count on your fingers the women who had ever received this honor, even for services rendered to the army. Sister Rosalie alone got the cross for her devotion to the poor and the sick. The mere fact that my name had been brought up in that regard gave me a certain right to feel proud.

While I was living in the rue d'Assas, artists and fashionable people often dropped by the studio. That gave me a very flattering circle of friends, but if I hadn't upped and decided to seek exile in the Fontainebleau forest, in no time flat they would have made it impossible for

1. A.K. Rosa Bonheur was elected as an honorary member to the Amsterdam Academy in 1854, the Brussels Watercolor Society and the Rotterdam Academy in 1856, the Fine Arts Academy of Milan in 1862, the Pennsylvania Academy in Philadelphia and the Society of Belgian Artists in 1863. She was also elected to the Fine Arts Academy of Anvers in 1867 and that of Lisbon in 1868, the Royal Academy of Watercolor Painters in London in 1885, and finally the Royal Academy of Lisbon in 1890.

2. A.K. "Nuns and vivandières have been decorated with the Legion of Honor. So why exclude from the same honor women artists who, like our heroine, have such undeniable talent and above all such a pure life, such a worthy character, a history so rich in noble acts, charity and virtue?" (Eugène de Mirecourt, *Les Contemporains. Rosa Bonheur,* p. 93).

me to go on working. I've had far fewer visitors here, but some of them have been very important people, as you shall see for yourself.

On June 14, 1864, a few days after that letter from Duke d'Aumale, I was in my studio working on *Deer at Long Rocks*—you know the painting I'm talking about: a stag with a huge rack of antlers followed by a whole family of does and fawns—when all of a sudden I hear carriages rumbling, bells jingling, whips cracking (fig. 9). All this commotion stops dead at my door. A second later Nathalie bursts into my studio shrieking: "The Empress!3 The Empress is coming! Quick, off with your smock. You've just barely got time to put on this skirt and jacket," which she handed me. In less time that it took to say it, I had changed clothes and thrown the doors to my studio wide open. The Empress was already on the threshold, her ladies-in-waiting, officers, and uniformed court dignitaries following close behind. With that sovereign grace that made her the queen of Parisian fashion, Her Majesty approached. Giving me her hand, which I kissed, she said that while out for a drive in the neighborhood she'd had a sudden whim to come meet me and visit the studio. I said I was deeply honored and showed her my paintings and drawings there. She praised them all but seemed to prefer the one I was working on, *Deer at Long Rocks*,4 which brought forth several remarks.

Obviously hoping to keep me entirely under the spell of her visit, which lasted about an hour, she commissioned a painting for her private collection and invited me to come have lunch sometime at Fontainebleau. As she was leaving, she gave me her hand, which I kissed once again. This must have pleased her, for she promptly drew me forward and kissed me.5

I painted *Sheep by the Sea* for her. It was shown at the Exhibition of 1867 before going to the Tuileries. I don't know what has happened to it since September 4 and the Commune.6

3. Empress Eugénie, wife of Napoléon III.

4. A.K. This painting was shown at the 1867 Exhibition under the title: *Cerfs traversant un espace découvert*. It was engraved by Charles G. Lewis under another title: *Family of Deer Crossing the Summit of the Long Rocks (Forest of Fontainebleau)*.

5. A.K. In 1864 the village festival at By (July 24) was particularly brilliant. An arch of triumph was put up at the head of the main street, with this inscription: *To Rosa Bonheur, with gratitude from By. (L'Abeille de Fontainebleau)*.

6. On September 4, 1870, just a few weeks into the Franco-Prussian War, Napoléon III was defeated and deposed. That same day the Third French Republic was declared. For the first several months of 1871, Paris refused to sign an armistice with the victorious Prussians and more or less seceded from the French

Shortly after that memorable day, I received a specific invitation (for June 30?). I put on my black velvet dress uniform with the gold buttons. My narrow sleeves and drooping skirts must have looked funny in comparison with the enormous crinoline hoop dresses that were fashionable back then. Then I had myself driven to the foot of the grand staircase of the chateau at Fontainebleau. I had scarcely got out of the coupé when a guard told me to move on, this side being reserved for the Emperor and the Empress. I obeyed and went on; but I was stopped by another guard and told to go back where I'd come from. At that point I really just wanted to go home. Fortunately, when the first guard saw me back again, he took the trouble to read my invitation more carefully and let me climb up the stairs between two rows of halberdiers. At the top I paused to relive one of our tragic hours. This was the grand double staircase that Napoléon I descended on April 20, 1814, while bidding a last farewell to his faithful troops.

When I stepped into the François I drawing room, Mme de Metternich, the famous ambassador's wife, was deep in conversation with some young men. None of them paid me any attention, so I unceremoniously sat down in one of the big armchairs near the fireplace. I knew that people at court liked to poke fun, especially in Mme de Metternich's circle. My main concern at the moment was to avoid some huge blunder that would make a laughingstock out of me. Just then one young man broke away from the little cluster around the ambassador's wife, came up to me, and bowed.

"Mlle Rosa Bonheur?" he asked.

"Yes, monsieur."

"The Emperor will be here shortly, mademoiselle. Since you've never lived at court, you may not know that when Their Majesties enter a room, it is customary not to rise until they give the signal. I thought I ought to tell you."

I spied the trap and smartly replied: "True, I've never lived at court as you have, monsieur. Yet I won't wait for the signal, but shall promptly rise."

Somewhat abashed, my eager young mentor fell back to the group around Mme de Metternich. Much to my satisfaction, their little leers were soon wiped away.

nation. The provisional government that ruled Paris in that period came to be known as the Commune. When the Commune was put down in May 1871, many official buildings in Paris were damaged or totally destroyed. This painting is now at the National Museum of Women in the Arts in Washington, D.C.

The door finally opened. The Emperor and the Empress made their entrance, followed by the general who had brought me my invitation. My feeble notions as a court apprentice told me that he would be my escort. Contrary to what I'd been carefully told, everyone sprang up. My young man was of course one of the most zealous.

I was introduced. When the Emperor himself gave me his arm and sat me down to his right for lunch, I was terribly disconcerted. Throughout the entire meal he never once stopped talking to me and looked after my every need.

Needless to say, the menu was extremely refined. Yet I realized that not even an emperor always gets fresh eggs. Mine was inedible. My august neighbor noticed and told me with a smile that an emperor's hens were no match for those kept by an animal painter.

After lunch the Empress invited me for a little boat-ride on the Carp Pool. Rowing all by herself, she talked about art while we went round the pond. All of a sudden the young Imperial Prince appeared on the shore, and Her Majesty called out: "Come, child, and shake the hand of Mlle Rosa Bonheur. At home she has a zoo you'd really like."

"Oh!" he exclaimed, "let's go see it right away."

Two or three days later he popped in, and he often came back. You know that I've never liked to wear men's clothes in front of important visitors. That's why I once asked the Prince to wait a second or two. Since he seemed a bit impatient, Céline confessed that I needed time to get a skirt on.

"But I wanted to see her in her smock and trousers," he replied.

That gave me a good laugh. Whenever he showed up after that, I made a point not to change my clothes.

The Empress's visit sounded a signal. For a few years high-society women thought that status depended on a visit to Rosa Bonheur in her chateau at By. It's incredible how many letters I received. If I hadn't burned a whole mess of papers in despair over Nathalie's death, we could still chortle over these missives. Some were written on perfumed, glossy paper decorated with coats of arms and spelling errors. I never answered a one. I wound up not even opening them, but Nathalie often got into them. She had fun popping off the huge globs of the finest sealing-wax and showing me the funny parts. We'd both have a good chuckle.

Mme de Metternich's letters got the same treatment. She wrote me herself, but got no reply. Not to be rebuffed, she just showed up uninvited. Her manners were so seductive and her arguments so irresistible that she even got my personal Cerberus, Céline, to open up the gates. Suddenly

there she was in my courtyard in her landau. I knew her livery instantly, but I was trapped and had to show a good face. Yet I wondered what trick I could play to get back at her for the one she had played on me. I threw my "sanctuary" doors wide open and stood waiting. The famous ambassadress arrived in a flutter of young men.

"Ah! mademoiselle," she said, "you welcome me with open portals as if I were the empress."

"Indeed, madame, but just to let your crinolines by," I replied with my deepest curtsy.

My visitor turned a deaf ear to that. She carefully studied everything in the studio and showed great interest in a drawing.

"Would you let me have it for a few bottles of my best wine?" she asked in the sweetest voice.[7]

"Thank you, madame," was my curt reply. "I never barter, and I don't sell anything here. M. Gambart and M. Tedesco deal with my affairs."

After that, Mme de Metternich beat a hasty retreat. She looked put out and never came back.

But these are just trifles. Also, whatever fine memories I may have about the Empress's visit and my lunch at Fontainebleau, it was really a great day when she came back with my Cross of the Legion of Honor.

At the time the Emperor was on his way back from Algeria, having left the Empress as regent sovereign until his return. A year, almost to the day, had gone by since Her Majesty's first visit to my studio. On the afternoon of June 10—and I knew only from the newspapers that she had come down to Fontainebleau to await the Emperor—she once again popped in unexpectedly, creating the same surprise and excitement. I was in the garden and barely had time to rush in and cover up my trousers.

"Mademoiselle," she said, "I am bringing you a jewel from the Emperor. His Majesty has given me permission to inform you that you've been made a knight in the Imperial Order of the Legion of Honor."

As she spoke, she opened up a little jewel case and removed a gold cross. Deeply moved, I knelt at her feet. But there was no pin for the cross. Her Majesty bent over my worktable to look around for one. One of her officers found what she needed, and the Empress pinned the red ribbon with that glorious star over my heart. Then she raised me up and kissed me, saying: "You're finally a knight. I am so pleased to be the godmother of the first woman artist to receive this high honor. I wanted to devote my

7. A.K. It is well known that the famous Johannisberg vineyards belong to the Metternich family.

last act as regent to showing that, as far as I'm concerned, genius has no sex. Moreover, to underscore the importance that I attach to this great act of justice, you won't be part of a 'batch.' Your nomination will be announced a day later than the others, but in a special decree headlined in the *Moniteur.*"[8]

Then the Empress sat down and exchanged a few words with me. I remained respectfully standing.

"Mademoiselle, if the day were mine," she said with supreme kindness, "I would spend hours studying your work, but pressing duties call me back to Fontainebleau, where my son awaits me. We are expecting a telegram from the Emperor. He wants his wife and his son at his side this evening when he makes his entrance back into Paris. At this very moment, when I am so pleased to have given you this decoration, His Majesty is in

8. A.K. The decree announced in the *Moniteur* on June 11, 1865, read as follows:

"Napoléon,

"By the Grace of God and the Will of the Nation, the Emperor of the French, to all those who are here present and yet to come, greetings.

"According to the proposal of the Minister of the Imperial House and of the Fine Arts,

"We decree the following:

"Article One. The title of Knight of the Legion of Honor has been conferred upon Mlle Rosa Bonheur, landscape and animal painter.

"Article Two. The Minister of the Imperial House and of the Fine Arts and the Lord Chancellor of the Legion of Honor have been charged, each according to his duties, with the execution of this decree.

"Done in consultation with the Ministers of State,

"At the Palace of the Tuileries, June 8, 1865.

"In the name of the Emperor and by virtue of the powers

"that he gave us,

"Eugénie.

"In the name of the Empress Regent, the Marshall of France,

Minister of the Imperial House and of the Fine-Arts,

"Vaillant."

The *Constitutionnel*, a semiofficial newspaper, made this commentary on the imperial decree:

"The *Moniteur* of June 11 has published a decree bestowing the Cross of the Legion of Honor on Mlle Rosa Bonheur, a woman who has succeeded in winning for herself a brilliant place among contemporary artists. This decree was signed by the Empress Regent. A noble and delicate thought was its inspiration, and it will be applauded by all."

the good city of Lyons, and the prefect there is introducing to him the distinguished individuals whom the cabinet has deemed worthy of the honor."

When the Empress rose to leave, I was still stunned by this great honor. After she stepped back into her calash and the entire cortege disappeared in a cloud of dust,[9] Nathalie, good mother Micas and I fell into one another's arms and wept for joy.

There were some curious rumors afoot at this time. It was said, for example, that the Emperor gave me part of the forest. I really don't know how or why such a story got going. What the Emperor in fact gave me was hunting rights that let me pursue game in any season. I jumped at the chance, and my eye was soon as good as Nemrod's.

I'd go off at sunrise with my paint box on my back, dogs trailing behind and gun in hand, ready to shoot any game I might see. Nathalie always expected a choice morsel; but after a long walk and fruitless waiting, I'd often put my gun down on the heather and sketch the beautiful trees so that Nathalie wouldn't scold me for coming back empty-handed. But on those evenings our pickings were pretty slim.

Getting the Legion of Honor meant that I had to take part, as was my wish in any case, in the upcoming Universal Exhibition of 1867. Since 1855, so for ten to twelve years, no work of mine had been shown at the Salon. M. Tedesco and M. Gambart had been in such competition for my paintings, snatching them up before they were scarcely dry, that it had been impossible for me to send anything to the salons. This situation had given rise to some nasty remarks and misconceptions about my feelings.

In 1867, at least, I more than made up for my long-standing abstention with ten paintings at the Salon. *Haymaking*, which I had done in 1855, now owned by the state, was also in the retrospective exhibit.

While traveling through the Highlands and stocking my head with compositions, I had also crammed my portfolios full of studies. They were the basis of several paintings that I sent to the Salon, such as *Sheep by the*

9. A.K. During the Empress's brief visit to Rosa Bonheur, news of it spread throughout the hamlet. As the Empress was getting ready to leave, she found a great number of townspeople gathered in the courtyard. Some girls presented her with an improvised bouquet of garden flowers. They also gave her cherry boughs laden with fruit, which the ladies-in-waiting shared among themselves.

L'Abeille de Fontainebleau reports that at the festival of By, on July 23, 1865, the climax of the fireworks display represented the Cross of the Legion of Honor as an additional sign of homage to Rosa Bonheur.

Sea, which I did for the Empress, *Boat, Oxen and Cows, Scottish Shepherd, Ponies of the Isle of Skye,* and *The Razzia.*

The Fontainebleau forest showed up in two paintings: *Roes at Rest* and *Deer at Long Rocks.* I also had a *Béarnese Shepherd* and *Donkey Drivers of Aragon* as souvenirs of my trips to the Pyrenees with Nathalie.

After such a long time away from the Salons, I had to expect severe criticism, and I was not disappointed on that score. They accused me of being a turncoat on the French art-scene. People said that I had gone over, paintbrushes, palette, and all, to the English school and imitations of Landseer. Somebody even called me Miss Rosa Bonheur.

Others mixed praise with blame. In the *Gazette des Beaux-Arts,* de Saint-Santin wrote this in the middle of an article on Brascassat:

Ever since the Universal Exhibition of 1855, when she showed *Haymaking,* Mlle Rosa Bonheur abstained from our annual Salons. The legitimate success of her *Horse Fair,* certainly the most important piece at the Salon of 1853, was cleverly echoed in England by the special London showing of this huge canvas. From then on Mlle Rosa Bonheur earned nothing but honor and prosperity by working for the English. But in trying to satisfy this new clientele, she neglected France overmuch. When this hard-working, stalwart girl realized that she, as one of the finest members of our school, could not be just a spectator any longer—it was a question of doing battle with Europe, more hardened to war than in 1855—she sent us ten of her latest works. She saw, I would swear, even better than her friends that her style, once so French, before her chosen exile from our Salons, had taken on some annoying English accent, neither the brilliant, transparent delicacy of Landseer nor the unvarnished simplicity of our own painters. We recognize the Rosa Bonheur that we once knew only by her sheep. There is still no one who can paint fleece as she does, especially the unkempt variety, since Jacque and Brendel could show her a thing or two about sheep grooming in pastoral poetry. The *Sheep by the Sea* and the *Sheep in a Boat* are two fine pieces, worthy of her best period. Her delicate feminine instinct also gives her for drawing the subtle movements of stags and does—see her charming painting of *Roes at Rest* and *Deer at Long Rocks*—a light, graceful hand that is not to be found in either the *Scottish Cows* or *Donkey Drivers of Aragon.* . . . Moreover, no other European animal painter this year was able to show us a painting as powerful as her Scottish *Razzia.* The somber landscape is caught in a real gale, the buffalo and the rams seem so grand and wild, and the turmoil of these

superb animals crashing into each other creates the most vigorous effect ever conceived by the author of the *Horse Fair*.[10]

Since my move to By, I've been passionately involved with the graceful fauna of the forest. Stags and does interest me infinitely more than oxen ever did. On this score, I was carried away by the paintings of Sir Edwin Landseer, especially *Fog-Children* and *King of the Valleys*. The critics who judge me fairly will have to admit that, despite the influence of this great painter, I have remained true to myself, always French at heart and proud of the nation that will, I hope, continue to come first in the arts. But I know quite well that many people have wanted to know if my passion for Landseer was merely for his art.

10. A.K. *Gazette des Beaux-Arts*, June 1, 1868, vol. 24, p. 562 ff.

The Terrible Year

❖

The Lions

When war was declared,[1] I wasn't the least bit worried, but rather enthusiastic, as I was so sure that France would soon be glorified by new victories. By the same token, there are no words for my despair as reports of our disasters began to fly thick and fast.

When I learned the terrible news about the Emperor falling into enemy hands and the Prussians advancing on Fontainebleau forest for the siege of Paris, I had a patriotic fit.[2]

Hastily rounding up all the weapons I could get my hands on, I invited the people of By to the chateau for daily military exercises. Then I went to Thomery to inform the mayor that I meant to recruit a batallion and go meet the invader myself.

However sad he was about the deplorable state of the nation, the mayor couldn't hold back a smile that froze me down to the very depths of my soul. He said a few words, ironical perhaps, but very wise, that made me understand that, despite the men's clothes on my back, I couldn't be a new Joan of Arc. Yet I could make myself useful, he added, by rolling bandages for the wounded and providing supplies for the men defending the fatherland. I went back to By all in tears, grieving over my impotence, yet resigned to let the storm pass over my head.[3]

Doing my best to follow the mayor's fine advice, I dashed off a letter to M. Gambart, who had just become the Spanish consul in Nice, and told him to send me a few dozen sacks of wheat. I also bought all the supplies I

1. France declared war on Prussia on July 19, 1870.

2. After a string of Prussian victories, Napoléon III was captured at Sedan on September 1, 1870, and the French forces utterly routed.

3. Theodore Stanton, in his *Reminiscences of Rosa Bonheur* (pp. 315–37), produces a good deal of testimony that suggests that the artist was less submissive than she reports here. She was apparently a regular participant in the all-male home guard, even going so far as get a neighbor to shoot at Prussian sentinels with her; she invited Paul Chardin to go fight, guerrilla style, with her against the enemy; she had her house wired with explosives in order to stymie any attempts at Prussian occupation.

could and hid them all over my property. All my valuables were piled behind a wall I'd had built in the cellar.

The news of our defeats put me in such a frenzy that I was utterly unable to work. Yet from time to time I'd get away from these terrible preoccupations by taking refuge in a caravan, a gift from Mme Carvalho's brother, that I parked in the middle of the grounds. All alone among my beautiful trees and locked away in the bosom of nature, there I could briefly forget the horrors of reality.

One day while I was in my "sanctuary" picking up a few studies to take out to my favorite retreat, Céline burst in, all bug-eyed.

"Mademoiselle," she shouted, "we're saved!"

"What!" I exclaimed. "Did Chanzy win a battle? Did Trochu sally forth?"

"No," replied the disconcerted housemaid. "A man just came from Pithiviers with a letter from the mayor and another one from the crown prince of Prussia. He says the chateau won't be harmed, ransacked, or burned, and we'll be left in peace."

I feverishly snatched the big envelope out of Céline's hands. Much to the poor woman's amazement, I tore up the two letters, saying I didn't want to owe a single thing to the enemies of France.

Nathalie soon learned about this. She took me to task for my hasty temper and picked up the scraps of paper all over the ground. She, too, was a great patriot, but less of a hothead. Just in case we ever needed the letters, she carefully pasted the bits back together.

This was the message from the mayor of Pithiviers:

Pithiviers, September 27, 1870

Mademoiselle,

The mayor of Pithiviers, amid the sad business that war requires of him, is happy to remit to a person going to Malesherbes (since the road is free in that direction) the enclosed safe-conduct, which he has just received from a Prussian commander. He sincerely wishes you to have it posthaste.

Please accept, mademoiselle, his compliments and respects.

H. Brierre

A second letter was attached:

Versailles, September 26, 1870

Mademoiselle,

His Royal Highness the Crown Prince of Prussia has asked me to trans-

mit to you the enclosed safe-conduct, which I have the honor of sending you along with my respectful compliments.

Count Leckenhoff,
Aide-de-camp

This is a translation of the safe-conduct:

General Command of the Third Army
The Royal Barracks. Versailles, September 26, 1870

By order of the Commander of the Third Army, His Royal Highness the Crown Prince of Prussia, all military commanders are enjoined to respect the property of Rosa Bonheur, artist, and her chateau at By, near Fontainebleau, and to give her all the protection that she may require.

By order of the High Commander of the Third Army,
The Quartermaster General,

O. V. Göttberg

Despite the way I'd treated the safe-conduct, I was at bottom grateful for this token of respect. More than once it became obvious to me that there really had been orders to respect my property.

Be that as it may, every day Nathalie and I made enormous kettles of hearty soup that we'd dish out at certain times to the poor locals who came to fetch it with pots and pans.

Fortunately, my role as the area Amphitryon was made easier by the fact that food was once again cheap, since it could no longer go up to market in Paris. Every now and then I'd send Céline out shopping with the wagon. I made a point not to touch my menagerie, so my animals stayed safe and sound all through the war.[4]

One day when my servants had driven to Fontainebleau, I got worried when they weren't back by evening. They finally showed up, on foot and dragging their baskets as best they could. Seeing my surprise, Céline told me what had happened, which proved that the Crown Prince's safe-conduct, despite everything I'd done to it, hadn't lost its force. The servants had left the wagon with an innkeeper at Avon and gone to market.

4. Rosa Bonheur's animals were luckier than many in the Paris zoo during the long months of Prussian siege in 1870–71. While poor Parisians were reduced to eating rats, more fortunate citizens could dine on exotic meats provided by the zoo at very high prices. Edmond de Goncourt, for example, reports having had elephant blood sausage on December 31, 1870. See Rosalie Shriver, *Rosa Bonheur* (Philadelphia: Art Alliance Press, 1982), pp. 39–40.

Their shopping finished, they went back to the inn, but the wagon was gone. They were lodging a complaint when a German captain came up and said in broken French something like: "Wagon, requisition." It was useless to protest, but Céline had the presence of mind to shout: "Wagon Rosa Bonheur."

At the sound of that name, the officer raised his head and tried to explain in a nicer tone: "Madame, absolute need wagon for wounded; when finish, return Rosa Bonheur."

He was as good as his word. The next day two uhlans brought me back the wagon.[5]

Another time I had to deal with a bunch of soldiers who wanted to seize my menagerie. From my studio I heard excited voices. Living in fear that someone might lay hands on my boarders, I instantly put two and two together and tore downstairs.

I was right. The soldiers were shouting: "Requisition! Requisition!" and pointing at my animals. I explained as best I could that they could find something to eat in the kitchen. They grumbled but obeyed.

I later learned that they complained in Thomery about a little old man who had stopped them from taking some animals.

"That little old man was Rosa Bonheur," they were told.

"Ah! If we'd known that," they exclaimed, "we would have been much nicer! The great artist has a fine reputation at court, and she enjoys the special protection of the Prince of Prussia."

My house turned into a kind of army road post during the amnesty and after the Frankfurt treaty was signed. Nathalie was usually in charge of taking in the soldiers and seeing that they were decently looked after.

She carried out these unpleasant tasks so well that one day an officer asked her to join him at table. When she tartly refused, he exclaimed: "If all French women are like you, mademoiselle, it's no wonder the men are so fierce."

As things were going from bad to worse at the beginning of the invasion, people grew obsessed with spy stories and entertained dark suspicions about every unfamiliar face. The most trifling little tramp became a

5. A.K. This anecdote should be followed up by another one that Etienne, Céline's husband and our coachman, liked to tell. He used to take his horse out into the forest where the Germans often pursued French snipers. One day Etienne was surrounded by Germans not far from the Cross of Montmorin. "Fort geschwind!" (Get out of here!), shouted the commanding officer. Before he obeyed, Etienne made a point to say: "Rosa Bonheur's horse." Hearing that, the officer excused himself and went on his way.

Prussian agent. There were so many silly arrests in which the poor devil finally had to be turned loose.

One day there was an accusation I took more seriously. Instead of intervening for the man's release, I thought he ought to be taken to Thomery for questioning in the event of a court-martial.

The mayor of Thomery disagreed. "What do you want me to do with your spy, mademoiselle?" he asked. "We can't even feed our own poor soldiers, and there's no way to make him give up a taste for bread without some kind of trial. So let him go hang somewhere else."

"Right again, Mayor," I replied. "I'll take him to the station myself and put him on the next train, just to make sure he leaves town."

And that's just what I did. On the way to Moret in my tilbury, I tried my best to convince him that Fontainebleau forest was full of snipers.

One day during the Prussian occupation three German officers in dress uniform showed up at my door, asking permission to visit my studio.

"Go say," I told Céline, "that no way can I let the enemies of my country be the first to see my new work."

"But it's Prince Frederick-Charles himself, mademoiselle!"

"So what? I cannot receive him, but he may visit the grounds as a thank-you for the safe-conduct he sent me."

I had an old stag who could still be nasty in his moments. Even so, whenever I went to see him, he would press up against the latticework and let me pet him. When he saw the officers approach, he took a few steps in their direction, then all of a sudden plopped down into a little ditch, splattering mud and water all over their beautiful uniforms.

When Céline told me about it, she maintained that the stag was only being patriotic. I didn't want to contradict the good woman on this point, but on another I found her zeal a bit much. After doing her best to wipe off their uniforms, she stubbornly refused to let them have even one of my old brushes or paint tubes as a souvenir. Having spied this gear through the windows of my field studio, they had found it tempting. Céline didn't understand the delicate homage the prince had meant to offer me with this request.

When I asked Céline if she were quite sure that it had been Prince Frederick-Charles: "Absolutely, mademoiselle," she confidently replied. "Before he left, he gave me two thalers."[6]

6. A.K. Céline told me that, since he could not get even the tiniest bit of Rosa Bonheur's painting gear, the prince plucked a miniscule bouquet of leaves from a tree and said: "I hope that no one will prevent me from leaving with this."

There have been all kinds of rumors about that fine Céline. People take her for some kind of Cerberus. It's even been said that once she took my little gig out of the shed and cut a set of tracks in the dirt to make people think I'd gone out. Lots of folks think it's impossible to get near me without first greasing her palm.

The war gave my thoughts a tragic turn. After concentrating on peaceful animals for so long, I turned my attention to lions and tigers. This change of heart was due to our disasters.

One day in 1873 M. Dejeans, director of the Paris Winter Circus, invited me to come sketch his tame lioness at Saint-Leu, near Melun. She was kept loose. This gave me the willies, I must confess, but Nathalie, who wasn't afraid of anything, went right up and stroked Pierrette's back. I drew her several times, so she soon grew used to seeing me and got more and more cuddly. While I was resting, Pierrette would watch over my painting gear, and nobody could touch a thing. M. Dejeans used to say: "If that lioness lets you near her, it's because she loves you, but never will she obey you."

Pierrette was born in the circus, and Mlle Bellan, M. Dejean's niece, bottle-fed the cub in her bedroom like a puppy. When the lioness grew big and strong, she got her own bed.

She was in Paris for the duration of the siege.[7] Toward the end, when everybody was starving to death, Pierrette went three whole days without a thing to eat. Finally someone managed to get her the thigh of a horse. Maybe you think that lioness, as any other wild animal would have done, leaped on her prey and tore it apart? Not at all. She waited patiently while someone diced her food. That beast was really something. She used to let a cat eat its supper between her paws, and people were simply amazed to watch her play hide-and-seek with the horse and donkey that grazed in the meadow. She'd dash back and forth up to them, woofing like a dog at play. Whenever the boy watching the cows fell asleep on the job, she'd tug at his smock. Once I saw her trying to drag her mattress backward into her little house. She loved to play tricks and hide under beds, but she never hurt a single soul. She was even so polite that she'd retreat to a certain little room when nature called. Yet, since she didn't usually lock the door, unwarned guests sometimes got quite a start.

And to think there are people who stubbornly maintain that animals are stupid!

7. The siege of Paris during the Franco-Prussian War lasted from September 1870 to April 1871.

Anyway, even wild lions never attack unless they're really hungry. In my own psychological study of the animals I've lived with, lions are the most intelligent, noble, and grateful of all.

When I decided to study big cats, I didn't consider keeping any at home at first. For a long while I was content to go find my models, aside from Pierrette, at the Jardin des Plantes or in zoos. Yet for a little while I rented Brutus the lion from Bidel. Then I got more ambitious. In order to work entirely at my ease and leisure, I decided to buy a couple of lions that M. Gambart shipped me up from Marseilles. If memory serves me right, they arrived in mid-1880 (June), and I kept them for about two months. They were superb beasts.

Though I'd been warned that it was dangerous to go near the ferocious male, I managed to tame him. Nero recognized my voice from afar. Whenever I petted him, he'd stand up on his hind legs just like a cat.

At dawn, as soon as his cage was put out on the lawn and the shutters removed, he'd cast an eye up to my window. If it was open, that meant I'd soon be along to paint him. I had a little tented platform built in front of his cage to shield me from sun and rain. My work required inexhaustible patience. I don't know how often I had to redo studies to get them right. If I started out looking the lion straight in the face, I'd scarcely have begun working on his mouth, eyes, or mane when he'd up and turn his back on me with an ironic wag of his tail. What naughty fun!

Those two lions used to eat twenty pounds of beef a day. The servants handed them chunks on pitchforks between the bars of the cage.

They were certainly fine watchdogs. You could hear them roar from Thomery. But they were also rather cumbersome, expensive boarders. I gave them to the Jardin des Plantes when they were of no more use to me. The day they left, Nero studied me with a reproachful eye.

I went to see him at the zoo. Nero had turned mean after being separated from his mate. Although the zoo had promised me not to do it, they eventually thought it necessary. A short time later the lioness died of some spine disease (July 19, 1889).[8]

When I spoke to Nero, he recognized my voice, gave me a tender look, and let me pet him through the bars.

I went back to see him several times. One day I was told that my poor lion, who had gone blind, was dying of boredom. I cut through the curious crowd in front of his cage, went up close, and called his name. He sat up

8. Although this is the date recorded in the text, there must be an error as to the year. A few lines down, it is said that Nero, who outlived his mate, died in 1884.

and tried to drag himself toward me. Alas! he couldn't see and looked around in vain. His pitiful efforts touched me more than I can say, and I made a sad retreat. I later learned that he died near the end of 1884 (October 15).

My little lioness Fathma, the one you saw Céline pet on your first visit, also met a very moving end, but first let me tell you how I got her. One day—in 1885, I think—I received a telegram from M. Bidel, who was in Paris at the time, saying that there was a basket with two wild cats waiting for me at the Gare d'Orléans.[9] Nathalie and I tore up there to fetch them. They were in fact two lion cubs, a male and a female, but no bigger than Yorkshire terriers. Of course, we didn't tell the station employees that they'd been keeping two lions. They'd probably have died from retroactive fright.

Although the male lived only a year and a half, the female reached the age of three. Fathma, as I named her, was cuddly and even more affectionate than Pierrette. She followed me around like a poodle. She was even so nice that Céline let her come and go into her bedroom (fig. 10). In her frolics she often made a great mess of things. "Don't you worry," I'd tell Céline, "I'll replace everything she ruins."

When she was fully grown, I had a night cage built for her. Otherwise, there would have been fights with the dogs. Yet she was so tame that I'd let her put her two paws around my neck, then I'd take her head in my hands and kiss her. She was a model of obedience and docility.

One day, I didn't know why, Fathma didn't want me to leave her side. She held me back and gave me pitiful looks. I left anyway, telling her that I had to get to work. Could I have guessed that my poor Fathma was sick? Two hours later I came back downstairs, meaning to give her a pat and make her forget I'd been away. Alas! she was dead! No doubt wanting to die someplace closer to me, she'd managed in her last moments to drag herself to the bottom of the stairs . . . Poor beast!

9. Despite its name, this station is in Paris. Trains going in the direction of Orléans leave from there.

CHAPTER 19

Stays in Nice
❖
The Duchess of Saxe-Cobourg-Gotha
❖
Nathalie's Death (1889)
❖
Rosa Bonheur Named Officer of
the Legion of Honor (1894)

Around 1874 Nathalie and I got terribly worried about our good mother Micas's fading sight. While Nathalie was up in Paris for her mother's treatments, I did my best to keep her up on things at By, as you can tell by this letter found among my poor friend's papers.

By, Saturday morning

My dear old Nathalie,

Madame Gauthier has just read me your letter. I think the doctors are going to send you both home as soon as possible. I wanted to go up and see you. Yet, since I'm not any good at housekeeping, it's better to wait until I can help you bring your mother back down. So send me a letter, better yet a telegram, telling me when I should come meet you in Paris. Don't neglect your own health, and try and be patient and brave. Otherwise, you won't be any good for your mother. Remember what I've told you: we'll do everything we can for her down here.

I give you a big kiss. Everybody in your little world is doing fine. Yours truly is being fattened up on Céline's cooking. If this keeps up, I can hope to tip the scales at three hundred someday. Ah! don't worry about your donkey. He's working like a real love and helped the draught horse Roland the Bold stow your new load of coal. Everything's in fine shape.

Gamine, who never leaves my side, sends her mistress a big kiss. Your birds are splendid. Last evening I petted your turkey, who seemed affectionate. I think she liked it. She snuggled up to my hand and looked pleased. There we are.

I'm not in despair about your mother's eyes. Like you, I think she'll never really get her sight back, but if she can just see well enough to get

around, we're saved. Let's see how things are in a few more days. Fresh air and calm will help.

I give you both a big kiss, etc.

R. Bonheur

Nathalie and her mother soon returned to By, but Mme Micas's sight continued to fade. During those sad weeks of ever deepening darkness she was wonderfully brave. She often needed our help, but sometimes her feeble calls didn't reach our ears. So a young servant was assigned to stay with her and lead her around. This fine girl slept so soundly that she didn't always hear everything. Nathalie hatched the idea of tying a stout string around the servant's foot and giving her mother the other end. This invention amused the good patient, who smiled and said: "So, like a bus conductor telling the driver to stop, I've got to give a tug?"

Poor mother Micas! I was like Nathalie's sister for her, and she loved the two of us just the same. Sometimes my jokes made her head spin, but she always had a good laugh, like when I bet her twenty francs she couldn't get my trousers on. We never agreed about who won, but it was a really jolly scene.

Despite all our care, Mme Micas went blind. Worse yet, her general state deteriorated and was soon desperate. She died on May 11, 1875, at the age of sixty-four. This was a dreadful time for Nathalie and me; but grief made our love even stronger. Yet this death gouged a grievous hole in my life. I trembled at the thought that Nathalie, who was never very well, could leave me all alone in the world some day.

We decided to spend winters on the French Riviera, a milder climate than our dear Fontainebleau forest. When I told M. Gambart, he promptly rented us one of his villas in Nice for five thousand francs a year, to be paid in paintings. Everything was shaping up wonderfully.

Villa African is one of the most beautiful houses on the Riviera, a real palace. Down there it would have been silly to try and maintain our simple ways, scarcely suitable for women of the backwoods. So we arrived in Nice with more luggage than would fit in a baggage car, only to find that M. Gambart had sent for us too early. The improvements that he was having done weren't finished, and for the first few months we had to camp out amid hunks of plaster and workmen, with a whole battery of crates, most still nailed shut. Despite these little nuisances, which bothered Nathalie much more than they did me, I got right down to work.

Every morning I'd dress like a man and jump a little tram. For six sous it would sometimes take me far down the tracks to new and wonderful

sights. What a joy to see all around, growing right out of the ground, palm trees much more beautiful than the hot-house palms at the Jardin des Plantes! With every step I found magnificent cactuses that I copied for my backgrounds. I even found a few lions—in cages. If only the sentries I ran into had been caged up, too! Quite the opposite, they once tried to put *me* in a cage. Thinking I was trying to get a quick picture of their fortifications, they took me for a German spy!

This happened right near Cape Ferrat. My poor servant spent a nasty time in jail while Nathalie and I were being vigilantly eyed by a guard posted outside our carriage. The only thing that saved me from arrest was my little red ribbon.[1]

This mess was the result of an innocent whim: I was trying to photograph an Italian shepherd leading a herd of goats. He had such a picturesque silhouette.

The silly sentry absolutely insisted that I show him my film to make sure I hadn't got a picture of the fort. It was all quite beyond him that he wouldn't have seen a thing on my plates and that the sunlight would have wiped them clean.

Every afternoon I'd take off the men's clothes that let me go wherever I wanted on the sly and dress up like a great lady. Who would ever have recognized, in this getup, the rustic little man who mingled with the good, decent peasants of the Riviera every morning? Sometimes they even talked to him about Rosa Bonheur, without suspecting—and this really tickled me—that they were speaking to her very person.

This transformation, this return to my sex, was imposed on me by fine M. Gambart. My former art dealer, who had been the honorary consul of Spain for several years, enjoyed considerable prestige in Nice. Whenever he heard that royalty was going to visit, he rushed to their palace with expensive engravings and the most famous paintings, which, like a great gentleman, he loaned for the duration of their holiday.

I was scarcely settled when he recruited I don't know how many princes, dukes, marquesses, and simple bankers in my honor. He was also careful not to forget American millionaires, whom he ranked right up there with kings and queens, for he was an astute merchant and knew how easily they were parted from their dollars. So, one right after the other, I met the duke de Montpensier, the count and countess d'Eu, Infanta Eulalia, and the excellent Dom Pedro, emperor of Brazil. This prince of princes, an enlightened protector of the arts, wanted me to go back to Brazil with

1. Bonheur is referring to her Legion of Honor insignia.

him. In an attempt to persuade me, he said Brazil had palm trees infinitely more majestic than those at Nice. He also talked about legions of parrots, hummingbirds, great flocks of all kinds of gaudy creatures who flew around and shimmered in the sun.

Incredibly enough, the high life that Nathalie and I led in Nice earned us some—yes, even several—marriage proposals. Of course, we briskly turned them down. How could we have ever parted? The promises we had exchanged over Father Micas's deathbed were sacred vows.

The following letter that Nathalie wrote to Mme Bourdon, one of our good friends at By, gives a good idea of our life at Nice. Mme Bourdon wasn't happy until we returned to our dear Fontainebleau forest each summer.

April 22, 1880

My dear Mme Bourdon,

The house we're living in is an enchanted palace! From our bed we can feast our eyes on the sea, and the grounds are a garden of Eden. Nothing but roses, palm trees, cactus, orange trees laden with golden fruit. There aren't words to say just how magnificent this part of the country is. So I won't tell you everything until we return, which may be a bit later than we had thought. Since our friend is getting back a bit of her strength, we don't want to arrest this salutary progress. Ah! God willing, we've still got happy days in front of us. She dreams only about beautiful paintings.

Good-bye, my good Mme Bourdon, etc.

Jeanne Micas

In Nice I had the pleasure of meeting the duchess of Saxe-Cobourg-Gotha, the admirable princess of the reigning House of Baden who has given me such precious friendship.

Villa African was just opposite Fabron Castle, where she wintered with her husband, Ernest II of Saxe-Cobourg-Gotha. They had been married for over forty years, and they loved each other as much as on their wedding day.

Ah! happy are the women with such marriages! They are the two halves of Plato's androgyne, who meet on earth and join for all eternity.

The duchess translated several passages out of her husband's memoirs for me. They glow with the beautiful soul of a prince who tried to make his subjects happy. I forget exactly when, but at some point Ernest II gave them, without any prompting on their part, such a liberal constitution that

they never dreamed of rising up against him, not even during the stormy days of the Frankfurt Parliament.[2]

No other sovereign has been so devoted to the principles that the French Assembly proclaimed at the dawn of our Revolution in 1789. Ernest II was the idol of his country, a great monarch on a little throne.

At his side was a woman who understood his lofty ambition to reform Germany from the top down and to quell revolution by embracing all legitimate forms of progress.

This was also the policy of Prince Albert and Queen Victoria, their closest relatives and intimate friends.

It wasn't only in politics that this profound thinker showed that Germany can make something besides Bismarcks. Ernest II was a learned man, an archeologist. With his faithful companion he led a party of explorers, distinguished scientists, and artists up the Nile and into Abyssinia. His book about this expedition won't ever be forgotten.

Ernest II was a musician, too. He composed several fine operas. *Zaïre* is the best and most famous, since the German prince was inspired by one of Voltaire's tragedies.

One day Duchess Alexandrine asked me for my photograph, saying that it was for her nephew, the Prince of Wales, who loved my paintings.[3] She sent me this letter in return for it:

Fabron Castle, Nice, April 3, 1885

My dear friend,

I have just received the enclosed photograph of the Prince of Wales. He asked me to send it to you along with his most fervent thanks for yours, which he finds excellent. In order to give the photograph its full value, he begs you to write your name and the date on a little piece of paper, which he will attach. This will mean so much to him.

I am also enclosing my nephew's letter so that you can read it yourself and see how happy he is to have your portrait.[4]

I embrace you and your dear friend.

Your devoted Alexandrine

2. A national assembly convened in the wake of the liberal revolution that swept Germany in 1848.

3. Edward VII (1841–1910), the eldest son of Queen Victoria, was the Prince of Wales for over sixty years. He reigned as king from 1901 until his death. The change of name for the royal house—from Saxe-Cobourg-Gotha to Windsor—occurred in 1917 during the reign of George V, the second son of Edward VII.

Duchess Alexandrine stirred me down to my very heartstrings. To see her, in spite of her high birth and rank, so kind and affectionate toward me, I couldn't help thinking that maybe the noble woman knew the secret

4. A.K. Since I wanted to know just what the Prince of Wales, who later became King Edward VII, had said about Rosa Bonheur, I asked Her Highness the duchess of Saxe-Cobourg-Gotha in March 1904 if she would consider sending me, as she had once done with Rosa Bonheur, his letter. She sent me this very gracious reply, which clearly shows the writer's high intelligence and generous soul as well as her admiration for the character and talent of the great artist, now departed.

"*Cobourg, March 12, 1904*

"Madame,

"I am infinitely sorry not to be able to send you the letter in question. In spite of the most scrupulous searching, I cannot find it among my old letters. That makes me think that this letter from the Prince of Wales was addressed to my dear husband, who gave it to me so that I could share it with our dear Mlle Rosa Bonheur. I clearly remember that I was in Nice with my beloved husband. It was March 1885, and we were neighbors of the great artist, who was living with her friend, Mlle Nathalie Micas, at Villa African, just opposite Fabron. In just two steps I was in her garden, and I was only too happy to dare take advantage of her gracious permission to make a little visit from time to time! I do not have words to describe how very kind, affectionate, and indulgent she was for me, how very affably she explained her sublime work to me and let me admire and study her magnificent paintings. We spent many enjoyable times, sweetly secluded in her beautiful studio. With her dear little Gamine sitting on her lap, I would listen to her charming, instructive conversation, so warmhearted, so affectionate, often so merry! Such are the dear, precious memories of your benefactress that I keep in my heart.

"I know that King Edward VII, on his annual trips to Cannes, never went to Nice without paying a visit to M. Gambart in order to admire the superb works of the great artist of whom he spoke to us with great enthusiasm.

"I understand how satisfying it must be for you to write the history of an artist who is as distinguished by her eminent talent as by the noble qualities of her mind and spirit, her great kindness, generosity, touching simplicity, and tireless labor. For all this, she is haloed by eternal glory. . . .

"I am now eighty-four, and I beg your indulgence for these lines that I have written with very poor eyes.

"Please accept, dear madame, my deepest respects.

"Alexandrine"

A few months after this letter, the duchess of Saxe-Cobourg died. Her testimony about Rosa Bonheur, given so close to the tomb, is even more precious for this reason.

of my poor mother's birth. I owe her the Cross of Merit of Saxe-Cobourg-Gotha for the Arts and Sciences. That honor, which brought me several others in its wake, is as dear to me as if I'd been born a subject of the man who gave it to me.

Last year I received this flattering remembrance from her:

Kallenberg, May 28, 1897

Dear Mlle Rosa Bonheur,

It has been a very long time since I have had any news from my dear friend.

So I eagerly take up my pen to respond to a request from my beloved niece, Princess Henry of Battenberg, Her Majesty Queen Victoria's youngest daughter. She will be on holiday at Fontainebleau, in your neighborhood, so to speak, and would dearly love to make your acquaintance and talk with you about all your beautiful works of art, which she so warmly admires.

She has been endowed with an excellent soul, which will endear her to you. I am delighted to think that she will be able to enjoy your dear companionship, the memory of which is forever precious in the mind of

Your faithfully devoted,

Alexandrine de Cobourg

A few days later Queen Victoria's favorite daughter, accompanied by Miss Minnie Cochrane, dropped in. I suppose that these ladies weren't sorry to catch me in trousers. It was very hot, and I was just back from a drive in the forest. I was wearing a white percaline jacket, and I just barely had time to slip a velvet skirt under it. I must have looked rather bizarre, since the princess begged me to let her maid of honor take my picture with my mare Panther, who was freshly unhitched and nibbling grass close by (fig. 11). I let the princess do as she pleased, and some time later I received a most gracious note and a photograph from Her Highness.

As for M. Gambart, about whom I had only good things to say when I was getting settled in Nice, we were on excellent terms. That was the case for a long time. At one point I was annoyed to hear that I was getting free hospitality at Villa African. That was plain wrong. Whether you pay your rent in paintings or in cash, doesn't it amount to the same thing? Later we had more serious problems that damaged our relationship for several years.

I got so angry that I left Villa African and bought Villa Bornala, a seven-

and-a-half-acre estate where I had a studio built. In order to cope with the heavy expenses of the new house, Nathalie hatched the idea of earning money like Alphonse Karr, by growing flowers. She raised camelias, a very fashionable bloom worth a franc apiece back then.

In Nice, just as at By, I had goats, izards, and mouflons, which are a kind of wild sheep. I've got one of their skins under my worktable.

Every winter as we packed our bags for Nice, Nathalie would decide she had to send down huge crates of dirt from the beds of heather in Fontainebleau forest. She considered the stuff almost magical, like everything else on our estate. In her mind, By was the height of agricultural and horticultural perfection, all because of her scrupulous care for the farmyard and the vegetable garden.

Also, my friend couldn't leave for Nice without huge supplies of potatoes and all kinds of fruit. Once Nathalie got to Nice, Céline had to send down huge bunches of asparagus, sacks of beans, and dozens of heads of lettuce. She'd also have her farmyard sacked for our dinner parties.

The best turkeys, the noisiest ducks, the tenderest chickens, and nice little rabbits that reminded me of my Salon début would arrive from By, all upset from their trip down.

"Don't you see, my dear Nathalie," I'd say, "that all this stuff disappears from the pantry too fast? No way could we devour so much in so little time! I'll just bet that a lot of it winds up at the shop down the street, that the birds we buy down here in Nice, that we get skinned alive for, come straight from By. Our servants are getting rich with all their double-dealing."

I wasted my breath. Every year Nathalie started up the same old game. My poor dear friend!

After she died in 1889, I just couldn't go back to Nice and tried to get rid of Villa Bornala fast. That's why I sold it for a ludicrous sum. After paying off the forty-thousand-franc advance from the Crédit Foncier for various improvements and six thousand francs for other expenses, I got only thirty-four thousand francs for that superb country house with all its fine furniture. But I didn't give a hoot about losing money! Thanks to the Tedescos, I would surely want for nothing all the rest of my days. All I had to do was polish off any old study, and my till was full of gold again.

Besides, work was my only refuge from grief, and I went at it with a rage.

I returned to watercolors. Despite myself, they made me relive my

beautiful trip through Scotland with Nathalie, and I wound up painting a picture of those Highland oxen engraved under the name *Scottish Chiefs.*

Then Buffalo Bill and his Indians came to town. Observing them at close range really refreshed my sad old mind. I'd always been interested in Indians, and they were so different from any other people I'd ever seen. I think I've already told you how, thanks to Mr. Knoelder and the Tedescos, I was free to work among the redskins, drawing and painting them with their horses, weapons, camps, and animals. I even painted a portrait of Colonel Cody on horseback, which you've probably seen on the huge posters he used to plaster all over the walls of cities he was touring. We became very good friends. Once I had lunch in his tent with M. Tedesco, Mr. Knoedler, and two magnificent Indians. Afterward, we all had our picture taken (fig. 12). That's a memory I really relish.

In order to repay some of his kindness, I invited Buffalo Bill to By and loved showing him my studio and animals (September 25, 1889). Because of his frequent shows, he didn't have time to sample my fare. So I took him to lunch at the Hôtel de France in Fontainebleau after giving him Apache, Mr. Arbuckle's famous horse, and another mustang, Clair-de-Lune. Although this horse was less spirited than Apache, I had no use for him. Some cowboys arrived a few days later, caught the two horses with a lasso, and mounted them with marvelous skill. After some brief resistance, futile with such master horsemen, the horses went off peacefully to the train (December 6, 1889).

That's not the only time animals have been chased around my place. I've often had to go after certain boarders, who weren't always gracious about it. Yet this was the first time I'd seen anyone use a lasso. They're practically unheard of around here, where we rely on traps and snares. Sometimes I've used my gun, as for a doe so old she had to be put down.

The year after the Universal Exhibition I was flattered to receive a great honor, a visit from M. Carnot.[5] The president of the Republic had been at the chateau of Fontainebleau for a while when one of his aides-de-camp informed me that he meant to come by. I was also told he wanted me to wear my ordinary work clothes. That's why I was wearing a smock, just like today, when he arrived on a Sunday afternoon (September 15, 1890) with Mme Carnot, his son M. François Carnot, and Commander de Maigret. I showed them my studio and several things I was working on.

5. The son of the Saint-Simonian Hippolyte Carnot, Sadi Carnot was president of the Third French Republic from 1887 to 1894.

The president sat down on the lounge chair that still has the same old gray cover and told me his father had been a Saint-Simonian, too. The two had met at the house in Ménilmontant, which his father remembered fondly, even though he hadn't shared all of Enfantin's extravagant ideas.

"Though I've never been a Saint-Simonian," M. Carnot added, "my upbringing benefited from the elements of truth in that generous doctrine. My parents taught me that women will be called upon to fulfill a great and saintly role in future society, and they convinced me that we've got to abolish the prejudices that prevent girls from considering themselves the sole guardians of their dignity. Aren't French women capable of exercising freedom with the same care as their English and American sisters?

"I'm sure that women will have a huge part to play in the betterment of humanity, and there's no doubt that republican institutions will soon put fathers, mothers, brothers, and sisters themselves in that same frame of mind. Then France, already the queen of good taste and the fine arts, will be at the forefront of the moral development of both halves of the human race."

The proud doctrine that the president of the Republic explained so well has been mine since the start of my career, and I'll stand up for it as long as I live.

This was my first meeting with M. Carnot, but just that would have sufficed to make it impossible to forget him. Yet, after my nomination to the rank of officer of the Legion of Honor, I had the great pleasure of returning his visit at the Elysée Palace[6] with my old friend Cain.

I received this nomination in 1894, twenty-seven years after the Empress Eugénie's visit.[7] The Chicago Exhibition provided the occasion.

Shortly before the exhibition opened in celebration of the American centennial, M. Gambart told me that because of my great popularity over there I simply had to take part. I had nothing ready. He promptly got around that problem by offering to send in *The King of the Forest* and *The Stampede of Scottish Oxen*. The exhibition's Fine Arts Commission, after reviewing a list of all my paintings in America, also asked Mr. Jay Gould to lend them my *Pastoral* and General Alger my *Sheep*, which they readily agreed to do.

Many talented artists also sent works to Chicago. France's brilliant representation was entirely worthy of our reputation.

6. The French presidential palace.

7. In this text, Rosa Bonheur mentioned visits from Empress Eugénie in 1864 and 1865, but none in 1867.

When the international panel of judges decided to give only one category of awards, the Ministry of Fine Arts protested, and the French contingent was declared out of the running.

Instead of prizes, we each got commemorative plaques. The French government decided, moreover, to make up for our losses by giving awards to the best artists.

Would I, a knight of the Legion of Honor since 1865, share in these honors? I'd already been given hope of receiving the Rosette of the Legion of Honor for participating in the exhibition. M. Carnot himself had said as much to M. Auguste Cain. I also knew that for the first time the powers that be were leaning toward naming a woman artist to the rank of officer of the Legion of Honor, but what would come of all that?[8]

My best advocates were Prince Stirbey and my old colleague Cain, the animal sculptor. They spared no effort, lobbying government ministers and paying visits to the Elysée Palace. Cain, as he wrote me, acted like the captain going to see about his colonel's medal. They won their case, and I got my nomination (April 3, 1894).[9] Along with the joy of having you near, this is no doubt the last great felicity in store for me in this life.

Auguste Cain was my sponsor. He elevated me to my new rank during a great banquet attended by the most distinguished artists and writers.[10] He also escorted me to the Elysée Palace when I went to thank M. Carnot.[11] The president sang my praises and said the government meant not only to reward me for my individual merit; they also considered me a representative of those women whose work, talent, and virtue do honor to their sex and the nation.[12]

8. A.K. In the *Abeille de Fontainebleau* of August 29, 1890, M. Bourges, so attentive to everything that concerned Rosa Bonheur, had already recommended that the great artist be promoted to the rank of officer of the Legion of Honor.

9. A.K. A few days later, Prince Stirbey rendered further homage to Rosa Bonheur by giving her a diamond cross.

10. A.K. Henri and Georges Cain remember this banquet as a particularly joyous occasion. Auguste Cain got an idea for an altogether novel centerpiece: a cactus studded with rosettes of the Legion of Honor. Rosa Bonheur found it absolutely delightful (May 12).

11. A.K. All this did not prevent her from getting back to work with obvious pleasure. "Two more days I've lost because of them. To hell with the bother of artistic glory! I'd rather sell candles" (excerpt from a letter published by Mr. H. Becker in the *Petit Temps* of June 1, 1900).

12. A.K. Here it might be useful to list all the honors that various governments bestowed upon Rosa Bonheur, as well as all the other prizes that she received from

How outraged I was a few months later to learn that this president with such admirable ideas about the future role of women had been stabbed to death.[13] That atrocious news turned my thoughts to politics and history for a while. I reread Maxime du Camp's stories about our most recent struggles, the brief and bloody Commune. All these crimes prove, alas! that the aftermath of war can sometimes be even more horrible than war itself, however great its ravages. Despite my devotion to science, I can only curse a certain branch of it. How on earth could I ever admire those mechanists, chemists, and engineers who are always trying to discover new weapons of destruction, not only to make sure that civilized nations dominate primitive folks, but also to give us ways to make war on each other and to shed yet more of our own blood?

Nothing can match my horror for the great slaughters in which our history takes such pride. God willing, the twentieth century, of which I'll

several cities and artistic societies, here and abroad.

1843, bronze medal at the Rouen Exhibition; 1845, third-class medal at the Paris Salon, bronze medal at the Boulogne Exhibition, silver medal at Rouen, and a certificate of merit from Toulouse; 1847, silver medal at Rouen, bronze medal given by the king for the Free Art School; 1848, first-class medal at the Paris Salon; 1853, declaration of automatic acceptance for all future work submitted to the Paris Salon; 1854, cameo brooch from the Royal Society of Ghent for the Encouragement of the Fine Arts; 1855, gold medal at the Universal Exhibition; 1858, silver medal for her bronzes at the Toulouse Exhibition; 1865, the Order of the Legion of Honor and the Order of San Carlos of Mexico; 1867, second-class medal at the Universal Exhibition; 1880, Order of Leopold on the occasion at the Triennial Exhibition at Anvers, and Cross of the Commander of the Order of Isabella the Catholic of Spain; 1885, Order of Merit for the Fine Arts of Saxe-Cobourg-Gotha; 1890, Order of Saint James of Portugal; 1894, Cross of Officer of the Legion of Honor and Officer of the Order of Saint James of Portugal.

13. A.K. On April 22, 1894, about two weeks after her promotion to the rank of officer, Rosa Bonheur was the guest of the duke d'Aumale at Chantilly. Also invited were General Billot and his wife, Colonel (now General) Avon with his wife and daughter, MM. Lavisse, Bouquet de la Grye, Rodocanachi, Auguste Cain and his two sons. M. Gustave Macon, the prince's former secretary and now the adjunct curator of the Condé Museum, kindly told me about the reception, in the course of which the good artist gave the prince her little medal from the Salon of 1845 with the likeness of King Louis-Philippe. "It has brought you luck, mademoiselle," he told her. She fondly remembered her welcome at Chantilly, the many kindnesses that were shown her and that did not prevent her from smoking her usual cigarette.

see just the dawn, won't quarrel with the nineteenth century for the privilege of reinventing gunpowder.

Ah! if only the world's nations could come together and use their resources for improving agriculture, speeding up transportation, educating their daughters, what happy changes there would be, what an explosion of joy all over the earth! This is my dream, my obsession.

The longer I live, the more I think, the more firmly I believe that all human endeavor ought to be directed toward just one goal: the soul's elevation.

As for the poor friend who gave me such support,[14] he died a few months after my nomination. I grieved a great deal lot for him. We'd been together for so long! His wife was Hortense Mène, the daughter of the old sculptor who had been such good friends with my father. His two sons, Henri and Georges, often filled my house with their good cheer. They were friends forever.

14. Bonheur is once again referring to Auguste Cain.

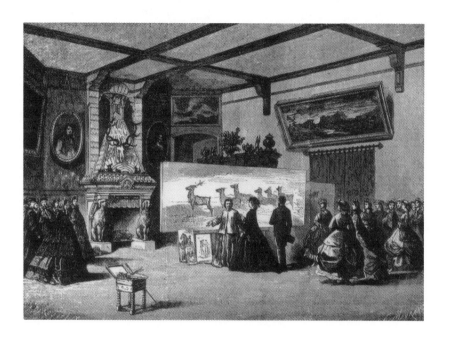

*Fig. 9. Empress Eugénie of France visiting Rosa Bonheur's studio in
1864. The following summer the Empress named Rosa Bonheur to
the Legion of Honor, making her the first woman artist so honored.
Reproduction of an engraving by Maurand, based on a sketch
by M. Deroy, from* Le Monde Illustré, *June 25, 1864).
(Original French edition, p. 257.)*

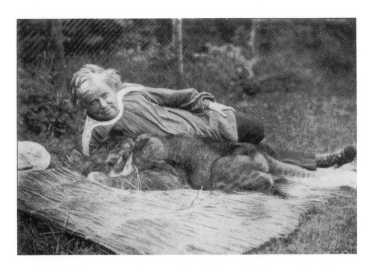

Fig. 10. Rosa Bonheur and her lioness Fathma. A loving member of the artist's numerous menagerie at the Chateau of By, Fathma used to follow her around like a poodle. (Original French edition, p. 281.)

Fig. 11. Rosa Bonheur and her mare Panther, summer 1897. As photographed by Miss Minnie Cochrane during the visit of Queen Victoria's youngest daughter, Princess Beatrice, during the summer of 1897. (Original French edition, p. 290.)

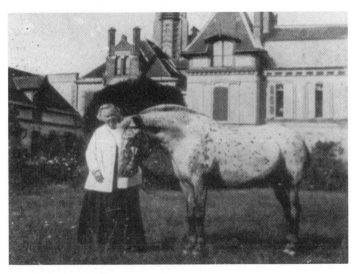

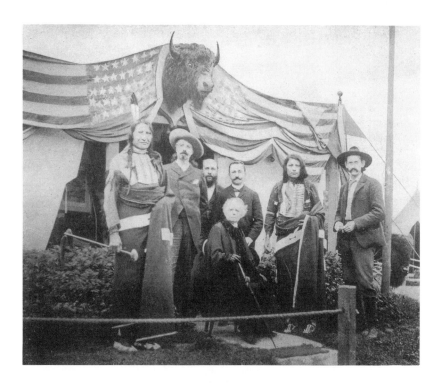

Fig. 12. *Rosa Bonheur with Buffalo Bill (Colonel William Cody),*
Mr. Knoelder, Monsieur Tedesco, Red-Shirt, and Rocky-Beard, 1889.
Once an army scout and buffalo hunter in the American West,
Cody turned to show business and traveled throughout
the world with his Wild West Show.
(Original French edition, p. 295.)

*Fig. 13. One of Rosa Bonheur's cross-dressing permits,
dated May 12, 1857. (Courtesy of Hacker Art Books.)*

"We, the Chief of Police, given the regulation of 16 Brumaire Year IX (7 November 1800); given the certificate from Mr. Cuzaline, a doctor of medicine with a diploma from the University of Paris; also given the affidavit from the Police-Commissioner of the Luxembourg precinct; authorize Miss Rosa Bonheur, living in Paris, 32 rue d'Assas, to dress as a man, for reasons of health, although she may not appear in such attire at shows, dances and other public meeting places. The present permit is valid for six months only, starting from this date."

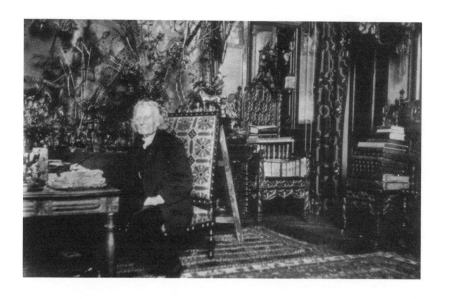

Fig. 14. Rosa Bonheur in her studio, 1899. Photograph by
Anna Klumpke. (Original French edition, 129.)

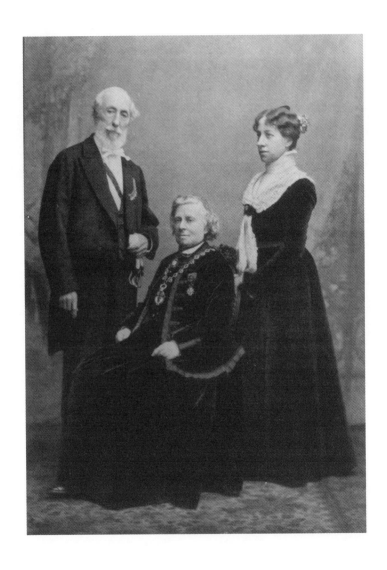

Fig. 15. With Anna Klumpke and
Ernest Gambart, Rosa's London art dealer, 1899.
(Original French edition, p. 349.)

Fig. 16. The Medal of Honor and The Bouguereau of Cows.
A mannish caricature of the trousered Rosa Bonheur by
Guillaume that appeared in Le Monde Illustré, *May 27, 1899.*
William Bouguereau was a renowned and highly decorated
painter of the French academy at this time.
(Original French edition, p. 369.)

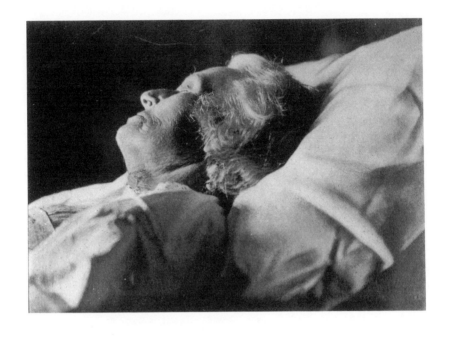

Fig. 17. Rosa Bonheur's death portrait, 1899.
(Original French edition, p. 399.)

Anna Klumpke's Story

CHAPTER 20

Rosa Bonheur's Birds
❖
Remarks on Her Mode of Dress and Feminism
❖
Her Great Affection for Mme Carvalho
❖
Her Love of Music
❖
Her Religious Ideas

In the second part of this book I thought it necessary, so as not to weary the reader, to string together Rosa Bonheur's stories and confidences without interrupting them by my own remarks or the questions that had brought them forth while we worked in the studio, drove through the forest, or chatted after dinner. This method helped me draw my famous friend's traits more clearly and retrace her life's beautiful unity, but it made no sense for the last moments of her noble career. Rosa Bonheur didn't have to tell me about a life we shared. In addition, several of her remarks on religion, art, music, and so forth arose out of things that happened during our life together. It would be difficult to isolate them from these causes and nearly impossible to connect them to a general conversation.

I beg the reader's pardon if notes from my diary make me intervene in the story in the following pages. I'll try to do so only for clarity's sake, except when it becomes absolutely necessary because of the place I involuntarily came to occupy in the artist's life and because of the role that her love assigned me in her final moments, and in her last will and testament.

Rosa Bonheur's bedroom at By ran the whole width of the second floor. Each end was lit by a huge window, one facing east and the other west. The sculpted rosewood furniture had the usual stern look. Her bed, far back in a wide alcove, had crimson rep curtains with a velvet border embroidered by Mlle Micas.

Anyone coming into that room for the first time was astonished to find it, and the hallway too, full of birdcages, all shapes and sizes of gilded cages hopping with birds. She had more than sixty little wingèd boarders of all kinds and colors, who made a deafening din from morning until night.

Although she never drew or painted birds much, Rosa Bonheur found this little feathered world very interesting, as the birds in her bedroom attest.

Every morning she fed them. In spring she'd put proper nests in the cages, and she even bought a little music box to teach them how to sing.

During a chat in the studio one day, I expressed my surprise that they didn't seem to bother her at all.

"Not in the least," she replied. "My birds only sing when they see me getting out of bed. They're all saying good morning in their own tongues."

"You mean they don't wake you up?"

"Not at all. I never close the curtains, and the sun wakes me before my birds start warbling. I love to catch the morning's first ray of light. That's why I'm so happy every morning when the clouds haven't deprived me of my favorite wakeup call.

"Come look at my Little Cloud Cuckoo Land.[1] You know the city of clouds and cuckoos that Aristophanes dreamed up in *The Birds*. The Olympian gods will never come down here to upset my feathered friends as they did in Athens some two thousand years ago.

"When my whole little world is peeping, cheeping, and hopping about, it looks like they're flocking together at the hoopoe's call to hear what I've got to say.

"By listening hard to their songs, I've noticed that each kind has its own language, just as Aristophanes said. The sounds his actors made for the Athenian public are so right. If I could only understand the many tongues my birds use, I'd learn so many interesting things!

"Take a good look at those canaries. They're a model of conjugal harmony that humans should try and imitate. The males look after the females' every need and bring them food when they're sitting on the eggs. If the mother jumps from one perch to the other to stretch her wings, the father rushes to take her place before the eggs get cold. Every year there are the same couples. I've been watching them closely, and I've never seen any infidelity. The males, however, are very jealous, but that doesn't bother the females.

"Look at these two cages. In one the canaries are all green, in the other, all yellow. I worked like the dickens to get that result.

"The problem I had is one of the main reasons why I think these little creatures have souls that finally become human. Even in their ultimate form, these souls keep some old feelings, despite all their metamorphoses.

1. Bonheur uses the transliterated Greek term, Néphélococcigie.

"Look at this little one hopping around. Now he's in his gray winter overcoat, but come spring, when he wants to please his mate, he'll be all shimmering turquoise, and his shy, monotonous song will become truly moving.

"That one over there is a Parisian ladies' man. Come summer, he goes right back to his bourgeois habits and gorges on birdseed. He starts neglecting his poor mate and won't bring her even a single miserable thread for the nest.

"Now come see my little tropical birds and admire their wonderfully gaudy feathers. Each one has rainbow wings. I'm always afraid they'll break their delicate feathers or, worse, catch cold. So I got the Tedescos to go to all the bird shops in Paris and find them little beds where they spend the night huddled under tufts of cotton.

"Despite all my care, I sometimes feel a twinge of conscience. I wonder if these poor little things wouldn't be happier in their native land. Even though I'm looking after them, don't they really resent me for taking away their freedom?"

There is no real need to tell the reader who has come this far that Rosa Bonheur cared for other creatures, too. She loved all her animal guests over a span of sixty years, whether they came from the plains or the mountains, the forest or the African desert, whether domestic animals or wild beasts: dogs, horses, donkeys, oxen, sheep, goats, red deer, roe deer, izards, mouflons, boars, monkeys, the sweetest and the fiercest lions. No doubt it would be ridiculous to say that they loved her in return, but it's true for the most part. Often these poor creatures expressed their gratitude and affection for the great artist who knew so perfectly how to watch and understand them. Rosa Bonheur believed that they could think. She readily ascribed them a soul destined to mysterious metamorphoses. Descartes's theories about animals revolted her, and she was not shy about saying that the talking animals in La Fontaine's fables were not just humans in disguise.

I found among her papers this meditation on horses:

Like man, the horse is the most beautiful or the most wretched of creatures. Yet man becomes ugly and shameful through vice or poverty; he is almost responsible for his decadence. The horse, on the other hand, is just a slave that the Creator entrusted to man and which man abuses in his ingratitude and cowardly, selfish wretchedness, even to the point of making himself lower than the most brutish beast.

It will come as no surprise that Rosa Bonheur often talked about women's place in contemporary society. The contrast between her struggles crowned with success and the dismal effacement that is too often our lot in Europe gave her great ambitions for her young French sisters. No doubt she didn't want them to square off against all the old habits and prejudices, to try and escape the mission imposed on women by nature and the facts of life. Yet she wished for a certain number of these prejudices to be abolished. Likewise, she wanted an end to the practice of relegating women, in any domain where their intelligence or talent made them men's equals, to an inferior rank by the mere fact of sex. And what hasn't been said or thought about Rosa Bonheur's habit of wearing men's clothes? Wasn't that the sign of some bold emancipation? Yet how many times during our short months together did I hear her say things like: "I strongly disapprove of women who refuse to wear normal clothes because they want to pass themselves off as men. If I thought trousers suited women, I would have given up skirts altogether, but that's not the case; so I've never advised my sisters of the palette to wear men's clothes in ordinary circumstances.

"If you see me dressed this way, it's not in the least to make myself stand out, as too many women have done, but only for my work. Don't forget I used to spend days and days in slaughterhouses. Oh! you've got to be devoted to art to live in pools of blood, surrounded by butchers. I was also passionate about horses; and what better place to study them than at horse fairs, mingling with all those traders? Women's clothes were quite simply always in the way. That's why I decided to ask the prefect of police for permission to wear men's clothing (fig. 13).

"But these are my work clothes and nothing more. I've never been upset by jeering idiots. Nathalie set no store by them, either. It didn't bother her at all to see me in men's clothes. Yet, if you're the least bit offended, I'm quite ready to put on skirts, all the more since I only have to open a closet to find a whole assortment of women's clothes.

"Out in the woods I wear an overcoat, felt hat, big boots, and often spats. Yet at home I prefer patent leather ankle boots. As you know, that's one of my coquetries."

"I do believe," I said, "that at bottom you're much more of a coquette than you want to admit. Didn't you have, for example, academic palms[2]

2. An honor conferred by the Ministry of Public Education.

embroidered on the trim of your smocks? They remind me a bit of the famous purple insignia."[3]

Rosa Bonheur cast an eye on these embroideries and laughed.

"True," she said, "but you can be sure that there's nothing symbolic about these little palms.

"Trousers have been my great protectors," she went on. "I've often felt proud to have dared break with traditions that would have made me drag skirts everywhere, making it impossible for me to do certain kinds of work. As for my women's clothes, when I began to get famous, Nathalie gave me a very clever bit of advice: 'Don't even try to be a fashion plate,' she said, 'just pull together an outfit that'll stand outside the vagaries of feminine elegance. Hang on to it your whole life long, and it'll become your trademark.' Nathalie was right. I followed her advice and took up Breton dress modified to my taste. I confess I've often looked a bit ludicrous with my narrow sleeves, vest, and full pleated skirt, but Nathalie used to console me by saying: 'Enough of that nonsense. People will know Rosa Bonheur by her petticoats, just like Napoleon by his little hat.'

"Since I've been living at By with all my animals, I've hardly had time to play the great lady. Visitors have to take me as I am. Yet if I go out or do something official, I always put on a dress and feathered hat. Oh! the hat problem! Fashionable hats have been my bugbear for a long time. Not a one would ever stay on my head since I didn't have a chignon to poke pins through. One day a friend of Nathalie's took the bull by the horns and got me wearing a dowager's bonnet. Hats like that were all the rage back then, even for elegant young ladies. It was a fatal bit of advice. I regret to say I did what she said, and I've had at least one notorious misadventure because of it.

"Two years ago (October 8, 1896) when the Czar and his wife were visiting Paris, the Minister of Fine Arts wanted them to meet some celebrities of the French art-world during their tour of the Louvre. I was honored to receive an invitation.

"As usual in such circumstances, I put on my beautiful black velvet dress and my little feathered bonnet. With my short hair, the only reason it stayed on was because of a chin strap going from ear to ear. You can imagine what that looked like.

"As soon as I arrived at the Louvre, I would've given anything for my gray felt hat. I was the only woman in a crowd of men, all decked out with medals, since the only ones invited were artists in the Legion of Honor.

3. Perhaps some Masonic emblem?

Everyone was staring at me. I didn't know where to put myself. It was quite an ordeal, and that day I really longed for men's clothes. Seeing how embarrassed I was, M. Carolus-Duran was brave enough to come up and give me his arm. I took it gratefully and hung on for dear life.

"Reassured by his support and cheered by the welcome my colleagues gave me, I forgot a bit how ridiculous I looked. Yet my ordeal was not over. A few days later the illustrated papers came out. I was terribly put out when I recognized myself in a silhouette that became the laughingstock of all Paris.

"Despite my metamorphoses of dress, none of Eve's daughters appreciates subtlety more than I. Though I'm gruff, even fierce by moments, my heart has always remained perfectly feminine. Had I liked jewelry, I certainly would worn such finery. Nathalie did, and I never criticized her for it.

"Why shouldn't I be proud to be a woman? My father, that enthusiastic apostle of humanity, told me again and again that it was woman's mission to improve the human race, that she was the future Messiah. To his doctrines I owe my great and glorious ambition for the sex to which I proudly belong, whose independence I'll defend till my dying day. Besides, I'm convinced the future is ours. I'll give you just two reasons. Americans march at the forefront of modern civilization because of the wonderfully intelligent way they rear their daughters and respect their wives. On the other hand, the Orient wallows in hopeless barbarism since husbands there don't have enough respect for their wives, which is why the children don't love their mothers.

"Our timid beauties of old Europe are too easily led to the altar, like ewes going to sacrifice in pagan temples.

"A long time ago I understood that when a girl dons a crown of orange blossoms, she becomes subordinate, nothing but a pale reflection of what she was before. She's forever the leader's companion, not his equal, but his helpmate. No matter how worthy she is, she'll remain in obscurity.

"My mother's wordless devotion reminds me that it's men's nature to speak their minds without worrying about what that may do to their mates.

"Sure, there are some fine husbands who are eager to make their wives' qualities stand out. You know a few. Yet I've never dared go stand before the mayor with a man.[4] Still, unlike the Saint-Simonians, I consider the

4. In France, the civil marriage ceremony is obligatory. It may be followed by a religious ceremony.

sacrament of marriage essential to society. What a great idea to give human law the power to establish a contract so powerful, so exalted that not even death can dissolve it.

"When I read the enlightening account of Auguste Comte's[5] doctrines in Littré's *Positive Philosophy*,[6] I was struck to find something I've thought for a long time: the institution of widowhood for both men and women is an admirable idea. Children need it for their peace, well-being, and protection. What happened to us so long ago? My father couldn't bear being alone, as I've told you. A year before he died, the woman who took my mother's place gave him a son, and I paid for most of his schooling. Well! rumor had it that I was his mother, not his benefactress. That can be forgiven, but never ever forgotten!

"Like Rachel,[7] George Sand, and so many others, I certainly could have taken advantage of the indulgence generally conceded to prominent women. Then people could have said whatever they pleased about me. Instead, I've always led a pure, decent life. I've never had lovers or children.

"Even though my father sometimes scolded me for my free, boyish ways, he can at least rejoice up in heaven. He used to call me his most precious asset, and I've remained without stain my whole life long."

One evening when we were talking about music, I asked Rosa Bonheur if she played the piano.

"I've never taken lessons," she replied, "but as a child I so loved listening to my mother that each tune she ever played is engraved in my ear. That's probably why I was so fond of the inimitable Mme Carvalho.[8] Whenever she sang, I always felt pure joy because she sounded like my mother.

"I've always liked Gounod, but especially Mme Carvalho's renditions of his music. Her voice wasn't very strong, but she knew just what to do in the huge Opera hall. She never strained, yet even her softest notes reached the ear.

5. A nineteenth-century philosopher who, after having been Saint-Simon's secretary, went on to found positivism.

6. Emile Littré was a nineteenth-century philosopher and lexicographer. The complete title of the work Bonheur refers to is *Auguste Comte et la Philosophie positive* (1863).

7. A famous, even notorious nineteenth-century actress.

8. A well-known nineteenth-century prima donna.

"How many times during her visits did she turn my 'sanctuary' into a concert hall? While she was singing, I'd close my eyes and imagine my mother close by. I'd be back in Bordeaux, in Grandfather Dublan's house, and Mama, moved by my ecstasy, taking me up in her arms and covering me with kisses. When she died, I felt such grief and despair that I refused to see anyone for a while. It was almost like my mother dying all over again. And I felt all the more alone since Nathalie was no longer there to share my pain."

A short time later I accompanied Rosa Bonheur to the Paris Opera, where one evening we heard the *Valkyrie*. During "The Ride of the Valkyrie," she whispered in my ear: "I'm so impressed by the imitative harmony of the voices of nature in this piece. This is the first Wagner I've heard, but it won't be the last.

"I like Gluck and Beethoven," she told me after the opera. "What masterfully simple works! But I especially love Mozart's *Magic Flute*. When you play bits of it in the evening, while I'm stretched out in my lounge chair, you've got no idea how you're bringing back my tenderest childhood memories."

Although Rosa Bonheur was no musician, talented composers dedicated some eloquent pieces to her. César Pyrnet, still a student at the Conservatory when she received the Legion of Honor back in 1865, wrote for her a delicious lullaby for cello entitled *The First Imperial Rose,* and even the great Bizet composed a cantata in her honor.

One day I brought up Félicien David, whom she'd already mentioned in connection with the Saint-Simonians.

"How could I ever forget him!" she exclaimed. "The great piece, *The Desert,* that he composed for the Saint-Simonians' departure for Egypt, made him immortal. The sunrise, the Arab's prayer, the camels' march, the whistling sandstorm, the far-off mirages, it's just like one of Ossian's poems.

"Do you know Ossian? What inspiration he's given me! I can't read his poetry without seeing paintings of all the great happenings of nature."

She got Macpherson's book, opened it to the chapter on Fingal and read these passages with feeling:[9]

On Lena's dusky heath they stand, like mist that shades the hills of autumn, when broken and dark, it settles high and lifts its head to heaven . . .

9. Obviously Bonheur read these poems from a French prose translation.

His masts are many on our coasts, like reeds on the lake of Lago. His ships are forests clothed with mist, when the trees yield by turns to the squally wind . . .

Fingal who scatters the mighty warriors, as storms scatter the heather when raging torrents torment Cona's echoes and night settles with all her clouds on the hill!

Taking advantage of this swell of enthusiasm, I asked her to sing one of Félicien David's pieces.

"Gladly," she replied. "Sit down at the piano."

While I was getting ready to play, she paged through my music and happened on *The Lake,* Niedermeyer's version of Lamartine's famous elegy. Félicien David was forgotten.

"Mme Carvalho used to sing this for me," she said. "Please play me the introduction, Anna, and I'll try and recite it for you."

In a very soft voice she began:

Un soir, t'en souvient-il, nous voguions en silence;
On n'entendait au loin, sur l'onde et sous les cieux,
Que le bruit des rameurs qui frappaient en cadence
 Les flots harmonieux,
Qui frappaient en cadence les flots harmonieux.[10]

Her voice got firmer and she continued:

O lac! rochers muets! grottes! forêt obscure!
Vous que le temps épargne et qu'il peut rajeunir
Gardez de cette nuit, gardez, belle nature,
 Au moins le souvenir,
Gardez, gardez au moins le souvenir.[11]

At the beginning of the third stanza, Rosa Bonheur stopped and said: "Use the soft pedal and let the last verse end in a murmur, for a change."

10. A prose rendition of these lyrics could read:

One evening, you remember, we were gliding in silence; we could only hear far off, over the water and under the heavens, the sound of oars striking in cadence the harmonious waves, striking in cadence the harmonious waves.

11. O lake! mute rocks! grottos! dark forest! You who are spared by time, you that time can rejuvenate, keep, beautiful Nature, keep at least the memory of this night; keep, keep at least the memory.

The way Rosa Bonheur sang, the feeling that she put into the great French poet's beautiful lines gave me undeniable proof that her talent and sense of beauty weren't just for painting, but for all forms of artistic expression.

I even wonder if she hadn't tried writing poetry. Among her papers I found some lines dedicated to her dear trees in Fontainebleau forest. She seemed to have written them just after Nathalie's death, no doubt intending to put them into verse.

One afternoon while we were working together in the big studio, Céline announced that some tourists were asking to visit the "Rosa Bonheur gallery."

"But there's no gallery here," the artist replied. "Tell those gentlemen I don't show paintings at home."

After the maid left, Rosa Bonheur burst out laughing. "I've got it. They saw a gallery by that name in the Denecourt guidebook, and they came looking for it here, even though it's in the forest. My gallery is really a magnificent grove. We've often strolled in its shade, but I never thought to tell you that Denecourt dedicated it to me. This man who did so much for artists was a true friend of nature. He spent his life, his fortune opening up Fontainebleau forest to the public. We have him to thank for more than two hundred kilometers of carriageways and, even more precious, hundreds and hundreds of little footpaths going in all directions, itineraries marked with red or blue rocks—you've seen them—so that hikers won't get lost.

"Let's get the gig and drive out to my gallery. That'll be today's outing."

In a picturesque little valley not far from the Fairy Pond, Rosa Bonheur pointed to the branches overhead: "These are the trees Denecourt named for me. Look at the leaves. In these last rays of sun they've become luminous, as transparent as the most magnificent stained glass, don't you think? There's nothing more splendid in any basilica.

"Old trees like this, with their crisscrossed branches, inspired medieval architects for the arches of their cathedrals. Leaves falling in the autumn, sap rising in the spring, doesn't that symbolize our future life? Like the Druids, I've made the forest my temple. I come here to pray and thank God for his overwhelming kindness to me throughout my career. Providence has been especially good to me. I'd be terribly ungrateful if I didn't thank God for the happy, exceptional life he's granted me and the real protection I've had because of my dear mother's soul. I believe in divine justice, if not in this world, then the next. As I've often told you, our

material life alone is just a brief trifle in the eyes of those who know how to recognize the Creative Spirit at work.

"I get blamed for not going to church! I may have more religion than the folks who, instead of doing their best to lead a blameless life, go mutter prayers there everyday in a language they don't understand.

"I believe in the unity of God's great manifestations. Every religion is good as long as people adore the Infinite Spirit in the wonders of his creation. The Creative Spirit didn't want us to learn the secret of life until after death. He insists on leaving everybody free to act according to conscience, but we can't say anything for sure without conceit or guile. We can neither imagine nor judge the Creative Spirit."

Our drive through the gallery was over, but Rosa Bonheur was still thinking about religion. As soon as we got back to the chateau, she took me into the studio and showed me an engraving of the Virgin with the Child on her lap.

"Here on the back," she said, "I've written my own versions of the most important Catholic prayers."

Salutation

Hail, O earth full of grace, the living God is with you, blessed are you among all the planets, the fruit of your womb is our salvation. Holy earth, mother of love, pour out your grace on those who suffer, now and in our divine transformation.[12]

The Lord's Prayer

Our Father who art in all things and all places, may thy divine name be glorified and thy reign of love come to earth as in heaven, where is thy Christ.

Creed

I believe in God, the all-powerful, everlasting Father, creator of all things eternal; I believe in his beloved Son, the saving Two, androgyne Christ, the highest point of human transformation, the sublime manifestation of the living God who is in everything that is; who was conceived in the bosom of our glorious human nature, forever mother and forever virgin; who was born and suffered death, to be born again

12. Although it is customary in French to address God and the Virgin Mary in the familiar voice, Bonheur uses the formal mode in this prayer, which is clearly a revision of the traditional "Hail Mary."

always more perfect; who ascended to the future that he opens to us, where the quick and the dead shall be judged.

I believe in holy love, God the giver of life to all things, in the holy Church to which all are called in body and spirit, in universal human communion, sanctified by holy work, for all shall be saved; in the remission of sins; in life eternal.

CHAPTER 21

Electric Lights at By
❖
Building a New Studio
❖
Treading Wheat
❖
Rosa Bonheur's Comments on Painting

After Nathalie Micas died, Rosa Bonheur lived for years in chosen solitude, entirely devoted to her labors. Grief had not diminished her passion for art, in part because work provided a powerful distraction from her often gloomy thoughts. I took sweet satisfaction noticing the change that a confidante and friend brought forth in her. "You're rejuvenating me," she was fond of saying. She became chatty and cheerful. Indeed, she came alive again and took renewed interest in things. For a long time she couldn't have cared less about her estate, but now she was busy imagining beautiful new transformations.

In the past she had dreamed of getting electric lights so as to keep on painting through dark winter days and those endless evenings that set in as early as four o'clock. In the summer of 1898 Rosa Bonheur finally decided to do it. One fine morning, everything—motor, dynamo, storage cells— arrived from Paris, creating quite a commotion in town. The hamlet of By has electricity now, but Fontainebleau is not so lucky.

"With that beautiful incandescent light, which is just like the sun, I'll work so well through those long winter evenings!" my famous friend went on enthusiastically. "It'll be so good to get my lions done faster and prove that old Rosa Bonheur can still make people talk. Nathalie wanted to help me show the world that, despite my age, I still haven't lost the fire of my *Horse Fair.*"

Already for several years finishing *Treading Wheat* had been one of her chief preoccupations. Its colossal dimensions and the superb movements of the horses struck everyone who entered the big studio. I've already mentioned the painting several times and even noted my offer to help her finish it up for the Exhibition of 1900. She had agreed, and it was understood that we'd get down to work as soon as the new studio was done. This was an absolute prerequisite since she just couldn't bring herself to

213

complete the painting in the old studio. The room was too small for the canvas, and the light inadequate, both of which she considered insurmountable obstacles.

I pointed out that it would have been cheaper and faster to get better light by enlarging the big window.

"Maybe so," she replied, "but I don't want to change anything here. Even twenty thousand francs for the new studio would be next to nothing compared with the three hundred thousand the Tedescos have promised me the day I deliver *Treading Wheat.*

"When the old studio was under construction, I couldn't supervise things (fig. 14). The architect wore himself to a frazzle decorating it inside and out. He came up with fluted mantelpieces, little Tudor beams, patterns of red and white bricks. On one side of the roof there's a dovecote topped by a pompous weathervane with my initials; on the other, a terrace for stargazing. But my fine man forgot the most important thing for large paintings. A huge skylight flooding my 'sanctuary' with light would have been much better than this magnificent chandelier and all these ceiling ornaments.

"I won't touch *Treading Wheat* until everything's in place for the creation of a masterpiece. I've got to be able to paint as if I were outside."

The next day Rosa Bonheur saw her architect, told him the dimensions of the little building she wanted, and staked out the site.

"It's simple as can be," she said. "Four walls, a big window, and a glass ceiling. All these bushes around here are a problem, so you've got to give me some shutters to block out the green reflections they throw."

She turned to me and said: "Once we've sent *Treading Wheat* off to the Universal Exhibition, you'll take the new studio. And to prove that it's already yours, you'll pay the first installment.

"I've told the architect to build a platform in one corner. That's where you'll set up a rustic home-scene for your genre paintings.

"I hope, my dear Anna, that you'll have several long years of happy inspiration here. I wish you all the perseverance of my hardworking spider friends who decorate the beams of my 'sanctuary.' Their webs are absolutely safe with me. They get rid of the flies that pester me every summer, and I like to see this constant proof of Arachne's daughters' fine industry."

Two weeks later we had a little ceremony to celebrate the laying of the first stone of the new studio. Holding her palette and a fat, round brush, Rosa Bonheur jauntily drew on the stone:

R.B.—A.K.

By, 29 August 1898

Then she picked up a hammer and gave the traditional first blow.

When the frame was up, the workmen gave us a nice surprise. Instead of placing the usual bouquet of flowers on the roof's highest peak, they raised two flags, one French and one American.

"These fine men have guessed the true nature of our bond," Rosa Bonheur remarked. "They know I was drawn to you for personal reasons, but also because of the nation you belong to. For me, you're a symbol of the alliance between the Old World and the New."

While the studio was still under construction, Rosa Bonheur wisely decided to finish up all her other projects, which was no small task. Then we'd be ready to devote ourselves entirely to *Treading Wheat.*

To those many labors I owe the honor of becoming Rosa Bonheur's student and even partner. Starting in the fall of 1898, the main goal of our daily drives was to study the effects she wanted in her paintings. Accordingly, we went to the flat open country, the woods, or the banks of the Seine. During one of these drives she said: "I like to get the mysterious atmosphere around the trees when the first rays of sun still haven't burned off the morning fog or when the lengthening shadows herald evening. If I weren't so old, I'd devote myself to landscapes, which I've always loved."

Rosa Bonheur now had such a prodigious memory that she no longer needed to have her paint box with her. She just studied a scene for a while, taking what she called her mental notes.

Yet one day at dusk she wanted to take down on paper a certain effect. No sketchbook could be found, so she used a half-torn thank-you card. With magical speed she drew a few hieroglyphs in which I could recognize the trees.

One evening Rosa Bonheur sat down in her favorite chair, lit a cigarette, and began talking about her *Treading Wheat.* She was adamant that I understand the high ambition of the painting I was to collaborate on.

"On my trip to Scotland, at Falkirk fair I saw a torrent of oxen rush at a flock of sheep.[1] Despite all the shepherds' blows to their shoulders, the huge things ran down their victims and crashed into each other with all of hell's fury. A great subject for a painting, don't you think? I got all fired up. In order to paint it, I went right out, as you know from Nathalie's letters, and bought a herd of oxen and sheep at the fair and shipped them to M. Gambart's place, where I did my first studies. But the best was yet to come. I made arrangements to keep my animals in Paris and got the huge canvas

1. A.K. See chapter 15.

that still takes up most of the studio. I set my heart on doing something masterful.

"When everything was ready, the French government got stubborn and wouldn't let my sheep and oxen cross the border, their pretext being an epidemic in some corner of Britain. My heart sank!

"For several years I didn't know what to do with that canvas. I finally decided to use it for *Treading Wheat,* which depicts an old method of threshing still used in the Camargue, a big island with huge herds of loose, half-wild horses at the mouth of the Rhone. Once the harvest's in, the owners of these horses have them rounded up by a *gardian.*[2] That corresponds, in these parts of France and it's probably the same thing in the United States, to the men on horseback who oversee the animals and send them from farm to farm with threshing machines.

"The sheaves of wheat are untied and put on a circular track, with the *gardian* in the center.

"In groups of three or four, the horses are tied to a rope held by the *gardian.* Then they start moving around the track, at first just plodding along, since the sheaves underfoot slow them down; but soon the stalks are crushed, the horses pick up speed and begin to whirl like a tornado. At that point the kernels of grain slip out of the ears. Every now and then they stop so that the farmhands can gather up the harvest and bring in fresh sheaves.

"Well-trained horses are left loose, which simplifies the *gardian*'s role. It's enough to call the horses by name and give them hand and voice commands.

"I wanted to paint this scene since it gives a better idea about how smart these wonderful beasts are. To liven things up, I got inspired by a legend in Mistral's *Mireille.*[3] A young shepherd tells that the Crau region was once a fertile wheatland. But a greedy farmer made everyone work through the entire harvest without a single day off, not even the Feast of the Assumption. Here, I'll read it to you:

Over the sheaves shaking off their wheat, a circle of Camargue horses endlessly trod—Not a moment of rest!—Their hooves always hobbled!—and on the dusty, tortuous threshing floor—always mountains of sheaves to be stamped![4]

2. Provençal term used in the original text.

3. Verse romance (1859) by Frédéric Mistral, a French poet who wrote in Provençal.

4. A.K. Frédéric de Mistral, *Mireille,* canto VIII.

"To punish him, lightning struck his barn and burned it down, and an earthquake swallowed up everything: the farmer, his threshing floor, his family, harvest, and herds. Since then, every Assumption Day, you can hear those horses treading round and round in the clouds.[5]

"It's my dream to show the horses snorting fire and dust welling up around their hooves. I want this infernal waltz, this wild tornado to make people's heads spin. Even at high noon they've got to hear an echo of the horses treading up a great storm.

"Although M. Tedesco offered me three hundred thousand francs some twenty-five years ago, I still haven't finished it up because of various ups and downs and, most of all, the bad light in my 'sanctuary.' "

Rosa Bonheur stopped talking and went over to the canvas. I followed her and marveled for the hundredth time at her horses' energy, saying they were a sign of their author's fiery nature.

"It's just like *The Horse Fair, Stampede of Scottish Oxen,* and *Scottish Oxen.*[6] I let myself get carried away, but you mustn't think that's always the case. No doubt some artists let the inner self take over against their will; but I know how to resist that and yield to the subject. I never shrink from work, however thankless it may seem. It's all right to paint something intense in a bold, free way; but for something calm, the technical side of the painting needs polish, even down to the minutest details, which are the center of interest, but without getting finicky, of course. By studying all the subtle graduations, you can produce amazingly real effects.

"Look at Van Berghem, Metzu, Teniers,[7] Wouwermans, Verboeckhoven.[8] They neglected nothing. Everything is right where it should be. The tiniest perfect details are a pleasure, yet they don't detract from the general effect. That's why I'm so devoted to them."

"And which modern animal painters do you like?" I broke in.

"Carle Vernet, Géricault, Troyon, and de Dreux, who was one of my favorite guides. There was a time when I bought everything I could find of his.

5. In the arid south of France there is often a great storm around August 15, the Feast of the Assumption.

6. The French title given here is *Les Boeufs écossais,* which has not been mentioned before. Perhaps Rosa Bonheur is referring to another Scottish painting previously mentioned under the title *Boeufs dans les Highlands,* which was translated as *Oxen in the Highlands.*

7. David Teniers II, called the Younger, was a seventeenth-century Flemish genre painter.

8. Eugène-Joseph Verboeckhoven was a nineteenth-century animal painter.

"As for that fine Brascassat, some nasty gossips once said he was jealous of me. He put an end to all that by sending me one of his great lithographs with a very flattering dedication."

During a chat under one of those age-old oaks that make the grounds of her estate so beautiful, Rosa Bonheur talked about technique.

"See how vividly green those trees stand out against the sky. Yet they've got a bluish tone, and there's wind in the branches. I'd get that effect with Prussian blue and yellow ochre and do the shadows in blue-gray.

"Raw sienna with Prussian blue produces a vivid, transparent green. A bit of gold ochre gives it more body. Raw sienna and dark cinnabar green give transparent tones. Some great artists are against mixing these colors, but it all depends on how you do it.

"Pigments with a sulfur base, like cadmium yellow and vermilion, mustn't be used with white, since they may turn dark.

"Cobalt blue, Prussian blue and ultramarine, chrome yellow, Naples yellow, the various ochres, siennas, and cadmiums all stand up well to light.

"For a strong, rich brown like that notorious Jew's pitch which played such nasty tricks on our modern painters,[9] mix some Venetian red or burnt sienna with Prussian blue.

"When you're painting a sky, start with the palest parts, meaning the background; then paint the grays and the rest over that. Bright, shiny colors for the light parts; but keep the dark parts transparent.

"When I'm starting on a new canvas, I sketch things out in broad strokes with burnt red ochre, get the essential lines, rub the background with a neutral gray made up of white, blue, and a little bit of red ochre. Then it's got to dry before I begin painting.

"My method is totally different for watercolors. First I rough everything out in gray. When I've got the values where I want them and all the details worked out, I do the light colors, the local colors, etc.

"Many artists use a linseed-oil base. I never touch the stuff.

"It's bad to use siccatives to speed up your drying time. The reactions they cause will change your colors.

9. Although oil paints prepared with Jew's pitch or Judean bitumen produce beautifully rich color, they have little practical use, since they never completely dry. Used alone, they may run; used with paints that dry quickly, they make the surface of the painting crack. Prud'hon, Géricault, Decamps, and Courbet had some disastrous experiences with Jew's pitch.

"Forty years from now, the paintings of some famous colorists will be nothing more than form and texture. It's already happening to Courbet, and it'll be the same thing for Henner.

"Too bad we don't know how to mix paints like Rubens, Rembrandt, Teniers, Salvator Rosa, Van Dyck, and the like. Then our works would last as long as theirs.

"As for organizing my palette, first I put on the greens, the blues, next white, then the yellows, the reds, the browns, and finally the blacks. Here they are, just as I said." Rosa Bonheur picked up one of her palettes. "Emerald green, Veronese green, cobalt green, chrome-oxide green; cobalt blue, ultramarine, Prussian blue; silver white; Naples yellow, yellow ochre, gold ochre, burnt gold ochre, raw and burnt sienna; vermilion no. 1, Venetian red, Indian red, Van Dyck red, red ochre, burnt lake, madder lake, Van Dyck brown; ivory black, peach black.

"The impressionists imagine they're bamboozling people with their far-fetched technique. Sure, you can paint with anything any which way, but not without knowing how to hide the tricks of the trade.[10]

"Young artists nowadays are in too much of a hurry. They say it's a waste of time trying to figure out what made the Old Masters so great; and they're always spouting formulas like realism and impressionism, as if they'd invented something new. Weren't the great painters, even before the Renaissance, impressionists and realists, too? As Michelangelo so rightly said, it's not enough to have a hand that obeys the mind; you can't recreate life unless the soul tries to understand its mystery.

"Always begin with a vision of truth. The eye is the way to the soul, and the crayon or brush must simply and faithfully render what you see. Never

10. A.K. In her letter of March 28, 1897, to M. Gambart, which was published in *L'Estampe* for the unveiling of the Rosa Bonheur monument in Fontainebleau, she wrote:

"Let's not make so much fun of the impressionists. There are a few good ones. Besides, the name has nothing to do with it. I think that all painters, great and humble, have been impressionists, impossibilists, or charlatanists."

In his book *The Reminiscences of Frederick Goodall, R. A.* (London: W. Scott and Co., 1902), the English artist tells about meeting Rosa Bonheur in London and accompanying her on some of her travels through Scotland. He also reports one of Rosa Bonheur's remarks about Ruskin. She told the famous Romantic critic that although shadows never looked the same to her two days in a row, she had certainly never seen any purple ones. "Oh! but to me," said Ruskin, "they always look purple, yes, red and blue." After Ruskin was out of earshot, Rosa Bonheur added: "He's a theoretician, and sees nature with tiny eyes, just like a bird."

forget that there are no razor-sharp lines in nature. Everything comes with its own atmosphere. Without these things firmly in mind, you'll never get things right."

"I only use round brushes, never flat ones.

"Washing up at the day's end is such a serious thing that I've never let my servants do it. I wouldn't even let Nathalie help me. Each brush gets washed twice with yellow soap and warm water, then rinsed, ten times at least, until there's no trace of soap left, not even a single little bubble. Soapy colors will destroy your painting.

"When I'm washing up, I hate anyone interrupting me. Nothing can make me stop. You must have noticed this when the mayor of Thomery came by to introduce his flirtatious young daughter-in-law who got all dressed up to meet me. You remember the amazed look that came over her pretty face when I kept messing around in my tubs with my sleeves all rolled up."

"All artists have to devote a lot of time to exercising their hands and gathering documents on everything they see. This is material for future creations. If you can remember all the different vivid impressions that you maybe only jotted down in your sketch, you can sometimes get really inspired.

"I've done all kinds of studies. I'd rather eat nothing but dry crusts of bread for the rest of my life than get rid of them. They are real tools for my work. Selling them for a few pieces of gold would have meant wallowing in idleness in my winter years. Do you know what Vasari told painters in his book on Titian?

"You must," he says,

"first draw your ideas in various ways. It is sorely oppressive to have to look at a model every time you pick up your brush. On the other hand, if you start out drawing, you paint more easily. This way you gain dexterity, find a style, improve your judgment, and avoid much pain and exhaustion. Finally, drawing stocks the mind with great ideas, and you learn to recreate everything from memory without always needing nature's reminder and without having to struggle with the problems encountered by painters who don't know how to draw."[11]

"I've always been faithful to that method. My whole life has been devoted to improving my work and keeping alive the Creator's spark in

11. A.K. Giorgio Vasari, *Vies des peintres,* trans. L. Leclanché (Paris: Tessier, 1892), 9:200.

my soul. Each of us has a spark, and we've all got to account for what we do with it.

"I try to follow in Schiller's footsteps. He said that what we have to give art comes from inside, and that what we take from outside must be reborn within. If you neglect the divine inspiration that has to make your canvas breathe, you feel nothing and your work remains lifeless."

Queen Isabella at By

❖

Christmas at the Village School

❖

Travels to Nice

❖

The Empress Eugénie

On September 20 around five-thirty in the afternoon, dusk was coming on. I was washing Rosa Bonheur's brushes in the bathroom when she blew in.

"Anna," she said, "Queen Isabella is downstairs for a visit. Quick, wash your hands and go to the studio. I'm going down to greet her."

For a moment I thought she was joking, but from the little parlor I spied two landaus that had just pulled into the courtyard. I ran to the studio to tidy up, arrange the chairs and easels, and throw open the doors.

The queen, a bit too plump for the stairs, was having a hard time coming up. An elderly man, very distinguished and perfectly elegant, preceded her, with a matron of honor and a young man following behind.

After all the greetings and introductions Rosa Bonheur offered her guest a chair. Still quite out of breath from the stairs, the queen needed a moment of rest to regain her composure. This unexpected visit hadn't given Rosa Bonheur time to change. Since it had been quite hot, she was still wearing her blue trousers and a white canvas jacket. Yet she seemed totally unabashed. I was a bit flustered, but loved watching her, so lively, yet so dignified, with a sparkle in her eye and a halo of gray hair around her beautiful face, do the honors of the house for her guest. The dethroned queen, catching her breath, admired *Treading Wheat* and a study of a horse sitting on an easel nearby.

Rosa Bonheur wanted to show Queen Isabella her most recent painting and went to fetch it in the little studio. Alone with the queen and her attendants, I feared making some kind of blunder. When I showed her some photographs of Rosa Bonheur's paintings, she looked at them absentmindedly. The studio was more interesting. When her eye fell on a pastel portrait I'd done of my mother, she asked: "Is that one of Rosa Bonheur's pieces?"

"No, madame, that portrait is mine."

The queen looked surprised and went over to study it.

"It's very good," she said. "I think you're very talented. You're French, aren't you?"

With the Spanish-American War raging at the time, I had a second's hesitation before replying that I was American.

Just then Rosa came back all in smiles with her painting of oxen[1] for the Pittsburgh Exhibition. The queen praised the painting and my old friend's talent. "It has a kind of nobility that cannot be dethroned," she said in a husky voice veiled with melancholy. In the same sad tone she added: "Both of you have a kind of nobility that cannot be dethroned."

Rosa Bonheur bowed. Trying to dispel the mood she read on the exiled queen's face, she went off to get the study-portrait that I had done of her. This would give her a brief chance to talk to Queen Isabella about me and the feelings we shared. The queen deigned to say that the portrait captured a great likeness and gave me the nicest compliments. Meanwhile her young secretary went over to Rosa Bonheur and whispered a few words that I couldn't make out. She promptly opened a portfolio, took out a drawing that she signed with her firm hand, and gave it to the queen, who very graciously thanked her. Then Rosa Bonheur told me to show the queen various photographs of my portraits. She particularly seemed to like one of an old woman near a well.

"Please sign it, Anna, and give it to Her Majesty."

I got flustered and wondered what would be a suitable dedication. Fortunately, the chamberlain came to my rescue.

When the queen was about to leave, it was almost dark and a maid brought in a lamp. Rosa Bonheur took it and lit the way downstairs for her august visitor, who then gave me her hand. I touched that royal hand and curtseyed, yet never dreamed of kissing it.

While the queen was on the stairs, her matron of honor stayed back and told me that the painter Madrazo was her cousin and that she had a portrait he had painted of her.

When the queen reached the front hall, the general gave the servants generous tips, and from the window I watched them heading back to the landaus. Then they were gone. Rosa Bonheur came right back upstairs and kissed me.

The day after that memorable visit, she showed me a letter she was writing to M. Gambart. Aside from saying that she expected my portrait

1. *Oxen and Bulls of Auvergne.* See chapter 6.

of her, the best she had ever seen, to be wildly successful in America, she included these words about the queen's visit (fig. 15) and asked me to make a copy:

> Queen Isabella of Spain paid us a visit, for which I'm very grateful and proud. I was overjoyed that she admired my friend. There's no end to my love for her, since she is good and charming. I'm sure you'll like her. Everyone who meets her does. Indeed, my old heart adores her, though I haven't forgotten my beloved Nathalie, whom you loved, too.

> She clasped me to her heart, saying: "My child, how much I love you! I'll never be able to say it often enough. Our souls are sisters. You're so much like the one who was the model of perfect affection."

In dreary December I asked Rosa Bonheur if village schools in France, like those in America, put up Christmas trees for that moving holiday.

"We don't do anything for Christmas," she replied, "but that's a great idea. We'll have to do something like that here."

Although By is just a little hamlet, it has its own school, thanks to Rosa Bonheur and Nathalie Micas, who gave most of the money for it. The rest was raised by the townspeople, delighted that their children would no longer have to walk half an hour through rain, snow, or hot sun to school at Thomery. Since there weren't many children at By, the two friends thought a coeducational school would do. However natural the idea, it aroused fierce debate, and M. Gauthier, the mayor at that time, had a hard time getting official approval.

The mayor of Thomery[2] was happy to let me throw the little party for the children at school. We began our preparations. Rosa Bonheur brought in a piano and insisted on hanging up photographs, for all to see, of Nathalie Micas and M. Gauthier. We put up the tree, a magnificent pine as big as the room would allow. Taking our chances with the police, we had taken it out of Fontainebleau forest. A gigantic *Noel* spelled out with pine boughs and framed by clusters of French and American flags decorated the wall.

Our plans didn't remain a secret, and it's easy to guess how impatient the children were on Christmas morning. It was finally time. The children flocked around the blessed tree sparkling with candles. Parents huddled at the back of the room. A few mothers even brought their newborns, not wanting to deprive them of the beautiful memories promised each child.

Although Rosa Bonheur donned her most formal dress for the occasion, I was the one who made a little speech explaining that the celebration was

2. A.K. M. Salomon.

in memory of Nathalie Micas. Then I sat down at the piano and the children struck up the joyful tune of "O Christmas Tree."

They were still singing when there was a great jingling of bells. In came Father Christmas, which utterly amazed them. He said that leaving Siberia on his way around the world, he had seen lights and heard voices at By. Delighted to be honored in this little village, he was dropping in to give toys to the good children and whips to the bad.

He passed out his presents amid shouts of joy and peels of laughter. The children ended the celebration with a hymn Rosa Bonheur particularly liked:

Abide with me: fast falls the eventide;
The darkness deepens; Lord, with me abide:
When other helpers fail and comforts flee,
Help of the helpless, O abide with me.

On our way home after the party Rosa Bonheur smiled and said: "Next year we'll have to do something even better,[3] but I'm really sorry Father Christmas forgot me. I didn't get a single thing."

"Dear friend," I said, "before you make yourself miserable, let's go up to the 'sanctuary.'"

In secret I had put up a little tree. Rosa Bonheur hooted with surprise. Overjoyed, she helped me light the tiny candles. The branches were full of all kinds of presents for various creatures.

Charley got a chicken bone, chewed up on the spot. Daisy had the same. For Rosa Bonheur there was a pretty little Japanese doll holding an umbrella.

"This toy makes me so happy and so sad," she said with a deep sigh. "You'd never believe, my dear Anna, how it takes me back . . . My white dress, my red shoes, my little Punch doll . . . and mama . . ."

While the candles slowly burned down, she grew melancholy and gave way to a flood of memories.

"I've never let a day go by without thinking of my mother. Whenever something good happened to me, I always wistfully imagined her happiness. Oh! if only she could have been with me in my triumphs! She's inspired me my whole life long. My father, on the other hand, was a great dreamer; his first thought was to save humanity. True, fame and fortune have been awfully good to me. Yet how many times have I felt what

3. A.K. That little celebration took place in 1900 and has been repeated every year, but Rosa Bonheur is no longer here, alas! to rejoice with the village children.

Lamartine put so well in his inaugural speech at the French Academy.[4] Still that poet was luckier than I. He could lay his joys, triumphs, and crowns on his mother's tomb, while I don't even know where mine is buried.

"Yet I thank God for the happy, exceptional life he's granted me. This I owe to the soul of my mother, for whom I'll never stop grieving."

Then came the New Year, which we celebrated in a very peaceful but merry fashion. One of my happy mementos is a copy of Rosa Bonheur's New Year's greetings to her brother and nephew. I beg the reader's forgiveness for reproducing it here, but its high spirits show a characteristic side of my old friend, all at once cordial, frank, a bit rough, and devil-may-care:

By, January 2, 1899

My dear Dodore,
My dear nephew René,

The New Year is a nasty disease. It always takes you a year farther away from your mother's belly. And at our age, old brother, it gleefully removes another year from us. Yet my ship *(the house)*[5] has been being awfully nice since I got a first mate *(the author of this book),* and I'm less sad when I hear the northwest wind drowning flies in the chowder. *(There was a howling storm.)*

My dear nephew René, life's not bad on the upper deck, despite the water coming in. *(There was a leak in the studio.)* My hands all have sponges in hand since Saunier *(the architect)* was such a great shipbuilder!

Right now the lifeboat *(the new studio)* that Jacob is building me is also floating in distress. I still hope to take shelter there while sailing around the equator.

I hope, my old Dodore, first king of Ostrogoths, that your cold will get the hell out and you'll come wink at my Miss Klumpke, who never stops talking about you and the Philippines. *(Double allusion to an almond shared with M. Isidore Bonheur and to events of the Spanish-American War.)*

4. A.K. "No day in the course of a long life can give a man back what he loses on the fatal day when he reads in the eyes of friends what no mouth would dare say: 'You no longer have a mother!'

"All the delicious memories of the past, all the tender hopes for the future vanish at these words. Life is covered over by a shadow of death, a veil of mourning that not even fame can raise!"

5. Anna Klumpke added these parenthenses.

Meanwhile we send you all our best. Despite the disgrace I'm sure to suffer at Pittsburgh, you'll always find good fare on my ship; no need for an invitation. Good night, I still don't see very clearly during the day while I'm painting, but I'm up to my 108th letter by lamplight and turning out prose like M. Jourdain.[6]

I send you a kiss, silly old brother, as well as you, my dear colleague and nephew, without forgetting your old fogey father.

Your sister,

Rosa Bonheur

Your aunt,

Rosa Bonheur

Let me quote another very different kind of letter, one sent to Rosa Bonheur from London that same January that needed special help from the post office to reach its destination. Among all her many tokens of admiration, few touched her as much as this child's simple, spontaneous gesture.

The envelope bore only these words: "To Mme Rosa Bonheur, the Great artist, Paris (France)." The letter read:

London, January 23, [1899]

Dear Mme Rosa Bonheur,

I must write and thank you for painting such beautiful pictures. I've always admired the engravings. Yet I've seen only one of your paintings, at the Lefèvre gallery, King Street, Saint-James, *The Duel*. That Arabian horse is magnificent. You must be a very hard worker, and that painting surely cost you many exhausting hours and much worry.

I'm happy that you can be famous and popular while you're still alive. I hope that you are happy and that everyone tries to make you even happier.

An admirer of a great woman,

A poor little English boy

"Poor little English boy" was the only signature.

"The poor little scamp," exclaimed Rosa Bonheur, moved to tears, "why didn't he put down his name and address so I could send him a pretty drawing? No gift would have given me more pleasure."

Even with electricity, the short, sunless days of winter make it difficult to paint. One can't go out into the fields and forest because of the rain, mud, and fog. In these cold weeks of winter, so hard on old people, one gladly dreams about lands where the sun is less greedy with its rays.

6. Allusion to Molière's *Bourgeois Gentilhomme*.

Now that Rosa Bonheur was again happy to be alive, she often remembered that not-so-distant past when she and Nathalie Micas spent the worst part of the winter in Nice. She wanted to take me there and show me the places where she'd been so happy, the paths she'd walked, the wonderful views she'd contemplated. A long-standing and oft-repeated invitation from M. Gambart urged her on. To make it all the more tempting, that old friend went on and on about Empress Eugénie, who was living at Cape Martin, and Rosa Bonheur's pleasure in seeing her again. He even requested an invitation for Rosa Bonheur from the distinguished woman who brings her double burden of pain and sorrow every year to Nice, and one January day he gladly announced that his negotiations had been successful: she should come down and bring her decorations.

Of course, the famous artist was moved by this honor. It was settled that we'd leave two days later, despite the risk of taking inadequate wardrobes. Rosa Bonheur didn't like that thought.

The special attention she received from the Lyons Company,[7] on orders from M. Noblemaire, the head of the firm, restored her good cheer, since she was treated like a queen. The Paris express, whose first stop is usually Roche, paused to pick us up at Moret at eight-thirty in the evening.

We left in a horrible hailstorm. But next morning in Nice there was splendid sun, and everything looked festive.

M. Gambart's carriage was waiting to whisk us off to his magnificent villa.

On the morning of February 1, the day of her visit to the empress, Rosa Bonheur donned her black velvet dress and big feathered hat and opened a satchel. I expected her to take out a whole brochette of decorations, but the only thing she wanted was her Cross of the Legion of Honor, the one she'd received in 1865.

"Pin this jewel on me," she said, "I just want the one the Empress fastened on my breast."

All prepared, Rosa Bonheur got into her carriage and drove to Cape Martin. I was imagining the violent contrast between that scene in 1865 and the one about to take place. Now Eugénie, all in black, was pale and thin, a living personification of pain and misfortune. Thirty-four years earlier the glorious sovereign, her youth and beauty in full bloom, surrounded by brilliant court society, came to By bringing Rosa Bonheur, in the prime of life, the reward for her talent.

7. A railroad firm.

How much had happened since then! How many ruins, tears, wars, deaths, heartbreaks, and dashed hopes!

That evening Rosa Bonheur told me about her visit to Cape Martin. "What a warm welcome! The Empress seemed even more imposing than on that long-past day when she brought me my cross. She still looks queenly, but haloed with pain.

"Her Majesty asked me about my work and life at By. I told her we're building a studio to finish up *Treading Wheat* and that you, with your youthful brush, are going to spare me the dirty work of that huge sky.

"After lunch she took my arm and we strolled over the grounds for half an hour or more, remembering old times, her visit to the studio, my triumphs and lunch at Fontainebleau. We also talked about Prince Loulou and shed some tears.[8]

"I think the Empress must know my own pain since she said: 'Only a girl who never stops grieving for her mother can understand as you do how a mother's heart is torn apart.'

"Then she tearfully told me how she has suffered, and I could see all the horrible anguish a great soul can feel on the throne.

"The Empress bent down to pick me a flower and sighed: 'This is all I can give now, dear great artist.'

"And I replied: 'Madame, this gift, sanctified by pain, is as precious as the first.'

"As I was leaving, Her Majesty affectionately took my right hand. I was very moved and kissed her fingers. Then, my dear Anna, she surprised me and said that the day after tomorrow she'd send the duchess of Ossena round for a visit."

Rosa Bonheur gave me Eugénie's Mediterranean winter flower and told me to treasure it.

Four days later, on February 5, the duchess of Ossena came to M. Gambart's villa for a great luncheon in her honor. There was a magnificent bouquet of Parma violets at each place on the flower-covered table.

While we were talking about Spain and its capital, the duchess invited us to go see her there. Like a child, Rosa Bonheur jumped at the chance. Having always wanted to see Madrid's wonderful museums, she would also have enjoyed seeing, close by the Murillos, Velazquez, and Goyas, her *Young Prince,* the lion's head that had earned her the Order of Isabella the Catholic in 1880.

8. The only son of Napoleon III and Eugénie had been killed while serving in the British army.

Remembering Nathalie
❖
Rosa Bonheur's Will
❖
The Domain of Perfect Affection

One day during the summer of 1898, around the time of Queen Isabella's visit, Rosa Bonheur took me into the hallway leading to her bedroom. She stopped in front of one of the big birdcages there, which put her boarders all in a twitter, and showed me a secret door. Turning the key, she pushed the door open and said in a solemn voice: "Come in, my dear Anna. This is Nathalie's bedroom. Except for Céline from time to time, no one but me has crossed this threshold since she died."

I felt a bit flustered entering that room whose existence had been unknown to me. With its yellow wallpaper and elegant furniture, it was much more luxurious than Rosa Bonheur's bedroom. "When I bought this house, I kept a few pieces of the old furniture on Nathalie's advice. They were in terrible shape, but my friend had them fixed up to her liking. She was more coquette than I am. She loved yellow, as you can see, and used to say it was the color of mirth, not envy. She was right. Is there any better way to get the feeling of warm, shimmering light?

"On that sewing table you can see her monogram embroidered inside some arabesques. That's one thing she did much better for me than for herself. Her curtains don't have embroidered trim, but mine all do, and artistic at that. She didn't need a pattern even for the most complicated embroidery. Her needle was as inspired as my paintbrush.

"My poor friend adored the Riviera and its luminosity. Yet, when she realized that, despite Nice's beautiful sun, her end was near, she begged me to take her back to our dear happy home at By. She wanted to breathe her last where her mother had done the same.

"I made haste to grant my dear patient's wishes. It was high time. Just a few weeks later, on June 21, 1889, it was all over.

"Perhaps at the last moment she received some celestial consolation. Her face, grown so thin with her long suffering, suddenly went ecstatic, and I clearly heard her murmur: 'How beautiful these roses are!' Nathalie left me nine years ago, but it feels like only yesterday!

"When I'm about to render my soul to God, bring me to this bed. Nathalie died here, and I will, too!"

After a moment of musing, she pulled open the mirrored wardrobe. On one of the shelves was a little rosewood box. She opened it up and showed me a magnificent braid inside. Its silky sheen and beautiful Van Dyck brown were as vivid as when it had fallen beneath the scissors.

"This beautiful hair is Nathalie's," she said in a strangled voice. "I cut this off as they were putting her in the coffin. Oh! those terrible hours. I can't tell you how awful it was. Some sympathetic souls did their best to console me in my grief. I'm especially grateful to Duchess Alexandrine of Cobourg. She understood that two women can feel strong, passionate, and pure love for each other.

"Here's the letter she wrote me a few days after Nathalie's death:

Schlotz Kallenberg, near Cobourg, June 25, 1889

My very dear and unhappy friend,

I cried out in distress when I read the first words of your sad letter that came so unexpectedly! This terrible affliction seemed impossible, and I cannot tell you how devastated and overwhelmed I feel! You know with what respectful tenderness I loved her and how grateful I felt in my heart for all the warm interest she always showed me, which made me so happy. When we said good-bye, I carried away all these precious memories and the best hope to see the two of you again! And now, it's all finished for this world. You are alone, bereft, without this loyal heart that no one can ever replace!

Your beloved friend was your most precious treasure, your soul's soul. You were always joined in my memories and my affections, full of admiration and gratitude for you both!

I understand and I share the vastness of your deep, cruel pain. After shattering all your joy, all the charm of your life, it will be with you for evermore. My thoughts are always with you and follow you through all the stages of your terrible anguish, from the time you knew that you would lose her up until the moment when her beloved remains were forever removed from your sight.

How you must have suffered during those desolate days. And now, your bitter tears and cries of pain in this dreary silence.

That beloved voice, that loving gaze, mute and dark. . . .

O my God! how will you ever bear this terrible, irreparable loss, this overwhelming loneliness, this total wrenching apart of a shared life, which I considered the ideal of earthly happiness!

I know how strong your great heart is. Wondering how to fulfill your friend's wishes, you'll learn in time to carry on a life so richly, so nobly endowed by the genius she loved and admired. That dear, noble soul is not lost to us in Eternity, and her beloved remembrance lives on in my heart inseparably joined to yours. God bless you, my dear beloved friend, who, in the midst of your greatest affliction, have still given a thought to

Your very sad and so devoted friend,

Alexandrine

After that poignant letter, Rosa Bonheur continued: "Ah! despite such loving consolation, you simply can't understand what a burden my lonely life was! Sit down next to me, Anna. How good to be together with you, no longer alone in this big house, far away from the world! I've often shut myself up in Nathalie's room to contemplate the tragic things that have happened to me. What would my life have been without her love and devotion! Yet people tried to give our love a bad name. They were flabbergasted that we pooled our money and left all our earthly goods to each other.

"Had I been a man, I would have married her, and nobody could have dreamed up all those silly stories. I would have had a family, with my children as heirs, and nobody would have had any right to complain.

"My father is buried in Montparnasse cemetery with my sister Juliette and my old aunt, who died at the age of ninety with an allowance from me right up to the very end. I've got every right to be buried in the Bonheur family vault. I paid half what it cost to buy the plot and have it built, and everything for the stone cross on top. But my stepmother, who died just a few years ago, is in there beside my father. I couldn't stand being buried next to her, since she gave me so much misery.

"Whenever I go put flowers on my father's grave, I just want to cry, remembering how wretched we must have been to let my mother be buried in a potter's field! Sometimes I even wonder if my father gave much thought to her after she died in 1833. For five years she lay buried in the same place. During that time he could have bought her a permanent plot for only five hundred francs. In a cinch, he could even have put off the final catastrophe by renting, for a much smaller sum, a temporary plot. He didn't do a thing.

"By the time I was rich and famous, it was unfortunately too late to raise a momument over my mother's remains, to mark the place where I could have gone to grieve for the rest of my days and, when my turn came, to sleep for all eternity at her side. What remained of Sophie-Dorothée-

Marchisio was just part of the jumble of bones tossed pell-mell into the trench! At least I can console myself with the thought that I'll be reunited with her beloved soul in a better world.

"I arranged with Nathalie to be buried at Père-Lachaise cemetery, in the Micas family vault. After me, there'll be room for one more in the tomb. Will you take that place, my dear Anna? Then you'll be close to me even in the grave. Nathalie won't be jealous, I know. Her love for me is big enough to understand that when souls share everything, each one's happiness only increases the other's."

Rosa Bonheur was deeply moved. She took my hand, squeezed it, and went on in a quavering voice: "Sure, you'll be far away from home, in a foreign country, but at least your bones will lie next to old Rosa Bonheur's. So in death I'll be surrounded by the women I loved through-out my life, who gave me so much happiness.

"Nathalie was my childhood companion. She witnessed my trials and tribulations, she shared my joys and sorrows. And you, my dear Anna, you've taken such hold of my heart that I'd declare you my very own daughter before an assembly of the Muses.

"Let's forget about the past and think about the present. Life is sad enough without all these gloomy thoughts. God will give us a few more years together, Anna. Then I want you to keep on working here in my place. Nathalie would have been my sole legatee if I hadn't been hers. I want the same thing for you.

"I'm asking you to keep this estate where I've known so much fame and success and, as you know, been surrounded by such love. If I left it to my nephews, everything dear to me would soon be gone. Here, within these walls, I've given so many years to work and love. Wherever I cast my eye, there are traces of that happiness.

"I call the studio my 'sanctuary' because everything there reminds me of something dear to my heart. The horns and antlers up on the walls adorned the sheep, stags, and oxen who used to pose for me. These animals lived with me as my friends, and I drew them over and over. The heads of the horses are still wearing the bridles and harnasses Nathalie and I bought during our travels through the Pyrenees.

"Empress Eugénie put her hand down on my worktable the day she pinned the red ribbon to my breast.

"President Carnot sat in my lounge chair during his visit. More and more I like to stretch out there and silently relive that day.

"If Providence hadn't brought us together, I would have kept on living alone and given everything away, bit by bit. Before you came, I'd already

begun. The vegetable garden next door belonged to Nathalie. Without waiting until after I had died, I gave it to Mme Gauthier. So you can see I wouldn't hesitate to get rid of everything while I'm still here.

"Tell your family that if mine ever managed to separate us, I'd arrange things so that your leaving wouldn't do them a single bit of good.

"My point is to make you understand that, aside from my conscience, I consider myself absolutely free to dispose of my estate. I'm giving you what we used to call the Domain of Perfect Affection not only out of love for you, but in memory of Nathalie.

"This is my good mother Micas's watch and her husband's chain. Nathalie used to love wearing this little ring. Take them in remembrance of my friends.

"I'm also giving you Nathalie's bedroom with all her mementos. Be happy there, but when the moment of supreme separation comes, get me to her bed. Stay with me, let me rest my head on your shoulder until I go to my eternal rest."

A few weeks later Rosa Bonheur took me to Paris to see her dear Nathalie's grave at Père-Lachaise. After putting a wreath of white roses on the tomb, she meditated a moment and said: "You'll have inscribed on this stone my name: *Rosa Bonheur,* and yours underneath, *Anna Klumpke.* As soon as I've come to sleep in death beside Nathalie, you'll add this thought at the end of the epitaph: *Love Is a Divine Affection.*"

"Don't you want Nathalie's name engraved next to yours?" I asked.

She pointed to the monument's frieze: "The inscription *Micas Family* marks Nathalie's place well enough. There's no need to have our two names, since we'll both be guests here."

I told my mother, of course, about Rosa Bonheur's plans concerning her estate and the wishes of which she meant to make me the supreme executrix. While I felt overwhelmed by such love and trust as well as exceedingly grateful, my mother was alarmed by the great task that would be mine some day. She begged me to make my friend see the disadvantages and difficulties that I would surely be up against. My mother's fears echoed my own preoccupations only too well. I simply had to say something to Rosa Bonheur, but she turned a deaf ear to all my exhortations.

"Your mother may be right in general," she replied, "but people are wrong about my family situation. I'm not all that rich. Maybe I've got three hundred thousand francs in the bank, but a third of that comes from Nathalie. I've received only one inheritance. Nothing from my poor mother, who didn't even get a proper grave. Nothing from my father, either, except the debts I had to pay. Aside from Nathalie's legacy of one

hundred thousand francs, I've earned all the rest. A few studies that I've got here are my whole life. The Tedescos have always hoped that I'd hand them over, but I'd rather eat nothing but dry crusts of bread for the rest of my life. If your family or mine ever separated us and cut short our happiness together, I'd destroy everything here, I swear it. They wouldn't get a single thing. Providence sent you to me, my dear Anna."

Under the sway of that constant preoccupation, Rosa Bonheur carried out her chosen plan as fast as she could. She signed her will on November 7, but remained unsettled. She even lost interest in her work for a while.

In the evening of November 28 she asked to see me. In a solemn tone that indicated how important this conversation was to her, she said: "Give this letter to M. Tollu, my notary, the day I die. He'll read it to our assembled families. It explains why I've made you my sole legatee and how I met and came to love you. I also talk about my friends the Micases. I spell out everything I did for my family and prove that my conscience is clear regarding them. These papers will also tell you, more or less, what to do about my brother Isidore. I trust you."

The too few months that followed changed nothing in Rosa Bonheur's arrangements concerning me. Up to the last day her love remained strong and her trust absolute. Whatever confusion or embarrassment I may suffer telling the reader about the feelings that I welcomed with my tenderest love, my most respectful admiration and absolute devotion, I won't finish this chapter without providing in support of the preceding remarks a letter that Rosa Bonheur wrote to my mother in March.

By, March 31, 1899

Dear and a thousand times good madame,
Your Anna is an angel of goodness. The better I know her, the more I respect and love her.

At my age, with my experience of life and the human race, I have the right to try and protect her, for she'd be easy prey for sly customers.

We are happy, and I hope that evil people won't succeed in disturbing our honorable, laborious life.

I hope that you'll soon be with us. Your Anna adores you and I share her sentiments for the best of mothers. Don't worry about a thing, and know, dear Mme Klumpke, that, despite the fact that I'm older than you, I have for you and your family the most well-placed love and the most profound esteem and respect.

Rosa Bonheur

CHAPTER 24

Visiting the Salon of 1899 and the Luxembourg Museum

The Salon returned in the spring of 1899. The portrait of Rosa Bonheur with Charley in her arms was finally done, and I meant to show it there. Eager to promote a work that she, out of love for me, thought very good, my elderly friend decided to show her *Oxen and Bull of Auvergne,* just back from the Pittsburgh Exhibition.

"It's just a visiting card," she said, "a mark of courtesy for your painting so that we'll be together in the catalog, and not for the last time, I hope. Nineteen hundred will be something else again. I daresay my painting for that Salon[1] will make the last half of my career as brilliant as my *Horse Fair* made the first."

After sending off our two paintings, we were extremely pleased to see how the Parisian press welcomed Rosa Bonheur back to the Salon of French Artists after an absence of forty-four years, broken only by a brief appearance at the Universal Exhibition of 1867.

Among the many critiques, I'll quote M. Roger-Milès's article in *L'Eclair:*

> Rosa Bonheur, whose artistic career began over fifty years ago, deserves that we pause with infinite respect in front of her painting. She has been living among her guests in her forest retreat, totally devoted to her work and art. Indifferent to current trends, she has been fulfilling her artistic mission with an ardor untempered by age. She has a beautiful face and soul, and her piece is worthy of her. Her animals' eyes have just the right expression. Rosa Bonheur seems to have stolen their secret in her silent conversations with them, rather her half century of painstaking, curious, and tireless study. Furthermore, her brush is still steady, and she continues to paint with the virility that astonished even Thoré how many years ago!

The other artists at the Salon were so impressed by the elderly artist that some of them immediately put her up for the medal of honor. This gave rise to feelings of quite another sort. A few anonymous lines in the *Journal*

1. The painting in question is *Treading Wheat,* which remained unfinished at Rosa Bonheur's death.

of May 13 had the undeserved honor of frequent repetition (fig. 16). After noting that Rosa Bonheur had not appeared in any Salon for forty years,[2] the article continued:

If we were to honor Mme Rosa Bonheur only as an emeritus painter, it could be objected that an award so glorious and definitive should not be given to age alone. In that case, the medal of honor would become the Old Soldiers' Home[3] of the art world. But without debating the more or less debatable merit of the artist, whose paintings have been the object of foreign speculation—which has nothing to do with art—it is only right to point out a sinister tendency here, which, in the event of triumph, would become a despicable precedent.

Indeed, those who are promoting Mme Rosa Bonheur for the medal of honor are obviously the self-interested allies of two or three art dealers. They own several of her paintings and naturally want to raise the price of their stock on the American art exchange.

This is what people are saying.

Rosa Bonheur jumped at the goad. "Given such attacks," she promptly declared, "I cannot be a candidate."

I tried to calm her down and dissuade her from some ill-advised resolution. It was no use. Despite everything I said, she wrote *ab irato*[4] the following letter to M. Jean-Paul Laurens, president of the Society of French Artists:

M. le Président,

I have just read in a recent issue of the *Journal* that a few gentlemen of the Society of French Artists intend to propose my name for the medal of honor.

Please let these gentlemen know, M. le Président, that I absolutely refuse to let my name stand for the award this year.

It would be ridiculous for my little painting this year to receive such a high honor.

Most respectfully yours,

Rosa Bonheur

2. Actually thirty-two, not forty years, considering her participation in the Salon of 1867.

3. Les Invalides, which makes for a dreadful pun in French.

4. Term used in the original French text.

Despite this nasty incident, she asked me to go to Paris with her a few days later. She wanted to visit the Salon, to see where our paintings were hanging and study the works around them.

For the occasion she had had made a navy blue outfit in her usual Breton style. The jacket, trimmed with black silk braid, fell over a full pleated skirt. Instead of her famous little bonnet, she wore a big black straw hat with feathers. No jewelry, but the Rosette of the Legion of Honor on her breast.

We went through the whole Salon. Despite her seventy-seven years, Rosa Bonheur showed me the way and walked amazingly fast. She wanted to see everything and did her best to do so.

Every now and then when I had to stop and sit down, she would go up and down the whole gallery.

She particularly liked an Aubert depicting two delicious cupids engrossed in a game of checkers. Right away she wanted to buy it and dragged me off to the museum office. A very kind, tall gentleman opened a huge ledger in front of Rosa Bonheur, looked for Aubert's name, and half-heartedly replied: "Madame, the price is not listed." Then he closed the ledger and let us go, apparently unconcerned with the lady's elevated rank in the Legion of Honor or her desires.

"You see how they look after painters' interests," Rosa Bonheur said at the door. "Why isn't there a good sales office here?[5] Not every artist has the luck I did to find two zealous apostles of my talent just as I was getting started. In this case, a painter wants to buy a colleague's work, and she knows how to go about it. As a matter of fact, I'm going to ask the Tedescos to put me in touch with M. Aubert. But if I were just an art lover, even a rich one, the harm would be beyond repair. Now, let's go find your old friend's portrait."

Continuing our visit, we soon found ourselves in a huge gallery. My portrait of Rosa Bonheur was hanging near a door.

"This portrait, at least, has got distinction," said my old friend, drawing closer. "And my little Charley isn't bad at all! You'll be a fine student, my dear Anna."

Casting an eye into the next room, I saw Rosa Bonheur's painting and pointed it out to her. A second later we were in front of *Oxen and Bull of Auvergne,* and my companion exclaimed with obvious pleasure: "It looks much better than I ever thought it would!"

5. A.K. Two years after Rosa Bonheur's death, her wish was granted. There now exists at the Salon the agency that she had wanted to see set up.

"There, you see! Oh! I'm so sorry you sent that letter to the president of the Society of French Artists," I said.

"As for me, I'm not the least bit sorry," she curtly replied.

"Yet you know as well as I that the medal of honor is most often awarded for an artist's whole career, and not just one painting at some Salon."

"I know, I know, that's the way it's usually done, but I don't like it. That prize should go only to the best piece. Besides, my painting is too small for such a great prize."

"When *Treading Wheat* is done," I hastened to say, "I certainly hope that an eighteen-by-ten-foot canvas will seem big enough for you so that next year you won't turn down the medal of honor."

"Ah!" she said, with a gleam in her eye, "that's quite another thing."

"Well! my dear professor," I replied, "even with a huge canvas painted by you alone, it's still your whole career that will be honored next year."

"At bottom," Rosa Bonheur went on without seeming to have heard me, "I think young artists bear me more of a grudge for being a woman than for being old. They can't forgive me for having proved that the sex of the artist doesn't matter. I'm afraid this tension will never be resolved. Yet today women can compete for the Rome prize.[6] That's great, since I'm not afraid of a fight. Otherwise, we'd have to resign ourselves to women-only shows. I can't bring myself to that. I can't even see that kind of show without thinking about Muhammad's notion of paradise, where our Muslim sisters have to have their own Garden of Eden.

"Yet I agreed to be the honorary president of the Society of Women Painters and Sculptors,[7] but only out of affection for Mme Demont-

6. Once the most prestigious art prize in France, the Rome prize was awarded by the Ecole des Beaux-Arts and granted the winner years of paid study at the French Academy in Rome.

Bonheur's reported remarks seem to contain some mistake. This conversation is situated in the spring of 1899. In the spring of 1897, women finally won the right to enter the Ecole des Beaux-Arts. The male students, however, protested this parliamentary decision so violently that the art school was ordered closed. When it reopened a month later, women were still allowed to study at the school, but their right to enter competition for the Rome prize had been rescinded. Women were not considered eligible for the competition until 1903. For more details, see the article by J. Diane Radycki, "The Life of Lady Art Students: Changing Art Education at the Turn of the Century," *Art Journal* 21 (spring 1982): 9–13.

7. Founded in 1881, this union stated these goals in its first newsletter:
"First, to mount annual exhibitions of members' work; second, to represent and

Breton,[8] a very talented painter, and in memory of Mme Léon Bertaux, the sculptor and first president of the Society.[9]

"My stand is altogether different. I think that as soon as women can aspire to the highest honors, there's no reason for them to form groups that shut out men. They'd do better to seize every opportunity to show that we women can be as good as men and sometimes even better."

The day after our visit to the Salon I asked my famous friend if she wouldn't like to go to the Luxembourg Museum, where her first masterpiece is hanging, before going back to By. She didn't need any coaxing. I can still see her climbing up the steps to the little palace of contemporary art and hear her whispering in my ear, as if she were afraid that someone might overhear her confession: "I know the Louvre by heart, but would you believe it, Anna? I've never set foot in the Luxembourg."

I couldn't hide my surprise and said: "Well! that means I can be your guide through this temple of the arts where you've always been present anyway."

Just then we entered the sculpture gallery. My visitor seemed struck by its grandeur. When the three guards saw the woman so merrily sporting the Rosette of the Legion of Honor on her black lapel, they gave her a solemn military salute and murmured with respectful admiration: "That's Rosa Bonheur!"

Amid all this marble the noble artist seemed to grow in stature. She spent a long time studying the *Tanagra*, whose stiff but quite human forms blush with life.

"It's beautifully grand," she said. "Do you know that Gérôme and I are contemporaries, and that we had our first great success the same year? That was a long time ago, back in 1848. I've often regretted not doing

defend the interests of its members; third, to establish a sense of solidarity among women artists; fourth, to contribute to raising the artistic level of women's work; fifth, to nurture to the best possible advantage the innate and acquired talents of women artists." Quoted Radycki, "Lady Art Students" (p. 9).

8. Virginie Demont-Breton, the daughter of the painter Jules Breton, herself a painter and medal winner at the Salons, and the second president of the Society of Women Painters and Sculptors. In her autobiography, she promised to devote herself to securing the entry of women into the Ecole des Beaux-Arts and their participation in the Rome prize competitions.

9. Mme Léon Bertaux, born Héléna Herbert, founded the Society of Women Painters and Sculptors in 1881. Ten years later, the Union had over four hundred members and was holding annual exhibits. See Radycki's "Lady Art Students" for more details.

both painting and sculpture like him, but it's never too late to do a good job.

"Here's something by Denys Puech, *André Chénier's Muse*! What exquisite feeling!"

Rosa Bonheur leisurely inspected the sculptures of Rodin, Falguière, and Frémiet.

"Look at those two funny little bears, Anna. Like fine gourmets, they're licking the honey off the end of Pan's reed. What wonderful technique!"

From the sculpture gallery we could see Cormon's immense canvas *The Flight of Cain,* taking up most of the back wall of the first gallery of paintings. Rosa Bonheur paused in front on it.

"What energy and movement!" she said. "The anxiety on the faces of these people looking for a new country is truly gripping."

In front of Ribot's *Saint Sebastian,* she exclaimed: "Superb! Splendid! Here you can see the influence of the fine Spanish school."

Rosa Bonheur was getting more and more excited. Yet in front of *The Poor Fisherman* of Puvis de Chavannes, she couldn't help saying: "Ah, one of his . . . what a pity! . . . since I really admire him. His *Saint Geneviève* is a masterpiece. Let's go see it at the Pantheon. It ought to be right next to the triptych called *Saint Geneviève in Her Youth.* You've got to see Puvis de Chavannes in that immense basilica to appreciate the marvelous talent of that artist whom we've just lost."

She was quiet for a moment, then said: "Fortunately, our works are less fragile than our bodies! For this we must thank the Infinite Being who gives us some great ideas and lets us draw a little furrow in the sands of time during our sojourn here below. Will mine remain? Ah! I hope so!"

While talking, Rosa Bonheur had walked by several paintings. She stopped near Bastien-Lepage's *Reapers* and said: "What a charming landscape with its delicate color, but when you're doing peasants, you've got to try and get not only the bark, the outward appearance of the man working in the fields, but most of all his soul. Are there any landscape painters in this room?"

"At the other end there's a great Harpignies."

"You're right to call him great," said Rosa Bonheur, closely studying the canvas. "I really like these superb old oaks! It's almost a Ruysdael. See, he's got every detail, but without detracting from the whole. This is a fine example of what I'm always telling you."

In the next room I directed Rosa Bonheur to the right and asked her to let me fulfill my role as guide.

"Sure, I'll just follow," she said, without suspecting that I intended to

surprise her with her own painting. She stopped at Jules Breton's *Blessing the Wheat*. "I've always liked this one for the details. It's got a generous, solid touch, and the sky is superb. He did a good job expressing the summer heat. I remember the success this painting once had. That was the same year I showed my *Ploughing in the Nivernais*. But I think the canvas has gone a bit dark."

She was already looking at Albert Dawant's painting and had no idea that when she turned around, she'd be face to face with her own painting.

"Now I'm going to show you," I told her, "two Bonnats. They're the dignified neighbors of that great canvas by Rosa Bonheur."

"What a child you are, my dear Anna," she said with a smile. "Just drop your 'great Rosa Bonheur' routine. You know how they've just skinned her alive and sent her off to the Old Artists' Home!"

"Maybe the ones who did that don't have to worry about winding up there themselves," I replied. "They'll probably be quite forgotten before they ever reach your age."

Rosa Bonheur made no reply. For a long time the elderly artist stood stock-still in front of the first famous painting of her youth. While she studied it in silence, I tried to figure out what was going on in her mind.

All of a sudden her eyelids began to flutter, and in a voice full of emotion she murmured: "1849! . . . What memories this painting awakes in my heart: my father's death, and the Micases' devoted affection. I haven't seen it for fifty years. Happily, nothing's changed. It's just the same."

"But what a glorious way you've come since then! It was truly wonderful to do that at the age of twenty-seven!"

"Though I was green in years, my dear Anna, I was no budding artist. I told you I began drawing almost in the cradle. When most children are happy with a rattle, I was already plying a pencil. Ah! if only my mother had been able to witness some of my triumphs!"

Then, in a playful voice, as if to change her train of thought, she asked: "And what does my Anna think about *Ploughing in the Nivernais*? It took her more time to copy it than for me to paint it, so she must know it almost as well as I do."

That unexpected question flustered me, since I had come to look, not give opinions.

"Well, speak your mind. I await your critique, as one friendly colleague to another."

After a moment's hesitation, I said that on the whole the painting hadn't changed in tone except for maybe the sky.

Rosa Bonheur couldn't hide her surprise. "You're right, the sky is the

worst thing about it, as Mazure said back in 1858. That sky has always been lifeless. For sure, had the sky changed, it would only have improved things. But my paintings don't budge. You know how careful I am with my tools. What else?"

"Huge, wonderful oxen serious and serene in their toils; a broad, firm hand; in the right background, one of those mysterious landscapes you're so fond of. Admirably nuanced color and wonderful details in the foreground . . ."

"Temper your enthusiasm, my dear Anna," Rosa Bonheur interrupted. "Yet I'm glad to see you know what you're talking about. Let's go look at the Bonnats now. Look, you could learn a lot from this portrait by Léon Cogniet. See how he's done the hands?"

"Didn't you used to work in his studio?" I asked.

"Never! Yet many critics, even a Salon catalog,[10] have said I studied under the great painter. As I've told you, my father and nature, in her beauty and grandeur, were my only teachers."

Turning to Bonnat's *Job*, she added: "Bonnat really outdid himself in this one. What fine anatomy on that wretch who looks practically vivisected by poverty and hunger! Bonnat's showing us everything he knows."

Looking up at Maignan's canvas, she said: "What a great idea to parade all his masterpieces in front of poor old Carpeaux as he lies on his deathbed. He did a superb job on that dazzling light. You're right, I've got good neighbors, but let's move on; people are eavesdropping."

As a matter of fact, we were getting curious looks from copyists and visitors alike, and I heard someone whisper her name.

So we left. When my old friend stopped to examine an information rack in the next room, I asked if someday she wouldn't like something like that to help admiring young artists really understand *Ploughing in the Nivernais* by showing them her studies.

"You're really ambitious for me, my dear Anna."

"I sure am, since you've only got two paintings in France, *Ploughing in the Nivernais* and *Haymaking*."

"That's right! *The Horse Fair, Scottish Oxen*, my sheep, stags, lions, and boars, they've all left the country. Back home I must pick out some studies to give to the government, with the stipulation that they be made available to students."

10. A.K. Salon of 1853.

Backing up, she caught sight of Tony Robert-Fleury's *The Last Days of Corinth*.

"See how anguished those poor Greeks are, throwing themselves at their goddess's feet. It's sad that she can't shield them from their brutal conqueror. A great idea, and a lifelike effect. Your dear teacher won his medal of honor for this one, didn't he? Was he even thirty then? One piece like that is enough to make an artist famous. Amazing that with his talent he still hasn't got into the French Academy. It's no doubt because he professes the right ideas about women artists."

We were moving toward the exit when Rosa Bonheur cast a last glance over the sculpture gallery and said: "How restful all this is compared to the Salon yesterday! What a great collection! I'm glad that so many people I grew up with have received the fame they deserve. Great men don't belong to their family, not even to their country, but to all humanity, and occasionally the century they live in becomes theirs."

Rosa Bonheur seemed twenty years younger for the time she had spent among all this art. I couldn't help saying so.

"You're right," she said. "I've never felt so well. However, before we go back to By, I want to see M. Tollu, my notary, and add a codicil to my will."

"Oh! can't you put that off for another time? It's already late."

"No matter," she said firmly. "True, I feel fine, but if I had an accident, you wouldn't know how to carry out my wishes since you don't yet know just what they are. I mustn't forget that even if young people can be struck down, old folks have to expect death from one day to the next. At my age you're never sure of tomorrow."

Alarmed by this gloomy turn, I exclaimed: "Get those black thoughts out of your head. Think instead about our visit to the Luxembourg, about *Ploughing in the Nivernais,* which you've found so well preserved. It'll stay just as luminous as its genial conception."

"No doubt, no doubt," Rosa Bonheur replied. "I was really glad to see that my brush, already half a century ago, knew how to paint for posterity. Anyway, let's go see my notary."

Last Instructions

The next day, after our morning drive in the forest, Rosa Bonheur asked me up to her little studio for a serious talk. She meant to put the final touches on her conversation with M. Tollu, to which I had just been privy.

She sat down and launched right in: "Just as you heard me tell my executor, I'm going to send him the deed to the chateau of By so that he can put it in your name."

"I've got to admit I don't really understand why that's necessary."

"Yet it's very simple," Rosa Bonheur said. "The inheritance tax that you, as an alien, would have to pay after my death would amount to about 12 percent of the real-estate value. On the other hand, it'll be a minimal sum if I make you a donation *inter vivos*. My mind won't be at rest until you're the legal owner of the Domain of Perfect Affection."

"Why are you worrying about this?" I replied. "Don't you have more pressing concerns? The new studio is all done, except for the shutters that go up tomorrow. In a few days you'll start work on *Treading Wheat*."

"Anna," she said a bit impatiently, "sit down beside me. What I'm going to say is more important, and we need to reach an understanding. I want to explain, once and for all, the solemn duty you're taking on. Indeed, I'm counting on you, your devotion and intelligence, to carry out the wishes that aren't specified in my will. Listen hard.

"I'm sorry not to have a bigger fortune, since I'd like to leave a lot of money to the Society of French Artists. At least, I can give some things to the Luxembourg Museum as you suggested yesterday. In a few days we'll get together and pick out the studies you'll give them after my death.

"I told my cousin, Madame Lagrolet, that she could have the little finished study of *Treading Wheat*. See that she gets it. Give Germaine, her little girl, ten thousand francs and five thousand to the Verdiers' daughter.

"Céline is getting a life annuity of eight hundred francs, but you'll add four hundred more to it. I want her to feel grateful to both of us.

"I want you to give lots of mementos to my friends. Do good works in my name around here, where I was so happy with my Nathalie. As for my brother, nephews, and nieces, I'm leaving you free. I don't want to create any obligations for you."

"What a huge responsibility!" I exclaimed. "Why not guide me in such an important task?"

"Your guide, Anna, will be my family's attitude. I trust you, I know you'll do more for them than I would have, but promise me that in no case you'll ever let my family live here and that they'll never get a single thing that belonged to my dear friends the Micases."

"What a hard role you're giving me!"

"That's true, my Anna, but it's the best one. Maybe I've dragged you into a real mess. As a matter of fact, I've noticed that my friends, no different from my family, aren't too happy about seeing us together. But do I have to forgo all comfort in my last years just because of them? Don't you worry about a thing. The day I die, you'll hand M. Tollu the sealed letter I gave you last November, and it'll explain the logic behind my will.

"I've got to tackle my funeral arrangements, which we'll go through together point by point.

"At the notary's office yesterday, you seemed surprised by the codicil asking you to decide what kind of funeral I'll have. Personally I'm for civil ceremonies, but I want to be buried with the Micas family, and that can't be done decently except through the Church, as Nathalie and everybody else lying in that tomb have done. I can't explain why I seem to have changed my mind. As my mediator, you'll try and reconcile my deep convictions with these scruples. However late in coming, they are no less serious and worthy of respect.

"Despite these concessions regarding my corpse, my philosophical convictions remain unshakeable. Give me your vow, on Nathalie's memory, that no priest will come near my deathbed."

"You have my vow, but I pray God grant you many more long, healthy years."

"So do I, but it's only natural for me to die before you. Respect my wishes. I want my funeral procession to be just like Nathalie's. Also, as for her, a service at the church in Thomery. From there my body will go to Père-Lachaise. There'll be a second service there in the cemetery chapel, like the one I arranged for Nathalie, but I simply won't have any honors that my friends the Micases didn't have. That means no soldiers, no graveside eulogy, either.

"Flowers? Yes, Nathalie had some. My family will head up the procession, then my friends."

"What about me? where do I go?" I asked.

"First come those with legal priority. I'm sorry, my dear Anna, kin takes

precedence over true love. But who cares where you'll march in my cortege, since you'll lie beside me in the tomb!"

She kissed me and continued: "Rest assured that my feelings for you won't end with my earthly life. The heart is old, but the soul immortal."

I found all this talk horribly painful. Yet, since Rosa Bonheur insisted on settling these matters once and for all, I was determined to question her on various points that it would have been distressing to bring up later on. In a quavering voice I asked whether she wanted to buried in men's or women's clothes.

"Neither one," she shot back. "I'll be laid to rest wearing my nightgown and black stockings."

"And what about your decorations? Don't you want to take one with you?"

With an ironical smile she replied: "There is a certain pleasure in wearing medals while you're alive, but not when you're dead. Yet, my Anna, when I've rendered my soul to God, place next to my heart the crown of laurel you wove for me. And on my tomb you'll inscribe, I repeat, *Love Is a Divine Affection.*"

Just then Rosa Bonheur's white hair was illuminated by a sunbeam.

"Let me give you my blessing," she said. I got down on my knees, eyes brimming with tears. The noble woman placed her hands on my head, saying: "I pray God that my Anna will be happy here below and that later on we'll be reunited for all eternity in a better world."

She raised me up, held me in a long embrace and murmured: "When I'm about to be reunited with my mother and Nathalie, don't forget I want to go to my eternal rest cradled in your arms!"

These gloomy words woefully impressed me. It seemed that without there being any omnious forebodings, Rosa Bonheur, healthy, lively, and alert as ever, had received some secret warning that her end was near. Alas! no premonition was ever more true, for scarcely five days later my noble friend's soul went to join her mother and dear Nathalie! What a hard task to talk about those grievous days.

On Saturday, May 20, the day after our talk and the eve of Pentecost, two of my sisters came down for the holiday. My mother had already been at By for several weeks. For some time Rosa Bonheur had been pleading with her to come live with us at the chateau, to take the place that good mother Micas had once filled so well. It was her heartfelt dream and aspiration to recreate the family she'd been deprived of for nine long years.

I was painting in the studio when Céline came in to tell her mistress that

the architect and the locksmith for the new studio were waiting for her in the courtyard.

Rosa Bonheur got up. So did I, ready to follow her down, but she told me to stay, saying that she'd be right back up. How sorry I am today to have listened to her.

She was gone for over half an hour. I was just about to take down her short cape and hat when she finally returned all upset.

"What a mistake," she said, "letting myself get dragged into a discussion right there in the wind. I didn't realize that my head and neck were bare. Now I feel like there's something in my throat. And one of those men had such bad breath that I felt sick to my stomach. What a stench! I really hope I haven't caught something contagious."

She stretched out on her lounge chair and continued: "Ah! I'm so eager for the two of us to get down to work on my *Treading Wheat*. The shutters I devised for the new studio to block reflections off the lawn are finally up, but they're so heavy that it would take two men just to maneuver them. Yet this time I think I've made myself clear. Not bad, after complaining for eight months."

After dinner we went right back to the big studio. Rosa Bonheur sat down in her armchair. I'd fashioned a lampshade for the electric light out of a huge chestnut leaf, so she was deep in shadow. She began studying her big painting, and I thought I could guess how happy she was about finishing this piece that meant so much to her, the crowning glory of her career.

While she lit a cigarette, her Yorkshires were dancing all around their mistress. Then Daisy bullied her way onto the artist's lap, leaving Charley wagging his tail off and scratching at his mistress's ankle boots. After she gave him a friendly little slap on the back, he calmed down and stretched out at her feet.

"Do you remember," she asked, "this lovely passage from Xavier de Maistre's *Journey around My Room*: 'An armchair is an excellent piece of furniture, so good for an occasional lazy sprawl . . . A good fire, books, pens—some music, too—what safeguards against boredom . . . The hours glide by and silently slip into eternity without making you feel their sorry passing.' Play me a Mozart sonata, please, one of my mother's lullabies, then sing me something by Gluck. For the finale, accompany your sister Julia, who'll certainly play us some Handel on her violin."

I sat down at the piano and began to play. Rosa Bonheur closed her eyes and listened. Several times I thought that she had fallen asleep. Yet when the final chords had resonated, she got up and said: "Let's stay on that great harmony. It was like Paradise. Good night, my dear friends."

Before lunch on Pentecost Rosa Bonheur took us to the new studio to admire the huge skylight.

"At last the wonderful light I've been dreaming about for so long. By the end of the week we ought to have *Treading Wheat* set up and ready to go. Another year of work, and Nathalie's wish will be fulfilled. You see that empty spot above the mantelpiece? It's for a bas-relief I'm going to start working on. It'll be wild horses, in memory of the ones that so providentially brought Anna and me together."

While talking, she noticed a spiderweb at a window. She smiled and said: "My little friends have already moved in. They're more on the ball than I am, since I won't take possession for another two or three days. It bodes well that they're busy. That means we'll get lots of work done here."

On our way back to the house Rosa Bonheur pointed out to my mother the architect's wonderful symbol for the love between his two girl artists (Rosa and me): a sculpture of two roses tied together with a ribbon decorated a window pediment of their studio.

Just before lunch she admitted that she'd not felt quite right since the previous evening and had no appetite.

"I'd better just stretch out on my lounge chair," she said.

She did just that. Lunch was sad without her.

Once we'd finished, I went back up to the studio where Céline was looking after Rosa Bonheur. Her solitary thoughts must have taken a gloomy turn, for she said abruptly: "Anna, don't auction things off after I'm gone. If you need money, just sell one of my studies."

"Dear friend," I replied with a pang of anguish, "why are you thinking about that? What have you got to fear?"

"I'm not afraid of dying. Yet, by the grace of God, I'd really like to spend a few more years with you."

Early in the evening I noticed that she had trouble talking. The inside of her mouth was all white. I got terribly upset and worried.

One of my sisters had died of diphtheria,[1] and in my naïveté I wondered if Rosa Bonheur didn't have it. I put in an emergency call to Dr. Gilles in Thomery.

"It's not diphteria, but the flu," he said after examining his patient. "Mlle Rosa will have to stay in bed for a few days." He prescribed various treatments and left.

My mother, Céline and I sat up with her.

1. Mathilde Dalton née Klumpke.

Rosa Bonheur had a bad night. Yet the doctor thought she was a little better by morning. He painted her chest and back with iodine and gave her some quinine. When Mme Gauthier dropped by a bit later to see our patient, they could exchange a few words.

In the afternoon Rosa Bonheur began to cough and complain about fierce pain in her back.

"I feel tired and broken," she said, giving me a tender look with her beautiful eyes.

At seven, another visit from the doctor. He prescribed the same treatments. Although her throat was all inflamed, he saw no reason for alarm.

Yet Tuesday morning, between four and six, the patient began having such pain that I had the horse hitched up in a rush to go fetch the doctor. He just prescribed more iodine and some laudanum.

I asked if we shouldn't consult one of his colleagues from Paris. He didn't think so.

"It's only intercostal rheumatism. Don't worry, I've seen Mlle Rosa much sicker than this."

Rosa Bonheur slept a while and said she felt a bit better.

Around 11:00 A.M. she asked for some bread soup and watched with interest as Céline gave her birds their daily ministrations.

Later Rosa Bonheur dictated several letters to me, telling her friends that she was confined to bed.

Wednesday morning, the third day of her illness and the eve of her death, she asked me to help her put on a bathrobe so that she could go into Nathalie's bedroom, now my own. Fearing that she'd catch a chill, I did so reluctantly; not daring to refuse her this favor, I lent her my arm.

Upon entering the room, my friend collapsed into an armchair, from where she looked around in silence at all the furniture. Finally she fixed her gaze on the bed. Thinking that she'd come here for a change of air, I asked if she wanted to lie down. A few seconds went by until she half-heartedly replied that she preferred going back to her own bed.

While I was helping her back to bed, she turned her beautiful black eyes on me and asked me to venerate the memory of Nathalie, who had died in that room.

Her words and tone wrenched my heart. Did Rosa Bonheur think she was dying? Had she gone to Nathalie's bed to die there, according to her wish? And had she given up this sorry plan for fear of alarming me?

The doctor came back at two. After careful examination of his patient, he said, in an anxious tone that made me shudder, that he was going to send an urgent telegram up to Dr. Apostoli in Paris. He had treated Rosa

Bonheur several times, and she had great confidence in him. All of a sudden her condition had become very serious; she had pulmonary influenza.

I also called my brother-in-law, Dr. Déjerine. Both arrived promptly.

Come evening the doctor from Thomery decided it was imperative for him to spend the night with his patient, which opened my eyes to the gravity of her situation.

In my distress I went to my mother. We knelt down and fervently prayed.

The next day, May 25, when the doctor told me he had to go see some other patients, I felt reassured and stayed with Rosa Bonheur. At one point, when I saw her lips move, I leaned down and asked if she didn't want a sip of milk.

"No, my Anna," she said, stroking my hair. "Sing me *The Lake.*

I was in no mood to sing, yet dared not refuse. I opened all the doors between the bedroom and her dear "sanctuary" and began Niedermeyer's prelude on the piano. My voice was quavering, and I struggled through the first verses of the famous romance that Rosa Bonheur so loved and that she had taught me to love, too.

I stopped short when my mother swept in. Rosa Bonheur was calling for me.

I rushed to my dear friend who said in a slow, sad, and broken voice: "Even if we must soon part, our souls will be reunited. I've given my best fight. I'm all worn out!"

"Don't give up," I sobbed.

Her only reply: "Be an angel always!"

And her eyes closed. I dared not say a word.

Soon the doctor returned, who looked at her hands straightaway. Instinctively I did the same and was struck by the bluish spots all over her fingernails.

Without a word to me, he promptly left the room and announced that it was all over!

Alone with the dying woman, I watched with terror as her face went livid.

Gripped with violent despair, I couldn't hold it back and cried out: "No! no! my dear friend, don't leave me! Rosa, my dear Rosa Bonheur!"

Her eyes slowly opened, she looked at me and murmured: "Anna! My Anna!"

A prayer of thanksgiving rose in my heart. It suddenly occurred to me that Nathalie's soul had to be there, ready to join her friend; but taking

pity on my despair, Rosa Bonheur generously put off our painful separation.

"Rosa Bonheur isn't dead," I exclaimed. "She lives, she lives!"

The doctor rushed back in and ordered warm towels. I felt the room filling up with people, then I don't know what happened. I had passed out.

I came to in the arms of my sister, Mme Déjerine, who had come down from Paris at my call.

"Don't worry about me, save Rosa Bonheur."

Alas! my fervent wish was granted, but only for a few hours. Like a candle burning down, her life gradually subsided.

From time to time the dying woman still murmured: "Anna! . . . Anna!"

Then I recalled her last bidding. I sat down on her bed, put my arm around her, her temple touching mine, and waited, my heart in a vice. From Rosa Bonheur's lips there escaped a few last words, like a breath: "I . . . shall . . . be . . . your . . . guardian . . . angel."

I couldn't believe that she was so close to death. In my brokenhearted, naive desire I kept repeating: "Tomorrow you'll feel better. Sleep well. Happy . . . Happy . . ."

Alas! All of a sudden she went cold. I pressed her hand in mine to warm it up, but an icy shudder ran through my veins. I felt that I, too, was going to die.

"Doctor!" I cried, "put your hand on her forehead!"

"You need my care now more than she does!" was his blunt reply.

I looked at him in horror and sobbed when I heard him say the terrible words: "It's over. Give her a last kiss."

While I contemplated her wan face through my tears, everything in me dissolved into grateful homage to the famous woman who had found me worthy of her trust and love.

Rosa Bonheur seemed peacefully asleep. Her face took on a look of sublime serenity (fig. 17). What impenetrable mysteries lie between life as we know it and the one death opens up to us!

The studio doors had already been sealed[2] shut when my sister Julia reminded me about the crown of laurel Rosa Bonheur wanted with her in the coffin. Moret's justice of the peace agreed to break the seals he had just affixed so that I could go fetch the relic. I carefully removed the dry twigs, whose leaves were still a bit green, from the antlers where my old friend

2. As required by French probate law, in order to ensure that the estate remain intact.

had hung them. Placing the crown on her breast, my trembling lips kissed once more the little hand forever stiffened by death.

The morning of the funeral I wanted a moment alone underneath the great oaks that had been Rosa Bonheur's pride and joy. She had used to love to sit in their shade. That day she was leaving them forever, and they had never looked so majestic. For a second I relived the happy, fleeting hours I had spent there with the great woman whose soul was now shining in the infinite realm. With the leaves rustling imperceptibly in the wind, I thought I heard a far-off echo of a wonderful song. Goethe wrote the words to it on the door of a hut in the Black Forest, and Schubert put them to music:

Über allen Gipflen ist Ruh,
In allen Wipflen spürest du kaum einen Hauch;
Die Vögelein schweigen im Walde.
Warte nur, balde,
Ruhest du auch.[3]

I went back into the house.

In accordance with her last wishes, Rosa Bonheur had a religious ceremony.

Her coffin left in a white-draped hearse through the main entrance, with the iron gates thrown open wide. Surrounded by choirboys, the priest from Thomery led the way for the schoolchildren of By and most of the townspeople.

The procession slowly wound through the streets to the church. The climbing roses that covered the walls seemed to send a final farewell to a beloved sister who was leaving them. Their perfume was sweet as incense.

After a ceremony identical to Nathalie's, the coffin went by train to the Gare de Lyon in Paris. Friends who hadn't been able to come to By and a great many artists assembled there to accompany to her final resting place the woman who had carried her banner so high in their glorious legion.

According to her wish, Rosa Bonheur had none of the military honors to which she was entitled as an officer of the Legion of Honor. There was no graveside eulogy. But as soon as her coffin was placed on the slab covering Nathalie's, it disappeared under heaps of flowers.

3. A prose rendering of these verses could read:
Above these treetops is rest, through the leaves you scarcely feel a breath of wind; the birds are silent in the forest. Just wait a little while, you'll also find your rest.

Rosa Bonheur left this world on the very same day that the Society of French Artists met to award the Salon medal of honor.

A few weeks later M. Tony Robert-Fleury told me: "If only we'd had a premonition that she'd die so suddenly, my colleagues and I would have certainly voted for Rosa Bonheur, but we couldn't foresee this totally unexpected catastrophe. We wanted to give her a higher distinction, the medal of honor at the Universal Exhibition of 1900. That would have been a fine way to crown the career of one of the greatest animal painters of the nineteenth century."

Executing Rosa Bonheur's Will
❖
Distributing Her Works
❖
Homage Rendered Her

Several years have already gone by since Rosa Bonheur was buried at Père-Lachaise next to her old friend Nathalie Micas. After finishing the story of such a full life, the surviving companion has apparently completed her task. Yet there remains the duty, for Rosa Bonheur's sake and for her very own, to tell how the great woman's last wishes were fulfilled.

To give the reader some idea of my delicate role, so difficult because so vague on more than one point, I thought it right to put her will and follow-up letter about her estate in an appendix to this volume. Even so, these means cannot truly express the depths of my perplexity.

Rosa Bonheur's letter, in its poignant melancholy, entrusted me with the mission of handing over to her brother what she, according to the circumstances, would have given him, had she been able to make herself heard from beyond the grave! Yet her last wishes forbade me to touch her house as well as anything that had belonged to Nathalie and her mother. So her brother's share could only come out of her movable property. After mulling it over, I finally decided to offer M. Isidore Bonheur half of his sister's three hundred thousand francs. When I went to tell M. Tedesco, who was holding these funds, about my plan, I was dumbfounded to hear him exclaim: "So you've got no idea that Rosa Bonheur left quite a fortune in all kinds of artwork. We'll offer you 1.5 million francs for her portfolios."

One and a half million francs! Were there really so many valuable studies at By? I was aware of about only twenty, which Rosa Bonheur had shown me now and then to help explain her work methods. Seeing that I was truly incredulous, M. Tedesco called in his elder brother, who confirmed this by saying: "At least forty years ago my father, who was such a fine connoisseur, offered Rosa Bonheur a million for all her studies. She just shrugged her shoulders and said: 'Shut the hell up, Tedesco!' And then she kept right on working. By the time of her death she may have accumulated two million worth. We're offering you a million and a half today

because we're not only Rosa Bonheur's friends, but serious businessmen as well."

Faced with such new and unforeseen circumstances, I asked for some time to think. Didn't I need to consult with M. Tollu, the executor of Rosa Bonheur's will, before making any decision? I won't hide that, happy deep down, I was ready to accept the Tedescos' generous offer. It seemed the best way to fulfill, far beyond my wildest dreams, the beautiful role entrusted to me.

Yet, while I was telling M. Tollu about the Tedescos' offer, I thought I heard a very dear voice whispering in my ear: "If the whole lot gets sold, not a single trace of them will remain behind."

I understood the point of this precious bit of advice and told M. Tollu: "If I accept their offer, I'll obviously lose the right to reproduce the studies. Now, that's a bit Rosa Bonheur's spiritual legacy to me, don't you think? I can't just give it up like that. I'd rather hand over three-quarters of them to her brother, as long as I retain the copyright on the whole lot. He can do as he likes with his part."

"But don't you understand," exclaimed the notary, "that you can't just divvy up works of art like shares of stock? If you want to be generous, you've got to do one of two things: accept the Tedescos' offer or have an auction. But with all the gifts you've still got to make, don't hand him over three-quarters. Half will be just fine, and that's still a magnificient gift. Do you think Mlle Micas would have done what you're proposing?"

Rosa Bonheur hadn't wanted an auction. Yet, wasn't that the only easy solution?

My offer to turn over to M. Isidore Bonheur half the auction proceeds, after payment of all the expenses, had been virtually accepted when all of a sudden I received a subpoena. The family accused me of having obtained Rosa Bonheur's succession by insidious means, by hypotizing the great woman. There was to be a trial with all its attendant nightmares.

There was no doubt a very simple way to get out of these straits: renounce the role that Rosa Bonheur had entrusted to me, give up the title of sole legatee and the inheritance. That would probably help cut short the calumny; but such was not Rosa Bonheur's wish. I had been honored by her love; so it was my duty to prove I was worthy of her trust.

Meanwhile, to get on with the legal inventory, the seals were lifted inside the chateau. M. Tedesco's statements were confirmed by the discovery, in every nook and cranny, of boxes chock-full of carefully filed studies: horses, oxen, sheep, stags, boars, lions, and so on; in short, all the animals that had paraded in front of Rosa Bonheur for sixty years.

Though I'd been forewarned, I was still astonished by the sheer number of them. A whole life's work was spread before my eyes, and I finally understood the full import of the words Rosa Bonheur often repeated to me: "I'd rather spend my whole life eating nothing but dry crusts of bread than sell my studies. Ah! to think, all for a few pieces of gold, of giving up my tools and condemning myself to idling away my winter years!"

Deep in my heart I thanked my noble friend for inspiring me to draw up a vast repertory of her works and to help prevent them from being scattered to the winds.

Rosa Bonheur's family soon realized that her last will and testament was invulnerable to attack and that they'd probably lose their case. So they accepted my offer for half the net proceeds from the sale. I was glad to work things out with them, since that would make it so much easier to set up an exhibition worthy of Rosa Bonheur's fine reputation. But I won't say what my life was like during that whole year of hostilities and hardship before we reached our amicable understanding. Given my determination not to let the precious love that Rosa Bonheur had pledged me, which lived on beyond the grave, be muddied by a single word or deed that would have met her disapproval, how often did I have to push my pain deep down into my heart? She was my guide and counsel through the worst times. I could almost feel her dear presence at my side. In my gratitude I thanked her not so much for her unexpected legacy to me as for that supreme initiation into the artist's life and mind, which was her ultimate proof of love and trust. This most precious godsend was a kind of epilogue to ten years of unforgettable love and inspiration.

I am delighted to express here my deep gratitude to those who, in these painful circumstances, steadfastly gave me friendship, moral support, advice and encouragement: MM. Tony Robert-Fleury and Jules Lefebvre, my dear teachers; the executor of Rosa Bonheur's will, M. Tollu; M. Roche and Mr. Hardy, my legal counsel; M. and Mme Flammarion, Mrs. Hill, Miss Lilian Whiting, Mr. and Mrs. Grew, M. Deslandes, M. de Fonvielle, M. de Vuillefroy, and many others, friends from the Old and New World, who helped me maintain my willpower and peace of mind through it all.

On May 25, 1900, in the Georges Petit Galleries at 8, rue de Sèze in Paris, there began a presale exhibition of all the works—paintings, drawings, watercolors, engravings, bronzes—that Rosa Bonheur left at By at the time of her death. The great artistic and social event was hailed in the press.

The catalog, in French and English, made up two big in-quarto vol-

umes, with 105 heliographic plates and 50 Paillard wood engravings. It was expertly written by M. Roger-Milès, whose preface is one of the eminent critic's most respected pieces.

I did not think it right to put the great woman's collection up for auction without first removing some mementos for her friends. Above and beyond that, fifty studies went to the Luxembourg Museum, according to the welcome suggestion I had made to Rosa Bonheur just a few days before she died. Hanging near *Ploughing in the Nivernais,* these studies will bear witness to the strength and flexibility of one of the most honest talents of the nineteenth century.

The nine-day auction, conducted by M. Paul Chevallier with the expert help of MM. Tedesco and Georges Petit, met the most deserved success. Although the 1,181,498 francs it earned were less than the 1.5 million previously offered by MM. Tedesco, it was still a remarkable result, given the number of necessarily similar pieces. 799,209 francs were left, after deduction of the expenses. Half that sum, meaning 399,604 francs, was turned over to the Bonheur family.

Without keeping a single study for myself, I had given a few of Rosa Bonheur's works to her friends and to the Luxembourg Museum. So it will come as no surprise that I bought several for the great artist's house, including *Treading Wheat.* In front of that huge canvas my old friend had made so many beautiful plans for the future, all cut short by cruel destiny. When the painting went back to its old place in the studio, things looked again as they had for almost fifty years.

As for the 300,000 francs that made up Rosa Bonheur's movable property, I disposed of them in the following way. After subtracting the inheritance tax, the funeral expenses, all sorts of honoraria, building costs for the new studio, current debts, and so on, the 20,500 francs to be divided among Mlles Lagrolet and Verdier and the commune of Thomery, the 81,650 francs deposited for Céline and Mlle Mathieu's life annuities, the remainder was used to set up an annual prize for the Society of French Artists. The Rosa Bonheur prize will be given every year to one of the best paintings at the Salon, regardless of the painter's nationality or sex. It is my dearest wish that one of my fellow Americans will win it some day. This would help, however modestly, seal the friendship between old Europe and the young nation across the Atlantic.

While piously arranging the medals and crosses that marked Rosa Bonheur's road to fame, I suddenly thought to ask for an autograph letter from the august sovereign who had opened up to her the ranks of the

Legion of Honor. Her Majesty the Empress Eugénie consented with such kindness that I was touched beyond words. So, among the parchments proclaiming in every language that the great artist was a member of the Academies of Amsterdam, Milan, Rotterdam, Anvers, Lisbon, London, and Philadelphia; among the decrees of Emperor Napoleon III, President Carnot, Prince Ernest of Saxe-Cobourg-Gotha, King Leopold, Emperor Maximilian, the Kings of Spain and Portugal, the safe-conduct from the Crown Prince of Prussia, the Ghent Exhibition cameo and the Salon medal bearing Louis-Philippe's effigy, I proudly placed this card:

> Rosa Bonheur is the first woman decorated for her artistic talent. No woman had ever received this high honor except for courage or devotion.
>
> I fondly remember that on June 15, 1865, during my Regency the Emperor gave me permission to create this *precedent,* under the aegis of great artist's name.
>
> <div align="right">Eugénie
February 22, 1902</div>

I still have one ambition to fulfill: to keep alive in Rosa Bonheur's house the spirit that she imparted to the place and to make sure that her memory lives on after I've gone to lie at her side in the tomb at Père-Lachaise.

Were I to finish this book without saying a few words about the posthumous honors Rosa Bonheur has received, not only would I be shirking my chosen duty and falling short of my goal; I'd also be forgetting these gestures, great and small, all of which interest me because of my devotion to her glory.

In the village of By, the street where she lived for forty years will henceforth be known by her famous name.[1] In addition to that shady "gallery" that the occasional stroller came looking for at the chateau, there is now a Rosa Bonheur Lane through the Fontainebleau forest. She thought the forest charmingly picturesque and often painted its wild hosts, gigantic trees, and rugged terrain.[2]

In 1901 a notable monument dedicated to Rosa Bonheur by M. Gam-

1. A.K. Decision of the municipal council of Thomery, June 11, 1908.

2. A.K. Through the intervention of M. Reuss, inspector of Waters and Forests, the name of Rosa Bonheur was given to a lane in the canton of Rozoir Plain that goes from the road between Veneux and Montigny and ends at the road to Zamet. (Municipal decree of March 10, 1903).

bart and sculpted by MM. Isidore Bonheur and Hippolyte Peyrol was erected on place Denencourt in Fontainebleau.[3] It is a bronze bull, adapted from one of the great animal painter's little sculptures. The bas-reliefs on the pedestal, except for the likeness of Rosa Bonheur on the front, are bronze reproductions of her most famous works: *Ploughing in the Nivernais* and *The Horse Fair* are on the sides, while the superb stag that she called *King of the Forest* is on the back. All the civil and military authorities were present when this monument was unveiled on May 19, 1901. The mayor of Bordeaux also came, bringing Rosa Bonheur her compatriots' homage and saying that this city—which had recently named one of its streets after the artist—would soon put up a marble statue to the glory of one of the most illustrious women born within its walls.

Although Bordeaux still hasn't fulfilled its promise, Paris promptly honored the woman who, as a young girl, did her artistic apprenticeship in its museums and gathered her first laurels in her studios in the rue de l'Ouest and the rue d'Assas.

The new neighborhood built on the site of the Grenelle slaughterhouses has a street named after Rosa Bonheur. A four-sided monument dedicated to the celebrities of the nineteenth century stands in a central intersection. One side presents a larger-than-life profile of Rosa Bonheur on a marble medallion. It was sculpted by M. G. Loiseau-Bailly. Other sculptors have also been tempted by her features. Visitors to the Salon of 1902 admired in the main gallery of the Grand Palais the life-size statue by a citizen of Bordeaux, M. Gaston Leroux. His compatriots accepted this superb invitation, and in 1903 Bordeaux bought his statue for the municipal museum. The statue shows her seated, holding her palette and brush, in a noble, yet familiar pose that she would have liked.

No doubt, praise from academies, approbation from the press, painted and sculpted likenesses, and haughty monuments are most fitting ways to sustain an eminent reputation for posterity. Yet fluctuations in fashion and taste over time can quickly dim the radiance that once seemed to surround a name. It is my hope and conviction that Rosa Bonheur will escape this all-too-frequent fate. Her work will defend her memory better than the greatest praise and the grandest monuments. Her thousands of

3. This commemoration is no longer in existence. Like so many other bronze monuments, it was melted down by the occupying German army during World War II.

works are found on every continent, in the proudest museums and the greatest private collections in Europe and America. How could she be forgotten, when every one of her pieces announces her technical skill and dexterity, her love of nature, her fondness for the animals she painted, and her marvelous understanding of what she called their soul?

Rosa Bonheur's Last Will and Testament
Will of November 9, 1898

This is my formal will and testament, entirely written out in my own hand.—R.B.

I, the undersigned Rosalie-Marie, known as Rosa Bonheur, artist-painter, of sound body and mind, freely express here my last wishes, free of all debt, free by force of will and by dint of what I've earned from my work, chaste and childless.

I want to be buried in the same vault as my friend Mlle Nathalie-Jeanne Micas, as is my right; for I was her sole legatee and sole heir, as was agreed between us. This vault, the Micas family tomb, is my property. It is located at the cemetery of Père-Lachaise, in Paris, and maintained at my expense by my marble mason M. H. Edeline, domiciled in the rue du Repos.

My funeral ought to be a civil ceremony, modest, but decent, without military or other pomp. I leave my friend Mlle Anna-Elisabeth Klumpke free to do as she wishes for the other arrangements.

I give and bequeath to Mlle Anna-Elisabeth Klumpke, my friend, companion, and artistic colleague, everything I own on the day of my death and institute her as my sole legatee. Thus, this legacy will include in particular:

My entire estate at By, including the little vegetable garden across from the main entrance of my house, known as the Chateau of By, in the hamlet of By, no. 12 in the street known as rue des Arts. Also, the strip of woods or brush at the boundary of the forest and marked on the cadastral survey. By this I mean that nothing can be diverted, that everything, movables and fixtures, including my medals and awards, finished or unfinished studies, finished or unfinished paintings, drawings, sketches, bronzes, horses and carriages, will remain there as Mlle Anna-Elisabeth Klumpke's property; in a word, everything in my studios as they are, everything in my house, plus my furniture in Paris. No one else is entitled to it, and I leave Mlle Anna-Elisabeth Klumpke free to do as she pleases with it.

I also give and bequeath to Mlle Anna-Elisabeth Klumpke all my stocks and bonds held by MM. Tedesco, brothers, 33, avenue de l'Opera, in Paris. Everything shall belong to her. Such is my formal wish, freely written in this will.

I give and bequeath to my god-daughter, Mlle Rosa Justin Mathieu, and to her sister Jenny, florist, presently living together at 36, rue des Vinaigriers, Paris, an annual life annuity of 1,200 francs, with no reduction when one of them dies. This annuity will be paid quarterly to Mlle Rosa Justin Mathieu and her sister by my sole legatee, and arrears will be paid from the day of my death. I give this annuity to the daughters of one of my father's childhood friends.

I give and bequeath to my servant Céline, wife of Etienne Ray, if she remains in my service at the day of my death, an annual life annuity of 800 francs, to be paid quarterly by my sole legatee. I do not leave anything more to my servant Céline Etienne Ray because of the generous wages she's always had from me (170 francs per month for twenty-five years).

These two annuities will be paid out of my assets, stocks, and bonds, with interest and dividends, held by the Tedesco brothers, art dealers, now located at 33, avenue de l'Opera, who agreed to take care of my affairs and invest my capital.

My accounts are settled every six months before my notary at Moret-sur-Loing (Seine-et-Marne) and recorded on two ledgers, one in my possession and the other with the Tedesco brothers. At my death the Tedesco brothers must give my legatee, Mlle Anna-Elisabeth Klumpke, an account of all the stocks, bonds, and assets that I entrusted to their good care and friendship. I want the two special legacies made in this will to be delivered after payment of all inheritance taxes.

I hereby declare to all those who thought me very wealthy: Since I do not have a sufficiently large fortune to divide up among the members of my family for whom I did my best before and after my father's death, I decided I had the right, owing nothing to anybody, to ask Mlle Anna-Elisabeth Klumpke, likewise a professional artist who has earned a fine reputation for herself, whose family enjoys the same, to stay with me and share my life. I've also decided to compensate her and protect her interests since she, in order to live with me, sacrificed the position she had already made for herself and shared the costs of maintaining and improving my house and estate. This will is a duty of honor for me, as all good people and my true friends will agree.

In the event that Mlle Anna-Elisabeth Klumpke dies before I do, I institute her sisters jointly as sole legatees in her place.

As I and my friend Mlle Anna-Elisabeth Klumpke both wish, she will be buried with me at Père-Lachaise in the vault that my friend Mlle Nathalie Micas bequeathed to me.

Now I must thank God for the happy, exceptional life he has granted

me and for the protection in this world that I owe to my dear mother's soul.

<div align="right">Signed: Rosa Bonheur</div>

Paris, November 9, 1898

Testamentary Letter of November 28, 1898

I am writing this letter because I consider it my honor-bound duty to justify my past conduct toward Mmes Micas, my friends, and my present and future conduct toward Mlle Anna Klumpke, who has agreed to live with me. I also want to make people understand what I must honorably do to protect Mlle Anna Klumpke's interests, which could be compromised by staying with me.

I made Mlle Klumpke my sole legatee by a proper will, writing out two signed copies in my own hand and depositing them with two notaries. My purpose is to make the truth known: I was the one who asked Mlle Klumpke to live with me. No one must think that she agreed out of material self-interest. She was motivated by her love for me and also her desire to stay in France near her mother and sisters.

I want people to know that after the cruel loss of my venerated friend Mlle Micas I was alone and frequently ill. Bereft of a friend to look after my interests and help me keep my house in order, life did not seem absolutely lovable any longer. I lost time taking care of things alone, time that I now regret. It was unlikely that any of my nieces could come live with me, even nurse me when I was seriously ill, since one is married and the other two need to stay with their mother. I was tended to by my servants alone, as I no longer had my dear Nathalie Micas.

Three or four months ago Mlle Anna Klumpke, whom I've had the honor of knowing, as well as her family, for eight years, wrote me from Boston (America), where she had been living for three years, saying that she wanted to paint my portrait. I accepted, knowing how talented she is. I invited Mlle Klumpke, who was also coming from America to see her mother and sisters, to stay with me for as long as she wanted in order to paint my portrait and any studies that she could do in the forest and countryside around By. After nearly three months of a life that had become delightful to me, and since Mlle Anna Klumpke's loyal, frank, and noble character had made me grow seriously attached to her and very sad about her departure, I asked Miss Anna to stay with me. After taking time to think about it, Mlle Klumpke decided, to my great joy, to stay in France

and share my country life, although she would still keep a studio in Paris for painting portraits of her fellow Americans. This is a fine arrangement for two artist-painters who, not practicing same genre, can work freely and independently, but are determined to be together as much as possible and to work, to make our lives pleasant and comfortable and to improve our house. This new life, plus entering into friendship and society with a family as distinguished and honorable as possible, has made me happy.

But having reached an age that gives me much experience of the ways of the world, I, as an honest and loyal woman, also had to protect Mlle Klumpke's material interests, as I had previously done with my friend Mlle Nathalie Micas, providing us with mutual protection if either one of us died. I did this so that in the event of my death Mlle Klumpke, having come to live with me, would run no risk of being evicted, not even being entitled to take away her personal belongings, and losing the benefit of her financial investments in my property, where we have the right, both being free and unmarried, to give ourselves the enjoyment of comforts with the money we earn through our work.

I therefore wanted to do things fairly, as was my duty, by protecting the interests of my friend Mlle Klumpke, given that I am perfectly free with regard to my property.

In the second place, my family has always taken a dim view of my right to live as I please. Having done my duty by my family, I was entitled, like any adult earning her own living, to my independence. I did not want to insult my friend Mlle Micas and her mother, both eminently respectable, and let the disparaging things said about these ladies while I lived with them (that they were living off me) to weigh down on their memory. Now that I have the chance, it is my duty to say the truth, because these ladies helped me pay off debts when my father died, and my friend, Mlle Micas, made me her sole heir at her death. Therefore, I did not want my family, for the sake of their own dignity, to be able to profit later on from what my friends Mmes Micas gave me.

My conscience is also clear with regard to my aunt. I alone provided for her support with a monthly allowance of three hundred francs. Following my father's death, I paid the family's bills and debts and gave them all the money I earned as head of the Drawing School for Girls after I took over for him there. Finally, up until then, I gave them almost everything I had begun to earn with my paintings. I have to say all this here because the truth must be known. It is also my duty to prove that I am free to do as I

please and to defend once and for all the reputation of others as well as my own.

I also had the right, after my dear father's death, to leave the family to go live with Mmes Micas and to have my own studio. My brother Auguste, who had a wife and children, could not help me. As for my brother Isidore, the best and most honest of men, he never left my sister, who became Mme Peyrol, our stepmother's son's wife. He has spent his whole career running my brother-in-law Peyrol's bronze business. Before ending this long letter justifying my conduct and that of my chosen friends, I must also say that after I bought my estate at By, I've always, as was only right, entertained my sister, her husband, and children, as well as I could, giving them the best possible hospitality.

So I have nothing to reproach myself for with regard to my family, and now I've got the right to live for myself and to do as I please with my personal property, having had no children or tender feelings for the stronger sex, aside from good, forthright friendship for those men who enjoyed my full respect.

My nieces, thank God, have a father who worked like a horse and earned more than I ever have so that they might live a peaceful, decent life, whether they marry or stay single like me. As for my two nephews, they are stalwart, healthy men. They should just do as I have, because men, with all their physical strength, must not, if they're proud and upstanding, count on inheriting from a woman whose work was often interfered with by the condition of her sex. For this reason men who are worthy of the name have rightfully thought that they ought to work for women and children; but unfortunately women often have to step in when they fail in their duties.

I end this long letter explaining my legitimate resolve to leave my estate to a companion who is, like me, an artist, who, like me, earns her living with dignity, who wants, like me, to work in peace, continue her career, and be my loyal companion until the last day of my sojourn here below.

I'm done now. I hope that my family and true friends will give this letter their understanding and approval when it is read to them.

Signed: Rosa Bonheur

By, November 28, 1898.

I also add here that if, because of unforeseen circumstances, my brother Isidore ever had money problems, I know my friend Mlle Klumpke well enough to entrust her with the duties that I myself would assume.

Signed: Rosa Bonheur

Rosa Bonheur

Codicil of May 18, 1899

Mlle Anna E. Klumpke, my sole legatee, has the right to arrange, as she wishes, a civil or religious funeral for me; and I name M. Camille Tollu as my executor.

Signed: Rosa Bonheur

Paris, May 18, 1899

Major Dates in the Lives of Rosa Bonheur (1822–99) and Anna Klumpke (1856–1942)

1822 Rosalie-Marie Bonheur is born on March 16 in Bordeaux, the first of four children. Her father Raimond was an artist of humble means and origins; her mother was reared in the household of an aristocratic merchant. As a young woman, the artist dropped her baptismal name and made "Rosa Bonheur" her professional signature.

1824 Her brother Auguste is born.

1827 Her brother Isidore is born.

1828 Raimond Bonheur leaves his young family in Bordeaux and goes to Paris.

1829 Sophie Bonheur and the children follow Raimond to Paris, where they begin a hard, itinerant life.

1830 Her sister Juliette is born. Raimond Bonheur becomes a fervent disciple of the Saint-Simonian faith, a utopian socialist movement that combined farsighted schemes in engineering, industry, and banking with radical reconceptions of work, property, marriage, and the role of women in society.

1832 Raimond Bonheur abandons his wife and children in order to join a select group of Saint-Simonian men in celibate retreat at Ménilmontant, their communal house in northeastern Paris. Left to fend for herself in precarious circumstances, Sophie tries hard to make ends meet and faithfully takes the children to Ménilmontant for weekly visits with their father.

1833 Sophie Bonheur dies of exhaustion at age thirty-six. Rosa's pained awareness that Raimond sacrificed Sophie to his utopian aspirations shapes her attitudes toward men and marriage for the rest of her life.

1835 Rosa finally overcomes Raimond's opposition to her artistic vocation. Since there was virtually no professional training available to aspiring women artists outside the home, Raimond becomes her only teacher.

1836 Raimond Bonheur is commissioned to paint the portrait of Nathalie Micas, who becomes Rosa's close friend and devoted companion. For Rosa, meeting Nathalie was "the start of a new life."

1841 Rosa exhibits her first paintings at the annual Paris Salon.

1842 Raimond Bonheur marries a young widow.

1844 Rosalie-Marie Bonheur drops her baptismal name and chooses her professional signature, Rosa Bonheur, to honor her mother.

1845 Rosa earns a third-class medal at the Paris Salon, and travels to Bordeaux to fetch her sister Juliette, who had been sent to live with Sophie Bonheur's old nurse after their mother's death. Rosa tries in vain to learn more about her mother's real identity.

1848 Rosa earns a gold medal at the Paris Salon and receives a State commission for *Ploughing in the Nivernais*. Monsieur Micas dies. From his deathbed he blesses the union of Rosa Bonheur with his daughter Nathalie and begs Raimond never to separate the loving couple.

1849 Raimond Bonheur dies in March at age fifty-three. After her father's death, Rosa leaves home and goes to live with Nathalie Micas and her mother. This trio forms a uniquely supportive environment for the development of Rosa's talents and happiness. Rosa and Juliette follow in their father's footsteps and become directors of the Drawing School for Girls in Paris. Rosa exhibits *Ploughing in the Nivernais* at the Paris Salon. The French government buys the painting for 3,000 francs. The Tedesco brothers become her main art dealers.

1850 Rosa gets her first cross-dressing permit to facilitate her travels through the Pyrenees with Nathalie.

1853 Rosa exhibits *The Horse Fair* at the Paris Salon. The painting immediately becomes a great success.

1855 The renowned London art dealer, Ernest Gambart, buys *The Horse Fair* for 40,000 francs. Rosa wins a gold medal for *Haymaking in Auvergne* at the Paris Salon.

1856 Rosa and Nathalie travel to Great Britain with Gambart. Queen Victoria has a private showing of *The Horse Fair*. Anna Elizabeth Klumpke is born in San Francisco on August 22.

1860 Rosa Bonheur, Nathalie Micas, and Madame Micas leave Paris and move to Rosa's new country estate, the chateau of By near Fontainebleau. The chateau has been the site of the Musée Rosa Bonheur since 1924.

1864 Empress Eugénie of France, the wife of Napoleon III, drops in for her first visit to Rosa's studio at By.

1865 Empress Eugénie awards Rosa the Cross of the Legion of Honor, eager to demontrate her conviction that "genius has no sex." Rosa is the first woman artist ever to receive this high honor, which many of her

supporters deemed long overdue because of ingrained prejudice against women.

1875 Madame Micas dies at the chateau of By.

1877 Anna Klumpke's mother, Mrs. Dorthea Klumpke, along with her five daughters and one son, settle in Paris around this time. This ambitious matriarch chooses the French capital because of the educational opportunities it made available to women.

1880 Anna Klumpke enrolls at the Académie Julian, one of the rare art schools offering professional training to women in this period.

1882 Anna exhibits her first painting at the Paris Salon.

1884 Auguste Bonheur dies.

1885 Anna wins an honorable mention at the Paris Salon for the portrait of her sister Augusta.

1886 Anna paints a portrait of Elizabeth Cady Stanton, the famous American feminist and suffragist.

1887 American industrialist Cornelius Vanderbilt buys *The Horse Fair* for $55,000 and gives it to Metropolitan Museum of Art.

1888 Anna wins first prize in the Académie Julian competition.

1889 Anna becomes the first woman to receive the Pennsylvania Academy of the Fine Arts' Temple Gold Medal. Nathalie Micas dies at the chateau of By. Colonel William Cody ("Buffalo Bill"), traveling through Europe with his Wild West Show, visits Rosa Bonheur in her studio at By. Rosa's portrait of the showbiz army scout and buffalo hunter becomes the main feature of his billboard publicity. Anna fulfills a childhood dream by meeting Rosa Bonheur at the chateau of By. Anna returns to the United States and sets up a studio in Boston, where she paints for the next nine years.

1890 President Carnot of France honors Rosa by paying a visit to her studio in By.

1891 Juliette Bonheur dies.

1894 Rosa is promoted to the rank of Officer of the Legion of Honor. She is the first woman ever to obtain this rank.

1895 Anna, on a visit to Paris, travels to By again to see Rosa. Their relations are growing more and more cordial.

1898 In June, Anna begins work on her portrait of Rosa. Much to the American's surprise, Rosa confesses her love and begs Anna to stay with her forever. Although Anna had intended to spend only a few months in France, she agrees to become Rosa's biographer and companion.

1899 Rosa dies on May 25 at the chateau of By, which she bequeathes to her American companion. Anna and her mother go on living at the chateau of By. The Rosa Bonheur Memorial Art School is established on the premises. There Anna and other artists offer instruction to women of all nationalities.

1901 Isidore Bonheur dies after abandoning his lawsuit against Anna Klumpke. He had accused her of having obtained Rosa Bonheur's succession by devious means and attempted to invalidate his sister's will.

1908 Anna publishes *Rosa Bonheur: sa vie, son oeuvre* in Paris.

1914 Anna offers the chateau of By to the French government. For the duration of the war the estate becomes a convalescent home for wounded soldiers.

1922 On the one hundredth anniversary of Rosa's birth, Anna gives her first portrait of the French artist to the Metropolitan Museum of Art.

1924 Anna receives the Cross of the Legion of Honor.

1932 Anna returns to her birthplace, San Francisco, where she will live out her remaining years.

1936 Anna is promoted to the rank of Officer of the Legion of Honor.

1940 Anna publishes her *Memoirs of an Artist* in Boston.

1942 Anna dies in San Francisco.

1945 Anna's ashes are buried in Paris alongside the remains of Rosa Bonheur and Nathalie Micas in the tomb they shared at the Père-Lachaise Cemetery in Paris.

Selected Works of Rosa Bonheur

This appendix contains the works that have been mentioned in this volume, the works that the artist showed at the Paris Salons, as well as some works that are available to the public in museums in the United States and France. The works mentioned in this volume are preceded by an asterisk.

In order to facilitate reference to the original, the French title follows in brackets. An English title alone is given when the French title has not been made available. When I have been unable to ascertain if comparable titles in French and English refer to the same work, I have reported them separately. Some English titles of works in museum collections carry titles that are rough translations or adaptations of the French titles.

The place in parentheses is the location of the first known exhibition of the work.

Known locations of various works are so noted. The sources for most of these locations are given as AH (Anne Henderson), *Rosa Bonheur: Selected Works from American Collections,* Catalog for the Rosa Bonheur Exhibit at the Meadows Museum, Dallas, Texas (September 8–October 22, 1989) and at the National Museum of Women in the Arts, Washington, D.C. (December 12, 1989–March 11, 1990); or RS (Rosalie Shriver), *Rosa Bonheur, with a Checklist of Works in American Collections,* 1982. When the two conflict, I report the later one as most reliable.

Just as this work was going to press, the catalog of the Rosa Bonheur exhibit in Bordeaux (*Rosa Bonheur 1822–1899,* ed. Francis Ribemont [Bordeaux: William Blake and Co., 1997]) appeared. This catalog gives several other titles and locations of undated works by Rosa Bonheur, including many studies, that were sold at the auction of the artist's holdings following her death. These works are for the most part conserved at the Musée Rosa Bonheur (Thomery, France), the Musée de Fontainebleau (Fontainebleau, France), the Musée des Beaux-Arts (Bordeaux, France), and a few other locations in France. Interested readers ought to refer to the above-mentioned catalog.

Unfortunately, as Rosa Bonheur frequently sold straight into the hands of private collectors, the majority of her works are inaccessible to the

public and their locations are unknown. This was already the case when Anna Klumpke wrote her book at the beginning of this century.

This list is not meant to be exhaustive.

Dated Works

1840 *Two Rabbits [Deux lapins]. (Salon of 1841). Musée des Beaux-Arts, Bordeaux, France.

*Goats and Sheep [Chèvres et moutons]. (Salon of 1841)

1842 *Animals Grazing, Evening Effect [Animaux dans un pâturage (effet du soir)]. (Salon of 1842)

*Cow Lying Down in a Pasture [Vache couchée dans un pâturage]. (Salon of 1842)

*Horse for Sale [Cheval à vendre]. (Salon of 1842)

*Shorn Ewe [Brebis tondue], terra cotta. (Salon of 1842)

The Shepherd and his Sheep [Le Berger et ses moutons].

The Happy Family [L'Heureuse famille].

1843 *Horses Leaving the Watering Place [Chevaux sortant de l'abreuvoir]. (Salon of 1843)

*Horses in a Meadow [Chevaux dans une prairie]. (Salon of 1843)

*Bull [Taureau], plaster. (Salon of 1843)

1844 *Cows Grazing on the Banks of the Marne [Vaches au pâturage, bord de la Marne]. (Salon of 1844)

*Sheep in a Meadow [Moutons dans une prairie]. (Salon of 1844)

*The Meeting, Landscape with Animals [La Rencontre, paysage avec animaux]. (Salon of 1844)

*Donkey [Ane]. (Salon). An undated painting by this name is located at the Portland Art Museum, Portland OR. (RS)

1845 *The Three Musketeers [Les Trois Mousquetaires]. (Salon of 1845)

*Ewe and Lamb Lost in the Storm [Brebis et son agneau égarés pendant l'orage]. (Salon of 1845)

*Ploughing [Labourage]. (Salon of 1845)

*Bull and Cows [Taureau et vaches]. (Salon of 1845)

*Ram, Ewe, and Lamb [Bélier, brebis et agneau].(Salon of 1845)

*Grazing Cows [Vaches au pâturage]. (Salon of 1845)

Portrait of Juliette Bonheur.

Lamb [Agneau].

1846 *Herd on the Road [Troupeau cheminant]. (Salon of 1846)

*Rest [Repos]. (Salon of 1846)

*Sheep and Goats [Moutons et chèvres]. (Salon of 1846)

Ewe [Brebis]. (Salon of 1846)

*Pasture [Pâturage]. (Salon of 1846)

Ewe and Lamb [*Brebis et agneau*]. (Salon of 1846)

1847 *Ploughing, Landscape and Animals (Cantal)* [*Labourage, paysage et animaux (Cantal)*]. (Salon of 1847)
Grazing Sheep (Cantal) [*Moutons au pâturage* (Cantal)]. (Salon of 1847)
Studies of Pureblood Stallions [*Etudes de chevaux étalons pur sang*]. (Salon of 1847)
Still Life [*Nature morte*]. (Salon of 1847)
Brittany Cattle [*Troupeau de boeufs bretons près d'un gué*].

1848 *Oxen and Bulls of Cantal* [*Boeufs et taureaux, race du Cantal*]. (Salon of 1848). R. W. Norton Art Gallery, Shreveport LA. (RS) According to Rosalie Shriver, this painting, dated 1888, may be a copy painted by Rosa Bonheur.
Grazing Sheep [*Moutons au pâturage*]. (Salon of 1848).
An undated painting entitled *Sheep Grazing* is located at the Columbus Museum of Art, Columbus OH. (RS)
Oxen Grazing in Solers [*Pâturage des boeufs de Solers*]. (Salon of 1848)
Running Dog [*Chien courant, race de Vendée*]. (Salon of 1848)
Miller on the Road [*Le Meunier cheminant*]. (Salon of 1848)
Ox [*Boeuf*]. (Salon of 1848)
Bull [*Taureau*], bronze. (Salon of 1848)
Ewe [*Brebis*], bronze. (Salon of 1848)

1849 *Ploughing in the Nivernais* [*Le Labourage nivernais*]. (Salon of 1849). Musée d'Orsay, Paris (AH); copy by Rosa Bonheur dated 1850, John and Mable Ringling Museum of Art, Sarasota FL (RS & AH).

1850 *Morning Effect* [*Effet du matin*]. (Salon of 1850)
Sheep [*Moutons*]. (Salon of 1850)
Team of Nivernais Oxen [*Attelage de boeufs nivernais*].

1851 *Returning from the Fields* [*Retour des champs*]. Columbus Museum of Art, Columbus OH. (RS)
Souvenir of the Pyrenees [*Souvenir des Pyrénées*]. (Brussels Exhibition of 1851)
Cows and Sheep [*Vaches et moutons*]. (Brussels Exhibition of 1851)
Ox in the Mountains, Scene from Auvergne [*Boeuf à la montagne, vue prise en Auvergne*]. (Brussels Exhibition of 1851).
Three Brothers in Arms (three donkeys) [*Trois frères d'armes* (trois ânes)].
Grazing Scene in the Rhine Valley [*Pâturage dans la vallée du Rhin*].
Ploughing Scene [*Scene de labourage*]. Walters Art Gallery, Baltimore MD. (RS & AH)

1852 *Maternal Care* (cow and calf) [*Sollicitude maternelle*].
Wagon with Six Horses [*Le Chariot à six chevaux*].

1853 *The Horse Fair [Le Marché aux chevaux].* (Salon of 1853). Metropolitan Museum of Art, New York. This museum also has three undated studies for *The Horse Fair* in its collection. (RS & AH)
Brood Mares in the Morvan [Juments poulinières dans les plaines du Morvan].

1854 *Off to Market [Le Départ pour le marché].*
The Chalk Wagon [Le Tombereau de pierre à chaux en Limousin].
Sheep [Moutons].
Returning from the Fair [Retour de la foire].

1855 *Haymaking in Auvergne [La Fenaison (Auvergne)].* (Salon of 1855). R. W. Norton Art Gallery, Shreveport LA and the Musée de Fontainebleau, Fontainebleau, France. (RS)
Morning in Scotland [Matin en Ecosse].
Herd of Sheep [Troupeau de moutons].

1856 *Wasp* (Skye terrier).
Gathering for the Hunt [Rendez-vous de chasse]. Pioneer Museum and Haggin Galleries, Stockton CA. (RS)
Shepherd in the Pyrenees [Berger des Pyrénées].
Gascon Peasants Going to Market [Paysans landais allant au marché].
Resting in the Prairie (sheep) *[Le Repos dans la prairie (moutons)].*
Worry [Inquiétude].

1857 *Donkeydrivers of Aragon [Bourriquaires aragonais].* (Salon of 1867)
Morning in the Highlands [Le Matin dans les Highlands].
After Dinner [Après-dîner].

1858 *Souvenir of the Pyrenees, Cows and Sheep [Souvenir des Pyrénées, vaches et moutons].* (Brussels Exhibition of 1858)
Cow in the Mountains, Scene from Auvergne [Vache à la montagne, vue prise en Auvergne]. (Brussels Exhibition of 1858)
Denizens of the Highlands [Habitants des Highlands].
In the Landes [Dans les Landes].

1859 *Scottish Shepherd [Berger écossais].* (Salon of 1867)
Grooms Leading a Dog to Shelter [Piqueurs conduisant un chien au gîte].

1860 *Razzia, or Scottish Raid [La Razzia (Ecosse)].* (Salon of 1867)
Grazing Oxen and Sheep [Boeufs et moutons au pâturage]. (Chicago Exhibition of 1893)
Brittany Oxen [Boeufs bretons].
Resting Sheep, Sunset Effect [Moutons au repos, effet du coucher de soleil].
Brittany Shepherd and his Herd [Berger breton et son troupeau].
The Herd [Le Troupeau].

1861 *Ponies of the Isle of Skye [Poneys de l'île de Skye (Ecosse)].* (Salon of 1867)

Herd of Sheep [*Troupeau de moutons*]. An undated painting entitled *Sheep* is located at the Cleveland Museum of Art. (AH)

Ponies and Sheep by the Sea (Scotland) [*Poneys et moutons au bord de la mer (Ecosse)*].

Cows and Sheep by the Sea [*Vaches et moutons au bord de la mer*].

Lords of the Herd (Scottish Oxen) [*Les Chefs du troupeau* (boeufs d'Ecosse)].

Huntsmen Taking Hounds to Cover [*Chasseurs ramenant leurs chiens*].

Shetland Ponies [*Poneys des îles Shetland*].

1862 *Herd in the Pyrenees* [*Un Troupeau dans les Pyrénées*].

Shepherd in the Pyrenees [*Berger des Pyrénées*].

Shepherd's Dog [*Chien de berger*].

1863 *Deer Family* [*Une Famille de daims*].

Boat (Scotland), or *Sheep in a Boat* [*Une Barque (Ecosse)*, ou *Moutons dans la barque*.] (Salon of 1867). Under the title *Changement de paturage* at the Kunsthalle, Hamburg, Germany.

1865 *Sheep by the Sea* [*Moutons au bord de la mer*]. (Salon of 1867). National Museum of Women in the Arts, Washington DC. (AH)

Deer at Long Rocks [*Cerfs traversant un espace découvert*]. (Salon of 1867) Under the title: *A Family of Deer Crossing the Summit of the Long Rocks in the Forest of Fontainebleau*, John and Mable Ringling Museum of Art, Sarasota Fl. (RS)

1866 *Greyhound* [*Lévrier*].

Percheron Horse [*Cheval percheron*].

1867 *Andalusian Bulls* [*Taureaux andalous*]. Walters Art Gallery, Baltimore MD. (RS).

Oxen and Cows (Scotland) [*Boeufs et vaches* (Ecosse)]. (Salon of 1867)

Roes at Rest [*Chevreuils au repos*]. (Salon of 1867) Under the title: *Deer in Repose*, Detroit Art Institute. (RS & AH)

Bearnese Shepherd [*Berger béarnais*]. (Salon of 1867)

Stampede of Scottish Oxen [*Bousculade de boeufs écossais*].

Stags and Does at Long Rocks [*Cerfs et biches aux Long-Rochers*].

Stampede [*La Bousculade*].

The Straits of Ballachulish [*Le Détroit de Ballachulish*].

Fording the Stream (oxen and sheep) [*La Traversée du ruisseau* (boeufs et moutons)].

Maternal Affection [*Affection maternelle*].

Stag Listening to the Wind [*Cerf écoutant le vent*]. Loeb Art Center, Vassar College, Poughkeepsie NY.

1868 *In the Far West: Fighting Bulls* [*Dans le Far-West: Un Combat de taureaux*].

Saint Hubert's Stag [*Le Cerf de saint Hubert*].

Scottish Deer [*Cerfs écossais*].

1869 *Brittany Sheep* [*Moutons de Bretagne*].

Horses Tied Up [*Chevaux à l'attache*].

Two Studies of Dogs [*Etudes de chien*].

Dog's Head [*Tête de chien*]. Five works by this title are at the Musée des Beaux-Arts, Bordeaux, France.

1870 *The Lime Cart* [*Le Tombereau de pierres*].

Sheep in the Pyrenees [*Moutons aux Pyrénées*].

Recumbent Ram, Ewe and Sheep in the Pyrenees [*Bélier, brebis et moutons couchés dans les Pyrénées*].

Wounded Eagle [*Aigle blessé*]. Los Angeles County Museum of Art.

1871 *Brittany Oxen and Sheep* [*Boeufs et moutons de Bretagne*].

1872 *Basque Shepherd and His Herd* [*Berger basque et son troupeau*].

Dog and Sheep [*Chien et moutons*].

1873 *Returning from the Horse Fair* [*Le Retour du Marché aux chevaux*].

Oxen on the Long Rocks, Fontainebleau [*Les Boeufs sur les Longs Rochers, à Fontainebleau*].

Hasty Flight [*Une Fuite précipitée*].

Donkey in the Stable [*Ane dans l'étable*].

1874 *Pierrette* (study of a lioness) [*Pierrette* (étude de lionne).

1875 *Ploughing Scene* [*Labourage*].

The Charcoal Burners [*Les Charbonniers*].

1876 *Haymaking* [*La Fenaison*].

Off to Market [*En route pour le marché*].

Waiting (standing donkey in woods) [*L'Attente* (âne debout en forêt].

Goat in the Pyrenees [*Bouc des Pyrénées*].

In the Pyrenees: Cow and Her Calf [*Dans les Pyrénées: vache et son veau*].

A Foraging Party [*Famille des sangliers*].

1877 *Tiger in the Mountains* [*Tigre dans les grands monts*].

Horse and Cows Under an Oaktree [*Cheval et vaches sous un chêne*].

1878 **King of the Forest* [*Le Roi de la forêt*]. (Chicago Exhibition of 1893). Warner Collection of Gulf States Paper Corporation, Tuscaloosa AL. (RS)

Head of a Dog. University of Michigan Museum of Art, Ann Arbor. (RS)

Head of a Royal Tiger. (ca. 1878) Fine Arts Museums of San Francisco. (RS)

Humble servant [*Humble serviteur*].

Herd of Sheep [*Troupeau de moutons*].

1879 *Weaning the Calves* [*Le Sevrage des veaux*]. Metropolitan Museum of Art, New York. (RS)

*Young Prince (lion's head) [Un Jeune Prince (tête de lion)].
An Old Monarch (lion's head) [Un Vieux Monarque (tête de lion)].
Ready (dog's head) [Ready (tête de chien)].

1880 Off to Market [En route pour le marché].
Recumbent Bull [Taureau couché].
The Noble Charger [Le Vaillant Coursier].
A Norman Sire [Etalon normand].
An Old Pensioner (mule's head) [Le Vieil Invalide (tête de mulet)].

1881 Head of a Horse with Arabian Blood [Tête de cheval, croisement arabe]. (Brussels Exhibition of 1881)
Head of a Lion [Tête de lion]. (Brussels Exhibition of 1881)
Head of a Horse, Norman Half-breed [Tête de cheval, demi-sang norman]. (Brussels Exhibition of 1881)
A Sheep In Bramble [Mouton traversant un buisson de ronces].

1882 Seven Deer at Rest, Prairie Sunset [Sept cerfs au repos, soleil couchant en plaine].
Mountain Izard [Isard dans la montagne].
Hunting Dog [Chien de chasse].
Chamois [Le Chamois].

1883 Lord of the Herd [Le Roi du troupeau]. Smith Barney Corporate Art Collection, New York.
Stag on the Watch [Cerf aux aguets]. (ca. 1883) Fine Art Museums of San Francisco. (RS & AH)
Stag Under an Oaktree [Cerf couché sous un chêne].
Deer in the Forest, Sunset [Cerfs en forêt, crépuscule].
Stags and Doe in Woods; Snow [Cerfs et biche en forêt; neige].

1884 Rest (two oxen hitched to a plough) [Le Repos (deux boeufs à la charrue)].

1885 Cattle at Rest on a Hillside in the Alps. Art Institute of Chicago. (RS)
Deer at Rest [Cerfs au repos].
Team of Oxen at Rest [Attelée de boeufs au repos].
Resting Bull [Taureau au repos]. Sterling and Francine Clark Art Institute, Williamstown MA. (AH)
*Lion at Home [Le Lion chez lui]. Under the title: Royalty at Home, Minneapolis Institute of Art. (AH)

1886 Three Izards in the Pyrenees [Trois Isards dans les Pyrénées].
Hunting Break [Halte de chasse].
Two Horses in the Grass [Deux chevaux dans la prairie].
Bull in the Grass [Taureau dans la prairie].
Four Deer in the Woods [Quatre Cerfs dans la forêt].
The Herd [Le Troupeau].
Pride of the Forest [Splendeur de la forêt].

1887 *Deer on the Alert.* New Orleans Museum of Art. (RS)
 Relay Hunting. Saint Louis Art Museum, Saint Louis MO. (RS)
 Forest Relay of Three Saddle Horses [*Relais de trois chevaux de selle dans la forêt*].
 Deer on the Moor [*Cerfs dans la lande*].
 Stag [*Un Cerf*].
 Grazing Herd [*Troupeau au pâturage*].
 Lion Family [*Famille de lions*].
 Three Deer in the Clearing [*Trois cerfs dans la clairière*].
 Sheep [*Moutons*].
1888 *Izards in the Pyrenees* [*Isards des Pyrénées*].
 Herd of Sheep with Shepherd [*Troupeau de moutons et berger*].
 Deer at Rest [*Cerf au repos*].
 Cows and Calf [*Vaches et veau*].
 Cows and Oxen [*Vaches et boeufs*].
 Stagecoach, Nocturnal Effect [*La Diligence, effet de nuit*].
 Don Quixote and Sancho Panza [*Don Quichotte et Sancho Panza*].
1889 *Colonel William F. Cody.* Buffalo Bill Historical Center, Cody WY. (RS)
 In Auvergne [*En Auvergne*].
 Cart Pulled by Cows and Herdsman [*Charrette attelée de vaches, et bouvier*].
 Scottish Cattle at Rest [*Boeufs d'Ecosse couchés, à Glencoe*].
 Buffalo Hunt [*La Chasse aux bisons*].
1890 **Scottish Chiefs* [*Chefs écossais*].
 Team of Oxen [*Une Attelée de boeufs.*]
 Grazing Horses [*Chevaux au pâturage*].
 Herd of Cows [*Troupeau de vaches*]. At the Cincinnati Art Museum there is an undated painting entitled *Cowherd.* (RS)
 American Mustangs [*Mustangs américains*].
 Deer Coming to Drink [*Cerfs venant boire*].
 The Wyoming Stallion [*L'Etalon du Wyoming*].
1891 *Deer Herd at the Watering Place* [*Harde de cerfs à l'abreuvoir*].
 After the Storm in the Highlands [*Après la tempête dans les Highlands*].
 A Happy Mother [*Une Heureuse Mère*].
 Afternoon in Scotland [*Après-midi en Ecosse*].
 Freshly Shorn Ram and Ewe [*Bélier et brebis après la tonte*].
 Three Does and a Stag at Rest [*Trois Biches et un cerf au repos*].
 Deer Shelter in the Forest [*Remise des cerfs dans la forêt*].
1892 *Rams and Sheep* [*Béliers et moutons*].
 Scottish Sheep [*Moutons d'Ecosse*].
 Recumbent Stag [*Cerf à la reposée*]. At the Cleveland Museum of Art there is an undated painting entitled *Recumbent Stag.* (RS)

Head of a Dog [*Tête de chien de face*].

Head of a Dog [*Tête de chien de trois quarts*].

On Guard (four recumbent lions) [*Sur le qui-vive* (quatre lions couchés)].

1893 *Two Horses.* The Philadelphia Museum of Art. (RS)

Sheep in the Region of Berry [*Moutons du Berry*].

A Couple of Roes, Winter Effect [*Un Couple de Chevreuils, effet d'hiver*].

1894 *Ox* [*Un Boeuf*].

Cattle and Sheep in Scotland [*Boeufs et moutons d'Ecosse*].

The White Cow [*La Vache Blanche*].

1895 **Duel* [*Le Duel*]. Warner Collection of Gulf States Paper Corporation, Tuscaloosa AL. (RS)

Two Oxen [*Deux boeufs*].

Nubian Lion at Rest [*Lion de Nubie au repos*].

Cart with Two Oxen [*Voiture avec deux boeufs*].

Stag [*Un Cerf*].

The Lion Cubs' Repast [*Le Repas des lionceaux*].

Donkey in an Orchard [*Ane dans un verger*].

Deer in the Forest [*Cerf dans la forêt*].

Couple of Roes [*Couple de chevreuils*].

Lioness, Lion, and Two Cubs Devouring a Doe [*Lionne, Lion, et deux lionceaux dévourant une biche*].

1896 *Donkey* [*Ane*].

Cows at Rest [*Vaches au repos*].

1897 **Stag in Fog* [*Cerf dans la brume*].

Bébé, My Favorite Horse [*Bébé, mon préféré*].

Stags and Does in the Underbrush [*Cerfs et biches sous bois*].

Deer in the Woods, Autumn Effect [*Cerf dans un bois, effet d'automne*].

Bringing in the Hay [*La Rentree des foins*].

Moonlight. Herd of Sheep in the Pyrenees [*Clair de lune. Troupeau de moutons dans les Pyrénées*].

The Deer, Morning Effect [*Les Cerfs, effet du matin*].

Emigrating Buffaloes [*Emigration de bisons*].

1898 *Cows and Bull in Auvergne* [*Vaches et taureau d'Auvergne*]. (Salon of 1899)

Horse [*Cheval*].

Seven Oxen Up High [*Sept boeufs sur une hauteur*].

1899 *Man and Woman on Horseback in Auvergne* [*Cavaliers d'Auvergne: homme et femme à cheval*].

Barbaro after the Hunt. Philadelphia Museum of Art. (RS & AH)

Barney. Forbes Magazine Collection, New York. (AH)

Sheep Pen [*Bergerie*]. Sterling and Francine Clark Art Institute, Williamstown MA.

Black Sheep. Portland Art Museum, Portland OR. (RS)

**Buffaloes in Snow* [*Bisons dans la neige*].

**Buffaloes Fleeing a Fire* [*Bisons fuyant l'incendie*].

Conversation. Walters Art Gallery, Baltimore. (RS)

**Crossing Loch Loden* [*La Traversée du Loch Loden*].

Does at Rest. Currier Gallery of Art, Manchester, NH. (RS)

Ewe Grazing, bronze. R. W. Norton Art Gallery, Shreveport LA. (RS & AH)

Farmyard. Cleveland Museum of Art. (AH)

Harvest Season. Pioneer Museum and Haggin Galleries, Stockton CA. (RS)

Head of a Bull. Brooklyn Museum, Brooklyn NY. (RS & AH)

King of the Desert. Forbes Magazine Collection, New York. (AH)

Limier Briquet Hound. Metropolitan Museum of Art, New York. (RS & AH)

Lion Cubs, Bowdoin College Museum of Art, Bowdoin ME.

Lioness's Heads. Fine Art Museums of San Francisco. (RS)

**Oxen and Bulls of Auvergne* [*Boeufs et taureaux d'Auvergne*].

**Oxen in the Highlands* [*Boeufs dans les Highlands*].

**Pastorale* [*Pastorale*]. An undated painting entitled *Pastorale—Landscape with Cattle* is located at the Philadelphia Museum of Art. (RS)

**Red Oxen* [*Boeufs rouges*].

**Saint George* [*Saint Georges*].

**Scottish Cows* [*Vaches écossaises*].

She-Goat. Isabella Stewart Gardner Museum, Boston. (RS)

**Sheepfold* [*Parc aux moutons*].

Studies of a Lioness. Sterling and Francine Clark Art Institute, Williamstown MA.

Steers at the Gate. Tweed Museum of the University of Minnesota at Duluth. (RS)

Study of a Cow. Chrysler Museum, Norfolk VA. (AH)

Study of a Dog. Art Museum of Princeton University, Princeton NJ. (RS)

Study of a Lion's Head. Sterling and Francine Clark Art Institute, Williamstown MA. (RS & AH)

Study of Lions. Vizcaya Museum, Miami FL. (AH)

Study of Two Male Figures. The Fine Art Museums of San Francisco. (RS & AH)

**Treading Wheat [La Foulaison du blé en Camargue].* Musée de Fontainebleau, Fontainebleau, France. (RS)

Two Goats. Milwaukee Art Center. (RS)

Two Horses. Tweed Museum of the University of Minnesota at Duluth. (RS)

** White Horse.* Art Museum of Princeton University, Princeton NJ. (RS)

** Wild Boars [Sangliers].*

** Wild Horses [Chevaux sauvages].*

** Wild Horses in the Far West [Chevaux sauvages dans le Far West].*

Selected Works of Anna Klumpke

Like the works of Rosa Bonheur, the majority of Anna Klumpke's oil
paintings and pastels are in private hands and inaccessible to the public.

The following is a selection of her works in collections available to the
public. Dates of composition are recorded in parentheses if available.

While compiling this list, I received the generous and expert assistance
of Dr. Britta C. Dwyer, University of Pittsburgh.

1895 *Portrait* (sketch) *of Sarah Whitin* (ca. 1895). Wellesley College, Wellesley MA.

1886 *French Peasant Girl.* Alan and Louise Sellars Collection, Marietta GA.
 Portrait of Elizabeth Cady Stanton. Smithsonian Institution, National Portrait Gallery, Washington DC.

1888 *In the Wash-house.* Pennsylvania Academy of the Fine Arts, Philadelphia.

1891 *Child with a Doll.* National Park Service, Longfellow National Historic Site, Cambridge MA.
 Mother and Son. New Hampshire Historical Society, Concord NH.
 Portrait of Mrs. Ira de Ver Warner (Lucetta M. Greenman) (1891). Fairfield Historical Society, Fairfield CT.

1893 *Girl in a Field.* Sotheby Parke Barnet. New York.

1895 *Portrait of Nancy S. Foster* (ca. 1895). Foster Hall, University of Chicago.

1898 *Portrait of Mary Sophia Walker.* Bowdoin College Museum of Art, Brunswick ME.
 Portrait of Rosa Bonheur. Metropolitan Museum of Art, New York.
 Rosa Bonheur, Study for a Portrait. Bowdoin College Museum of Art, Brunswick ME.

1899 *Portrait of Rosa Bonheur with Charley.* Musée de Fontainebleau, Fontainebleau, France.

1902 *Portrait of Rosa Bonheur in Studio.* Rosa Bonheur Museum, Thomery, France.

1908 *Cossette in the Woods.* Fine Arts Museums of San Francisco.

1909 *Among the Lilies.* Fine Arts Museums of San Francisco.

1910 *The Breeze.* Fine Arts Museums of San Francisco.

1919 *Vive La France et l'Amérique.* Fine Art Museums of San Francisco.

Selected Works of Anna Klumpke

Undated Works

Portrait of Mrs. Hugh Reid Griffin. General Federation of Women's Clubs, Washington DC.
Portrait of the Artist's Father. Fine Arts Museums of San Francisco.

SELECTED BIBLIOGRAPHY

Please note: The items preceded by an asterisk were included in the bibliography that Anna Klumpke appended to the original text.

Alesson, Jean. *Les Femmes décorées de la Légion d'honneur et les femmes militaires.* Paris: G. Melet, 1886.

Ashton, Dore, and Denise Browne Hare. *Rosa Bonheur: A Life and a Legend.* New York: Viking Press, 1981.

*Augé de Lassus, L. "Rosa Bonheur." *Revue de l'art* 8 (May 1900).

*Bentzon, Th. "Rosa Bonheur." *Outlook* (New York), May 6, 1899.

Boime, Albert. "The Case of Rosa Bonheur: Why Should a Woman Want to Be More Like a Man?" *Art History* 4, no. 4 (December 1981): 384–409.

*Bonheur, Rosa. "The Story of My Life." *Ladies' Home Journal,* December 1896.

*Bonnefon, Paul. *Artistes contemporains des pays de Guyenne, Saintonge et Languedoc. Rosa Bonheur.* Bordeaux: Gounouilhou, 1889.

*———. "Une Famille d'artistes: Raimond Bonheur et Rosa Bonheur." *L'Art,* 3d series, 3–4, 1904.

*Bonnefont, Pierre. *Nos grandes Françaises, Rosa Bonheur.* Paris: Gedalge, 1893.

Brice, Raoul. *La Femme et les armées de la Révolution et de l'Empire (1792–1815, d'après des mémoires, correspondances et documents inédits.)* Paris: L'Edition Moderne, 1913.

*Cain, G. "Rosa Bonheur." *Revue Illustrée,* July 1, 1897.

*Cantrel, E. "Mlle. Rosa Bonheur." *L'Artiste* 8 (September 1, 1859), 5.

Carlisle, Robert B. *The Proffered Crown: Saint-Simonianism and the Doctrine of Hope.* Baltimore: Johns Hopkins University Press, 1987.

Chadwick, Whitney. *Women, Art, and Society.* London: Thames and Hudson, 1990.

Charléty, Sébastien. *Histoire du Saint-Simonisme.* Paris, 1896. Reprint. Paris: Paul Hartmann, 1931.

*Claretie, J. "Rosa Bonheur; an appreciation." *Harper's Magazine* (London), December 1901.

*Clement, Clara Erskine, and Laurence Hutton. *Artists of the Nineteenth Century and Their Works.* Boston: Houghton, Mifflin, 1884.

Crastre, Fr. *Rosa Bonheur, Huit Reproductions Facsimile en Couleurs.* Les Peintres Illustres. Paris: Pierre Lafitte et Cie., n.d.

*Delbarre, P. "Rosa Bonheur." *Revue de la France moderne,* 1899.

*Demont-Breton, Virginie. "Rosa Bonheur." *Revue des Revues,* June 15, 1899.

Digne, Danielle. *Rosa Bonheur ou l'insolence: L'Histoire d'une vie, 1822–1899.* Collection "Femme." Paris: Denoël/Gonthier, 1980.

Dunford, Penny. *A Biographical Dictionary of Women Artists in Europe and America since 1850*. Philadelphia: University of Pennsylvania Press, 1989.

Dwyer, Britta C. "Anna Elizabeth Klumpke." *Iris* 13, no. 1 (summer 1993): 33–35.

———. "Anna Elizabeth Klumpke: A *Salon* Artist *Par Excellence*" *Revue française d'études américaines*, 59 (February 1994): 11–23.

Fine, Elsa Honig. *Women and Art: A History of Women Painters and Sculptors from the Renaissance to the Twentieth Century*. Montclair, NJ: Allanfield and Schram, 1978.

Flobert, Laure-Paul. *La Femme et le costume masculin*. Lille: Imprimerie Lefebvre-Ducrocq, 1911.

*Fould Consuelo, Mme. "Rosa Bonheur (souvenirs)." *Revue Illustrée*, November 1, 1899.

*Front, V., ed., *Panthéon des Illustrations françaises du XIXè siècle*. Paris: Pilon, 1865.

Garb, Tamar. *Sisters of the Brush: Women's Artistic Culture in Nineteenth-Century Paris*. New Haven: Yale University Press, 1994.

Grand-Carteret, John. *La Femme en culotte*. Paris: Flammarion, 1899.

Greer, Germaine. *The Obstacle Race: The Fortunes of Women Painters and Their Work*. New York: Farrar, Straus and Giroux, 1979.

———. "'A tout prix devenir quelqu'un': The Women of the Académie Julian." In *Artistic Relations: Literature and the Visual Arts in Nineteenth-Century France*, ed. Peter Collier and Robert Lethbridge. New Haven: Yale University Press, 1994.

Gubar, Susan. "Blessings in Disguise: Cross-dressing as Re-dressing for Female Modernists." *Massachusetts Review*, autumn 1981, 477–508.

Gutwirth, Madelyn. "The Taming of Rosa Bonheur." Unpublished paper.

Harris, Ann Sutherland, and Linda Nochlin. *Women Artists, 1550–1950*. New York: Knopf, 1977.

Heller, Nancy G. *Women Artists: An Illustrated History*. New York: Abbeville Press, 1987.

*Hervier, P.-L. "Lettres inédites de Rosa Bonheur." *Nouvelle Revue*, January 15, 1908.

*Hirsch, A. *Die Bildenden Künstlerrinen des Neuzeit. Rosa Bonheur*. Stuttgart: Euke, 1905.

*Hubbard, Elbert. *Little Journeys to the Homes of Famous Women. Rosa Bonheur*. London: Putnam's Sons, 1897.

Klumpke, Anna Elizabeth. *Memoirs of an Artist*. Ed. Lilian Whiting. Boston: Wright and Potter Publishing Co., 1940.

———. *Rosa Bonheur; sa vie, son oeuvre*. Paris: Flammarion, 1908.

Larousse, Pierre, ed. *Grand Larousse universel du dix-neuvième siècle*. Paris: Larousse, 1866–76.

*Lepelle de Bois-Gallais, F. *Biographie de Mademoiselle Rosa Bonheur*. Paris: Gambart, 1856.

Levy, Darlene Gay, and Harriet B. Applewhite. "Women and Militant Citizenship in Revolutionary Paris." In *Rebel Daughters: Women and the French Revolution*, ed. Sara E. Melzer and Leslie W. Rabine. New York: Oxford University Press, 1992.

*M. V. "L'Atelier de Rosa Bonheur." *Gazette des Beaux-Arts* 23 (May 1900).

Manuel, Frank. *The New World of Henri Saint-Simon*. Cambridge: Harvard University Press, 1956.

———. *The Prophets of Paris*. Cambridge: Harvard University Press, 1962.

Manuel, Frank, and Fritzie Manuel. *Utopian Thought in the Western World*. Cambridge: Harvard University Press, 1979.

*Mirecourt, Eugène de. *Les Contemporains. Rosa Bonheur*. Paris: Havard, 1856.

*Montrosier, E. *Les Chefs-d'oeuvre d'art au Luxembourg*. Paris: Baschet, 1881.

*———. *Grands Peintres français et étrangers. Rosa Bonheur*. Paris: Launette et Goupil, 1880.

Moses, Claire Goldberg. *French Feminism in the Nineteenth Century*. Albany: State University of New York Press, 1984.

Moses, Claire Goldberg, and Leslie Wahl Rabine. *Feminism, Socialism, and French Romanticism*. Bloomington: Indiana University Press, 1993.

Nochlin, Linda. *Women, Art, and Power and Other Essays*. New York: Harper and Row, 1988.

Nochlin, Linda, and Ann Sutherland. *Women Artists, 1550–1950*. New York: Knopf, 1977.

*Perraud de Toury, E. "Notice biographique sur Mlle. Rosa Bonheur." In *Musée biographique, Panthéon Universel*. Paris, 1855.

Petersen, Karen, and J. J. Wilson. *Women Artists: Recognition and Reappraisal from the Early Middle Ages to the Twentieth Century*. New York: Harper Colophon, 1976.

*Peyrol, René. "Rosa Bonheur, her life and work." Trans. J. Finden Brown. *Art Annual* (London), 1889.

Radycki, J. Diane. "The Life of Lady Art Students: Changing Art Education at the Turn of the Century." *Art Journal*, spring 1982, 9–13.

*Roger-Milès, L. *Atelier Rosa Bonheur*. 2 vols. Paris: Georges Petit, 1900.

*———. *Rosa Bonheur, sa vie, son oeuvre*. Paris: Société d'édition artistique, 1900.

Rostand, Edmond. *Cyrano de Bergerac*. Trans. Helen B. Dole. New York: Three Sirens Press, 1931.

Shriver, Rosalie. *Rosa Bonheur, with a checklist of Works in American Collections*. Philadelphia: Art Alliance Press, 1982.

Slatkine, Wendy. *Women Artists from Antiquity to the Twentieth Century*. Englewood Cliffs, NJ: Prentice-Hall, 1985.

Stanton, Theodore. *Reminiscences of Rosa Bonheur*. New York: Appleton, 1910. Reprint. New York: Hacker Art Books, 1976.

Steele, Valerie. *Paris Fashion: A Cultural History.* New York: Oxford University Press, 1988.

van Slyke, Gretchen. "Addressing the Self: Costume, Gender, and Autobiographical Discourse in l'Abbe de Choisy and Rosa Bonheur." In *Autobiography, Historiography, Rhetoric: A Festschrift in Honor of Frank Paul Bowman,* ed. Mary Donaldson-Evans, Lucienne Frappier-Mazur, and Gerald Prince. Amsterdam: Rodopi, 1994, 287–302.

———. "L'Autobiographie de Rosa Bonheur: Un testament matrimonial." *Romantisme* 85, no. 3 (1994): 37–45.

———. "Does Genius Have a Sex? Rosa Bonheur's Reply." *French-American Review* 63, no. 2 (winter 1992): 12–23.

———. "Rebuilding the Bastille: Women's Dress-Code Legislation in Nineteenth-Century France." In *Repression and Expression: Literary and Social Coding in Nineteenth-Century France,* ed. Carrol Coates. New York: Peter Lang, 1996: 209–19.

———. "Reinventing Matrimony: Rosa Bonheur, Her Mother, and Her Friends." *Women's Studies Quarterly* 19, nos. 3–4 (fall–winter 1991): 59–77.

———. "Who Wears the Pants Here? The Policing of Women's Dress in Nineteenth-Century England, Germany, and France." *Nineteeth-Century Contexts* 17, no. 1 (winter 1993): 17–33.

———. "Women at War: Skirting the Issue in the French Revolution." Forthcoming in *L'Esprit Créateur,* 1997.

Waters, Clara Eskine Clement. *Women in the Fine Arts.* Boston: Houghton, Mifflin, 1904. Reprint. Boston: Longwood Press, 1978.

Weber, Eugen. *France: Fin de Siècle.* Cambridge: Harvard University Press, 1986.

Yeldham, Charlotte. *Women Artists in Nineteenth-Century France and England.* 2 vols. New York: Garland Publishing, 1984.

INDEX

Rosa Bonheur—masculine attire: xi, xxxi–xxxvi, 8, 12–13, 19–20, 22, 31, 34, 58–60, 77, 79, 105, 113, 137–38, 169, 171–72, 177, 180, 186–87, 191, 193, 204–6, 222, 247

Rosa Bonheur—opinions on marriage: xvii–xviii, xxxii, 10, 21, 101, 136–37, 188, 202, 206–7

Rosa Bonheur—works discussed in this volume: *Béarnese Shepherd,* 175; *Boat,* or *Sheep in a Boat,* 152, 175; *Buffaloes Fleeing a Fire,* 13–14, 24; *Buffaloes in Snow,* 55–56; *Cows and Sheep,* 145, 150; *Crossing Loch Loden,* 152; *Deer at Long Rocks,* 169, 175; *Donkey Drivers of Aragon,* 175; *Duel,* 20–21, 227; *Goats and Sheep,* 120; *Haymaking in Auvergne,* 36, 149–51, 166, 174–75, 243; *Horse Fair,* xi–xii, 5, 13, 69, 147–53, 162, 175–76, 213, 217, 236, 243, 260; *King of the Forest,* 13, 40, 194, 260; *Lion at Home,* 13; *Miller on the Road,* 123, 128; *Off to Market,* 123; *Oxen and Bulls of Auvergne,* 47, 223, 236–39; *Oxen and Cows,* 175; *Oxen in the Highlands,* 23, 152, 217; *Pastoral,* 194; *Ploughing,* 122; *Ploughing in the Nivernais,* xi, xxiii, 36, 45–47, 128, 130, 132–35, 148, 240, 242–44, 258, 260; *Ponies of the Isle of Skye,* 175; *Razzia,* 152, 175; *Red Oxen,* 56–57, 62, 66; *Roes at Rest,* 175; *Saint George,* 13; *Scottish Cows,* 175; *Scottish Chiefs,* or *Scottish Oxen,* 193, 217, 243; *Scottish Shepherd,* 15–16, 175; *Sheep,* 145, 194; *Sheep by the Sea,* 169–70, 174–75; *Sheepfold,* 55–56; *Shepherd in the Pyrenees,* 167; *Stag in Fog,* 55–56; *Stampede of Scottish Oxen,* 13, 152, 194, 217; *Treading Wheat,* 10, 13, 48, 52, 69, 213–17, 222, 229, 236, 239, 245, 248–49, 258; *Two Rabbits,* 120, 192; *White Horse,* 21–22, 29, 45; *The Wild Boars,* 40; *Wild Horses,* 71; *Wild Horses in the Far West,* 24; *Young Prince,* 229

II. Klumpke family

Klumpke family circle: Déjerine, Dr. Jules, 73, 251; Klumpke, Augusta (Mrs. Jules Déjerine), xi–xii, 10, 71, 252, 264–5; Klumpke, Dorothea (Mrs. Isaac Roberts), xi–xii, 10, 17–18, 73, 264–65; Klumpke, Mrs. Dorothea, xi–xii, xxviii–xxix, 10, 12, 14–15, 18–20, 30, 50–51, 54, 59, 64–65, 68, 70–75, 222, 234–35, 247, 249, 251, 265; Klumpke, Julia, xi–xii, 248, 252, 264–65; Klumpke, Mathilde (Mrs. Dalton), xi–xii, 17, 249

Anna Klumpke's friends, patrons, and buyers: Foster, Nancy, 21; Miller, Douglas family, 27–28, 34; Stanton, Elizabeth Cady, xvii; Thaw, Mrs. William, 4, 22–23, 30, 33; Walker, Sophie, 21–23, 29, 45

III. Micas family

Micas, Mme, xx, xxiv–xxxi, xxviii, 14, 63, 72, 114–15, 118, 124–27, 136–45, 152–58, 163–65, 174, 185–86, 230, 234–35, 242, 246–47,